Black and Blur

consent not to be a single being

Black and Blur

FRED MOTEN

DUKE UNIVERSITY PRESS DURHAM AND LONDON 2017

© 2017 Duke University Press
All rights reserved
Printed in the United States of America on
acid-free paper ∞
Designed by Amy Ruth Buchanan
Typeset in Miller Text by Westchester
Publishing Services

Library of Congress Cataloging-in-
Publication Data
Names: Moten, Fred, author.
Title: Black and blur / Fred Moten.
Description: Durham : Duke University
Press, 2017. | Series: Consent not to be a
single being ; v. [1] | Includes bibliographical
references and index.
Identifiers: LCCN 2017024176 (print) |
LCCN 2017039278 (ebook)
ISBN 9780822372226 (ebook)
ISBN 9780822370062 (hardcover : alk. paper)
ISBN 9780822370161 (pbk. : alk. paper)
Subjects: LCSH: Blacks—Race identity—
United States. | African Americans—Race
identity. | African diaspora.
Classification: LCC E185.625 (ebook) |
LCC E185.625 .M684 2017 (print) |
DDC 305.896/073—dc23
LC record available at https://lccn.loc.gov
/2017024176

Cover art: Harold Mendez, *but I sound
better since you cut my throat*, 2013–2014.
Digital print transferred from unique
pinhole photograph. 20″ x 24″. Courtesy
of the artist.

CONTENTS

PREFACE

The essays in *Black and Blur* attempt a particular kind of failure, trying hard not to succeed in some final and complete determination either of themselves or of their aim, blackness, which is, but so serially and variously, that it is given nowhere as emphatically as in rituals of renomination, when the given is all but immediately taken away. Such predication is, as Nathaniel Mackey says, "unremitting"—a constant economy and mechanics of fugitive making where the subject is hopelessly troubled by, in being emphatically detached from, the action whose agent it is supposed to be.[1] Indeed, our resistant, relentlessly impossible object is subjectless predication, subjectless escape, escape from subjection, in and through the paralegal flaw that animates and exhausts the language of ontology. Constant escape is an ode to impurity, an obliteration of the last word. We remain to insist upon this errant, interstitial insistence, an activity that is, from the perspective that believes in perspective, at best, occult and, at worst, obscene. These essays aim for that insistence at its best and at its worst as it is given in objects that won't be objects after all.

In its primary concern with art, *Black and Blur* takes up where *In the Break: The Aesthetics of the Black Radical Tradition* leaves off.[2] *In the Break* was my first book and is, therefore, the cause and the object of a great deal of agony. For instance, I suffered, and continue to suffer, over the first sentence, which I can't repeat because it was meant to be second. I can only tell you what the first sentence was supposed to be: "Performance is the resistance of the object." Sadly, agony over the absence of the right sentence is not lessened when I consider that there is something wrong with it, and when I recognize that most of the writing collected in *Black and Blur*—and its companion volumes, *Stolen Life* and *The Universal Machine*—attempts to figure out what's wrong with it and, moreover, to understand the relationship between the devotional practice that is given in recitation of the sentence "blackness is x" and the analytic practice that moves to place under

an ineradicable erasure the terms *performance* and *object*. There is a rich, rigorous, powerful, and utterly necessary analytic of anti-blackness that enables that devotional practice. But to be committed to the anti- and ante-categorical predication of blackness—even as such engagement moves by way of what Mackey also calls "an eruptive critique of predication's rickety spin rewound as endowment," even in order to seek the anticipatory changes that evade what Saidiya Hartman calls "the incompatible predications of the freed"—is to subordinate, by a measure so small that it constitutes measure's eclipse, the critical analysis of anti-blackness to the celebratory analysis of blackness.[3] To celebrate is to solemnify, in practice. This is done not to avoid or ameliorate the hard truths of anti-blackness but in the service of its violent eradication. There is an open set of sentences of the kind blackness is x and we should chant them all, not only for and in the residual critique of mastery such chanting bears but also in devoted instantiation, sustenance and defense of the irregular. What is endowment that it can be rewound? What is it to rewind the given? What is it to wound it? What is it to be given to this wounding and rewinding? Mobilized in predication, blackness mobilizes predication not only against but also before itself.

The great importance of Hartman's work is given, in part, in its framing and amplification of the question concerning the weight of anti-blackness in and upon the general project of black study. It allows and requires us to consider the relation of anti-blackness as an object of study—if there is relation and if it is the object—to the aim of her, and our, work. Any such consideration must be concerned with how blackness bears what Hartman calls the "diffusion" of the terror of anti-blackness. For me, this question of bearing is also crucial and *In the Break* is a preliminary attempt to form it. Subordination is not detachment. Disappearance is not absence. If blackness will have never been thought when detached from anti-blackness, neither will anti-blackness have been thought outside the facticity of blackness as anti-blackness's spur and anticipation; moreover, neither blackness nor anti-blackness are to be seen beneath the appearances that tell of them. The interinanimation of thinking and writing collected here might be characterized as a kind of dualism, but I hope it would be better understood by way of some tarrying with Hartman's notion of diffusion, which is inseparable from a certain notion of apposition conceived of not as therapy but alternative operation.

In my attempt to amplify and understand the scream of Frederick Douglass's Aunt Hester, which he recalls and reconfigures throughout his body of

autobiographical work in successive iterations of the brutal sexual violence to which it violently and aninaugurally responds, I began to consider that the scream's content is not simply unrepresentable but instantiates, rather, an alternative to representation. Such consideration does no such thing as empty the scream of content. It makes no such gesture. Rather, it seeks after what the scream contains (and pours out), and after the way that content is passed on—too terribly and too beautifully—in black art. In seeking after that content and its irrepressible outpouring, distance from the vicious seriality of Aunt Hester's rape, and the general "theft of the body," in Hortense Spillers's terms, it can be said to (dis)embody, is impossible.[4] Any such distance could only ever be an absolute nearness, an absolute proximity, which a certain invocation of suture might approach, but with great imprecision. Black art neither sutures nor is sutured to trauma. There's no remembering, no healing. There is, rather, a perpetual cutting, a constancy of expansive and enfolding rupture and wound, a rewind that tends to exhaust the metaphysics upon which the idea of redress is grounded. That trauma—or, more precisely the materiality of her violation and of the violence that makes that beating possible and legible and, in the view of the violator, necessary—is carried in and transmitted by Aunt Hester's scream as a fundamental aspect of its own most ineluctable and irresistible sharpness and serration. This bearing and transmission are irreducible in the scream even if the scream is irreducible to them. Aunt Hester's scream cannot be emptied of the content it pours out in excess and disruption of meaning, of the modality of subjectivity or subjective embodiment that makes and interprets meaning, and of the sense of world or spatiotemporal coherence or global positioning or proprioceptive coordination that constitutes what Amiri Baraka might call the "place/meant" of possessed and/or possessive individuation. Aunt Hester's scream is flesh's dispossessive share and sharing, and the question, really, for those who attend to it, is whether it is enough. My tendency is to believe that in the material spirit of its absolute poverty, Aunt Hester's scream is optimal, as absolute wealth. Where some might see in my analysis a decoupling of her scream from the context of violence, I think of myself as having tried, and in the intervening years having continued to try, to forward a broader, richer, and more detailed understanding of that context. Not only are Aunt Hester's scream and its content themselves uncontained by the boundaries that emerge in the relay between self, world, and representation but the violent context of that scream and its content, and the very content of violence itself, are so uncontained, as well. *In the Break* was a preliminary report on

my attempt to study the nature of this uncontainment of and in content. Somehow, in extension of that study, *Black and Blur* manages to be more preliminary still.

I remain convinced that Aunt Hester's scream is diffused in but not diluted by black music in particular and black art in general. But if this is so it is because her rape, as well as Douglass's various representations of it, is an aesthetic act. Evidently, the violent art of anti-blackness isn't hard to master. My concern, however, is with the violence to which that violent art responds—a necessarily prior consent, an unremitting predication, the practice of an environment that is reducible neither to an act nor to its agent. This brushes up against the question of what the terms *diffusion* and *celebration* bear and is, therefore, a question for Hartman, who writes:

> Therefore, rather than try to convey the routinized violence of slavery and its aftermath through invocations of the shocking and the terrible, I have chosen to look elsewhere and consider those scenes in which terror can hardly be discerned—slaves dancing in the quarters, the outrageous darky antics of the minstrel stage, the constitution of humanity in slave law, and the fashioning of the self-possessed individual. By defamiliarizing the familiar, I hope to illuminate the terror of the mundane and quotidian rather than exploit the shocking spectacle. What concerns me here is the *diffusion of terror* [Moten's emphasis] and the violence perpetrated under the rubric of pleasure, paternalism and property. Consequently, the scenes of subjection examined here focus on the enactment of subjugation and the constitution of the subject and include the blows delivered to Topsy and Zip coon on the popular stage, slaves coerced to dance in the marketplace, the simulation of will in slave law, the fashioning of identity, and the process of individuation and normalization.[5]

In the Break also began with an attempt to engage Hartman; as you can see, I can't get started any other way. What I can say more clearly here than I did there is that I have no difference with Hartman that is not already given in and by Hartman. It is her work, for instance, which requires our skepticism regarding any opposition between the mundane and quotidian, on the one hand, and the shocking and spectacular, on the other, not only at the level of their effects but at the level of their attendant affects as well. Similarly, violence perpetrated under the rubric of pleasure demands our study not just because its commission is in relation to paternalism and property

but also because anticipatorily alternative modalities of such violence in-duce paternalism and property as regulatory modes of response. If the slave owner's enjoyment of enslaved song and dance is rightly to be understood as a mode of violent appropriation it can only adequately be so understood alongside the fact of the expropriative, radically improper violence that is held in and pours out from song and dance in blackness. Because the terror that infuses black music "can hardly be discerned," say, in Louis Armstrong's extraordinary rendition of "What a Wonderful World," I thought, in *In the Break*, I would talk about it via Max Roach's and Abbey Lincoln's "Triptych." The point was precisely to follow Hartman in her concern for the diffusion of terror. Indeed, I have been trying critically to understand and also creatively to augment that diffusion. This is to say, more generally, that my work, in bent echo of Hartman and Spillers, of Denise Ferreira da Silva and Laura Harris, is invested in the analysis, preservation, and diffusion of the violent "affectability" of "the aesthetic sociality of blackness," to which the violence of the slave owner/settler responds and to whose regulatory and reactionary violence it responds, in anticipation.[6] For some, diffusion might mean some-thing like the process by which molecules intermingle; or maybe it means something like the net movement of molecules from an area of high to one of low concentration, thereby signaling dilution. My willingness to claim the term, to express my own concern with it, holds out (for) something other than either of these. It does so by way of, and in thinking along with, Hartman. With regard to the matter in question, first of all, the violence of which we speak is non-particulate, which is to say that it is not a matter of its intermin-gling with some imagined counterpart or moving from a state of high concen-tration to low. The concentration is both constant and incalculable precisely in its being non-particulate. At stake is an ambience that is both more and less than atmospheric. In this regard, diffusion might be said imprecisely to name something that the intersection of gravitation and non-locality only slightly less imprecisely names. It is a pouring forth, a holding or spreading out, or a running over that never runs out and is never over; a disbursal more than a dispersal; a funding that is not so much founding as continual finding of that which is never lost in being lost. It is the terrible preparation of a table for a feast of burial and ascension. Neither the violence nor the suffering it induces, nor the alternative to that violence that anticipates even while it can-not but bear that violence, are submissive to the normative ethical calculus from whose exterior some propose to speak, as dissident or supplicant, advo-cate or prosecutor, in the classic, (self-)righteous, unavoidably contradictory

and neurotic stance of the impossible subjectivity that is our accursed share. Against the grain of that stance, which always laments standing from outside of and in opposition to its framework, black art, or the predication of blackness, is not avoidance but immersion, not aggrandizement but an absolute humility.

Hartman writes, with great precision, "The event of captivity and enslavement engenders the necessity of redress, the inevitability of its failure, and the constancy of repetition yielded by this failure."[7] But here's the thing. The event of captivity and enslavement is not an event. *Event* isn't even close to being the right word for this unremitting non-remittance, as Hartman's own writing shows and proves. This formulation is testament to the ways she exhausts the language and conceptual apparatuses with which she was given to work. Precisely because she establishes with such clarity that slavery conditions an aftermath that bears it, an afterlife that extends it, Hartman uses up the word *event*. There's nothing left of it, nothing left in it for us. Moreover, the ubiquity of such exhaustion in her work is why faithful reading of Hartman's must be deviant. Her work, it seems to me, is for building, rather than scolding, that deviance. In this regard, the notion of time that underwrites the very idea of the event is also offline. *Event*, here, is fantasmatic in a way that Hartman teaches us to understand when she teaches us to ask: "What if the presumed endowments of man—*conscience, sentiment,* and *reason*—rather than assuring liberty or negating slavery acted to yoke slavery and freedom?"[8] Here, again, in her very invocation of them, Hartman establishes for us that none of the terms she deploys are adequate. When slavery is understood to have always been yoked to freedom all throughout the history of man; when (the so-called free) man's yoking to the figure of the slave is also, of necessity, understood to be yoked to his struggle against the free man for his freedom (and the ambiguity of "his" is, here, intentional), then what we're talking about is better, if still inadequately, understood as durational field rather than event. Some may want to invoke the notion of the traumatic event and its repetition in order to preserve the appeal to the very idea of redress even after it is shown to be impossible. This is the aporia that some might think I seek to fill and forget by invoking black art. Jazz does not disappear the problem; it *is* the problem, and will not disappear. It is, moreover, the problem's diffusion, which is to say that what it thereby brings into relief is the very idea of the problem. Is a problem that can't be solved still a problem? Is an aporia a problem or, in fact, an avoidance of the problem, a philosophically induced conundrum predicated upon certain metaphysical and mechanical assump-

tions that cannot be justified? Let's imagine that the latter is true. Then, this absent problem, which disappears in what appears to be inhabitation of the problem of redress, *is the problem of the alternative* whose emergence is not in redress's impossibility but rather in its exhaustion. Aunt Hester's scream is that exhaust, in which a certain intramural absolution is, in fact, given in and as the expression of an irredeemable and incalculable suffering from which there is no decoupling since it has no boundary and can be individuated and possessed neither in time nor in space, whose commonplace formulations it therefore obliterates. This is why, as Wadada Leo Smith has said, it hurts to play this music. The music is a riotous solemnity, a terrible beauty. It hurts so much that we have to celebrate. That we have to celebrate is what hurts so much. Exhaustive celebration of and in and through our suffering, which is neither distant nor sutured, is black study. That continually rewound and remade claim upon our monstrosity—our miracle, our showing, which is neither near nor far, as Spillers shows—is black feminism, the ani*mater*ial ecology of black and thoughtful stolen life as it steals away. That unending remediation, in passage, as consent, in which the estrangement of natality is maternal operation-in-exhabitation of diffusion and entanglement, marking the displacement of being and singularity, is blackness. In these essays, I am trying to think that, and say that, in as many ways as possible.

ACKNOWLEDGMENTS

"Consent not to be a single being" is Christopher Winks's translation of Édouard Glissant's phrase *consent à n'être plus un seul*. The occasion of Glissant's utterance is an interview with scholar and filmmaker Manthia Diawara in which Glissant is asked to reflect upon the irony of traversing the Atlantic on the Queen Mary II while having written and thought so devotedly and brilliantly on the middle passage and its meaning. The term *consent* doesn't merely defy but rather unravels a set of normative discourses on agency that are either denied to or unsuccessfully salvaged for those who remain in middle passage which is, as Cedric Robinson and Ruth Wilson Gilmore have said, eternal. For Glissant, consent, which is not so much an act but a nonperformative condition or ecological disposition, is another way of approaching what he calls the "poetics of relation." With the utmost reverence and respect, I have been trying to think passage, by way of Winks's version of Glissant's words, against the grain of relation and the individuation that relation seems unable not to bear. I would like to think these essays are messages entanglement sends out to itself and I want to acknowledge, here, some of the beautiful and significant differences that nourish and enable this sending.

These essays emerge from long collaborative study with Laura Harris, and with Stefano Harney. Their making has been so influenced by the fundamental, mandatory examples of Glissant and Robinson, and of Amiri Baraka, Julian Boyd, Octavia Butler, Betty Carter, William Corbett, Angela Davis, Samuel R. Delany, Jacques Derrida, Thornton Dial, Charles Gaines, Gayl Jones, Martin Kilson, Nathaniel Mackey, Robert O'Meally, William Parker, M. NourbeSe Philip, Avital Ronell, Hortense Spillers, and Cecil Taylor, that proper citation is impossible and superfluous.

They were nurtured in friendship, in various forms of intellectual and artistic fellowship, and in a bunch of different kinds of conversation with Sadia Abbas, John Akomfrah, Julie Tetel Andresen, Samiya Bashir, Ian

Baucom, Herman Bennett, Anselm Berrigan, Rachel Blau Du Plessis, boychild, Rizvana Bradley, Dhanveer Brar, Daphne Brooks, Jayna Brown, Barbara Browning, Tisa Bryant, Adam Bush, Judith Butler, Garnette Cadogan, Manolo Callahan, Julie Carr, J. Kameron Carter, Sarah Cervenak, Nahum Chandler, Kandice Chuh, miriam cooke, Ashon Crawley, Cathy Davidson, Danny Dawson, Colin Dayan, Andrea Denny-Brown, Manthia Diawara, Joseph Diaz, Harry Dodge, Joe Donahue, Jennifer Doyle, Lisa Duggan, Brent Edwards, Erica Edwards, David Eng, Mercedes Eng, Lynne Feeley, Denise Ferreira da Silva, Licia Fiol-Matta, Jonathan Flatley, Nicole Fleetwood, Judith Jackson Fossett, Cindy Franklin, Malik Gaines, Theaster Gates, Ruth Wilson Gilmore, Renee Gladman, Macarena Gomez Barris, Avery Gordon, Maxine Gordon, Renée Green, Farah Griffin, George Haggerty, Jack Halberstam, Lauren Halsey, Sora Han, Michael Hanchard, Keith Harris, Deirdra Harris-Kelley, Saidiya Hartman, Mathias Heyden, Sharon Holland, Karla Holloway, Sandra Hopwood, Jonathan Howard, Vijay Iyer, Arthur Jafa, Alan Jackson, Willie Jennings, R. A. Judy, David Kazanjian, Doug Kearney, John Keene, Elleza Kelley, Robin Kelley, Kara Keeling, Bhanu Kapil, Jodi Kim, Mariam Lam, Ann Lauterbach, Ralph Lemon, Zoe Leonard, André Lepecki, George Lewis, Glenn Ligon, Akira Lippit, David Lloyd, Errol Louis, Katherine McKittrick, Dawn Lundy Martin, Farid Matuk, Harold Mendez, Herbie Miller, Seth Moglen, Pete Moore, Damien-Adia Morassa, Jennifer Morgan, Jennifer Lynne Morgan, Tracie Morris, Mark Anthony Neal, Linda Nellany, Maggie Nelson, Cecily Nicholson, Aldon Nielsen, Linda Norton, Zita Nunes, Tavia Nyong'o, Ann Pellegrini, Ben Piekut, Öykü Potuoğlu-Cook, Claudia Rankine, Joan Retallack, Ed Roberson, Dylan Rodriguez, Atef Said, Josie Saldaña, George Sanchez, Ines Schaber, Darieck Scott, Richard Schechner, Rebecca Schneider, Tonika Sealy, Jared Sexton, Setsu Shigematsu, Karen Shimakawa, Tom Sheehan, Andrea Smith, Darrell Smith, Fiona Somerset, Greg Tate, Diana Taylor, Kelly Taylor, Kenneth Howard Taylor, Wu Tsang, Deb Vargas, Alex Vazquez, Hypatia Vourloumis, Bryan Wagner, Gayle Wald, Priscilla Wald, Anne Waldman, Maurice Wallace, Alexander Weheliye, Alys Weinbaum, Allen Weiss, Frank Wilderson, Joshua Marie Wilkinson, Terrion Williamson, Ronaldo Wilson, Karen Tei Yamashita, and Rachel Zolf. There are so many others, whose names don't come to me just now even if their thoughts and voices do. I'll thank them now, anonymously and collectively and even though I think this is the best and purest way, I'll ask them for forgiveness, too.

Love and thanks to the Jazz Study Group, Issues in Critical Investigation, the Anti-Colonial Machine and The Formation.

I appreciate the generosity and indulgence of Duke University Press and, more specifically, Susan Albury, Elizabeth Ault, Amy Buchanan, and Ken Wissoker. And thanks to Alex Alston for preparing the bibliography and Celia Braves for preparing the index.

All the folks I have mentioned, and a whole bunch more, make it possible also to offer this book in celebration of what is lost in Lindon Barrett, Julian Boyd, Elouise Bush, Thelma Foote, Nasser Hussain, Richard Iton, Christopher Jackson, Marie Jenkins, Kathryne Lindberg, Bertha Marks, Masao Miyoshi, José Muñoz, and Cedric Robinson; and what is found, every day, a million times a day, in Laura, Lorenzo, and Julian. The lost and found are incalculable.

Earlier versions of some of the essays collected here appeared in the journals *TDR/The Drama Review, Callaloo, Hambone*; *Cambridge Opera Journal, Women and Performance*, and *The Journal of the Society of American Music*. Earlier versions of others appeared in the following books: *Experimental Sound and Radio*, ed. Allen Weiss (MIT Press); *Aural Cultures*, ed. Sylvia Mieszkowski, Joy Smith, and Marijke de Valck (Rodopi); *Ben Patterson: Born in the State of FLUX/us*, ed. Valerie Cassel Oliver (Contemporary Arts Museum Houston); *Theaster Gates: My Labor Is My Protest*, ed. Honey Luard (White Cube); *Harold Mendez: but I sound better since you cut my throat* (exhibition, Three Walls, Chicago); *Dancers, Buildings and People in the Streets: Danspace Project Platform 2015*, ed. Claudia La Rocco; Thomas Hirschhorn, *Gramsci Monument*, ed. Stephen Hoban, Yasmil Raymond, and Kelly Kivland (Walther König/Dia Art Foundation); Gregor Jansen, et al., *How to Remain Human*, ed. Rose Bouthiller and Megan Lynch Reich, with Elena Harvey Collins (Museum of Contemporary Art, Cleveland); Elodie Evers et al., *Wu Tsang: Not in My Language* (Köln, Verlag der Buchhandlung Walther König); *Organize Your Own*, ed. Anthony Romero (Soberscove Press); Anne Ellegood, *Jimmie Durham: At the Center of the World* (The Hammer Museum).

Not In
Between

1.

Remembering the Present—the lyrical, ethno-historio-graphic, painterly en-counter between Tshibumba Kanda Matulu and Johannes Fabian, retrieves Patrice Lumumba and the postcolonial future he desired and symbolizes.[1] The narrative lyricism that is given by way of technological mediation in the radio addresses of Lumumba, a lyricism whose supplemental force cuts and augments the authoritarian danger of the radiophonic voice and the neo-colonial recapitulations of historical recitation, is part of what Tshibumba attempts to reproduce in his art. Moreover, this lyricism is embedded in their visual registers by way of the mediation of their own voices and the voice, if you will, of a general phonography. In this sense Tshibumba—by way of and, to an extent, against Fabian—reinstantiates the lyric singularity, manifest always and everywhere as surplus, which is the *material spirit* of the postco-lonial future. This frayed singularity moves through the opposition of Afro-diasporic particularities and the universality that the West has mistakenly called its own. In order to understand this spirit of the postcolonial future as revolutionary, intellectual force we must make a detour through the work of C. L. R. James and Cedric Robinson.

2.

The writing of history becomes ever more difficult. The power of God or the weakness of man, Christianity or the divine right of kings to govern wrong, can easily be made responsible for the downfall of states and the birth of new societies. Such elementary conceptions lend them-selves willingly to narrative treatment and from Tacitus to Macaulay, from Thucydides to Green, the traditionally famous historians have been more artist than scientist: they wrote so well because they saw

so little. Today by a natural reaction we tend to a personification of the social forces, great men being merely or nearly instruments in the hand of economic destiny. *As so often the truth does not lie in between.* Great men make history, but only such history as it is possible for them to make. Their freedom of achievement is limited by the necessities of their environment. To portray the limits of those necessities and the realisation, complete or partial, of all possibilities, that is the true business of the historian.[2]

In *The Black Jacobins*, the Caribbean, the not in between, emerges narratively, in resistant aural performances, as the function of a materialist aesthetics and an aestheticized political economy of *appositional collision*. And so James will speak of a broken dialectic, ditch jumping, a spare serial logic disrupted by something missing. But how does the appeal he will amplify through concepts of Africa, of the African, work in this emergent self-consciousness of the Caribbean, in particular, and new world blackness in general, this postcollisive performance, this cut dialectic and not in-between submergence? What does the African bring to the "rendezvous of victory"?

The theory and practice of revolution is bound to the way the individual emerges as a theoretical possibility and phenomenological actuality in and out of the revolutionary ensemble. James is interested and implicated in this relation and operates in a translinguistic, Antillean harmonic unison. He is interested and implicated in the way that the truth of (such) relation lies not in between its elements. Therefore, James reopens the Afro-diasporic traditions' long, meditative, and practical concern with spacing, incommensurability, and rupture. He works in relation to, at some distance from, and not in between that concern and a Euro-philosophical theorization of aporia. James indicates that the question of comportment toward such issues, toward the form and content of the cut, is tied to another opposition—that between lyric and narrative—that in turn shapes yet another fundamental disjunction between the science and the art of history. The question, whose answer inhabits the not-in-between that both marks and is James's phrasing, concerns the irruptive placement—manifest in the practice of his writing and activism, his historical movement and research—of the outside in James's work; it concerns the way the literary achievement of exteriority embodies a theoretical achievement that is nothing less than a complex recasting of the dialectic.

The recasting of the dialectic that James's phrasing embodies and is directed toward disrupts the convergence of literary meaning and bourgeois

production that comes into its own with that reification of the sentence that animates and is animated by the rise of novelistic techniques of narration. Such disruption is noisy; and such unruly and ongoing reemergence of sound in literature is crucial because the lyrical interruption of narrative marks a different mode, within the same mode, of literary production, one that might be said to stem from something like what James might have called a socialism already in place in the factory, something like what Louis Althusser, after Karl Marx and by way of Frantz Fanon and Peter Brooks, would call a communism in the occult interstices of the market, in the cut outside of market relations and market aesthetics. This different mode is shaped by resistances. Transferences structure that mode of organization out of which comes another (mode of) aesthetic content. So a phrasal disruption of the sentence is crucial; so poetry remains to be seen and heard so to speak, and in excess of the sentence because it breaks up meaning's conditions of production. But how do we address that privileging of narrative that might rightly be seen to emerge from a certain politics, a certain theory of history, a certain desire? Not by opposition; by augmentation. This means an attention to the lyric, to the lyric's auto-explosion, to the auto-explosion the lyric gives to narrative. This means paying attention to the thing (to what endures of the object's disruptive anticipation of itself, to the commodity that screams its fetish character and the whole of its secret against the [deafness of the] proper) that notes the presence of that desire, that takes into account the lyric's infusion with narrative, that sees the historicity and political desire of the lyric precisely as the refusal that animates and is one possibility of the fetish character, the possibility of free association and total representation that emerges from a transference that is only possible in the form of the open secret, by thinking the rhythm of world and thing.

New grammar can emerge from conventional writing as another writing infused with another sensuality, where the visual might expand toward hieroglyphic, from purely phonetic, meaning and where aurality further serves to disrupt and trouble meaning toward content. David Walker, for instance, understood this, as it were, before Jacques Derrida who, in *Of Grammatology*, initiates a critique of the valorization of speech over writing that is always driven not only to infuse speech with writing but to infuse writing with speech and, deeper still, with what Amiri Baraka calls, under the rubric of poetry, "*musicked* speech."[3] The complex interplay between speech and writing (rather than the simple reversal of the valorization of speech over writing to which that interplay is often reduced) that animates *Of*

Grammatology touches on issues fundamental to the black radical tradition that James explores and embodies. I want to address the constructed, nonoppositional, material interplay between writing and speech, narrative and lyric, the European and the African—or, to invoke James's phrasing, Enlightenment and Darkness. It provides the framework for new revolutionary theory, practice, and identity that is marked in the form and content of Jamesian phrasing as the location and time of the not-in-between, where phonography rewrites the relation between writing and the unfinished work of man. This is to say that I want to address the nature of the address.

Toussaint L'Ouverture's failure was the failure of enlightenment, not of darkness.[4]

If he was convinced that San Domingo would decay without the benefits of the French connection, [Toussaint] was equally certain that slavery could never be restored. Between these two certainties he, in whom penetrating vision and prompt decision had become second nature, became the embodiment of oscillation. His allegiance to the French Revolution and all it opened out for mankind in general and the people of San Domingo in particular, this had made him what he was. But this in the end ruined him.

Perhaps for him to have expected more than the bare freedom was too much for the time. With that alone Dessalines was satisfied, and perhaps the proof that freedom alone was possible lies in the fact that to ensure it Dessalines, that faithful adjutant, had to see that Toussaint was removed from the scene. Toussaint was attempting the impossible—the impossible that was for him the only reality that mattered. The realities to which the historian is condemned will at times simplify the tragic alternatives with which he was faced. But these factual statements and the judgments they demand must not be allowed to obscure or minimize the truly tragic character of his dilemma, one of the most remarkable of which there is an authentic historical record.

But in a deeper sense the life and death are not truly tragic. Prometheus, Hamlet, Lear, Phèdre, Ahab, assert what may be the permanent impulses of the human condition against the claims of organised society. They do this in the face of imminent or even certain destruction, and their defiance propels them to heights which make of their defeat a sacrifice which adds to our conception of human grandeur.[5]

Toussaint is in a lesser category. His splendid powers do not rise but decline. Where formerly he was distinguished above all for his prompt and fearless estimate of whatever faced him, we shall see him, we have already seen him, misjudging events and people, vacillating in principle, and losing both the fear of his enemies and the confidence of his own supporters.

The *hamartia*, the tragic flaw, which we have constructed from Aristotle, was in Toussaint not a moral weakness. It was a specific error, a total miscalculation of the constituent events. Yet what is lost by the imaginative freedom and creative logic of great dramatists is to some degree atoned for by the historical actuality of his dilemma. It would therefore be a mistake to see him merely as a political figure in a remote West Indian island. If his story does not approach the greater dramatic creations, in its social significance and human appeal it far exceeds the last days at St. Helena and that apotheosis of accumulation and degradation, the suicide in the Wilhelmstrasse. The Greek tragedians could always go to their gods for a dramatic embodiment of fate, the *dike* which rules over a world neither they nor we ever made. But not Shakespeare himself could have found such a dramatic embodiment of fate as Toussaint struggled against, Bonaparte himself; nor could the furthest imagination have envisaged the entry of the chorus, of the ex-slaves themselves, as the arbiters of their own fate. Toussaint's certainty of this as the ultimate and irresistible resolution of the problem to which he refused to limit himself, that explains his mistakes and atones for them.[6]

Dessalines undertook the defence. He threw up a redoubt at some distance from Crête-à-Pierrot, left detachments to man them both, and went to meet Debelle who was coming south towards Verettes to make contact with Boudet. Dessalines would not give battle but retired toward Crête-à-Pierrot, keeping his forces just ahead of the hotly pursuing Debelle. *As he reached the ditch which surrounded the fortress Dessalines jumped into it and all his men followed, leaving the French exposed.* A withering fire from the fortress mowed them down. Four hundred fell and two generals were wounded. Hastily retreating, they took up position outside the fortress and sent to Leclerc for reinforcements. Dessalines entered the fortress and completed the preparations for the defence. But already his untutored mind had leapt forward to

the only solution, and, unlike Toussaint, he was taking his men into his confidence. As they prepared the defence he talked to them.

"Take courage, I tell you, take courage. The French will not be able to remain long in San Domingo. They will do well at first, but soon they will fall ill and die like flies. Listen! If Dessalines surrenders to them a hundred times he will deceive them a hundred times. I repeat, take courage, and you will see that when the French are few we shall harass them, we shall beat them, we shall burn the harvests and retire to the mountains. They will not be able to guard the country and they will have to leave. Then I shall make you *independent.* There will be no more whites among us." Independence. It was the first time that a leader had put it before his men. Here was not only a programme, but tactics. The lying and treacherous Bonaparte and Leclerc had met their match.[7]

These are some passages in *The Black Jacobins* that allow us to ground the not-in-between and also to disclose, by way of James's characteristic style, the impact of phrasing on the interinanimation of theory and history. And here I want explicitly to think about *The Black Jacobins* in two ways: 1) as the narrative description, on the one hand, of Toussaint's expansive vision and practical failure and, on the other hand, of his Lieutenant Dessalines's limited vision and practical success; and 2) as the irruption into that narrative of a radical energy, an exterior lyricism, whose implied victory has not been achieved or met (but which we are slowly working our way to in the name and spirit of Lumumba). I'm interested in the moments in James's texts in which he points to that energy, in which his phrasing records, is infused with or engraved by, that energy's phonographic weight. This is to say that I'm interested in those moments in James's historiography when meaning is cut and augmented by the very independent syntaxes and outer noises—conveying new and revolutionary content, mysterious and black magical politico-economic spells and spellings—that James would record. Those moments help to structure a collisive interplay in the work that is not in between but outside of the broad-edged narrative/historical trajectory of a familiar dialectical lineage now cut and augmented by the serrated lyricism of what Robinson calls the "black radical tradition." I intend to pay some brief attention to the mechanics of James's lyrical history in order to think what might appear only as a contradiction indicative of a failure. It would have been a failure on the part of the author that replicates the military/political failure

of Toussaint, a failure that operates perhaps in spite of, perhaps because of, the author's mastery. I think it is, however, something more than failure, more than some static or unproductive contradiction; that it indicates something that remains to be discovered in black radicalism.

What I'm interested in at this juncture could be thought, more specifically, as the question of what Robinson reads in James as a problematic enchantment of/with Hegel, one, to use Nathaniel Mackey's terms, both premature and postexpectant. Here James is working in direct confrontation, working through the opposition of subjective and objective freedom, undermining Hegel's attachment to the figure of Napoleon Bonaparte, in excess of that historical trajectory/dialectic for which Bonaparte is telic. And Toussaint, all hooked up and bound to the French, trapped in the no-man's-land between liberty (abstract-subjective-telic-white) and independence (national-objective-present-black: the position Dessalines seemingly naturally slips into) hips us, by way of James, to the need for something not in between these formulations. For James, the desire is for something not in between darkness and enlightenment, something not in between Dessalines and Toussaint. And we've got to think what it means not just for Dessalines to take the men into his confidence *but to talk to them.* We've got to think the form of that talk as well as its content, in untutored and broken dialect, unretouched, addressed to his followers and not to the French, sounded and not written and rewritten, seemingly unmediated by the graphic, and, finally, concerned not with liberty but with independence. The opposition between Toussaint and Dessalines, between (the desire for what is called) enlightenment and (the adherence to what is called) darkness, between direction to the French and direction to the slaves, is also between speech and writing. Dessalines leaps forward; he jumps into the ditch, sounding, descending. That jumping descent is coded as a jumping forward. Another dialectic. It's what James's phrasing does to the sentence. Oscillation, bridging over to leaping forward, jumping into. This is a question of music.

In *Black Marxism: The Making of the Black Radical Tradition,*[8] Robinson speaks of James's reaction to the Italian invasion of Abyssinia, the complicity of the nonfascist bourgeois states and the silence of the antifascist left. Robinson speaks of that reaction as the moment when the tutelage of European radical thought in James is broken. That emergence from a tutelage at once self-imposed and imposed by external forces is marked by *The Black Jacobins* and by its phrasing. What is the relationship between James's breaking of this tutelage and (his representations of) Dessalines's untutoredness, on the one

hand, and Toussaint's inability to break that tutelage on the other? James's phrasing occupies the place not in between these. Robinson says: "The force of the Black radical tradition merged with the exigencies of the Black masses in movement to form a new theory and ideology in James' writings."[9] Yes, but how does this actually work? Is *merge* the right word? Is this new delineation, this Dessalineation, in James's writing only at the level of a convergence of black radical thought and black mass movement? Does the end of his tutorship under Euro-radical thought constitute an erasure of that thought? Should it? What language does he offer to describe this movement? If, as James says in the appendix to *The Black Jacobins* titled "From Toussaint L'Ouverture to Fidel Castro," the road to West Indian national identity (and liberation) led through Africa, then how can we think the relation between Africa and the not-in-between?[10] The return to Africa is coded as a kind of future exteriority that is already there, the externalizing force of something already there, the revolution that is, somehow, brought with us, there when we got here, and left behind in a sound, a loud hurrah enacting a certain interference of and with what is falsely described as common sense and reason, the material hyperrationality of the undercommons.

Robinson writes of James's fascination with Hegel's mode of argumentation, played out most fully in *Notes on Dialectics*, as an obvious problem, a limitation of James's work. He objects to the Hegelian "distillation of history into rich concentrates used solely for the grounding of abstract discourse" and to the Marxian combativeness of the style, shaped by a "dismissive tongue used to humiliate opposition."[11] I want to think about *The Black Jacobins*, by way of Robinson's analysis and of the concept of the not-in-between, as a kind of anacrusis, a prefatory and dialectal bent note on/of dialectics. I want to look more closely at that style in order to look more closely at what Robinson calls James's "lyrical and sometimes mischievous literary 'voice,'" to think about how the far-reaching problems that are embedded in the paradoxical notion of literary voice play themselves out in the form and content of James's work as well as in the revolutionary theory and practice he would there both know and mimetically reproduce.[12] This is to ask how literary voice and political theory and practice are disrupted by the external and externalizing force of a sound not in between notes and words, not in between languages, in the not-in-between of accent, a sound that bends the regulatory musicological frame of notes, the hermeneutic insistence of the meaning of words, the national imperatives of European idioms, the dialect that reconstitutes dialectic as reason, historical motive, liberatory polyrhythm.

There is, in the work, a lyric disruption of a certain Europeanized notion of public/national history and historical trajectory as well as an exterior/ African disruption of the interiority of European lyric. The property sang, the commodities shrieked. Jumping in the ditch, revolutionary tactic and dance, lingering in the space between the notes, descending into the depths of the music. James seems to assert that Toussaint might have acted had he jumped, like Dessalines, into the ditch of *Vodun* ritual and revolutionary movement, slipping into darkness, into the musical breaks of the history he was making and by which he was enveloped, into those nodes of time, where it leaps forward, new rhythm and all. But that leap forward depends upon that sounding. And again, somehow, this is not in between.

Robinson argues that while the European radical tradition had been formed by and in relation to the bourgeoisie, a black radical tradition had formed independently, another tradition of radical resistance, another and separate revolutionary culture, another origination of resistance outside of the historical trajectories of either Marx or Hegel, not in between them at the same time as in excess of their oppositional limitations, the one racial, the other classed. This is to say, in Robinson's terms, that "black radicalism . . . cannot be understood within the particular context of its genesis."[13] Robinson says black radicalism's emergence "*implied* (and James did not see this) that bourgeois culture and thought and ideology were irrelevant to the development of revolutionary consciousness among Black and other Third World peoples. It broke with the evolutionist chain in, the closed dialectic of, historical materialism."[14] This break or arrhythmia: is it a complete detachment from that temporal/historical trajectory or is it a displacement, a retemporization disruptive of the very idea of absolute break and, by extension, an augmentative curvature of old harmonic notions of convergence or hybridity, a dissonant bending of the dialectic and its notes? Again, I think James's content, when seen in the context of a closer look at the mechanics of his phrasing, moves in another implication—not of the irrelevance of the bourgeoisie and by extension, in the breaking from or out of the evolutionist chain and closed dialectic of historical materialism, but in a dialectal bending of that dialectic that stems from a radical consciousness that cuts and anticipates, but is at the same time cut and anticipated by, Marxism. This is to say that the black radical tradition, as embodied in the figures of James and, for that matter, Robinson, has a complex origin of rupture and collision that moves across a range of negations of Europe. This is to say that the impossible location of the chain of origins of this tradition requires some

movement in the not-in-between of conditions and foundations, some improvisation through that opposition, taking into account both retention and disruption, originality and response, in the tradition. Song is a privileged site of such improvisation, and the not-in-between signifies a collision that guarantees the ongoing presence and the irrecoverable possibility of what gets coded as conditions and foundations. There and not there, not hybrid, not in between marks the presence and loss of Africa. Blackness and black radicalism are not in between but neither one nor the other. New things, new spaces, new times demand lyrical innovation and intervention, formal maneuverings that often serve to bring to the theoretical and practical table whatever meaning can't. Phrasing, where form—grammar, sound—cuts and augments meaning in the production of content, is where implication most properly resides.

Everything here depends upon some kind of not-in-between suspension and propulsion, a certain arrhythmia, the breakdown of the too-smooth historical trajectory of European domination and accumulative apotheosis that circulates around the conjunction of Hegel and Bonaparte. The line of that dialectic has got to be broken by another dialect; the trajectory of that narrative has got to be disrupted by some kind of lyric materiality. Nevertheless, according to James, such punctuation, such interruption of the sentence and law of Euro-history cannot or ought not devolve into hesitation. Here, James's critique of Toussaint's hesitation might be understood as the forecast of a certain postcolonial aura that is structured around such hesitation, its connection to a kind of hybridizing encounter of the in between, an oscillative lingering eternally prefatory to action, whose value depends upon the ongoing and necessarily groundless—and therefore doubly paradoxical—assertion that "freedom's basis [is] in the indeterminate."[15] The not-in-between of this opposition would be some kind of syncopated but nonhesitational phrasing, the kind of phrasing James gets at when he puts this notion forward. It would be not in between enlightenment and darkness, narrative and lyric, all of that. In a letter to the French Directory on November 5, 1789, a letter James identifies as a milestone in Toussaint's career, a letter whose phrasing James situates not in between truth and bombast, a letter whose aural origins in broken dialect are obsessively reworked in order to make possible their entry into historical dialectic (but always carrying the revolutionary force of that dialect; how much energy will it have? can it be sustained?), Toussaint writes: "I shall never hesitate between the safety of San Domingo and my personal happiness; but I have nothing to fear." It's the rhythm of

the phrasing here that's so profound, that James is always trying both to channel and raise to the level of theoretical principle and historical motive; the form and content of a dialectic of the not-in-between, of a disruptive but nonhesitational rhythm, of an identity and revolutionary political stance and movement not in between enlightenment and darkness (blackness), of a historiographical practice not in between narrative and lyric, disruptive of the rupture (between science and art, knowledge and mimesis) in historiography, illustrative of his belief that "the violent conflicts of our age enable our practised vision to see into the very bones of previous revolutions more easily than heretofore. *Yet for that very reason it is impossible to recollect historical emotions in that tranquility which a great English writer, too narrowly, associated with poetry alone.*"[16] The recollection of historical emotions requires that which exceeds tranquility and here, poetry is understood not only to have no monopoly on such tranquility but is also perhaps given as that which is in excess of tranquility itself. We don't appeal to prose, then, for that excess of tranquility required to recollect historical emotion; rather we see how poetry is marked by an excess of tranquility, a lyric and dialectical drive that brings the noise of such emotion. Not in between verse and prose, tranquility and turbulence.

The inevitability of that relation as Derrida would understand it, the nature of the dialectic or of the possibility of another dialectic as James would understand it, the place of the dialectic with regard to freedom, the relation between dialectic and dialect, the sonic irruption of the outside, of the not-in-between of the dialectic or of another dialectic, the refusal of an oscillation that seems, ultimately, to be part and parcel of the dialectic, the failure of its own internal resources to achieve the *Aufhebung* toward which it is directed and how that failure manifests itself in the colonial encounter: this would be Homi Bhabha's failure, perhaps Fanon's failure, the failure of *Black Skins, White Masks* and of the objectifying encounter, the failure that comes into relief when we look at *The Wretched of the Earth* (and which Robinson, above all, hips us to) and when we see the Dessalineation of Fanon, if you will, the reassertion of a dialect—carrying all the history of diaspora, all the history of proletarianization—into the dialectic. Here we mean something beyond simply a breakdown of the sententious along some oscillative and caesuric lines. The dialect carries breaking sound as well as broken grammar. And if the dialectic is the pulse of freedom, what's the nature of that pulse, its time? What bombs are dropped there? Must the pulse, the rhythm, be free in order to keep the time of freedom, to break unfree time, usher in new

times? This is what the infusement of lyric into historiographic narrative would do. The free pulse of a new dialect/ic is what animates James's phrasing, even if only intermittently, even if only in such a way as to replicate with differences something of the form, perhaps, of Toussaint's failure, a failure not of enlightenment but bound up in whatever oscillation occurs between enlightenment and darkness. Toussaint and Dessalines, anticolonial leadership and an anticolonial "proletariat," narrative and lyric, the idealization and materialization of freedom, of its trajectory and its presence.

Finally, for James the essence of a thing is its animation, its aspect or internal temporal-historical constituency, as much what it shall be as what it is and has been. This animation is a universalizing force, the generalizable, avant-garde, politico-aesthetic (we might say musical) energy of proletarianization. This requires rethinking the proletariat, at its transcendent moment, as more than a paradox. The proletariat realizes, actualizes, and universalizes man through, on the other side of, struggle and differentiation, through production, though the ongoing production and consumption of performances. The avant-garde is in the audience. The new universal is listening. What Robinson sees as a paradox, the unaccountable derivation of the proletariat from the bourgeoisie, James understands as one of those punctuated equilibria of the dialectic, an effect of syncopation in phrasing, the not-in-between.[17] Leaps! Leaps! Leaps! A mystery of *aufheben*. This is why Hegel is so important for James, why the nature of the dialectic is so crucial. Because it is all bound up in the relation of the bourgeoisie to the proletariat, in how to get from one to the other, in how one fulfills the etiolated universalism of the other. This is the future in the present, the invasion from the inside, socialism in the factory. It is the manifold content of the being of the worker, the trace of what the worker shall be that is the worker's essence. This is why, for James, the essence of Lenin is what he "surely" would have said if he'd lived, determined by what he did say right before he died. This kind of move is what Cornelius Castoriadis calls absolutism. It's what he critiques in Marx (and Robinson endorses this critique). But this mode of reading or improvisation, this anticipatory critique or future anterior maneuver, *is the dialectic*, for James. Titles like *The Invading Socialist Society* or *The Future in the Present* offer a glimpse of something powerful in James's phrasing: he puts forward for us a notion of an internal incursion that can be seen in relation to an interior force of exteriorization, moving toward a possibility coded as outside, an actuality inside. Inside and outside are, then, not only positions but forces; and the not-in-between marks an insistence in

the black radical tradition that is embodied in ancient and unprecedented phrasing. To insist, along with James, on this kind of fullness, on this Caribbeanness that exists only as a function of a return not to authenticity but to Africa, is to recognize, along with Wilson Harris or Édouard Glissant, that black radicalism is done necessarily in relation to or under water, something occurring in sound, as sounding, in depth, like a Dolphic-Mackeyan depth charge. This implies that the black radical tradition is not, though it is nothing other than, grounded in African foundations; that it is sounded in the impossible return to Africa that is not antifoundationalist but improvisatory of foundations; that it is a turn toward a specific exteriority; that it is not only an insistent previousness in evasion of each and every natal occasion but the trace and forecast of a future in the present and in the past here and there, old-new, the revolutionary noise left and brought and met, not in between.[18]

3.

All that was in preparation for an engagement with the record of an appositional collision between an ethnographer and an informant. In this case, however, the richness that cuts and augments every such encounter, making it always so much more than most ethnographers ever realize in their recording and analysis, is given in a more or less explicit and conscious way by the ethnographer. In this encounter between ethnographer and informant, Johannes Fabian is conscious of himself as mediator and sponsor and Tshibumba Kanda Matulu is conscious of himself as painter and historian. I want to read the political reason they amplify in their dialogue, though I begin with some remarks of Fabian, whose placement of Tshibumba is useful not only for the information it gives regarding Tshibumba's relation to Lumumba but for the example of an increasingly broken critico-administrative codification that it sets.

> When an exceptional artist such as Tshibumba Kanda Matulu broke away from genre painting and defined himself as a historian, he went to great lengths to stress national unity, if only because he needed the nation as the subject of a history whose narrative he could oppose to colonial and academic accounts. In this respect Tshibumba emulated his hero Patrice Lumumba, who pursued his resolutely unitarian course because he knew this was the only way to establish his country as a political power vis-à-vis the former colonizer and on the international scene.[19]

T: I am good, for instance, at the kinds of pictures you have in your house, the historical ones.

F: Mm-hmm.

T: I'm strong in history. Of the flogging there [points to "*Colonie Belge*, painting 34] I can do three a day. Pictures of Lumumba I can do two a day, if I work hard.

F: Mm-hmm.

T: Because you must seek to work with care on detail.[20]

A few days later (on December 16, 1973), we met again and picked up where we had left off. Most of the paintings turned out to be about historical events, especially the life of Lumumba. Could you do more of those, I asked (and this may have been the moment our project was born, in any case it was the moment I realized that Tshibumba had ambitions beyond painting the few historical subjects that had become an accepted genre).

T: I'll come with a lot.

F: Pictures showing Lumumba's history?

T: History and nothing but history.

F: But, as you said, you are an historian.

T: Fine.

F: And an artist.

T: I am an artist, yes, I am a historian.[21]

Tshibumba moves, here, in a kind of contrapuntal surplus and disruption of the project Fabian rightly and problematically sees as collaborative. This is not only in recorded pauses and interjections, sounds usually unassimilable to writing, but in the syntax of the response as well, a break of ethnographic grammar marked by no special spelling, by neither ellipsis nor emphasis. It's just the old rhythmic break of the non/response, cutting the flow of the interview, the continuity of an encounter still too laden with power. "Fine."

> "I am an
artist, yes,
> I am a historian."

This broken phrasing marks something on the order of a fantasy, bears whatever polyphonic disturbance even the accompaniment of the utterance leaves behind in its percussive recapitulation of what Fabian might otherwise think

of as the natural separation of the aesthetic and historical projects and impulses. Of course, it's not just the time of the ethnographer that Tshibumba cuts; it's the time of neocolonialism as well, moments and progressions that are not but nothing other than the same. The noncontemporaneity of these mo(ve)ments is crucial. What is the relationship between Mobutu's *"retour à l'authenticité"* and the ethnographic project? How does the one enable the other, literally allowing Fabian's project in all of its specificity, in all of its self-consciousness in relation to the problem of noncontemporaneity in anthropology, as a product of the linkage of *neo*colonialism and anthropology? Tshibumba's historico-aesthetic project is enabled by Fabian's, so much so that one is tempted along with Fabian to understand it as a joint affair. But the project of ethnography seems never fully able to separate itself from the desire for authenticity or originarity that marks an essential element of Mobutuism. Lumumba always moved outside of such recourse or regression and Tshibumba moves in his spirit, arguing almost at the outset of his project that "our 'recourse to authenticity' is really a 'blind return' to the past."[22] This initial formulation marks a stark counterpoint to Mobutu. That starkness is both muted and amplified by the rhythmic complexity of its repetition:

> President Mobutu said on October 10, 1973, at the United Nations—may I quote?—"Recourse to authenticity is not a narrow nationalism, a blind return to the past." All right, that is how he spoke. On reflection—the way I see it—this is true. Because—it's the story of the black man himself that I'm explaining to you, right?

> We go [back]—it is a blind return to the past. The thing is, we don't know the ancestors anymore; we have lost that knowledge.[23]

Here Tshibumba repeats his claims with differences. The differences are prompted not only by the danger of such speaking about/against Mobutu in Zaire in 1973, dangers Fabian amply points out, but by the necessity of a historico-aesthetic project whose adequacy depends, precisely, upon the transcendence of mere return. Tshibumba's project is necessarily a reconstructive, resurrective one, an image of totality seeking to capture the complex and multidirectional times and the manifold social layers of another understanding of development. The rhythm of the paintings and the interviews with Fabian mark all of this all of the time. Lumumba's death is constitutive here in its lack, as is his spirit in its supplementarity. This is part but not all of what Tshibumba is after when he characterizes Lumumba as the "Lord Jesus

of Zaire." Here we can look at three modes of Fabian's transcription, thinking their difference among other things. This is, for Fabian, a crucial moment where "there is no attempt . . . to escape into allegory. Speaking in the first person, and actually giving his name and profession, [Tshibumba] asserts his authorship of the story and assumes responsibility for its emplotment."[24] What happens via this mediation? What does Fabian assert/insert? Is it ever not aesthetic?

> You see that I made three crosses back there. [About] the meaning of this picture, I am saying that Lumumba d[ied; *he interrupts himself and makes a new start*] I, in my opinion, I, the artist Tshibumba, I see that Lumumba was like the Lord Jesus of Zaire.[25]

> So he died, but we don't know where his body lies. There are suspicions. Some say they threw it into sulfuric acid, or what do you call it? If you put a human body or whatever in it, this acid leaves only a liquid and some solid residue, and that's it. That is what some people said. In any event, you see that I painted three crosses back there. I am saying—I, speaking for myself, as the artist Tshibumba—that in my view, Lumumba was the Lord Jesus of Zaire. Above I painted six stars, because he died for unity. And I think you see the blood that is flowing from his side, how it spreads and writes something on the ground: Unity. What this means is that Lumumba died for the unity of Zaire.[26]

> F: Where is this scene? I don't recognize it; is it out in the bush?
> T: The actual place? In my thoughts it was inside a house. But then I did it in this way in order make the death more visible. Were I to present the scene inside the colors would not come out and it would not be as impressive. . . . And the three crosses you see there, that is my idea. Because when I followed his history, I saw that Lumumba was like the Lord Jesus. He died the same way Jesus did: between two others. And he was tied up the way Jesus was. It was just the same.[27]

Fabian outlines early in the text a certain apparatus, his curatorial choices. They are, first and foremost, typographic, visual, but their visuality marks always the inflection of the aural.

> Each painting . . . is introduced by portions of Tshibumba's narrative, which appear in sans serif type below the painting itself. They are fol-

lowed by excerpts from our conversations about the picture, with the speakers marked *T* for Tshibumba and *F* for Fabian . . . I must emphasize that not everything that was recorded was displayed. . . . In the narrative passages, traces of conversation—brief interjections, repetitions, hesitations, and much of the redundancy that characterize oral performance—have been silently omitted.[28]

Nevertheless, one notes with gratitude that Fabian, in his ethnographic/methodological essays, takes pains to recover the exigency and surplus of oral performance. One wants to say that this surplus of aurality 1) *is* Tshibumba's aesthetics and politics and 2) infuses the paintings as well as the utterance/performance around the paintings—accompaniment as essence in politics and aesthetics.

Tshibumba's transcendence of genre and its "predictable creativity" is seen by Fabian as a transcendence or disregard of the aesthetic as well. More precisely, for Fabian, "What [Tshibumba] *says* about art and aesthetics—or for that matter, about painting—remains of secondary importance compared to his ambitions as a historian. What he *does* as a painter is absolutely essential to his work as a historian."[29] However, Tshibumba's reprise of Fabian's pause at a juncture that in the political reason of Tshibumba gives no pause opens us to the question of whether the aesthetic—as something he enacts and, in so doing, theorizes—is elemental not only to Tshibumba's historiographic ambition but to his political desire as well. This is to say that the lyrico-narrative singularity that bears the content of Lumumba's political utterance/accompaniment, which is the essence and vehicle of African political reason in its universality, is an aesthetic concern, situated at the asymptotic nonconvergence of the autonomous aesthetic and the autonomous political. Moreover, the ethnographic object ruptures ethnography generatively, breaks ethnography's laws; but this is only possible because of ethnography. This is history and nothing but history.

T: That means we are all historians.

F: That is true.

T: They are writers, I am a painter.

F: Mm-hmm.

T: But we are the same; we join [forces].

F: Mm-hmm.

T: Because a man cannot have a complete life without a woman, only if he is with a woman.

F: Mm-hmm.

T: It's like a marriage.

F: Mm-hmm.[30]

The dramatics/erotics of the ethnographic encounter sounds differently here and now. Here Fabian indicates his method for forging an attunement to that sound in the discourses on the paintings:

> The texts that make up the Prelude, unlike the ones that accompany the paintings, are attempts at literal translation. Repetition, monosyllabic interjection, repair, and other elements of live conversation are preserved in this version, and only a few brief passages are omitted (marked by three dots). Just as shapes and shades are worked out in a painting, sometimes with much brushwork, sometimes by merely a few strokes, so are ideas developed in oral communication, which is characterized by both redundancy and ellipsis—too much and too little for the reader who was not present in the flow of speech and cannot benefit from clues that get filtered out when speech is transposed into writing.[31]

Fabian's method opts for a faithful transcription of these discursive performances rather than a faithful transcription of the utterance. This is to say, in Austinian terms, that Fabian transcribes the accompaniment of the utterance as well as the utterance. In this sense, he violates Austinian principles to which the transcribers of Austin's lectures faithfully and faithlessly adhere. Implicit in Fabian's decision is that the content of Tshibumba's work depends upon his faithless, faithful transcription. From this we extrapolate that the content of Lumumba's life and speeches—which is to say the essence of Lumumba's politics, the essence of African political rationality—depends upon the lyrico-narrative singularity of what cuts, augments, *accompanies* his utterance. This is to say that the rhythmic or temporal disruption and dislocation of Tshibumba, which occurs not only in his aural responses to Fabian but in the paintings as well (note, as Fabian does, the massive and content-filled compression of space, time, and history in Painting 5, which features fifteenth-century explorer Diego Cao in a nineteenth-century pith helmet, marking the concentration of a transnational history of colonialism into an enframed moment; and this is not some reduction, some "essential section" of African development, the mark of some out-of-time African "contemporaneity" somehow both in and out of Hegelian totality and temporality; it is

rather a framed but internally differentiated "moment" in which the movement and stasis of colonialism is given in all of its punctuated duration), is accompanied by a tonal supplement that is, again, in both the paintings and the aural responses to Fabian.

I would call, here, echoing Lumumba, for a political radiophonics, a political phonography beyond mere transposition, improvising through the opposition and—carrying forward the content—of faithful and faithless transcription. This requires thinking what it means to speak of the paintings and what accompanies them. Not just text but sound. Sound and content. The sound and content of Tshibumba and Lumumba are recorded in the paintings, reconstituting them not only against (what Derrida might call the law of) genre but as phonographic history as well. So that what occurs in the paintings is not prior to or outside of writing, but part of an ongoing reconstitution of writing and the political reason writing (and reading) allows. The edgy lyricism of the painting that shows up as an irreducible trace of its production—brushwork and out, off color—is Lumumba's spirit, the spirit of a postcolonial future, the breath of the utterance that is also the breath of its accompaniment. So that the internal, theatrical difference of the utterance and the irreducibly differential phonic substance that is the utterance's material and mystical shell mark the point where the essence and, for lack of a better term, (aural) appearance of the speech converge.

Is this accompaniment like that of the pauses, repetitions, noises, silences, that accompany the utterances of the prelude? What justifies the absence of these accompaniments? Are they really absent? How can we begin to speak of and hear the aural accompaniments of the painting that are not only underneath, but in it? Deleuze and Guattari give us a clue that might be expanded:

> The refrain is sonorous par excellence, but it can as easily develop its force into a sickly sweet ditty as into the purest motif, or Vinteuil's little phrase. And sometimes the two combine: Beethoven used a "signature tune." The potential fascism of music. Overall, we may say that music is plugged into a machinic phylum infinitely more powerful than that of painting: a line of selective pressure. That is why the musician has a different relation to the people, machines, and the established powers than does the painter. In particular, the established powers feel a keen need to control the distribution of black holes and lines of deterritorialization in this phylum of sounds, in order to ward off or appropriate

the effects of musical machinism. Painters, at least as commonly portrayed, may be much more open socially, much more political, and less controlled from without and within. That is because each time they paint, they must create or recreate a phylum, and they must do so on the basis of bodies of light and color they themselves produce, whereas musicians have at their disposal a kind of germinal continuity, even if it is latent or indirect, on the basis of which they produce sound bodies. Two different movements of creation: one goes from *soma* to *germen*, and the other from *germen* to *soma*. The painter's refrain is like the flip side of the musicians, a negative of music.[32]

It is precisely in the too much and too little of redundancy and ellipsis—cut and augmentation—that a surplus lyricism in form and sometimes in content mirrors the structure of the political totality, the particular and invaginative universality, that Lumumba was after in the first place, that provides for us, now, the aesthetic analog of an anarchy in excess of democratization, an anarchy given not as the absence of ground but as ground's improvisation in the absence of origin, something along the lines of what Fabian, here, anticipates:

Combining what I gleaned from *Power and Performance* with what I learned from the study of charismatic authority and popular historiology, I come to a conclusion that will probably be perceived as scandalous: *Political anarchy must be seriously considered as a realistic option for, and outcome of, "democratization,"* if the term is to mean political thought and action from the bottom up rather than just the importing or imposing of institutions whose history, after all, has been inseparable from capitalist and imperialist expansion. . . .

Anarchy as a rational option is emphatically not to be confused with pseudorealistic analyses of a factual breakdown and descent into Hobbesian chaos demanding brutal outside response in the form of outright intervention and ultimately political recolonization. Nor could anarchy be a rational option if it were conceived in mere negative terms—as the absence of effective government. It should be thought of as a discursive terrain of contestation, and it will be up to Africans— the people as well as those certified intellectuals who think from and for the people—to invent or reinvent models and institutions of political life that make possible survival with dignity. . . .

Finally, it should be obvious that I am not assigning anarchic democratization to Africans. Ernest Wamba dia Wamba—who has for many years been working on the palaver, communal litigation, as a viable form of dealing with power—points out . . . that "democracy must be conceptualized at the level of the whole planet Earth." If anarchy is a realistic option of democratization, it may have to be considered globally. I think that, in a time where once comfortable compartmentalizations and distinctions between democratic and nondemocratic societies are getting blurred, few need to be convinced that this is so. Therefore serious thoughts about Africa, and the study of democratization there, is anything but a matter of bringing ready solutions to that continent. Democratization as a solution is the problem.[33]

What is the relation between Lumumba's surplus lyricism—its lyrical disruption of the politics of meaning, of democracy as the politics of meaning—and anarchization? Everything. And what have these to do with a certain eclipse or cut of genre, a generic or sexual cut? Perhaps this: that Lumumba's transcendence of genre corresponds with Tshibumba's. Tshibumba achieves the memorialization or historicization, the recording and amplification, of Lumumba's lyricism in painting, a mode of painting that cuts genre precisely by way of its reproduction and incorporation of that lyricism, its reproduction of Lumumba's sound.

What are we to make of this? How does this signify? How do we think this beyond signification, on the other side of a certain set of restrictions of language, out from the outside of the discourse on value? By way of the fact that the object moves. Animating the paintings, fluxing their objectivity, is the spirit/value (if not some purely representational or significational meaning) of a postcolonial future. This spirit of the future works in conjunction with the ways in which the paintings are meant, as part of their commodification, to bring certain things to mind, to induce certain memories, even memories of the present. Political, migrational, choreatic. The music is the vehicle, drives and is the car. These are phenomena that we might fruitfully think in Eisensteinian terms. The paintings constitute what Sergei Eisenstein recognized in Leonardo da Vinci's *The Deluge*—notes for a painting never done, description figured by Eisenstein as a "shooting script"—as an early experiment in audio-visual relationships.[34] "[Such] forms included 'overtonal' montage. This kind of synchronization has been touched upon . . . in connection with *Old and New*. By this perhaps not altogether exact term, we are to understand

an intricate polyphony, and a perception of the pieces (of both music and picture) *as a whole*. This totality becomes the factor of perception which synthesizes the original image towards the final revelation of which all of our activity has been directed."[35] Eisenstein moves toward an analysis of color in film as the decisive element for "the question of *pictorial and aural correspondence, whether absolute or relative*—as an indication of specific *human emotions*."[36] And in this movement he will introduce a term that seems peculiarly well-designed to encompass what it is that Tshibumba accomplishes: "chromophonic or color-sound montage" where montage, at its most basic, is "Piece *A*, derived from the elements of the theme being developed, and Piece *B*, derived from the same source, in juxtaposition giv[ing] birth to the image in which the thematic matter is most clearly embodied."[37] The thematic matter, in this case, is the material spirit of the postcolonial future.

Tshibumba derives something from colonialism (by way of Fabian, by way of the ethnographic encounter which they both perform in a kind of animating contamination; this something is what we might call the opportunity of the book, the sequencing the book allows and the dissemination of that montagic form)—a certain modernity in techniques of form and subjectivity. But these are means. The work remembers its originary animation, its unachieved natal occasion, its before: the postcolonial future. And this memory drives it and instantiates what the work would enact. If Fabian's ethnographic performance is meant to produce and convey knowledge about Tshibumba's culture, this must be understood as a mediational condition of possibility for a certain movement of Tshibumba's work and as the echo or contemporary manifestation of those social and politico-economic conditions that make Fabian's work possible and the work of Fabian and Tshibumba necessary. But Fabian's ethnographic performance is, at the same time, made possible by and contained within the trajectory of Tshibumba's work. Fabian's aim is within Tshibumba's circle or frame. But Tshibumba's aim and work abounds and exceeds Fabian's. Tshibumba's work is (animated by the spirit/value) (a representation, which is to say a memory) of a postcolonial future prefiguratively cutting any return or recourse to authenticity.

Fabian speaks of the irruption of the outside into the performance/production of the project, the sound of the plane during a moment in which Tshibumba inserts commentary into his painted narration where aerial bombing is central; the insertion of commentary into narration in general. These irruptions lead Fabian to speak of the reproduction rather than the

representation of knowledge. These irruptions, however, don't stop Fabian's privileging of the historical over the aesthetic. It's as if his notion of the aesthetic is too narrow to admit modes of representation that are not immediately opposed to production. Such reconstructive modes are precisely what Tshibumba is about as painter/historian and political thinker in the Lumumba tradition. So that if Fabian understands Tshibumba's project as a window onto culture, a logic with history, a way of fulfilling his anthropological responsibility "to represent Tshibumba and his work in such a way that they add to or deepen our knowledge of the culture in which they emerged," he understands it only partially. This is to say that the aesthetico-political (historical) encounter in Tshibumba's work operates in a way that calls the idea of culture into question rather than merely illuminating that idea in some particular manifestation. This is to say that each of the paintings, the relations between the paintings and the performance that emerges from them and out of which they emerge, constitute an articulated combination that is, itself, always cut and augmented by a rhythmic and tonal surplus that is the difference between them that is common to them. Culture is a false, allegorical totality, an object given in a methodology that works in and toward the eclipse of the aesthetic and the (political/economic) historical, that means to stand in for the complexity of the social totality, that moves in relation to the articulated combination, the interinanimative autonomy, of the aesthetic and the politico-economic. The deepening of "our" knowledge of a culture has intense connections to the return to authenticity. Here is where the ethnographic and the neocolonial projects converge in a certain specificity. Here, also, is where the postcolonial project is reconstructed. Fabian is constitutive of every aspect of this complex. He is a necessary condition of the resurrection of a (geo)political aesthetic. And it's all about the irruption of the outside not just as a paradoxically essential accident of performance but as a fundamental element of the African political aesthetic, of African political reason. What Fabian sees as "an instance of . . . the intrusion of materiality into the immaterial world of representation," where "[noise] establishes physical presence," is, more precisely, a moment that reveals that fundamental im/materiality of representation of which Tshibumba is aware and upon which he depends as aesthetic and political theorist and practitioner. And if noise establishes presence it establishes it at a distance: of space in the case of the plane (which is there and not there, above and before, our hearing of it marking proximity and its other all the

time), of time in the case of Lumumba (whether memorialized in song or in Mobutu's totalitarian radio). All this is to say that our interest in the performance of the painting must be alloyed by an interest in performance in the painting—as sound and rhythm, as musical or radiophonic transfer. And here we get to painting 97, by way of one of Fabian's less aggressively edited transcriptions.

> T: . . . I went inside my house and thought every which way I was
> capable of. I failed. Just as I was about to go to sleep I put the radio
> down at the head of the bed. Then sleep took me. After sleep had
> taken hold of me I dreamed this and that, always with the idea that
> I should receive the future and what it would be like. But I failed
> completely. I just listened to the music. It began to play and it was
> already midnight.
> F: Mm-hmm.
> T: As the music was playing, it brought me a dream. I dreamed this
> building, the way you see it. I didn't really see that it was a building;
> it was in a dream, and the colors I put—all this was in the dream—but
> it did not sit still. You [=I] would look, and it was just different. Now,
> the music they began to sing—it was the night program about the
> Revolution—they began to sing a song, "Let us pray for a hundred
> years for Mobutu." All right. Now, the vision I had [*mawazo ile na-
> liona*, lit. "the thought I saw"] was this: There were those skeletons
> that were coming out of this building, here and there, on both sides.
> F: Mm-hmm.
> T: Then this one [here] comes. Then mournful singing started in
> female voices; that was there on the side of the building. So sleep
> had carried me [away], and I dreamed those skeletons . . . [38]

Fabian breaks here, following an interruption of Tshibumba's in which another painting is spoken of, a painting too dangerous to circulate or carry around, and so gives us a chance to do the same. In the break we notice the aspect dawning of Tshibumba's vision. Internally differentiated, it would not sit still—it was animated. And we notice Fabian's footnotes where the term *animation* is said to refer to "the dancing and singing of praise songs for the party that accompanied all public occasions at the time."[39] Tshibumba by way of Fabian points us to the truly revolutionary force of such accompaniment, its change in aspect out of the control of Mobutu, infused by another spirit. After the break Tshibumba resumes:

[T]: You see the skeleton standing up. Then they played another song that really woke me up, a song that Tabu Ley used to sing long ago: [in Lingala] "soki okutani na Lumumba okoloba nini."[40]

And here follows another interruption repeated by Fabian. This interruption is an aside on the importance of dreams in traditional African culture. Fabian does not include it. "Then he resumed his account exactly at the point where he had inserted his reflection."[41]

[T:] Now the tall skeleton just stood upright at the time. Then I woke up and began to tell my wife about it. Also, I was full of fear. When I thought about things [other paintings] to do, I failed [to come up with any]. Then I thought: No, I'll do that painting exactly the way my dream was. Because what Mr. Fabian asked me was whether I could do the future. All right. While such thoughts went by me, I set out to dream what was asked for. Actually, I did not consciously think anything, the ideas I had came as a surprise, [for instance] when those skeletons appeared there. In my sleep I ran as fast as I could, and I was startled to hear that they were singing this song, "Kashama Nkoy." That was the song they began to sing.
F: "Kashama Nkoy"?
T: "Kashama Nkoy"; it's a record by Tabu Ley.
F: Mm-hmm.
T: Now, he was speaking in Lingala; in Swahili he [would have] said: [*first repeats the Lingala phrase*] "soki okutani Lumumba: okuloba nini?" Which is to say: If you were to meet Lumumba right now, what would you say? All right. I woke up with a start and told my wife about it.
F: I see.[42]

This is what it is to receive the spirit of the postcolonial future. The recording of Tshibumba's dream, the recording of his passion, is all bound up with Lumumba's passion, where passion is not only suffering but an overwhelming aesthesis, a massive and surprising sensual experience that *happens* to you, an irruption of the outside in its fullness with regard to every sense, where the ensemble of the senses is established by way of each of the senses becoming theoreticians in their practice. To do the future, paint the dream exactly as it was, animation and all, not standing still and all. What it will then mean

to meet Lumumba; a general responsibility, the possibility of a scandal and a chance, for and in excess of Mobutu. Fabian's attunement to the performative aspects of Tshibumba's painting is crucial here but not far-reaching enough. His attention to Tshibumba's rhythm, his performative timing, his filmic cuts, the way the static frame incorporates movement are all welcome but all bound up with an aesthetic and political reason that undermines the notion of culture Fabian is interested in illustrating. You can't talk about performance without talking about the aesthetic. And when you talk about the aesthetic you've got to talk about it in its interinanimative autonomy vis-à-vis the political. And when you talk about all that, you're not talking about "culture" anymore. And here, the simple opposition between performance and recording, production and reproduction, are broken down by the inescapable fact of the surplus that is and marks the aesthetic and the political in their difference and commonality. Fabian is to be commended and appreciated for his intuition regarding the presence of truth in Tshibumba's work, even in the "vociferous silences" of his truly popular history. But that truth cannot ever be detached from a truly radical aesthesis that is a matter of danger for the big shots. Tshibumba has Fabian know that he thought about the future even before Fabian commissioned him to; that thought is aesthetic and political in Lumumba's spirit, the material spirit of the postcolonial future.

4.

So the not-in-between and the postcolonial, which return now as the question of the future, can be thought in terms of the relations between sound, image, and value. Marx images the commodity as soundless and the theory of value he puts forward depends upon that reduction—or, more precisely, impossibility—of phonic substance. He calls upon us to imagine the commodity speaking, ventriloquizing, because he knows it cannot, knows that if it said something the understanding given its valuation as a function of its silence would be inadequate. So that the substance of the sound in the image/commodity requires a revision, an improvisation of the labor theory of value. And it is important that the sound infuses the commodity/image/frame and is other than that which would operate on a parallel track. This would mark a difference between the sound of the painting and the sound of film that is decisive and momentary to the extent that it quickly invades the internal structure of film form and film frame. This is that excess of Deleuze

where sound track is redoubled by/as sound-image but in a way way out from Saussure's deployment of this term. This aural infusement of the visual, the very constitution of the visual in and with the aural, each condition of the other's possibility, each cutting and in abundance of the other, is, again, a theoretical disruption, the natal occasion of new sciences (of value) given by way of the material inspiration of the phonically infused frame. Tshibumba's work is an exemplary site of this occasion, this improvisation through the opposition of description and prescription, representational memory and theoretical vision, totalizing allegory and cognitive mapping. It marks a historical and aesthetic compulsion; a compulsion to make or to produce every day; to produce contradiction, painting, theory; to produce the lyrical, everyday disruption of ethnography, art, history, and what is not in between.[43]

Interpolation and Interpellation

Imagine incessant listening. It might provide great pleasure and, in so doing, produce great consternation and anxious questioning about the nature of such pleasure. Those questions might concern the psycho-political effects or politico-economic grounds of the submission of oneself to such pleasure. But in the end, both the fact and the depth of the questioning that is produced in immersion in Bach's *Mass in B Minor* seems always to amount to something that's all good.

But for a long time I've been caught up in an obsessive relationship with a song called "Ghetto Supastar," performed by Pras, Ol' Dirty Bastard, and Mýa. The song was produced by Pras and Wyclef Jean and contains what is referred to in the liner notes as an "interpolation" of Barry Gibbs's "Islands in the Stream" (originally recorded by Kenny Rogers and Dolly Parton). I want to draw you into this interplay of pleasure and questioning produced by "Ghetto Supastar," but there are those who would never admit the possibility that such an object bears depths that could produce such interplay. For some, this would indicate the object's fundamental lack of aesthetic value. For others who would champion the devaluation of the aesthetic, "Ghetto Supastar" might be valorized precisely because it has no value or, more to the point, works against the very idea. Then there are others for whom the song signifies a disavowal of depth, of the underneath, in the interest of crossing over into popularity. I want to work with and against the possibility of all these formulations.

Let me repeat, then, that the pleasure I derive from "Ghetto Supastar" raises questions. How could one derive pleasure from such a thing? And, if you've got some inkling about the first question, then what does it mean to derive such pleasure? Is such pleasure what Theodor Adorno would disparage as "culinary," an effect of an evacuation of reason that's bound to a certain giving up of, which is to say, giving oneself up to, the body and its base or

basic (or bassic) functions?[1] Is this a kind of pleasure that's too much a function of the hook, of being hooked to or by the addictive repetition of a catchy tune? Or, more drastically, does this song reveal what requires Althusser to claim (by way of, and in parody of, Kant) that aesthetic judgment in general is "no more than a branch of taste, i.e. of gastronomy"?[2] Either way, some attention to the song's flavor and my pleasure in it is required. I want to think that flavor in relation to a desire for music that is im/properly and unanxiously political. That which Cedric Robinson calls "the black radical tradition" has been acting on and out and theorizing that desire for a long, long time.

The themes of culinary enjoyment and musico-political desire have a re-animative, *quickening* function. They bring life and noise, and offer up a bit of anima and aroma, which airs out various venues that had been overwhelmed by a kind of putrefaction, the smell of death that hovers over even those spaces where folks are talking about resistance or hybridity or citizenship or whatever while believing or being driven by a belief that the times we live in or the modes of thinking that are now prevalent are, to use Judith Butler's term, "post-liberatory."[3] It's not that what Butler says is not true; or that if she'd said preliberatory that wouldn't have been true as well; it is, rather, that here in this vestibule, where we belatedly await our own invention of, our own coming upon, the liberatory, we operate within an incessant escape that might be said to cohabitate with incessant listening. The taste and smell of music messes up the very idea of the liberatory as well as its before and after. But the point is that it's not enough to assert the need for music or even to imagine a relation to the various contexts of various embarrassed discussions of freedom that would invoke Q-Tip, formerly of the group A Tribe Called Quest, when he says, "the job of resurrectors is to wake up the dead." This leads to another question: Why would anyone want to revive such contexts? Moreover, there is the question of the incorporation of the music into the larger culture, into the culture industry and thereby into an ensemble of relations of cultural production that now also determine the corporatized and industrialized production of academic stuff, which is to say not only what is called academic knowledge but also what are called academics; finally (and back to the matter at hand), what about the incorporation of "Ghetto Supastar" into the soundtrack of Warren Beatty's film *Bulworth*? This question, in its turn, raises others: that of the film's appropriation of the black radical tradition and its sounds; that of the American Left's aggressive and ambivalent incorporation of that tradition in general, its insight (at

once primitivist and progressive) concerning that tradition's special, vexed, complex, hopeful—indeed, necessarily utopian—relation to aesthetic, political, and libidinal freedom (and servitude). This, along with a valorization of a kind of hybridity that ought to make anyone who has ever valorized hybridity pause, is what the film both represents and enacts. But let this slide, too, though it's right to point out that the last ensemble of questions requires at least some thought regarding the fetish character of Halle Berry and her secret. What I will try to get to is bound up with the radical impossibility and undesirability of detaching the fetish character of the commodity from the commodity.

The main thing, in the end, is to think about what the foreclosure of music has wrought where music is understood not only as a mode of organization but, more fundamentally, as phonic substance, phonic materiality irreducible to any interpretation but antithetical to any assertion of the absence of content. This could be about the utopian function of dropping science where dropping signifies a critical, if appositional, engagement and dissemination rather than a mere and misguided dismissal. Obviously this interplay of science and utopia has to do with Marx, with the divided Marx that Althusser produces (without discovering), with the Marx that is beyond Marx, according to Antonio Negri, or the Marx that is before Marx. This last Marx, the one that is before Marx, is the one we're after insofar as he is anticipated in and by the black radical tradition. This essay just responds to a Marxian interpellative call that was itself anticipated by the black radical tradition, always already cut and augmented by an anticipatory interpolation. "Ghetto Supastar" extends that tradition by exemplifying its formal operations, even if on what some would think of as modest terrain, while awaiting the exaltation that life-giving and anticipatory revision makes possible. This is, in other words, what Pras and Mýa and Ol' Dirty Bastard do to and for "Islands in the Stream," which, in the version performed by Kenny Rogers and Dolly Parton, had a tune that did not fully exist—or, more precisely, was not fully alive—until Pras 'n' em killed it. The black radical tradition contains numerous other examples of such anticipatory interpolations, vicious revisions of the original that keep on giving it birth while keeping on evading the natal occasion.

This brings me to another version of "Ghetto Supastar," a novel cowritten by Pras and kris ex, and to the theoretical scene that version revises. The novel begins by anticipating its end. It tells the story of Diamond St. James, a young rapper struggling to escape the dangers of a (stereo)typical urban

nightmare by entering into the even more fearsome world of the culture in-dustry. Diamond's struggle is to be in and not of the latter, to be of and not in the former. His music would both instantiate and represent that struggle. The opening of the novel anticipates its end by showing us a mature and suc-cessful Diamond, fending off the interpellative telephone calls of his publicist and of his old partner in street crime, the now incarcerated Michael. Michael's call literally interrupts, via call waiting, that of the industry, given in the form of a call from Diamond's agent, knowingly figured as the one who endangers, by way of a kind of protection, Diamond's agency. You could say, then, that the novel is all about the vexed possibilities of resisting interpellation, a possibility given in musical interpolation. But Althusser makes sure to let you know that interpellation is, in essence, more fearsome than these initial examples. The interpellative call is exemplified by the call or sound (as KRS-One has had it—"Whoop! Whoop!") of the police rather than that of the publicist or old runnin' buddy. Pras figures that more fundamental and dangerous figure in the novel as well. Check it out:

He was two blocks away when he noticed a beat cop eyeing him knowingly.

Diamond didn't know what to think. He'd been through so much, done so much, seen so much in the past week, that he knew he was under arrest for something. It didn't matter what it was—he was sure that he was guilty. It was a long time coming, and he knew the rules—he wouldn't turn on Michael or Mr. B for all the amnesty in the world.

"Hey," the cop called, moving closer with a smile. "What's up?"

Diamond just looked at him. He knew the tricks, the traps, and the runnings. His mouth stayed shut.

The officer grinned widely. "You don't remember me, do you?"

Diamond peered underneath the man's cap.

"St. James—no Walkmans in the hall," he bellowed with a laugh.

Diamond smiled. It was Nixon—he used to be a security guard when Diamond was in high school.

"What's up man?" Nixon smiled. "What you been up to? How's the rapping thing? I hear you're still doing it."

"Yeah, yeah, no doubt," Diamond said anxiously. He was never more than passing acquaintances with the man when he was in high school, and now, even in parts removed from his home turf, he did not want to be seen cavorting with the police.

"You ever thought about getting down with the force?" Nixon asked with a recruiting smile. "It pays pretty well. You know," he said with secrecy, "we need more brothers in blue."

"Yeah," Diamond said. He needed to get the conversation over with as soon as possible.

"I'm fresh out the academy," beamed Nixon, proudly. "They'll be testing again in a few weeks. You don't want to miss it."

"Yeah, yeah."

"All you have to do is go down to a precinct and pick up an application—you have your diploma, right?"

"Nah," Diamond lied, hoping it would be deter the man and send him on his way.

"Well, you gotta get your G.E.D., brother," Nixon advised. "And sanitation is testing next Tuesday. It may be too late for that one—but my sister works there, she could help you out if you really want it. Let me get your number and I'll call you with all the info."

Diamond rattled off any seven numbers. The cop asked him to repeat the numbers four different ways, obviously part of his training to discern when those damned detainees were trying to pull a fast one. Had he not so much practice memorizing his rhymes he would have faltered.

"Alright, brother," Nixon said, slapping palms with the boy off beat, proud that he was able to merge his academy training, street savvy, and inside connects to the hood in one triumphant moment of community policing. He would run a search on the boy when he got back to the station house that night. Hell, he'd make sergeant sooner than anyone thought.[4]

Diamond comes upon the policeman and his gaze rather than being surprised by it from behind in the now-classic Althusserian scene; so we're working in the impossibility of a certain kind of surprise that comes on line when such scenes are transposed into a different venue and recast with different prospective subjects. It takes a special kind of subject-in-waiting to be surprised by the presence of the police or, more problematically, to respond to that surprising hail in a way that betrays the uncut version of what Butler calls a "passionate attachment" to the law.[5] Happily, this special kind of subject-in-waiting is not the universal model. Instead, we've got Diamond, the sentient, sounding object of a powerful gaze. His resistance to that power

predates it, indeed is the condition of possibility not only for that power but for a response to that power that is knowing, strategic, appositional. Nixon's interpellative call has practically every institutional apparatus behind it: school; the seductive, mystico-economic power of civil service and civil surveillance in the form of "the force"; even the vulgar parody of a kind of filial concern. And even if his insidious demand for recognition works in tandem with Diamond's multiply sourced feelings of guilt, the object resists here and in so doing rearticulates the condition of possibility of the liberatory. Nixon's attempt to reinitialize the "scene of subjection," to replicate the scene of his own subjection, is cut by another mode of organization, the (necessarily musical) theater of objection, black performance as the resistance of the object.

This is to say that black musical performance once again offers for us an instance of itself as the ongoing reproduction of that which disrupts reproduction from within the very process of reproduction of the conditions of capitalist production (that process being the original [aim and] object of study for Althusser's famous essay). What is invoked here, what remains here to be activated, is not merely an internalization of the outside as lost object but the always already given possibility of the exteriority of the inside, the becoming-object of the speaking, singing, commodified object. This becoming-object of the object, this resistance of the object that is (black) performance, that is the ongoing reproduction of the black radical tradition, that is the black proletarianization of bourgeois form, the sound of the sentimental avant-garde's interpolative noncorrespondence to time and tune, is the activation of an exteriority that is out from the outside, cutting the inside/outside circuitry of mourning and melancholia.[6] Here utopia is reconfigured in a morning song, at morning time, by a moan of pain and joy. "Ghetto Supastar" carries that sound, a mo'nin' for morning, as the beginning of a day made even closer when the dead awaken to a kind of *working for*, the working for all of the living, all who have lived, all whose lives have been stolen, all who shall live in stealing (their lives) away.

Objects Magic of

Performance studies is a very young discipline but its youth hasn't stopped some of its founders from characterizing it as postdisciplinary. For me, this characterization is troubling, since the terms *performance* and *performativity*—in the promiscuity of their applications and in the very indefinition of their own specific concept of an object of study—often threaten to assert themselves as the ground of every possible area of study. When faced with the conflict between global desire and an objectless locality where disciplinarity and discipline are eclipsed, one is called upon to ask certain questions that converge, I think, with the theme of this gathering. Is the postdiscipline a good model for the changing U.S. academy and, more broadly, for the forging of some understanding of the relation between humanity and the humanities?

Permit me, and please forgive, a long quotation from Randy Martin's brilliant book, *Critical Moves*, wherein Martin begins to address some of these issues:

Insofar as structure and agency retain the discrete separation of object and subject, practice emerges instead as the already amalgamated process of these last two terms. From the perspective of practice, it is no longer possible to insert human activity into a fixed landscape of social structure; both moments are formed in perpetual motion.

Where this insight has its immediate political application is to the series of practices articulated through race, class, gender, and sexuality. Each of these words points to a systematic structuration that appropriates different forms of surplus through racism, exploitation, sexism and homophobia. By extending a productionist model to domains not generally associated with an economy oriented toward exchange, I want to take seriously Marx's understanding of capitalism. He treats it as forcibly constituting, by the very organizing boundaries

it erects and then transgresses, in pursuit of increasing magnitudes of surplus, the global collectivity, the "combination, due to association," that he understood as the socialization of labor. . . . That race, class, gender, and sexuality, as the very materiality of social identity, are also produced in the process indicates the practical generativity—the ongoing social capacity to render life as history—necessary for any cultural product. Therefore, it is not that a productionist approach assigns race, class, gender, and sexuality the same history, political effects, or practical means. Instead, this approach is intended to imagine the context for critical analysis that would grant these four articulating structures historicity, politics, and practice in relation to one another, that is, in a manner that is mutually recognizable.

To speak of practices rather than objects of knowledge as what disciplines serve privileges the capacity for production over the already given product-object as a founding epistemological premise. The focus on practices also allows production to be named historically so as to situate it with respect to existing political mobilizations.[1]

I would briefly add a small set of formulations:

1. The epistemological shift that Marx allows, wherein practices are thought as if for the first time, as if in eclipse of objects, can itself be thought as an irruption of or into the sciences of value. I study black performances that are anticipatory manifestations of that shift/irruption.

2. Black performances work the second "as if" above in a specific way. The eclipse of objects by practices is a head, a necessary opening, that vanishes in the improvisatory work of those who are not but nothing other than objects themselves. (Black) performances are resistances of the object and the object is in that it resists, is in that it is always the practice of resistance. And if we understand race, class, gender, and sexuality as the materiality of social identity, as the surplus effect and condition of possibility of production, then we can also understand the ongoing, resistive force of such materiality as it plays itself out in/as the work of art. This is to say that these four articulating structures must not only be granted historicity, politics, and practice, but aesthesis as well. This is also say that the concept of the object of performance studies is (in) practice precisely at the convergence of the surplus

(in all the richness with which Martin formulates it—as, in short, the ongoing possibility or hope of a minoritarian insurgence) and the aesthetic.

3. Here is a particularly vicious irony: the assertion that a contingent postdisciplinarity characterizes performance studies allows the assumption and nonrecognition of hierarchies that legitimate one methodology, one mode of performance, one archive, at the expense of others. These issues are fundamental to the possibilities and impossibilities of minoritarian citizenship in performance studies, particularly when the would-be minoritarian citizen constitutes the embodiment not only of racial, class, gender, sexual, or national difference, but of analytic modes that constitute a certain desire for the nonstatist or nonstatic, for a dynamic concept of the object of performance studies, an object-in-practice. This indicates something crucial, finally, about not only the impossibility but also the undesirability of minoritarian citizenship, even as it does nothing whatever to militate against all of what's problematic in the denial of citizenship and all of what is needful in the fight against the effects of such denial. The point, however, is what minority does to the state, what minority ought to do—legitimately and rigorously—to the state of performance studies. The question remains: How can minority help to abolish the statist and static institutionality of performance studies while, simultaneously, reopening the possibility of establishing the concept of the object-in-practice of performance studies? Here, I am referring to and thinking by way of May Joseph's *Nomadic Identities: The Performance of Citizenship*. In *Nomadic Identities*, Joseph offers an extended meditation on the undecidability or indefiniteness of citizenship that never denies and ever more richly describes the reality of the experience of citizenship. To think citizenship as an experience is to think citizenship as a phenomenological problem and yet, as Ludwig Wittgenstein says, the existence of phenomenological problems does not obscure the fact that there is no phenomenology, no adequate phenomenological language. The locale where phenomenality resides in the absence of phenomenology is also the home of performance—the object-in-practice/the object-in-resistance. Citizenships, in this sense, are therefore (like) a set of performances. How can we avoid the inevitably failed applica-

tion of inadequate languages to phenomena like citizenships and performances? How can we move through the oscillational logic that places performances and citizenships between appearance and disappearance or, more generally, merely between? These are the questions upon which *Nomadic Identities* is, if you will, *kinetically grounded*. Joseph describes her book as delving into a sphere of "nervous enactment." Nervous enactment perfectly describes the possibilities and impossibilities of minoritarian citizenship in the state of performance studies in particular and in the United States academy in general. Ultimately, we would move beyond nervous enactment in the interest of a genuine engagement with the concept of the object of performance studies as well as with the concept of the universality in all of its resonances with the happy and tragic possibilities of the very ideas of the universal and/or the global. Such a move might best be described as disidentificatory in Jose Muñoz's sense of the term. It would be marked by an appositionality with regard to the state of performance studies that would itself be doubled by a renewed apposition of that state to disciplinarity itself, one that would shake that state's foundations. This is to say that the authoritarian comfort derived from the concept of the postdisciplinary—a comfort not unlike that B. F. Skinner derived from his pioneering conception of the posthuman—would be eschewed. And here I don't wish to alarm any of those I invoke in this essay who might, in spite of their intense detachment from anything like a Skinnerian legacy, not be as sanguine as me about embracing any kind of humanism—or even the idea of the humanities—no matter how unprecedented. Nevertheless, it seems to me that thinking the concept of the object of performance studies implies a convergence between the establishment of performance studies' disciplinarity and an extension of the black radical political/intellectual/aesthetic tradition that would work also within the project, which I think of now as Chomskyan, of the development of a theory of human nature (though it would disrupt Chomsky's scientism precisely by paying attention to the inconsistent totality of any and all non-"well-formed" human things). I assume the connection between the development of a theory of human nature and human development as such. The articulation of that connection is the theory of

history. This requires the exposure of that vicious irony I mention above. Indeterminacy doesn't ground freedom or equality (by way of some magic operation whereby the absence of basis becomes a basis). Rather, they are part of a complex field of scandal and chance, wherein the very idea of ground remains to be retheorized along lines established by Joseph among others. Meanwhile, the illusion of the postdiscipline is a ruse of illegitimate discplinarity. Perhaps if we think minority in relation to the surplus, perhaps if we accede to the surplus's demand that any thought of the object take into account its nature as practice, we can move toward abolishing the state of performance studies in the interest of performance studies and in the interest of an ever more fundamental transformation of the U.S. academy and its relation to the world. Here, abolition is to be thought as a kind of radical deconstruction and reconstruction, an out but rooted embrace of performance studies' locality in the interest of the promise of its globality. So that the study of black performances is a condition of possibility of performance studies in particular and the American university in general, neither of which has happened yet.

Earlier I spoke of the improvisatory labor of objects. My experience in Cuba has been one of a place animated by such labor which is always fraught with the dangerous traces of a terrible past and an uncertain future and is no less necessary for being so troubled. To put it in Martin's updated Marxist terms, the production of surplus—along with that which it produces and is produced by, "race, class, gender and sexuality as the very materiality of social identity"—has reemerged here with a vengeance. Surplus is the very magic of objects, their fetish character, their mysterious secret. That magic can be terrible, can produce some of the effects that have given some of us visitors pause or consternation precisely because those effects are so familiar to us being from the United States, the natural habitat of the hustle and its various complications, choreographies, and degradations. But there is also a liberatory force of the surplus, the magic of objects, which we see here in the midst of its very transformation, that requires us to make that undeniable claim on the revolution that it seems we *Yanquis* have no right to make. That claim is undeniable not only because of the uncanny familiarity of faces, bodies, and gestures that one has never seen before but also because of the centrality of the revolution to our own political formations and reformations. And

yet, for many reasons, that centrality is not as central as it should be, and so being here becomes or ought to become an occasion for radically rethinking our own political positions and practices. In the end, the magic of objects, the magic of the surplus, is a rough thing that we cannot simply abjure. I think that this is shown here over and over again; when I went to the *Museo de la Revolución* yesterday this magic was shown over and over again, most affectingly in the diorama where Ché Guevara and Camilo Cienfuegos move through the *Sierra Maestra* in a full, purposeful, now arrested stride. They were already and have become again magic objects. Their examples live. Raul Castro speaks especially of Camilo's "always trying to improvise a kind of joy." That's what revolution is. Such improvisation is, however, an almost always painful struggle that is constantly in need of renewal and recalibration. That work always remains to be done both here and in the United States, and the connection between those struggles needs constantly to be thought as they are, in and from both locales, humbly claimed and lovingly critiqued. Meanwhile, the revolution remains, in all its force, our object of desire and our model though it is, perhaps, the very reemergent minoritarian insurgence that the revolution in some sense subsumed that will animate it, grace it with the particular kind of black magic that is indispensable to the necessary cutting and augmentation of that of the dollar. And perhaps this minoritarian insurgence will draw strength from and give strength to its infinitesimally but unbridgeably distant twin in the United States, whose ongoing submergence is paradoxically indicated by our presence here today. The irony is that the magic of objects, the magic of the surplus, drives both this reemergence and this submergence. The question is how more fully to merge that errant magic with our own most human desires. Addressing this question is our improvisational task.

Sonata
Quasi Una Fantasia

François Girard's *Thirty Two Short Films about Glenn Gould* is situated at a double encounter: of fiction and biography, and of two animating drives of cinema—the fantastic and the documentary. I want to address some aspects of that encounter, its performativity, temporality, and residue. Part of that residue is a field of other, suddenly inoperative, oppositions, for instance that given by Theodor Adorno in *Beethoven: The Philosophy of Music*: "It is as a dynamic totality, not as a series of pictures, that great music comes to be an internal world theater."[1] Here, the contest between music and cinema that was decisive for Adorno is explicitly staged. Music, as dynamic totality, is understood to move and work in excess of linear sequence that, it is implied, is shaped and burdened by an essential sameness. Music's temporality constitutes a resource for resistance to that deadening rigor, which so often appears to lead to the reduction of aesthetic material to mere entertainment. But cinema and music cannot be so simply opposed, as the constant musicality of, for instance, Sergei Eisenstein's montage and some of the terms—*overtonal, contrapuntal*—he used to describe and theorize it suggest. Moreover, Adorno knew this. His awareness of the necessary vulnerability of a seriality that is essential to music was operative in his analysis of Beethoven, particularly of Beethoven's restructuring of the repetitive linearity of the sonata form.[2] In the case of op. 27, which is, at once both famous and forgotten, that restructuring occurs by way of contrapuntal means: *quasi una fantasia*—like a fantasy, where fantasy refers to a mode of polyphonic composition that is at once improvisatory, transportive (of composer, performer, and listener), and montagic (not only in its sequencing of musical sections that are not thematically connected but in its yoking together of seemingly disparate emotional contents). In Beethoven, then, the essential seriality of music is mirrored, broken, and infused by a fundamental counterpoint that is latent in the series and whose excavation and theorization awaits something like Eisenstein's elab-

oration of the specific materiality of the cinematic apparatus for its proper occasion. That occasion is given again by Girard, whose work allows us to linger where dynamic totality interacts with serial picturing, where polyphonic, polyrhythmic, multiply lined fantasy cuts and augments—and is cut and augmented by—the singular and straightforward adequation of a linear temporality that is often understood to be essential to documentation.

There is a scene in Girard's film in which the great, preternaturally and unnaturally rhythmic, romantically antiromantic, antitheatrically hyperperformative, solitary, multiply voiced, irreducibly and transhistorically baroque, pianist Glenn Gould is portrayed playing a recording of his interpretation of Beethoven's Piano Sonata 13, op. 27, no. 1, "Quasi una Fantasia."[3] In the scene's complex of performances, auditions, and technical reproductions and mediations, certain conventions that are meant to determine the strange attraction and estranged relation between sound and image are exceeded as an essential musicality of cinema becomes clear. That musicality is no more evident than in the high fantastical additive ruptures of seriality that documentation can neither assimilate nor control to the extent that it is driven by them. The "internal world theater" of which Adorno both tells and dreams is located where these elements converge. This would end up being something like *Quasi una fantasia* a little something like something like the contrapuntal in film, the dynamics of filmic counterpoint, which would be not only at the level of the sound/image relation, but also at the level of the relation between the documentary and the fantastic as drives. So that this is about the music of film, its mode of organization, the dynamic totality of a series of pictures. How does fantasy shape and disrupt the documentary drive of the fictionally hyped and disrupted biopic? By way of a specific and essential contrapuntality of film wherein the seemingly determining seriality of documentary drive is disrupted by a splice.

Gould would have approved of this splice, which is a slice of life. The short film titled *Hamburg* documents an incident that occurred in the fall of 1958 at the Vier Jahreszeiten Hotel in Hamburg—a place Gould called his *Zauberberg*, and which might best be understood as musical and cinematic development's last resort—while recovering from one of his frequent, concert-canceling illnesses. Gould recalled this convalescence as "the best month of my life—in many ways the most important precisely because it was the most solitary. . . . Knowing nobody in Hamburg turned out to be the greatest blessing in the world. I guess this was my Hans Castorp period; it

was really marvelous. There is a sense of exaltation . . . it's the only word that really applies to that kind of aloneness."[4] Otto Friedrich, one of Gould's biographers, recites the scene. We'll have his recitation first before reading the stage directions of Girard's fantastic, fantasmatic reprise:

> The only thing that could have made Gould's incarceration even better was a sense of the admiration of the outside world. And this too came to him in the new recording of his glittering performance of Beethoven's First Concerto, which included his own rather densely contrapuntal cadenzas. "I have been exulting for two days now in our Beethoven #1, which has sent me," he wrote to Vladimir Golschmann, who had provided the orchestral accompaniment. "I hope you have heard it and are as proud of it as I am. There is a real *joie de vivre* about it from beginning to end." And then there occurred a charming scene, when Gould was playing his new record of the Beethoven concerto in his hotel sickroom, and a chambermaid stopped to listen. "The maid," he wrote, "is standing entranced in the doorway with a mop in her hands, transfixed by the cadenza to movement #1 which is on the phonograph—it's just ended and she's just bowed and gone on to the next room."[5]

INT. DAY. THE HOTEL ROOM

Gould crosses the floor, anxiously unwrapping the package. He talks into the phone.

<div align="center">

G.G.

[to the phone]
</div>

. . . No, no, I . . . concerts tomorrow and Monday cancelled of course— not can't sell. That means something entirely different.

The chambermaid is finished. Gould stops her before she can leave.

<div align="center">

G.G.
</div>

Wait, wait . . . please stay.

Gould escorts her back into the room. He gestures for her to sit in an armchair in the centre of the room.

<div align="center">

CHAMBERMAID
</div>

Aber mein herr, entschuldigung Ich muss arbeiten.

Gould again gestures for her to sit. He takes the record he has un-wrapped over to the gramophone and sets it up, drawing the curtains over the window.

<center>

G.G.

[still talking into the phone]

</center>

No . . . go ahead . . . Yes . . . that's absolutely flawless. Could you send it off immediately, please. Room 318. Thank you.

He hangs up. There is a moment of awkward silence. Gould turns to face the chambermaid. She seems somewhat uncomfortable, wonder-ing what he is about to do. Keeping his eyes on her, he backs over to the record player and drops the needle. Suddenly, there is a miraculous outpouring of music. The music fills the room with a rush of emotion, unmistakably Beethoven.

The *Allegretto* from *Sonata #13* is heard with all its nostalgic candour. Gould, however, remains unconvinced. He steps behind the armchair and lowers himself to the chambermaid's ear level. After listening in-tently for a moment or two, he crosses back to the phonograph and deli-cately adjusts the treble and bass knobs. Then it's back behind the chair for another listen. This time he seems satisfied. He sits behind the maid.

The chambermaid has now completely given up on her schedule and resigned herself to this odd presentation. As the music plays, her anxi-ety is gradually allayed and her apprehensions are translated into cu-riosity. She examines her obliging captor and submits herself to the music. Gould, in turn, watches his audience. He holds his breath so as not to disturb the flow of the music.

Suddenly, she looks directly at him [THUS BREAKING THE ANO-NYMITY]. As he watches, she rises and picks up the record cover. Her suspicions are confirmed when she sees Gould's picture on the sleeve. She looks back at him. Their eyes meet and lock. In respectful silence, she turns away and walks slowly to the window. Gould awaits the judg-ment. The chambermaid pulls herself together and offers him her hand.

The music comes to an end.

<center>

CHAMBERMAID

</center>

Danke Schoen[6]

In Girard's composition of his scene, the music is Beethoven's; it is understood unmistakably to be so; it is as if the viewer will have recognized it not only because it carries Beethoven's unique signature but also because it bears, in and beyond that signature, a particular kind of candor, a truth or truthfulness that is aligned with but uncut by nostalgia's fantasmatic force. This alleged mode of truth is, however, always shadowed by the untruth that bears and/or accompanies it in an illicit partnership (Adorno calls it art's *Bewegungsgesetz*, or law of motion) that lends itself to and structures the truth of this particular cinematic document. The music's truth is troubled by its chronological placement, disturbed by and in the very instant of its having been replayed and seized in the absence—and also in the performative forgery or reforging—of the signature. This is to say not only that the Thirteenth Piano Sonata is often remarked, when remarked at all, as unremarkable and uncharacteristic by Beethoven scholars, but, moreover, that the *allegretto* of Sonata no. 13 could not have been the Beethoven Gould replayed for the chambermaid that day in 1958 because Gould recorded it in August 1981, a year before his death.[7] Indeed, the music upon which Gould insisted that day in Hamburg was, in the end, not Beethoven's at all but Gould's substitutive and disruptive augmentation of him. Girard's direction obscures the album cover, such concealment revealing a certain ruse of sequence and history.[8] Instead of portraying an almost surreptitious and unforced (meta-)audition in which Gould, in his cell, in his solitude, is caught (or, perhaps more precisely, overheard) listening to his own "densely contrapuntal" self-assertion into Beethoven's First Piano Concerto, Girard imaginatively, fantastically, substitutes a scene in which the chambermaid is rendered captive audience to a recording that had not yet been made. Where is the truth in this series of pictures? Between the dynamic totality of the sonata's expansion and the positive negation of the cadenza's counterpoint? Between documentary and fantastic versions of the event? What is gained and lost in the event's being given otherwise?

The short film directly preceding *Hamburg*, *Glenn Gould Meets Glenn Gould*, is also taken, as it were, from real life. It is a dramatization of Gould's already dramatic and imaginary interview of himself, an imaginary interview that took place as interior dialogue and broken, externalized soliloquy. In the interview, Gould, against as well as before himself, allows us to understand "Hamburg" as the re-imagined dream of a transcendence—on the part of a mourning audience, angry at Gould's self-imposed absence, like a suicide—of Gould's ideal 0:1 relationship between audience and performer:

g.g.: Mr. Gould, I don't feel we should allow this dialogue to degen-
erate into idle banter. It's obvious that you've never savored the
joys of a one-to-one relationship with a listener.

G.G.: I always thought that, managerially speaking, a twenty-eight-
hundred-to-one relationship was the concert hall ideal.

g.g.: I don't want to split statistics with you. I've tried to pose the
question with all candor, and—

G.G.: Well then, I'll try to answer likewise. It seems to me that if
we're going to get waylaid by the numbers game, I'll have to
plump for a zero-to-one relationship as between audience and
artist, and that's where the moral objection comes in.

g.g.: I'm afraid I don't quite grasp that point, Mr. Gould. Do you
want to run through it again?

G.G.: I simply feel that the artist should be granted, both for his sake
and that of his public—and let me get on the record right now
the fact that I'm not at all happy with words like "public" and
"artist"; I'm not happy with the hierarchical implications of
that kind of terminology—that he should be granted anonym-
ity. He should be permitted to operate in secret, as it were,
unconcerned with—or, better still, unaware of—the presumed
demands of the marketplace—which demands, given sufficient
indifference on the part of a sufficient number of artists, will
simply disappear. And given their disappearance, the artist will
then abandon his false sense of "public" responsibility, and his
"public" will relinquish its role of servile dependency."[9]

The technologically mediated relationship of anonymity Gould calls for here,
which he thought was a logical historical development in which the servility
and dependence of the audience that is removed from its own performative
capacity is cut by a kind of mechanized guarantee that *there is* music, is aug-
mented in *Hamburg* by the presence of Gould, manipulating the controls
of the record player, adjusting the playback, getting it just right. But Girard
unfaithfully indulges in Gould's fantasy of an absolute noncorrespondence
of absence and absolute singularity, substituting for it the dream of a captive
audition, the auditor as servant, mobility and response circumscribed, even
though, in the end, she is empowered not only by the limits within which
she makes her choice but also by the way the performer's control seems in-
evitably to slide into a servility all its own. What does Hamburg represent in

the film? Not that solitude that made it, for Gould, the happiest moment of his life and not only the fantasy of Gould's return to live, if mediated, performance. Perhaps, rather, it marks two interminable interinanimations: of (the flight of or into) solitude and the (constrained, constraining) knowledge of counterpoint; of composed, compositional, preformed, performative subjectivity and imposed, improvisational thingliness.

(Gould substitutes his own phono-manipulative power, given in the interstice between performer and audience, given as his own, specially informed auditory position, for the chambermaid's auditory servility; at the same time, in order to transcend that servility, by way of a certain proximity with the new hybrid performer/listener, the chambermaid must be rendered captive. This is to recognize that the traditional concertgoer, however servile, could always leave the concert hall. The relation/conflict between captivity and servility has to be played out on the person/body of the female chambermaid. How is she to be placed within a general phonic history of the servant girl? Perhaps this is where the question concerning the relation between counterpoint and thingliness—between the baroque and blackness—returns. Meanwhile, the audience is liberated by having been compelled to listen; only the spellbound are capable of flight. Moreover, the listener, having entered a fugue state, is inhabited by the artist—which is to say by the artist's position, as opposed to her personality, which remains hidden, absent. Nevertheless, the audience, forced truly to listen, takes up or is taken on by a certain productive function—a transferred or even transverse musical responsibility. Held, she will have been freed by becoming more than herself in having been brought up short of herself, by having inhabited an aesthetic position that inhabits and inhibits her. Did she take on his knowledge [of counterpoint] with his power? Note that "take" substitutes for "put" here, in order to mark how the difference between a metaphorics of position and one of apparel fails to signify. The taking up of a position must also bear the weight of bearing, of gest and gesture, of wearing and of being worn, of clothing and the imposition of non-nakedness, which is to say that what's at stake is an *imposition* of form as well as whatever attends the knowledge of nakedness. The servant girl, in her thingliness, which is to say her terribleness, is saved from the fate of formlessness, of bareness, while also bearing the knowledge of having been naked [for bare life only emerges against the backdrop of violation, the enactment of what will have been a retroactive withdrawal of form and the subsequent ascription and internalization of nakedness]. This is to say, more explicitly, that nakedness is an interior formulation. Her uniform, which is

her nakedness, justifies a demand that assumes her necessary availability to the imposition of a liberatory constraint. She improvises in and against and out of that imposition. She dances under the groove of Gould's extraordinary rendition.)

The fantastic in film, in these musico-technical senses, might be part of a complex metafantasy, a counterpoint not only between psychoanalytic and musical conceptions of fantasy, but between this relation and the contrapuntal relation between the fantastic and the documentary as cinematic and narrative drives. Consider the fantastic relation between counterpoint and imagination, the interconnected but athematic relation that is montage as such. A question of form and content and fantasy is situated at the point of that conjunction. Furthermore, fantasy requires thinking the intensity of the connection between the technical languages of classical music, psychoanalysis, and cinema. Is the documentary drive, not only against but also in its seriality, necessarily fantastical? Perhaps Gould's own (radio/stereophonic) documentary practice holds a clue. For Gould, *The Idea of North*, the first section in his *Solitude Trilogy*, the beginning of his experimentation in what he called "contrapuntal radio," was an occasion for the dramatic disruption of documentary linearity. How do we think this in relation to *Thirty Two Short Films*? How do we think contrapuntal radio in relation not only to the multiple tracks, lines, voices, and characters of extradocumentary cinema and of contrapuntal music, but also in relation also to what Peter Ostwald, another of Gould's biographers and a psychiatrist, speaks of as Gould's pathological experience of hearing voices?[10] Perhaps dramatic documentary emerges from a sort of obsessive and *compositional* overhearing—a discomposing loss or lack of normative composure that happens to or is imposed upon the composer in diners, at the telephone, in sites where interview and inner view converge, where simultaneity works through and over sequence, marking the motivation behind the valorization of fantasy. In a way, *The Idea of North* is analog to *Sonata Quasi Una Fantasia* in its extra- as opposed to nonformality, its prologue a trio sonata that veers off and out, centrifugally, into fugue.[11] The repressed, "densely contrapuntal" cadenza to Beethoven's First Piano Concerto has to reemerge somewhere in the film, at that moment, perhaps, when, as Gould remarks, "one must try to invent a form which expresses the limitations of form, which takes as its point of departure the terror of formlessness."[12]

Thirty Two Short Films about Glenn Gould begins and ends with an aria and is thus structured and numbered like the *Goldberg Variations*, Bach's

masterful set of contrapuntal piano exercises, Gould's brilliant recording and rerecording of which framed his career. Yet these poles are not absolute beginnings and endings and, further, they shadow even more crucial and attenuated origins and terminations. We could look, then, at *Hamburg* and *Leaving* as short films that have the function which the aria is supposed to have; and we could look at Beethoven's First Piano Concerto and his Thirteenth Piano Sonata as having a certain relation to Gould's career as a whole that people often assign to the recordings of the *Goldberg Variations*. This is to say that we might think Gould as more properly represented not in his creative submission to the already structured contrapuntal essence of Bach but in his amplification of a certain contrapuntal trace in Beethoven that serves to soften what Gould understands to be Beethoven's Napoleonic heroism while allowing Gould both to deny and to indulge his own. The film parallels this structure by representing Gould's performances, his complex ambivalence regarding performance in its relation to the recording, and his especially complicated relation to and desire for female audition in spite of his protestations regarding an almost morally necessary withdrawal or anonymity of the artist. Mechanical reproduction and telephonic communication are employed to make possible this virtual detachment. In choosing the Thirteenth Piano Sonata over the First Piano Concerto, Girard chooses to withdraw the more fully contrapuntal and disruptive music in the interest of making a more fully contrapuntal film, a more fully true because fantastic, document. This, in part, because the simultaneity such splicing allows marks a place where the present and the absent, the living and the dead, converge. The desire that is fantasy, simultaneity, is the desire for and disavowal of control over the interlocutor; the desire for a certain communication via solitude; the desire for an ideal polyphony in silence and solitude; the desire for the contrapuntal, perhaps pathological, ecstasy of solitude. And it is Eisenstein who thinks a temporal-pictorial conflict, a musical and thus contrapuntal form of montage, a certain field of and for gesture that is the object and locale conjured by Gould's absent presence, that is not but nothing other than the "internal world theater" that Adorno senses in Beethoven and of which he continues to dream.

For Adorno, "Beethoven's music does not merely contain 'Romantic elements,' as music historians maintain, but has the whole of Romanticism and its critique within itself."[13] Gould understands this; this explains his profound ambivalence regarding Beethoven. Beethoven's possession of (and by) romanticism and its critique would necessarily repel and attract one who, in

his mode of performance, on the one hand, and in his theoretical formula-
tions, on the other, both embodied and disavowed romanticism. Some fur-
ther formulations of Adorno are instructive here:

The *prima vista* most striking formalistic residue in Beethoven—the
reprise, the recurrence, unshaken despite all structural dynamics,
of what has been voided—is not just external and conventional. Its
purpose is to confirm the process as its own result, as occurs uncon-
sciously in social practice. Not by chance are some of Beethoven's most
pregnant conceptions designed for the instant of the reprise as the re-
currence of the same. They justify, as the result of a process, what was
once before. It is exceedingly illuminating that Hegelian philosophy—
whose categories can be applied without violence to every detail of a
music that cannot possibly have been exposed to any Hegelian "influ-
ence" in terms of the history of ideas—that this philosophy knows the
reprise as does Beethoven's music: the last chapter of the *Phenomenol-
ogy*, the absolute knowledge, has no other content than to summarize
the total work which claims to have already gained the identity of sub-
ject and object, in religion.

But that the affirmative gestures of the reprise in some of Beethoven's
greatest symphonic movements assume the force of a crushing repres-
sion, of an authoritarian "That's how it is," that the decorative gestures
overshoot the musical events—this is the tribute Beethoven was forced
to pay to the ideological character whose spell extends even to the
most sublime music ever to aim at freedom under continued unfree-
dom. The self-exaggerating assurance that the return of the first is the
meaning, the self-revelation of immanence as transcendence—this is
the cryptogram for the senselessness of a merely self-producing reality
that has been welded together into a system. Its substitute for meaning
is continuous functioning.[14]

Knowingly or not, Beethoven was an objective follower of this idea.
He produces the total unity of the obligatory style by dynamization.
The several elements no longer follow one another in a discrete se-
quence; they pass into rational unity through a continuous process
effectuated by themselves. The conception lies already, so to speak,
charted in the state of the problem offered to Beethoven by the sonata
form of Haydn and Mozart, the form in which diversity evens out into
unity but keeps diverging from it while the form remains an abstract

sheath over the diversity. The irreducible vision, in an eye that in the most advanced production of his time, in the masterly pieces of the other two Viennese classicists, could read the question in which their perfection transcended itself and called for something else. This was how he dealt with the crux of the dynamic form, with the reprise, the conjuring of static sameness amid a total becoming. In conserving it, he has grasped the reprise as a problem. He seeks to rescue the objective formal canon that has been rendered impotent, as Kant rescued the categories: by once more deducing it from the liberated subjectivity. The reprise is as much brought on by the dynamic process as it ex post facto vindicates the process, so to speak, as its result. In this vindication the process has passed on what was then going to drive irresistibly beyond it.[15]

The dynamic sonata form in itself evoked its subjective fulfillment even while hampering it as a tectonic schema. Beethoven's technical flair united the contradictory postulates, obeying one through the other. As the obstetrician of such formal objectivity he spoke for the social emancipation of the subject, ultimately for the idea of a united society of the autonomously active. In the esthetic picture of a league of free men he went beyond bourgeois society. As art as appearance can be given the lie by the social reality that appears in it, it is permitted, conversely, to exceed the bounds of a reality whose suffering imperfections are what conjures up art.[16]

How does the imperative to repeat manifest itself in the age of mechanical reproduction when the actual performance of the repetition can be substituted, even voided? One must move, despite Adorno's distaste, precisely where immanence and transcendence converge, precisely in order to get at this cryptogram, to get at the kernel that reveals or marks the autocritical romantic stage of enlightenment's autocritical devolution to mere functioning (as, here, Adorno—after Max Weber and Martin Heidegger—would have it). But what of Adorno's fearful and repetitive "revelation" of repetition's debt-ridden submission to the unfreedom it would internally disrupt? Of course, that to which Adorno shows a certain generosity, here, is only and severely vilified by him when it is manifest in jazz. And, the functionality of his repetitions of Weber and Heidegger and, above all, of himself, is left unremarked. This is to say that the question of the politico-philosophical work such an argument does is left hanging when, in our supposedly postideological mo-

ment, it works, certainly in spite of Adorno's best instincts and hopes, as a kind of dampening, a resignation in spite of his theoretical refashioning and disavowal of resignation. But perhaps there is something Adorno missed about repetition's resistance—as opposed and in addition to its (re)capitulation—to resignation. These are alliterative, repeating questions of rhythm. Technically, these are questions of the splice, of the deconstruction and reconstruction of performance's temporality by another technical apparatus. The time of performance, the time of documentary, the time of biography will be, now, fantastic.

At stake in Beethoven's music (especially in his setting into [com]motion of the sonata form), according to Adorno, is the birth of a new science and the idea of "a united society of the autonomously active." What is the relation of montage to this progressive rationality? What occurs in the filmic representation of music, this attempt to document the truth of a musical performance, to interpret cinematically the truth in music, to form some unity out of the diversity of modes of expression whose unique totalities and temporalities seem, according to Adorno, to be incompatible? How can the seemingly antifantastic essence of film, as discrete sequence and documentary drive, hope to make a fantasy of film and music?

Girard represents the playing of a recording. The performer "captured" on the recording plays the recording. He plays it for the maid who is cleaning up his room. We know him to be one who valorizes recordings over live performances. The playback is, nevertheless, a performance. It is a performance that marks, above all, a certain effect of rhythm. What does syncopation do to the sequence? What is the relation between the reprise, the sonata's serial development, montagic sequencing and the documentary drive when all are subject to syncopation—when all occur, as it were, within the syncopic blackout of an imaginary event? How can film be both a dynamic totality and a sequence of pictures, both fantasy and documentary?

Note that for Adorno the "authoritarian 'that's how it is'" of the reprise has a function similar to that of the backbeat, namely the signification of the ever-functioning of the hard, authoritarian line. But if the reprise, and the sequence it intimates, can work within the drive for a freedom even in unfreedom in Beethoven, why can't it work similarly in film, in twentieth-century black music, the two great aesthetico-political discoveries of "our modernity," the two great fulfillments of mechanical reproduction and its age, the two sides of a coin that Adorno disavows as if the enclosures or constraints by which they are shaped at the level of their form as well as

at the level of the content of their representations bring the dialectic to a halt? We can ask this question of Adorno with regard to Glenn Gould and the film made about him. The relations between musical fantasy and fantasy-in-documentary drive return now by way of Freud and the hint of any operative racialization will, of necessity, be more pronounced.

In *The Language of Psycho-Analysis*, Laplanche and Pontalis define fantasy in this way:

Phantasy: Imaginary scene in which the subject is a protagonist, representing the fulfilment of a wish (in the last analysis, an unconscious wish) in a manner that is distorted to a greater or lesser extent by defensive processes.

Phantasy has a number of different modes: conscious phantasies or daydreams, unconscious phantasies like those uncovered by analysis as the structures underlying a manifest content, and primal phantasies.

I. The German word *"Phantasie"* means imagination, though less in the philosophical sense of the faculty of imagining (*Einbildungskraft*) than in the sense of the world of the imagination, its contents and the creative activity which animates it. Freud exploited these different connotations of the German usage.[17]

Freud "refines" the distinction between fantasy and reality after dispensing with the seduction theory. In this refinement or displacement the operative distinction is now that between material and psychical reality, where psychical reality refers to "a nucleus within the ['internal world'] which is heterogeneous and resistant and which is alone in being truly 'real' as compared with the majority of psychical phenomena."[18] This move by Freud is interesting since it reinscribes a distinction, within psychical phenomena, between the real and its Other. It also locates the real in resistance, in a certain heterogeneity that we could think of as (the) contrapuntal, psychical reality as a dramatic counterpoint animating the internal world. Here we could speak, with Adorno, of the dynamic totality of the psyche, the melodramatic, musical theatricality of the internal world. Still, a sharp distinction remains between psychical and material reality that makes one wonder not only about the status of something we might call the external world theater (the social totality), but also about the relative place of sound—is it to be reduced or amplified?—in the formation of the internal and external worlds (as theaters). These are questions concerning a certain relation between the analytic encounter and music that move beyond any ascription of musical-

ity to psychical reality. Here, also, resides an echo of pianist Cecil Taylor's assertion that improvisation is self-analysis, an echo echoed by Gould's form-creating ambitions, prefigured by Beethoven's injection of improvisational fantasy into the sonata form, an injection clearly pronounced in the Thirteenth Piano Sonata. When thinking the self-analytic origins of psychoanalysis, Taylor's formulation becomes crucial. It's all bound up with what drives Freudian discovery. Laplanche and Pontalis explain: "[Freud] refuses to be restricted to a choice between one approach, which treats phantasy as a distorted derivative of the memory of actual fortuitous events, and another one which deprives phantasy of any specific reality and looks upon it merely as an imaginary expression designed to conceal the reality of the instinctual dynamic. The typical phantasies uncovered by psycho-analysis led Freud to postulate the existence of unconscious schemata transcending individual lived experience and supposedly transmitted by heredity: these he called primal phantasies."[19] Primal phantasies hook up with what are referred to in Freud's work as "our" "phylogenetic heritage," "man's 'archaic heritage,'" our "congenital libidinal factors." The question concerns whether or not this move to elements transcending individual experience is fantastical itself. This is the question of Freud's discovery *as* phylogenetic fantasy, a (kantrapuntal) fantasy not only of the universality (or "intersubjective validity") of the internal world, but paradoxically of that universality's emergence and in relation to a structuring and originary difference since such interiority, in the Freudian moment, is given in exclusion (from the [racialized] right/status/ opportunity to claim or forge such interiority). Note that fantasy is understood here to be the ground of both acting out and repetition. How might we think their relation each to the other? Here, *fantasia* could be thought of as the source of, rather than some prophylactic against, the reprise. Similarly, Beethoven's injection of *fantasia* into the form of the sonata could be understood as guaranteeing a certain reprise of the reprise, ordering and structuring another mode of its maintenance. This both confirms and disturbs Adorno.

These questions are all connected to the question of the topological position of phantasy. Its phylogenetic provenance, here, is to be thought, in relation to its position and movement in the psyche. How and where does it move? Where does phantasy start? Laplanche and Pontalis continue: "In the dream-work phantasy is to be found at both poles of the process: on the one hand, it is bound to the deepest unconscious wishes, to the "capitalist" aspect of the dream, while at the other extreme it has a part to play in the

secondary revision. The two extremities of the dream process and the two corresponding modes of phantasy seem therefore to join up, or at least to be linked internally with each other—they appear, as it were, to symbolise each other."[20] Phantasy moves in a complex series as a dynamic totality; as if by way of some faster-than-light communication it appears to be at two positions at once or there appears to be some strange connection or spooky action at a distance moving between the poles at which fantasy seems, simultaneously, to be located. In "The Unconscious" (1915), Freud establishes a link, according to Laplanche and Pontalis, between those aspects of phantasy which seem to be farthest away from one another:

> On the one hand, they [phantasies] are highly organised, free from self-contradiction, have made use of every acquisition of the system *Cs.* and would hardly be distinguished in our judgement from the formations of that system. On the other hand, they are unconscious and are incapable of becoming conscious. Thus *qualitatively* they belong to the system *Pcs.*, but *factually* to the *Ucs.* Their origin is what decides their fate. We may compare them with individuals of mixed race who, taken all round, resemble white men, but who betray their coloured descent by some striking feature or other, and on that account are excluded from society and enjoy none of the privileges of white people.[21]

Most striking here, though, is a manifestation of the phylogenetically fantastical in Freud, which is made more striking when seen in relation to the case of Beethoven, the uniqueness or outness of his personality which leads Adorno to a characterization of Beethoven as fatherless child, in the Althusserian sense, out from the bourgeoisie he symbolizes and helps to shape, of doubtful or shadowed origin. Adorno figures Beethoven as an arch-bourgeois protégé of aristocrats, on the one hand, but is hip to "reports on Beethoven's personality [that] leave little doubt of his anticonventional nature, a combination of sansculottism with Fichtean braggadocio . . . [that] recurs in the plebian habitus of his humanity." Adorno thinks this in relation to loneliness, the self-positing subjectivity of the self-acknowledged mindowner, as opposed and in relation to landowner; but we might also think this in terms, again, of a racialized, and therefore impossible to contain, lawlessness that, in the case of Gould playing Beethoven, manifests itself at the convergence and as the blurring, of composition (or of a certain compositional competence, resulting from a regulative, antisentimental musical education) and performance.[22] At any rate, the myth of origin in Freud is strong here, but

the complex pathways of phantasy make one think that establishing its origins is more complicated than Freud would have it. The claim to an originary connection is always broken. This would be the sexual cut of phantasy, its cryptographic heritage. It allows us to activate and elaborate, past Freud, the distinction between origin and initiality that he posits in his discussion of the drives in *An Outline of Psycho-Analysis*.

Laplanche and Pontalis begin to get at this in elaborating the relation between phantasy and desire:

> Even in their least elaborate forms, phantasies do not appear to be reducible to an intentional aim on the part of the desiring subject:
>
> a. Even where they can be summed up in a single sentence, phantasies are still scripts (*scénarios*) of organised scenes which are capable of dramatisation—usually in visual form.
> b. The subject is invariably present in these scenes; even in the case of the "primal scene," from which it might appear that he was excluded, he does in fact have a part to play not only as an observer but also as a participant, when he interrupts the parents' coitus.
> c. It is not an *object* that the subject imagines and aims at, so to speak, but rather a *sequence* in which the subject has his own part to play and in which permutations of roles and attributions are possible. [The reader's attention is drawn, in particular, to Freud's analysis of the phantasy '"A Child is Being Beaten"' and to the syntactical changes which this sentence undergoes; cf. also the transformations of the homosexual phantasy in the account of the Schreber case].
> d. In so far as desire is articulated in this way through phantasy, phantasy is also the locus of defensive operations: it facilitates the most primitive of defence processes, such as turning round upon the subjects own self, reversal into the opposite, negation and projection.
> e. Such defences are themselves inseparably bound up with the primary function of phantasy, namely the *mise-en-scène* of desire—a *mise-en-scène* in which what is *prohibited* (*l'interdit*) is always present in the actual formation of the wish.[23]

Now there's an immediate drive toward this thinking of sequence, syntax, sentence, and mise-en-scène: the cinematics of these formations get us back to that cinematics of a particular music, jazz, of which Adorno is so scared,

precisely because it threatens to devolve into that vulgarity of temporality that Derrida eschews. But it doesn't move there precisely because of the presence of phantasy as organizing counterpoint. We're still left, however, with dramatization as a possibility that Girard exploits, we might say. Here we can think, again, of the *Hamburg* film/script/*scenario* as a kind of fantasy, the fantasy of another audition, an audition mediated by the recording. The fantastical structure of the one on one, and, then, the maid starts humming, singing back, echoing Gould's own humming silenced by the recording but present in its inaudibility and impossible to suppress. What is totality: a contrapuntal sequence without origin, a world theater/world imagination irrupting through the opposition of internal and external? How does slavery—or the Euro-Afro-American encounter/eclipse—inhabit the structure of Freudian discovery?[24] Can we say that phantasy is structured like a sonata, a *sonata quasi una fantasia*? What will this reversal have to say for the structure of the unconscious in general; that it is structured not like a language but like music? What of Adorno's invocation of the cryptogram: can it be thought in relation to the phasic sequencing of phantasy, its evasion of origin, the oscillational rummaging of/between the sexes that constitutes the phasal relay or reversible/reprisal "development" of phantasy, the sexes initial but not original in relation to the motive forces of repression in general, which is what psychoanalysis is after in the end? Finally, what more can we say now about the relations between Freudian fantasy and counterpoint, counterpoint and cinema?

Please permit me three more lengthy quotations, of Gilles Deleuze and Félix Guattari, Adorno, and Edward Said.

> Beethoven produced the most astonishing polyphonic richness with relatively scanty themes of three or four notes. There is a material proliferation that goes hand in hand with a dissolution of form (involution) but is at the same time accompanied by a continuous development of form.[25]

> The more harmony freed itself from the triad, or more generally from the scheme of superimposed thirds; the more chords were created by simultaneously sounded notes; and above all, the more each note in the chord was able to maintain its separate identity, instead of melting into the homogeneous sonorities that operate with the simplest harmonic combinations—the more the chords became polyphonic in themselves. With the increasingly dissonant character of harmony,

the tension in individual sonorities also increased. No sonority was self-contained, like the old consonance, the "resolution" [*Auflösung*]. Every sonority seemed to be laden with energy, to point beyond itself, and every one of the distinct individual notes contained within it required an independent "melodic" continuation of its own, instead of there being a succession of one synthesized overall sonority after another. This emancipation of individual notes from their chord was probably what Schoenberg had in mind when he spoke of the instinctual life of sonorities.[26]

To master counterpoint is therefore in a way almost to play God, as Adrian Leverkühn, the hero of Thomas Mann's *Dr. Faustus*, understands. Counterpoint is the total ordering of sound, the complete management of time, the minute subdivision of musical space, an absolute absorption for the intellect. Running through the history of Western music, from Palestrina and Bach to the dodecaphonic rigors of Schönberg, Berg, and Webern, is a contrapuntal mania for inclusiveness, and it is a powerful allusion to this that informs Mann's Hitlerian version of a pact with the devil in *Faustus*, a novel about a polyphonic German artist whose aesthetic fate encapsulates his nation's overreaching folly. Gould's contrapuntal performances come as close as I can imagine to delivering an inkling of what *might* be at stake in the composition and performance of counterpoint, minus perhaps any grossly political import. Not the least of this achievement, however, is that he never recoils from the comic possibility that high counterpoint may only be a parody, pure form aspiring to the role of world-historical wisdom.

In fine, Gould's playing enables the listener to experience Bach's contrapuntal excesses—for they are that, beautifully and exorbitantly— as no other pianist has. We are convinced that no one could *do* counterpoint, reproduce and understand Bach's fiendish skill, more than Gould. Hence he seems to perform at the limit where music, rationality, and the physical incarnation of both in the performer's fingers come together.[27]

What can we make of this instinctual life of sonorities in cinema and of the tendency of individual notes (frames/narrative units/short films [for our purposes in Girard]) to spin off and free themselves? This is a question that Eisenstein asks in "A Dialectical Approach to Film Form" in regard to conflict or counterpoint in film. And the question of counterpoint

within something that manifests itself as a singular linearity is something we can think through Said's invocation of Leverkühn, through the way Gould's work, his portrayal in this film, seems to constitute the interinanimation of subject and object, harmony and counterpoint, singularity and multiplicity, Castorpian seclusion and Leverkühnian desire for polyphonic knowledge. One seeks the truth, as it were, contrapuntally, by way of a kind of questioning. That questioning takes the form of a kind of repeating. Such questioning in Gould is what Leonard Bernstein loved: "That's why," he says, "[Gould] made so many experimental changes of tempi. He would play the same Mozart sonata-movement *adagio* one time and *presto* the next, when actually it's supposed to be neither. He was not trying to attract attention, but looking for the truth. I loved that in him."[28]

Such questioning takes the form of interior dialogue, of listening to one's own voices, a listening that manifests itself externally as side effect and sound effect in Gould's performances on stage and on record, in his musical and literary compositions, in his self-conducted interviews. The prerequisite for honoring this interior multiplicity is solitude, what Adorno might hear as a romantic, subjective Beethovenesque loneliness. As he says, regarding Bach, "the particular polyphonic techniques used . . . to construct musical objectivity themselves presupposed subjectivization."[29] The materiality of an actual interplay exists as a kind of occasion, at best, as a kind of competitive falseness, at worst. Gould seems to have thought of the concerto generally as oscillating between these two possibilities. The magnificent and solitary multiplicity of voices in the head to which they should aspire is given in *The Idea of North* or in our repressed cadenza, perhaps more than in the *allegretto* from Beethoven's Thirteenth Piano Sonata. To be truthful to yourself is a contrapuntal task that manifests itself as multiple solitude in fictional splice.

The documentary drive is at the conjunction of a certain elaborative and developmental energy in form and content, on the one hand, and the fact of something actually happening. The fantastic (or speculative, as Samuel R. Delany teaches us) is all bound up with a certain representation of what hasn't happened yet. And what has and hasn't happened play out at the level of formal development as well as at the representation of facts or events. This is to say that the disruption, postponement, or unmasking of development might be given not only in the creative force that animates every note, not only in the tension between sameness and difference held within an heretofore undiscovered repetition, but also in what Adorno might dismiss as mere image, gross *peinture*, decorative gesture, or—in what many of Gould's crit-

ics dismissed in his playing as frenzied excess—the overblown ecstasy that always accompanies classical music performance as a threat of embarrassment in a certain revelation of unseemly origins, some dark song or secret at and before its heart (where everything that Adorno reviles under rubric of prematurity is given again by way of what Nathaniel Mackey desires in the name of the postexpectant). Is the trace of the contrapuntal in Beethoven to which Gould is so attuned a racial mark, the mark of someone being beaten, the mark of another beat? One could spin off a fantasy, here, on Beethoven's allegedly Moorish origins, what Adorno refers to in class terms as his position or movement beyond bourgeois society. And this trace might here seem to work not only as the trace of romanticism in Beethoven but also as the trace and condition of possibility of its critique, in Adorno's terms—the out, improvisational rationality of a *basso continuo*, a mystery train, an idea of south. Of course, so much of Gould's story, of Girard's fantastic documentation of it, is all bound up with Gould's profound ambivalence regarding performance. That ambivalence is marked especially clearly, here, in a conversation about film.

Gould: I've a feeling that [film']s changed our sense of distance . . . , and I know that since film became more and more important to me in the last decade or so, I've begun to think of music dimensionally in a way that just hadn't occurred before. You see, I have a feeling that what we're going to do eventually is forget about this funny notion that we've carried over into the recording of music strictly as a legacy, and a very poor one, of the concert hall. Which is to say that we should sit the listener down in front of his stereo speakers and confront him box-like with an experience. I don't think that we're supposed to confront him with anything at all, and I think that one way in which that can be broken through (and I'm trying this now because I think that it's the salvation of the audio recording at a time when video recording may very well play a large part in our future), is to think in terms of multiple perspectives—multiple perspectives which represent and which choreograph and which set forth the work as purely and as analytically as we can . . .

Davis: Would it be fair to say or to suggest that, for example, in the opening of the Beethoven *Hammerclavier Sonata*, you might

take those opening big chords in a very close microphone perspective, practically inside the piano lid and, the minute the sound got soft again, the minute the next musical idea came in, all of a sudden your microphoning was taken way off in the distance until it gradually approached the piano like . . .

Gould: Precisely, that way you could convey precisely what the motion of that piece is, just as an animator could convey to you what it's all about. You wouldn't violate the music; there would be no sense in violating the music. What you would violate is the ubiquitous, too-long-held perspective of the concert hall, which has kept us going and in business for a long time but . . .

Davis: Well certainly the two experiences can be complementary to one another and even though the concert hall experience has admitted severe limitations I think it would be nonetheless worthwhile recalling that music is a performed art . . .

Gould: Yes, but must it always pass through the mediation of a performer who is just that? I mean is it not possible that some sort of masterful technician could guide it much more successfully?[30]

Note that in the midst of Gould's explanations of his withdrawal from performance, one can't help but remark the recurrent invocation and celebration of a distance very much like the Benjaminian aura that animates a prefigurative critique of Girard's attempts at a mediated restoration of the live. His portrayal of a fussy Gould obsessively positioning the chambermaid in Hamburg might have been described by Gould both as a poor legacy of the concert hall and as an attempt to overcome that legacy by emphasizing a spatiality in musical performance and audition with which video recording and, more specifically, filmic animation (and this is in evidence in Girard's film as well) is more thoroughly and analytically concerned than is audio recording. Yet the truth of a certain spatial performativity in Gould's recording as much as in his live performances is given all throughout the film, and in *Hamburg* in particular, by way of a splicing upon which Gould could only have smiled.

Joseph Roddy writes that, for Gould,

as for most good pianists, a performance is far more than a matter of giving sound and musical shape to a set of symbols that the composer has fixed on paper; it is an attempt to deliver a perfect copy of the ideal performance he can hear in his head at any time, even when his

hands are in his pockets. When Gould talks about piano playing, he often illustrates his points by singing out sections of these ideal performances, and when he is giving a recital he sings along in an interior monologue, usually just sort of an audible mutter. On the stage, he conscientiously tries to keep the mutter inaudible, but sometimes— not as rarely as he would wish—in the middle of a recital he slips and breaks into full song, which can be heard loud and clear all the way to the back of the hall.

Ordinarily, abundant side effects of this sort are the by-products of a *con-molto-amore* performing style—a style that can easily tear any musical passion to tatters. This is not true of Gould. Frenzied as he appears to the eye, his music is essentially dispassionate . . . [31]

And here is Peter Ostwald's version of what I've come to think of as (the necessarily fantastic) "original" of what is, in turn, fantastically documented in *Hamburg*:

He was practicing a fugue by Mozart, K. 394, when the maid turned on the vacuum cleaner close to the piano. Suddenly his playing was shrouded in mechanical noise, a sensation he found not at all unpleasant. The way Glenn reported this experience later on was that "in the louder passages, this luminously diatonic music in which Mozart deliberately imitates the technique of Sebastian Bach became surrounded with a halo of vibrato, rather the effect that you might get if you sang in the bathtub with both ears full of water and shook your head from side to side all at once." The vacuum cleaner obviously interfered with his perception of the sound he was producing on the piano, but it heightened his perception of the movements he was making to produce that sound. "I could feel, of course—I could sense the tactile relation to the keyboard, which is replete with its own kind of acoustical associations, and I could imagine what I was doing, but I couldn't actually hear it."

What has happened was that the masking noise of the vacuum cleaner had shifted Glenn's attention to the internal sensations of his body and away from the acoustical results of his playing. It was like a trip to the interior—and he enjoyed it. The interruption of auditory feedback led to a heightened awareness of how he moved his fingers while playing, a new tactile awareness of himself.

. . . For Gould, the result of his experience with impeded sound perception was that it made him more keenly appreciate the difference

between music heard abstractly in the inner mind and music produced concretely by playing an instrument. The simple trick of vacuum cleaner noise had accomplished for him something akin to what deafness did to Beethoven. "I could imagine what I was doing," Glenn said, "but I couldn't actually hear it." And like many an introverted artist who may at times prefer the products of the imagination to the resulting creative effort, he enjoyed his inner hearing more than his outer performance. "The strange thing was that all of it suddenly sounded better than it had without the vacuum cleaner, and those parts which I couldn't actually hear sounded best of all.[32]

This necessary transcendence of aurality—wherein the valorization of the fantastical (as inner sound or sound image) is given in the reduction of phonic substance—is linked, for Gould, to a no less necessary transcendence of the tactile.

Now, the point is that you have to *begin*, I think, by finding a way to any instrument that gets rid of the whole notion that the instrument presents you with a set of tactile problems—it does, of course, but you have to reduce those problems to their own square root, so to speak, and having done that, adapt to any kind of situation in relation to that square root. The problem then is to have a sufficient advance and/or extra-tactile experience of the music so that anything that the piano does isn't permitted to get in the way. In my own case, my means toward this is to spend most of the time away from the piano, which can be difficult because you occasionally want to hear what it sounds like. But a certain analytical ideal (which is somehow contradictory, I can't quite think how—I'm a bit stupid today, but anyway . . .), an analytical *completeness*, at any rate, is theoretically possible as long as you stay away from the piano. The moment you go to it you're going to diminish that completeness by tactile compromise. Now, at some point that compromise is inevitable, but the degree to which you can minimize its effect is the degree to which you can reach out for the ideal that we're talking about.[33]

This passage reveals that Gould is a serial fantasist engaged in the sequential dematerialization of origin, the abstraction of and from tactile, auditory beginning(s). Perhaps the life that is organized around an open sequence of techno-performative avoidances of performance is best understood as a

series of short films that will have, in turn, become the broken, figurative ground for thirty-two more—each "original" event is a dematerializing fantasy composed of dematerialized events. The story is a cut sequence of cut sequences, an ongoing festival of splice and replay, relay and playback—the serial and fantastic revision of an always already broken backstory. If *Hamburg* represents an actual event that prefigures or is mixed with more vexed and difficult relations with immigrant maids in Canada (one remembers the maid in the subsequent short film "Crossed Paths" who said the Italian and Jamaican maids who worked at the Inn at the Park in Toronto, where Gould kept a small studio, wouldn't serve him because they thought he was some kind of pervert; of course, in a glorious sense he was some kind of pervert, as any cursory thinking of the erotics of this encounter, this forced audition, must reveal), it might also be prefigured by and mixed with a famous prior encounter with a maid, one whose disruption of Gould's practice/performance opened up whole new possibilities of performance-in-audition for him. Here, questions of overtone, counterpoint, and performance touch on the constitutive relation of fantasy to documentary. One thinks, especially, of the importance in Gould of the analytic, which he and Adorno both see as a necessary function of counterpoint, of how it is thought in relation to a certain framing, as well as a certain fragmentation, an irreducible discreteness and discretion of its elements, both of which are paradoxically essential to the secret, fantasmatic wholeness of (the) composition. This consideration, in turn, must touch on how Gould understands what he calls the image of the music, its workings in relation to a reduction of phonic substance and tactile experience that the partial withdrawal of performance partially enacts.

While Adorno requires recognition of the distinction between phonic substance or sound and musical material, Gould demands reduction of the tactile experience as well so that he might conceptualize what he can't imagine, imagine what he cannot hear. It is, however, by way of ecstatic singing and humming, irruptively involuntary movements of/and conduction, the supposedly degraded and degrading accompaniments of the pianistic utterance, that Gould achieves a certain content or essential music whose outward manifestation is the irreducible sound of the piano and his irrepressible phono-choreographic accompaniment. That ensemble of accompaniment— composition's disruptively constitutive innermost extremity, the native fugue-state of being-composed—is essential to that content; it is its condition of possibility. It is the embarrassment not simply of music's irreducible

materiality but of the origin and end of music's fantastic transcendence of that materiality *in* that materiality that is the source of what we might call Gould's performance anxiety, which is allayed and relayed in his performance of and through his love affair with the mediating force of forced microphonic rendition and stereophonic audition. This is all to say that Gould's recordings bear the trace, and Girard's film insists upon, the centrality of visual, tactile, and aural experience—a performativity that improvises through the opposition of media and the immediate—to the abstract truth in music. By way of fantasy, the recordings and the film document this unconcealment. Such animateriality always verges on scandal, whether it takes the form of discomposing song or abducted listening. Such fantasy, or counterpoint, in music and in cinema, is what Eisenstein theorizes here.

> Hence, with only one step from visual vibrations to acoustic vibrations, we find ourselves in the field of music. From the domain of the spatial-pictorial—to the domain of the temporal-pictorial—where the same law rules. For counterpoint is to music not only the form of composition, but is altogether the basic factor for the possibility of tone perception and tone differentiation
>
> In the moving image (cinema) we have, so to speak, the synthesis of two counterpoints—the spatial counterpoint of graphic art and the temporal counterpoint of music.[34]

> *Conflict within a thesis* (an abstract idea)—*formulates* itself in the dialectics of the sub-title—*forms* itself spatially in the conflict within the shot—and explodes with increasing intensity in montage-conflict among the separate shots: This is fully analogous to human psychological expression. This is a conflict of motives, which can be comprehended in three phases.
>
> I. Purely verbal utterance. Without intonation—expression in speech.
> II. Gesticulatory (mimic-intonational) expression. Projection of the conflict onto the whole expressive bodily system of man. Gesture of bodily movement and gesture of intonation.
> III. Projection of the conflict into space. With an intensification of motives, the zigzag of manic expression is propelled into the surrounding space following the same formula of distortion. A zigzag of expression arising from the spatial division caused by man moving in space. *Mise-en-scène.*[35]

Eisenstein moves through strictures regarding any taking into account of the merely gestural, of the decorative, or of accompaniments of the performance as it is reduced to a mere, but ideal, utterance. Such strictures, in relation to Gould, would be debilitating given the necessary relation in his performance between phonic substance, gesture, accompaniment, non-meaning, and truth. Thankfully, Girard is extraordinarily attuned to this supplementary complex in sections like "Practice" and "Passion according to Gould." Here, Gould is portrayed by actor Colm Feore in ecstatic gesture-in-stillness intensified to movement-in-space. Such gesture and movement is prompted in the one by the ideal image of the music (whose playback, in Gould's mind, substitutes for the tactility of practice) and in the other by the recording and a more literal playback that prompts gestures of conduction, movement around the room, a sort of possession, Gould held by a kind of quickening power. The playback mediates, then, not only between Gould and his ideal and danger-ous audience, but between Gould and the ideality of the music, an ideality undercut by the tactility of playing and the materiality of sound. Thus the accompaniments of the utterance, and the merely gestural, in Gould, work to extend a certain reduction of tactile, material, phonic substance while, at the same time, disrupting any possible reduction of mere gesture or mere ac-companiment of the utterance or mere nonmeaning, any possible reduction of everything to what would correspond, in music, to a textual or linguistic meaning. Finally, all this is bound up with how Eisenstein—both in relation to and in opposition to Adorno, in ways clearly manifest in the content of both Gould's music and Girard's film—helps us to think montagic sequenc-ing as counterpoint, dynamic totality as fantastic-documentary drive. Out of nothing, out of the mere insignificance of irreducible, conflictual seriality, comes everything.

Taste Dissonance Flavor Escape (Preface to a Solo by Miles Davis)

The object of theory is not something immediate, of which theory might carry home a replica. Knowledge has not, like the state police, a rogues' gallery of its objects. Rather, it conceives them as it conveys them; else it would be content to describe the façade. As Brecht did admit, after all, the criterion of sense perception—overstretched and problematic even in its proper place—is not applicable to radically indirect society. What immigrated into the object as the law of its motion [*Bewegungsgesetz*], inevitably concealed by the ideological form of the phenomenon, eludes that criterion.—**THEODOR ADORNO**, *Aesthetic Theory*

I was sent, tell that to history.—**LORNA GOODISON**, "Nanny"

To speak when and where one is not supposed to speak is to resist an even more fundamental disqualification: that such spatiotemporally disruptive enunciation relinquishes the possibility of thought or of being thought insofar as one (merely) provides the material conditions (in speech that is, as it were, beneath speech; speech borne in a phonocarnality that refuses to disavow itself) for another's thought and for another's being thought. But questions arise (when the transcendental aesthetic goes underground): What

happens if, impossibly, the matter that prompts thought—the purportedly bare materiality that is sent as an originary deviance inaugurating the very power that will, by a tortuous road of self-regulation, contain it—is matter of and for thought? What does being-sent (and by what? by whom? for what exploitative and/or salvific cause?), in what has been thought to be the impossibility of its being thought or of its thinking, in a materiality whose arrival might now be seen as the disruption rather than condition of a given epistemological line or chord, mean? What does being-sent into the terrible pathways and precincts of the human do to or for the human? What happens when we consider and enact the aesthetic, epistemological, and ontological escape of and from being-sent? I would like to address these questions—irruptions of that "thematics of flight," toward and within which Hortense Spillers moves, which forms the inspiriting, locomotive foundation of the theory and history of blackness—in the form of some hyperbolic liner notes given in the idiom of black studies, which Cedric Robinson calls "the critique of western civilization" and which could also be understood as a critique of enlightenment and even as a critique of judgment from the position of what Robinson might call an eternally alien immanence or, more precisely, from a radical materiality whose *anima*tion (fantasy of another [form-of-]life) has been overlooked by masterful looking.[1]

Scarsign

Harriet Jacobs composed *Incidents in the Life of a Slave Girl* in secret, "at irregular intervals," in the confines of an exhausted domesticity from which she had long been on the run.[2] Her work exemplifies that operation under the constraints of antiabolitionist discipline and surveillance that is essential to black intellectuality. Black art is often concerned with showing this operation. Black art stages it, performs it, by way of things breaking and entering and exiting the exclusionary frame of the putatively ennobling, quickening representations to which they are submitted, paradoxically, as the very enfleshment of the un- or subrepresentable; by way of parts improperly rupturing the w/holes to which they will have never belonged or never have been fully relegated but by which they have been enveloped; by way of outlaws moving without moving against the law they constitute; by way of captured motion constantly escaping in a cell like St. Jerome. Insofar as Jacobs cannot give the consent that, nevertheless, she can withhold, she consents not to be a single being. She is, therefore, a problem, a question, posed and thereby

revealing an agency that is interdicted, caught in the interval, but no less real. This interdicted agency of the interval, the interred, the incident; this agency that is revealed in the incident, by way of injury, by way of the injunction against action and self-certainty; *this anagential movement of the thing* disowns or unowns knowledge (of slavery, of desire) in the name of another, inappropriate knowledge, a knowledge of the inappropriable. I am concerned with the discovery of this knowledge and its secret location, concerned that this knowledge is locatable, that it is, as it were, *held* somewhere. Eventually this turns out to be a musical concern that one approaches by way of literature, painting, photography, and the essential structural apparatus and narrativity of cinema. I hope this concern will, in its turn, allow a more complete understanding of (black) performance as the irruption of the thing through the resistance of the object.

This concern requires that once more I begin again or that I echo, with differences, my various beginnings. What is it to be thrown into the story of another's development; and to be thrown into that story as both an interruption of it and as its condition of possibility; and to have that irruption be understood as both an ordering and a disordering movement? And what if one has something like one's own story to tell? One engages, then, in the production of a subplot, *a plot against the plot*, contrapuntal, fantastic, underground—a fugitive turn or stealing away (as Nathaniel Mackey or Saidiya Hartman might put it), enacted by a runaway tongue or dissenting body (as Harryette Mullen or Daphne Brooks might have it), from the story within the story.[3] Lydia Maria Child's editing was meant to regulate Jacobs's disruptions of the master narrative, but the irregular and its other regulations were already operative in Jacobs's work as a special attunement to a certain temporal insurrection in the music of constantly escaping slaves and to the status and force of a certain gap between emotional appearance and emotional reality. Jacobs's writing is infused by the music she overhears. That infusion occurs momently, carrying forward narrative disruption as a kind of anarchic principle. Stories don't survive this kind of thing intact; (good) taste demands this kind of disowning thing be disavowed. Here's a prime example in her text of the kind of thing that's too hard to take:

> I sat in my usual place on the floor near the window where I could hear much that was said in the street without being seen. The family had retired for the night, and all was still. I sat there thinking of my children, when I heard a low strain of music. A band of serenaders were under

the window playing "Home, sweet home." I listened till the sounds did not seem like music, but like the moaning of children. It seemed as if my heart would burst. I rose from my sitting posture, and knelt. A streak of moonlight was on the floor before me, and in the midst of it appeared the forms of my two children. They vanished; but I had seen them distinctly. Some will call it a dream, others a vision.[4]

In the crawlspace above the main floor of her grandmother's house, where she confined herself for more than seven years in order to escape mastery's sexual predation (in this first instance a Southern man with Southern principles), Harriet Jacobs (and/or Linda Brent, her shadowed, shadowing double and counteraffective effect) is on the way to cinema, precisely at the place where fantasy and document, music and moaning, movement and picturing converge. Hers is an amazing medley of shifts, a choreography in confinement, internal to a frame it instantiates and shatters. It's the story of a certain cinematic production and spectatorship prompted by transformative overhearing, driven by broken, visionary steps. This lawless freedom of the imagination, in all the radicality of its adherence to art's law of motion, occurs in a space Mackey would characterize as both cramped *and* capacious, a spacing Jacques Derrida would recognize as a scene of writing, that Hortense Spillers has called a *scrawl*space, in which Jacobs/Linda writes against what Maurice Wallace calls the "spectragraphic surrogacy of the black woman's body," in a tale that is punctuated, which is to say advanced, by small gestures of secret listening that cross into what emerges by way of having been relinquished, the impossible image of the incalculably distant children, just a few feet away from her, whom Jacobs has and cannot have, sees and cannot see.[5]

Incalculable distance crosses into incalculable rhythm: Jacobs extends her escape in part by imitating the rickety walking of sailors but her destination turns out to be the rickety bridge between things and the whole they (de)form. This is Jacobs's fugitive trajectory, her autobiographical problematic. She is not the one who would stand in for the one that is not the one. Her solo—*which must be indexed to a line of solos that are equally, impossibly, underwritten, overflowed and overflown*—is constituted and vexed by a set of unlikely interplays: of written life and the paradox of escape via graphic capture; of the pedagogical imperative and the double edges of thingliness and being-representative; of the audio-visuality of a complaint that can only be given both in more than one voice and in that solitary, autobiographical telling that is always in less than one voice; of aesthetic criminality and the

madness—as opposed to the absence—of the work. The "loophole of retreat" through and within which Jacobs sees and overhears while under the constant threat of being seen and overheard, is a scar and a sign.[6]

Catalogue Number 308
(The Black Apparatus Is a Little Girl)

Consider (the music of) the interplay of literature, painting, photography, and cinema—an interplay or interstice or interval that could be called, by way of Michael Fried but very much against his grain, *theatre*.[7] This requires concern for the story that animates that interplay and the apparatus that is necessary for both that interplay and that story to be carried out (where and when it is carried out precisely by way of the animating force of the interval). I will be concerned with a spasmodic trajectory, a line constituted by its fracture, a turn that turns on and against itself, that moves toward and away from and around the photograph of a little girl in a kind of art historical dimensionality that will bring into focus at the moment of its having been made secret an instance of the black apparatus, of the sound/image of the black in the modern Euro-American audiovisual imagination.[8] This photograph opens onto a Philadelphia story. The capital of nineteenth-century American photography and the point of departure for nineteenth-century pseudo- and social-scientific study of the negro is a scene we have to enter, following Tera Hunter in her investigation of the postemancipation struggle of black women workers to "'joy their freedom" and, on the other hand, channeling Hartman's wariness regarding the vexed history and interdicted possibility of black enjoyment and its doubled edge.[9] Entrance into that scene and its disciplinary pleasures means entering the history of the pose and its fictions that are carried in this image by a little girl's inaudible and imperceptible phono-choreographic quickening. In the photograph, she quickens against being stilled, studied, buried, stolen, as she steals away, moving without moving, like Harriet Jacobs.

I'm interested in the motion of the work, of the thing-at-work, at the intersection of cinema and music. The undisciplined image of a little girl resides there in a stillness that is always partial. It breaks the law that it bodies forth, the law of motion it lays down but cannot still. This law is the essence of a Philadelphia Story, of a Philadelphia Negro, having waited until what is given in literary reproduction is unheld, now, in mechanical reproduction. It's not about breaking the law of motion. Nor is it that the law of motion

exists criminally, fugitively, that the law of motion is a being against the law in all of its constitutive fugal, improvisational, fantastical terribleness. The black apparatus, black performance, the thing's interruption of the object in resistance, blackness-as-fugitivity, the teleological principle in suspense, the broken breaking bridge and broken circle, cuts the revolt become law, lies before the law, not as a criminality that is of the law but rather as a criminality that is before the law. The Negro must be still, but must still be moving. She steals away from forced movement in stillness. Meanwhile, music and cinema must show movement in stillness and so, who better to deploy in the service of that project? What public produces such forms? What public is produced by such forms? Early cinema and *neue musik* move from disruptive attraction to seamless arc, a forced movement embedded in the stillness of the little girl.

Specific individual attribution of the photograph is problematic; it was taken at Thomas Eakins's studio in Philadelphia by him or someone in his circle. The little girl is posed as an unarticulated question. She poses a question. The posing of the question is a gift. The little girl is posed. She poses. The little girl is (ap)posed, apposes. She is embedded in the history of a pose: the history of the pose of the thing, the commodity (stop now to consider what it is to be a person); the history of the pose of the prostitute; the history of the working girl; the history of the impossible domestic; the history of the *metoikos*; the history of the inside-outsiders of the city of brotherly love; the history of the outlaw; the history of fugitive gatherings inside the city. (Harriet Jacobs speaks of the crisis that ensued in her North Carolina "home" town immediately after Nat Turner's insurrection: "No two people that had the slightest tinge of color in their faces dared to be seen talking together."[10] Later, Du Bois reveals, in his catalog of the laws pertaining to the Negro in Philadelphia, that such crisis was eternal, that it elicited a kind of endless and terrorizing war on "terror" manifest in acts like the 1700 law against the "tumultuous gathering" of two or more blacks in the city but unable to establish that they were on their master's business.[11] The little girl poses a problem, posing as a problem, as a kind of thrownness; thrown into a problem and a pose and that pose's history, she exposes the venal etiolation of publicness that imposes exposure upon her; in her nakedness, finally, a form of life and the emergency it prompts is held and revealed.

In *The Painting of Modern Life*, T. J. Clark says Olympia has a choice, working against the definition of the prostitute offered by Henri Turot, for whom prostitution implies "first venality and second absence of choice."[12] For Turot, further, the prostitute's very existence depends upon the temporary

relations she entertains with her customers, the subjects, relations that are public and without love. An absence of privacy, then, where privacy implies a self-possession aligned not only with reason, will, choice, but also with feeling or with the ability to feel. An absence of sovereignty where sovereignty implies a kind of autopositioning, a positioning of oneself in relation to oneself, an autocritical autopositioning that moves against what it is to be positioned, to be posed by another, to be rendered and, as such, to be rendered inhuman, to be placed in some kind of mutual apposition with the in/human and the animal (the black female servant; the lascivious little cat). The little girl's image extends a line traced by Clark from Olympia's pose, to the pose of Titian's *The Venus of Urbino*. That line moves within the history of the idealization and rematerialization of the nude, the history of the prostitute as artist's model, the history of the wresting of modeling from prostitution and the yoking of it to pedagogy.

In *The Black Female Body: A Photographic History*, Deborah Willis and Carla Williams excavate the condition of possibility of a choice for the one who is said to have no choice, moving by way of Hugh Honour's phrasing to reveal what and who have been hidden on the edge of the image, which is also an archive. They pay attention to the "slaves of the Slaves of Lust," most famously given in the figure of Olympia's maid, and narrate a transition in which the black female shifts from upright servitude to "the salacious sexualization of the reclining body."[13] Clark's art historical line is worried, as it were, by another that cuts and enfolds it; by an underground that shadows, edges, blurs, and surrounds it. That underground ungrounds Clark's smooth trajectory. Willis and Williams show how such tilling is accomplished by secrets who are, and who deconstruct, and who reconstruct a (secret) archive that is extended beyond the little girl in Afro-diasporic photography that can respond to her pose or being posed with Seydou Keïta's reappropriative chastity or the expropriative challenge of Colleen Simpson's interdicted gaze.[14] The point, however, is that by way of the emergence of Olympia's servant from shadow, the little girl brings to the surface what had always lain at the heart of this history, as if Eakins, by way of the photograph, brings this line to its true self which is its end, as if the social force that had been allegorically represented by way of the painting can only now be realistically presented by way of the mechanical apparatus.

Olympia was shown in the Salon of 1865. Eakins began studying in Paris a year later. Eakins was in town for the retrospective of Édouard Manet's work that included *Olympia* and the *Dejeuner*. Of the 1868 Salon he writes:

"There are not more than twenty pictures in the whole lot that I would want. The great painters don't care to exhibit there at all. Couture Isabey Bonnat Meisonnier [*sic*] have nothing. The rest of the painters make naked women, standing sitting lying down flying dancing doing nothing which they call Phyrnes, Venuses, nymphs, hermaphrodites, houris & Greek proper names."[15] What Eakins wants, and what he will later incorporate, seems clearly to be, at least in part, what Manet offers. Eakins will fully commit himself to a kind of painterly natural description whose teleological principle is everywhere illuminated but dark to itself. His paintings exhibit a scientism that moves in the direction of an ever-greater accuracy that is, itself, the effect of an ever-greater deanimation of the body, the profound and necessary in/accuracy of the picture. This near-pathological deanimation (of the image, of the body, as exemplified in a painting like *The Gross Clinic*) is in the interest of a certain photographic naturalism that seeks to reflect and to attach itself to a law of development or movement—the mechanics of a more-than-personal history. I'm thinking, now, of the relation between the law of the movement of the body (by way of or in relation to the anatomical rigor in whose service he would put photography but for whose service photography would have to recognize its own inadequacy, an inadequacy that tends, eventually, toward Eadweard Muybridge—whose work Eakins championed—and the mechanical reproduction of motion, but which has to take a little detour into the seedy studios of Francis Galton's evolutionary criminology) and the law of a narrative development that we could think in terms of the story that must accompany the dispersion of sovereignty, a story animated by the interplay of race and teleology, a story that animates the particular scientific aims of Herbert Spencer to which Eakins makes a special appeal. Eakins seeks to discover, by way of the picture and, then, of the motion picture, the laws of movement, of motion in history as well as the motion of bodies. Such discovery comes by way of the consideration of the movement of the image as such; of the impossibility of its internal movement, the illusion of a movement imposed, transversally, from outside. From *tableaux-vivant* to *movement-image*, *The Philadelphia Negro* is a story that cinema is meant to tell. Cinematic means are directed toward this telling and must deploy, in a range of obsessive ways, the simultaneously invisible and hypervisible image and its forced, disruptive movement and gathering. Philadelphia is where Galton's aggregative superimposition of the criminal visage, his overlayering of the rogue's gallery of evolutionary criminology's objects of knowledge, is taken up in the serialization and de-layering of the palimpsest, in the service of

Eakins's naturalistic obsession with the production of the illusory movement of an individual body, so that the laws of such movement might be discovered and extended toward Cynthia Wiggins's critical redeployments of a black female image always crossing the borders between invisibility and hypervisibility, seriality and aesthetic criminality, as well as toward the kind of advanced cinematic technique that shows us the way back into cinema's racial ground.[16]

My point is that the story that cinema tells in general is held within the frozen and deanimated image of a little girl. Cinema is the animation of *that* image. Animation forced upon, then stolen from, an invisible flower that has the look of a flower that is looked at. Between Olympia and her maid lies, poses, this little girl, awaiting movement (the imposition of a natural anatomical law of motion/the imposition of a natural, racial law of development). The little girl blurs Olympia and her maid, blurs hypervisibility and invisibility, marking impurity, disease and degradation not only with the prostitute's direct gaze but with blackness as the essence of what is supposed to be always already degraded and degrading female sexuality. Animation releases a range of potential energies held within the story that awaits its telling. The story of racialized biopower is the story of this condensation and dispersal of the image and its time. In 1882 the image had to be concentrated, fully condensed, made entirely full by its animating story before being infused with and dispersed by movement so that a story could be told. We witness the full animation of the image (however much it awaits activation) by way of the full deanimation of the little girl. This is about how the interplay of painting, photography, and cinema begins to tell the story that animates it, the story of the interplay between freedom and determination, between movement and containment; the story of what Michel Foucault has called "the subjugation of bodies and the control of populations";[17] the story of a set of concentric legal and philosophical naturalisms; the story of the (imposed and stolen) life of the thing under (the constant threat of) sovereignty's power of death and its gentler, diffused but no less terrible, no less sententious, modern administration.

She is placed, then, within a certain history of sexuality, of life and death, of troubled and troubling enjoyment; within the art-historical trajectory of the female nude which is, it turns out, nothing other than a history of race; and within a history of photography as a scientizing aid for realist painting which, in the extremity of its fidelity, makes possible the profoundly imaginary unleashing of the very motion upon whose arrest its fidelity depends. Imaginary motion is unleashed, to be more precise, by way of the interplay

of fidelity and seriality. Motion within the frame is stilled so that motion between frames can be activated. Here's where fidelity and capture converge. Seriality makes a motion out of stillness, a one out of a many: so that the essence of cinema is a field wherein the most fundamental questions are enacted formally and at the level of film's submission to the structure of narrative. At the same time, blackness—in its relation to a certain fundamental criminality that accompanies being-sent—is the background against which these issues emerge. Po(i)sed between emergent techniques of motion capture and composite imaging, she is held at the crossroads of the history of art and the history of science, the history of race and the history of sexuality. This intersection is where Eakins's fascination with photography is inappropriately inaugurated, extending similar predilections in, and posing similar questions as, Manet. But Eakins turns to an actual thinking of the photograph as such, one that moved from its relation to the quest for anatomical fidelity to a concern for its capacities for the enactment of narration and the simulation of movement. The photograph displaces the prefatory, preparatory sketch. No painting follows from it. This study of a sent thing is a study for nothing that seems to be much ado about nothing precisely insofar as she is placed within the history of posing's relation to the trafficked woman (to a sexuality whose criminality lies in and before the fact that it is marketed). That placement simultaneously enacts and justifies her further placement within a movement of fugitive framing and the criminological photographic capture that responds to it. That movement and its attempted seizure are on the way to cinema. At the same time that she is posed or placed within these intersecting trajectories, the singularity of the photograph—its detachment from the movement and/or development that the series makes possible—seems to imply her being held. She lies, as it were, in a bare frame or cell, a photographic, choreographic, phonographic scrawlspace in which nothing is given to look at—no props, no things, no décor—save the arabesque printed couch that serves as a kind of pedestal for a literal thing, an anthropomorphized nothing. The girl on the couch stands in for what had been given earlier in this pose's history as décor. And it is precisely in this stillness, as this seizure, as a momentous enactment of escape, as fugitive momentum, that she constitutes a dissonance in the histories to which she is submitted and marks the dissonance of any attempt to harmonize them. She is a link within and between these lines even as she arrests and solicits both of them.

I speak of her placement, her position (within a structure), thereby raising, by way of a kind of submergence, the question of her agency, her transverse,

auto-excessive intervention in the history of agency. To attempt to locate her agency is precisely to mark the fact that it lies, impossibly, in her *position*, in an appositional force derived from being-posed, from being-sent, from being-located. Her agency is in her location in the interval, in and as the break. This is what it is to take, while apposing, the object position with something like that dual force of holding and outpouring that Heidegger attributes to the thing which, in its defiance of the ennobling force of representation, ennobles representation.

Jacobs famously recites the moment at which she became aware that she was a slave. Hers is also a sexual moment, poised between awakening, fitful awareness, and nightmare, when one becomes aware of one's placement within aestheticized, scientistic trajectories of predation and pursuit. But the moment in which you enter into the knowledge of slavery, of yourself as a slave, is the moment you begin to think about freedom, the moment in which you know or begin to know or to produce knowledge of freedom, the moment at which you become a fugitive, the moment at which you begin to escape in ways that trouble the structures of subjection that—as Hartman shows with such severe clarity—overdetermine freedom. This is the *musical* moment of the photograph. It's not just that this is not a story to be passed on, not a story that stories can simply pass; for insofar as these formulations are true, this is not just one story among others. If it could be said that D. W. Griffith establishes certain rules and techniques of cinematic narrative, activating those ruptural suspensions that move narrative film to a level that exceeds the realm of mere attraction, then it remains to focus more intently on the particular story that he had to tell, which is the teleological mechanization of the image. It's no accident that the story of the disciplinary animation of the image comes more fully into its own by way of the black apparatus. I'm thinking, here, outside of the opposition between narrative cinema and non-narrative cinema in order to think the question of the *essential narrativity* of cinema in its relation to the question of discipline or, to use more precisely Foucault's terminology, the question concerning sovereignty, biopower, and their interplay. This question turns out to be a historical one, articulable by way of the new apparatuses of aesthetic modernity (montage, dissonance, abstraction, and the emancipation of their seriality) and of the black apparatus. The beginning of *The Birth of a Nation* asserts that everything was fine till *they* came (as if of their own free will or by way of some combination of accident and corruption like Africanized bees), seeds of disunion breaking out criminally in dance, in the intervallic everyday step and fall of a runaway editorial blade, in

the complications of rhythm correspondent with fugitive—if never quite fully emancipated—dissonance, in the contagious disruption of polite, policed, legitimately political gesture, in abstract, *thingly* anti- and antefiguration.

Some Relationships

Adorno opens a late essay called "On Some Relationships between Music and Painting" with the following claim: "The self-evident, that music is a temporal art, that it unfolds in time, means, in the dual sense, that time is not self-evident for it, that it has time as its problem. It must create temporal relationships among its constituent parts, justify their temporal relationship, synthesize them through time. Conversely, it itself must act upon time, not lose itself to it; must stem itself against the empty flood."[18] Music "binds itself to time at the same time as it sets itself against it," thereby embodying art's *Bewegungsgesetz*, its law of movement, which Adorno characterizes as the revolt against the fact that "the inner consistency through which artworks participate in truth always involves their untruth."[19] Music's broken interiority—and the rebellion against that brokenness that redoubles it, that becomes the artwork's law of movement—manifests itself severally, in antinomian ensemble: as the juxtaposition of truth and untruth, stillness and movement, freedom and constraint, temporality and spatiality, structure and expression, matter and writing, regression and advance, part and whole. Music, as the temporal art (*Zeitkunst*), "is equivalent to the objectification of time," Adorno adds.[20] Moreover, he states, "If time is the medium that, as flowing, seems to resist every reification, nevertheless music's temporality is the very aspect through which it actually congeals into something that survives independently—an object, a thing, so to speak."[21] Music consists of the organization of events so that they do not dissolve or pass away but rather coalesce into a thing that seems to suspend time precisely by bodying forth a temporal progression that belies thingliness. Adorno adds, "What one terms musical form is therefore its temporal order. The nomenclature "form" refers the temporal articulation of music to the ideal of its spatialization."[22] I'm interested, finally, in the fact that this reference is unbound, in Mackey's terms, precisely by the irreducible materiality that constitutes and deforms the musical work and the musical sign. Even if the objectification of time is made possible by what Harryette Mullen might call a kind of "spirit writing," a fetishizing secrecy of technique from which the work emerges, such writing does not undermine and is indeed made possible by an irreducible

materiality that lies before the work as well and, as it were, *as writing*.[23] When Adorno says, "The most extreme esthetic progress is intertwined with regression," this interarticulation of writing and matter—something akin to what Deleuze and Guattari call "bodily inscription"—is part of what he means.[24] Adorno will speak of this material graphesis by way of the metaphor of electricity, which Akira Lippit requires us to consider in relation to animality and animation, as animetaphor.[25] This animetaphorical electricity lies between the hieroglyphic and the seismographic in Adorno's discourse, in the realm of nonsubjective language (akin to what Walter Benjamin calls "object-language"). Adorno is after a mode of writing that, in its renunciation of the communicative function, exemplifies an abandonment to impulse that "has an affinity with pure expression independent not only of its relation as a signifier to something that is meant to be expressed, but also of its kindred relation to an expressive subject that is identical with itself. This affinity reveals itself as a break between the sign and what it signifies."[26] This brokedown, broke-off musico-painterly *écriture* is, and not only in its impulsiveness, precariously close to what shows up for Adorno as an almost absolute antipathy.

This bodily inscription, this hieroglyphic-seismographic register, where mimetic and expressive impulses asymptotically (non-)converge, at the (dis)juncture of (abstract) painting and (atonal) music, is again what remains to be thought in and as the law of (e)motion. This is the place where Adorno addresses the transcendental clue of musico-painterly (in)separability, namely that "musical theory cannot manage without . . . quasi-optical term[s]."[27] But while Adorno sees a fundamental asymmetry such that the theory of painting and the theory of music approach each other awkwardly and unsuccessfully, that approach still constitutes another transcendental clue that allows something like a more precise, because improper, naming (an antinomial and antinomian nomenclature) of music and painting in their articulate difference from one another: on the one hand, this interarticulation is theater; on the other hand, it is cinema.

In the meantime, it's still necessary to consider Adorno's attention to that temporalization of painting as *Raumkunst* that corresponds to the spatialization of music as *Zeitkunst*. If, as Adorno says, "The nomenclature 'form' refers the temporal articulation of music to the ideal of its spatialization,"

> It is no less true that painting, *Raumkunst*, the spatial art, as a reworking of space, means its dynamization and negation. Its idea approaches transcendence toward time. Those pictures seem the most

successful in which what is absolutely simultaneous seems like a passage of time that is holding its breath; this, not least, is what distinguishes it from sculpture. That the history of painting amounts to its growing dynamization is only another way of saying the same thing. In their contradiction, the arts merge into one another.[28]

This too must be thought in relation to art's *Bewegungsgesetz*. (In both painting and music the law of motion redoubles itself in a way that is fateful for cinema's mixing of sound and image. I want to consider cinema, by way of Adorno's consideration of some relations between painting and music, not as hybridities or interstices or "pseudomorphos[e]s," but rather as nonconvergent interarticulation—the transcendental aesthetic given in a kind of material performativity.[29]) The paradoxically mobile stasis of artworks will manifest itself as simultaneity.

> In a picture, everything is simultaneous. Its synthesis consists in bringing together things that exist next to each other in space, in transforming the formal principle of simultaneity into the structure of the specific unity of the elements in the painting. Yet this process, as a process that is immanent in the thing itself, and by no means belongs merely to the mode of its production, is essentially one of its tensions. If these are lacking, if the elements of the painting do not seek to get away from each other, do not, indeed, contradict each other, then there is only a preartistic coexistence, no synthesis. Tension, however, can in no way be conceived without the element of the temporal. For this reason, time is immanent in the painting, apart from the time that is spent on its production. To this extent, the objectivization and the balance of tensions in the painting are sedimented time. In the context of his chapter on schematization [*q.v.*], Kant observes that even the pure act of thinking involves traversing the temporal series as a necessary condition of its possibility, and not only of its empirical realization. The more emphatically a painting presents itself, the more time is stored up in it.[30]

Adorno, working against his own opposition of music as internal world theater to cinema as a mere series of pictures, reintroduces the law of motion by way of the Kantian notion of the necessity to thought of motion, of traversing the temporal series. This is to articulate the "little heresy" that says the condition of possibility of music as an internal world theater is, precisely, its

temporalization as a series of pictures, events, details, frames, crawlspaces, each with their own internal strife and syntax.[31] Time is immanent in the painting as tension, the elements set in relation to one another trying to get away from one another. We could think this in relation to the history of the pose, the history of the com*position*: the nude from Titian to Manet to the little girl that Eakins seeks to possess. The becoming-theater of music—of, for instance, the symphony, or the truly symphonic as opposed to radio symphonic Beethoven—is always threatened, however, by the very seriality that makes it possible. For Adorno, the radio symphony

> ceases to be a drama and becomes an epical form, or, to make the comparison in less archaic terms, a narrative. And narrative it becomes in an even more literal sense, too. The particular, when chipped off from the unity of the symphony [as trivia, quotation, reductively expressive detail], still retains a trace of the unity in which it functioned. A genuine symphonic theme, even if it takes the whole musical stage and seems to be temporarily hypostatized and to desert the rest of the music, is nonetheless of such a kind as to impress upon one that it is actually nothing in itself but basically something "out of" something else. Even in its isolation it bears the mark of the whole.[32]

The denigrative invocation of narrative is instructive here if only because it confronts us with the duality of the little girl. The photograph contains a narrative, a story, a history. It is something out of something else, an emergent object, of the whole of the story. At the same time, as Adorno will get to in his "Little Heresy," this expressive detail, this picture, in its paradoxical temporalization, not only bears the theatrical continuum, as it were, but makes that continuum possible. As problematic as the image character of radio (or of the photograph) might be, it must be understood, in Adorno's terms, as the regressive motive of aesthetic advance. As Adorno writes:

> In highly organized music . . . the whole is in the process of becoming, not abstractly preconceived, not a pattern into which the parts need merely to be inserted. On the contrary, the musical whole is essentially a whole composed of parts that follow each other for a reason, and only to this extent is it a whole. . . . The whole is articulated by relations that extend forward and backward, by anticipation and recollection, contrast and proximity. Unarticulated, not divided into parts, it would dissolve into mere identity with itself. To comprehend music adequately, it

is necessary to hear the phenomena that appear here and now in relation to what has gone on before and, in anticipation, to what will come after. In the process, the moment of pure present time, the here and now, always retains a certain immediacy, without which the relation to the whole, to that which is mediated, would no more be produced than vice versa."[33]

To fight the one-sided emphasis on the hearing of the whole that he himself advances in his valorization of structural listening, Adorno would rehabilitate the moment of pure present time in the interest of the narrativity that it bears, a narrativity which here is not opposed to but is the condition of possibility of the symphony's theatricality. "The right way to hear music includes a spontaneous awareness of the non-identity of the whole and the parts as well as of the synthesis that unites the two."[34] The law of motion returns as that interinanimation of result and process that marks the demise of "overarching forms to which the ear could entrust itself blindly."[35] This impossible audiovisuality, this no-longer-operative blind trust of the ear, demands *"exakte phantasie,"* the precise improvisation of foresight, of a kind of insight of and through prophetic blindness, that I wish to think of in relation to the fugitive and the fugue, where *phantasie* holds imagination (in its lawless freedom, as the essential criminality of the law of [e]motion), improvisation, and the cut augmentation of rationality that is associated with the fugal interplay of voices. In the absence of overarching form, one turns to detail, to the unit of expression, as the condition of possibility of the whole, its anticipatory and retrospective—premature and postexpectant—effect. The whole is now given in something like an Ellisonian lingering in or over individual detail, in the depth, as it were, of such detail's surface, which is already stereoplexed in a black and blue underground scene. This phonographic movement between suspension and submergence becomes a critical model. The point, here, is to think the little girl in all of these terms—as exact imagination and expressive detail; as the possibility and effect of the whole of the story that is held within and animates the image—an anthology of material detail that, while nothing in itself, gets to the nothing that is not there and the nothing that is, like a snowman. Part of what's at stake here, at the level of affect and of the modes of bodily inscription or grapho-mimesis embedded in the pose and its vexed relation to the everyday, is the breakdown of the rigid opposition that Adorno makes between improvisation and writing, an opposition based on the assumption that "the act of notation is essential to art music,

not incidental. Without writing [there can be] no highly organized music; the historical distinction between improvisation and *musica composita* coincides qualitatively with that between laxness and musical articulation. This qualitative relationship of music to its visible insignia, without which it could neither possess nor construct out duration, points clearly to space as a condition of its objectification."[36] I want to consider improvisation as precisely that material graphesis which is, for Adorno, essential to the syntax, the articulation of individual detail, that makes the organized whole a possibility. Composition is imagining improvisation—*quasi una fantasia.* Improvisation is the animative, electric, hieroglyphic-seismographic tension that cuts the pose while also being its condition of possibility, even as the pose is the condition of possibility of the whole in its unavoidably narrative, unavoidably fantastic theatricality. All of this is embedded in the image of the little girl. Here's where the visible insignia is, again, a bodily and performative inscription, everyday and ordinary recomposition and/or repositioning, the audiovisual recording of a choreography of the scene of overhearing which, like the opera, requires a natural history, but one not quite so easily dismissive. *What if we consider that improvisation is the unacknowledged grapho-spatiality of material writing*—the arrangement of people at the scene as audiovisual condition and effect?

Such arrangement goes hand in hand with the effects of writing's irreducibility to communication and is bound up with the state of affairs of our modernity—and the place of the black apparatus within that modernity— wherein "*écriture* in music and painting cannot be direct writing, only encoded writing; otherwise it remains mere imitation. Hence *écriture* has a historical character; it is modern. It is set free on the strength of what in painting, with a devastating expression, people have taken to calling abstraction, through distraction of attention from its object-relatedness. In music this has occurred through the mortal contraction of all its imitative moments, not only its programmatically descriptive elements, but its traditional expressivity, as well."[37] Adorno speaks of this mortal contraction as that abandonment of music to its impulse that is essential to atonality, to the emancipation of the dissonance. The question concerns what telling a story is now, in the age of the emancipation of dissonance and in the age of a kind of abstraction, a distraction of attention from the object and from whatever narrative material is held within the image of the object, that accompanies Eakins's photographic scientism as a kind of mechanically reproduced anticipation. This is to say that Eakins's work is active in the historical preface

to the distraction from the thing that results in its reanimation and in its replacement within the whole of the story. One day it might be possible to consider Eakins's relation to abstraction, his relation to, say, Mondrian, which would be revealed in a comparative analysis of their understandings of the sociality that makes painting possible and that painting would bring about— two relations to Bohemia and, by extension, to Bohemia's relation to the black (socio-)apparatus that will have become the very model of the outskirts and underground. (The little girl, decapitated by shadow and discomfort, is a forethought and pathway, an anticipation of cubism's broken portraiture.) Then we would know what the little girl has to do with, how she is embedded in and as, narrative and music in, say, *Victory Boogie-Woogie* (the new abstract arrangement of things on the streets of a public sphere whose blackness can only be fully acknowledged in the wake of disaster).

While Adorno's late work gets us to the point of a necessary revaluation of the musical moment, it remains impossible to forget how much grief he gave such moments in the thirties. In "The Fetish Character in Music and the Regression of Listening," Adorno begins with the formulation that "music represents at once the immediate manifestation of impulse and the locus of its taming" in order to investigate the ways that the contemporary "golden age" of musical taste was only properly understood as the era of its almost complete degradation. When tameness is taken for abandon, when amusement no longer amuses, what obtains is a general anesthesia, a numbness that is paradoxically induced by what Adorno calls "the recklessness of a singer with a golden throat or an instrumentalist of lip-smacking euphony," elements that once "entered into great music and were transformed in it; but great music did not dissolve into them. In the multiplicity of stimulus and expression, its greatness is shown as a force for synthesis. Not only does the musical synthesis preserve the unity of appearance and protect it from falling apart into diffuse *culinary* moments, but in such unity, in the relation of particular moments to an evolving whole, there is also preserved the image of a social condition in which above those particular moments of happiness would be more than mere appearance."[38] My concern has been with the relation between fugitivity and the musical moment, between escape and the frame. Adorno, after Kant, is, on the other hand, interested in freedom. If freedom is a matter of taste, perhaps escape is a matter of flavor. I've never been one to heed Adorno's call to exclude "all culinary delights."[39] Indeed, I wonder what is lost in adhering to an ancient line in which the culinary indexes the sense that signifies a sensual degradation irrupting into the

breach between taste and the supersensual. Deeper still, the lip-smacking (*geschlekt*) euphony of the instrumentalist seems always to carry with it the unique varietal character (*geschlecht*) of some quite particular local soil. In "On Jazz," Adorno is already concerned that the trumpeter's embouchure carries a racial mark, a coloristic effect that bespeaks servitude, hysteria, impotence, or prematurity. But what if the constitution of the whole is precisely the intensified reproduction and internal structure of the climax (however premature or, more precisely, untimely), sustained and interrupted. That's what jazz is—in the break that is and breaks the climax. Tarrying, lingering, (productive) of bone-deep listening. Consider Marvin Gaye's plea "Don't make me wait" as a profound manifestation of musical patience, offered by someone who has been waiting for a long time, uttered so far behind the beat that its adherence is a kind of displacement.[40] His is a climax way too long in coming. It is Adorno who is impatient, who simply cannot wait for, refuses to wait upon, the continually auto-augmentative miniature that the black apparatus affords. It is, perhaps, an impatience born of the legitimate critique of the delusional work to which the black apparatus has been put. Nevertheless, Adorno relinquishes something that he cannot live without. This is to say that there is an experience of listening that Adorno cannot imagine until he begins seriously to meditate on the possibilities for structural listening that are held within the long-playing phonograph record. His little heretical deviance from the doctrine of musical ends, and even musical resolution or resoluteness, comes later, might even be said to manifest the fits, starts, and lyrical condensation and fragmentation that Adorno himself associates with late work of others.

The real issue, it turns out, is the relationship between authentic, as opposed to virtual, dissonance and the constitution of the cell, the frame, the crawlspace, the magic/fatal circle. Constant escape is uneasy. It demands the blinking intermittence, the radical flight, of a certain experience of constraint that will have been best understood as sustained, unflinching fantasy, as a look through or away, listening to and playing over, under. Perhaps constant escape is what we mean when we say freedom; perhaps constant escape is that which is mistreated in the dissembling invocation of freedom and the disappointing underachievement/s of emancipation. This is to say that Adorno is correct, however venomously, when he says, "to make oneself a jazz expert . . . one must have much free time and little freedom."[41] He's just wrong in thinking, however momentarily, that this condition is not his own. That momentary delusion is lost when he speaks of "the terror which

Schönberg and Webern spread." That terror stems "not from their incomprehensibility but from the fact that they are all too correctly understood. Their music gives form to that anxiety, that terror, that insight into the catastrophic situation which others merely evade by regressing. They are called individualists, and yet their work is nothing but a single dialogue with the powers which destroy individuality—powers whose "formless shadows" fall gigantically on their music. In music, too, collective powers are liquidating an individuality past saving, but against them only individuals are capable of consciously representing the aims of collectivity."[42] This is a pure expression of the persistent and terrible dialectic of constant escape, a condition with which many musicians beside Webern and Schoenberg are more than intimate. Think of the ones who were sent. Sent, because they already left and carry leaving with them like a scar; they want to go. Always they have already left and still are not arriving. How unfortunate for Adorno that the music one most loathes might best exemplify the fugitive impetus one most loves! It's difficult not to think of that convergence of patience and lateness as Miles Davis's personal temporal coordinate.

Crawlspace

There's a band playing outside the booth; the riff is a mode of confinement: the ear and hand of Gil Evans *drive* Miles who is placed, composed, arranged.[43] He shoots up an octave, ascending into the underground; narrates a constriction that he dances out of by dancing in. Dissonance escapes into a kind of resolution and victory is deferred by this successful outcome, as when Jacobs's mistress buys her freedom, thereby stealing her triumph. But this is an old-new sonority's old-new complaint and Miles, like Jacobs, keeps going past such emancipation by way of a deeper inhabitation of the song that makes it seem as if he were young again, as if embarking for the first time on the terrible journey toward some new knowledge of (the) reality (principle), the new knowledge of homelessness and constant escape. With the proper inappropriate differentiation, acknowledging what it is to own dispossession, which cannot be owned but by which one can be possessed, what Adorno says of Beethoven—that his is "the most sublime music ever to aim at freedom under continued unfreedom"—is applicable to Miles's ascendant Jacobsean swerve in and out of the confinements of Gershwin's composition and Evans's arrangement.[44] Freedom in unfreedom is flight and this music could be called the most sublime in the history of escape.[45]

The New International of Rhythmic Feel/ings

This is *Natures nest of Boxes*; The *Heavens* containe the *Earth*, the *Earth*, *Cities*, *Cities*, *Men*. And all these are *Concentrique*; the common *center* to them all, is *decay*, *ruine*; only that is *Eccentrique*, which was never made; only that place, or garment rather, which we can *imagine*, but not *demonstrate*, That light, which is the very emanation of the light of *God*, in which the *Saints* shall dwell, with which the *Saints* shall be appareld, only that bends not to this *Center*, to *Ruine*; that which was not made of *Nothing*, is not threatened with this annhiliation. All other things are; even *Angels*, even our *soules*; they move upon the same *poles*, they bend to the same *Center*; and if they were not made immortall by *preservation*, their *Nature* could not keepe them from sinking to this *center, Annihilation.* —**JOHN DONNE**, *Devotions upon Emergent Occasions*

Artworks' paradoxical nature, stasis, negates itself. The movement of artworks must be at a standstill and thereby become visible. Their immanent processual character—the legal process that they undertake against the merely existing world that is external to them—is objective prior to their alliance with any party.—**THEODOR W. ADORNO**, *Aesthetic Theory*

Rupert Westmore Grant, the Trinidadian calypsonian known as Lord Invader, recorded "Crisis in Arkansas" in March 1959.[1] Two months later, bassist/composer Charles Mingus recorded "Fables of Faubus."[2] The convergence of Mingus's and Lord Invader's musical indictments of former Arkansas Governor Orval E. Faubus, who tried to prevent black students from attending the all-white Little Rock Central High School in 1957, is of interest because of what it reveals of the articulate divergences in aesthetic and political ideology that animate Afro-diasporic culture. Mingus's politics are complicated by something Paul Gilroy has diagnosed elsewhere as "African-American exceptionalism"—an alleged parochialism derived, supposedly and in part, from a sense of messianic singularity that accompanies the refusal (however muted, however ongoing) of refused (however ameliorated, however suspended) national identification—even as the explicit political assertion embedded in calypso is something to which Mingus's protest impulse corresponds, and even as its musical forms and techniques are the object of Mingus's ambivalent desire.[3] Meanwhile, Lord Invader's pride in his and his music's West Indian origins is infused with its own complex and problematic national politics of rhythm, even as it exhibits profound transnational solidarity. The coincidence of their attention to Faubus occurs against the historical backdrop of a triangle trade in bodies and labor that Cold War politics updates into the trilateral movement of imperial troops, a long trajectory of catastrophe that still engenders the resistance that prompted it. In examining this coincidence, and placing it within the context of Lord Invader's and Mingus's musical careers and lineages, I hope to attend to some of what is left for us to emulate and correct in the tradition of anticolonial, antiracist, transoceanic aesthetic and political endeavor.

That Afro-diasporic resistance to the very conditions of possibility of the African diaspora often manifests itself as a kind of internal strife—between musicians and instruments, between (and within) locales and their corresponding styles and between confinement and fugitivity in the constitution of political aesthetics—is a matter that I would address with a kind of wary celebration. To accomplish this, I must also consider the relation between Mingus's political assertion, his formulation of the idea of "rotary perception"—a theory and practice of rhythmic flexibility in the music that he refused to call jazz—and his denigration of another great figure of the Los Angeles musical diaspora, Ornette Coleman. An international relay of seduction and marketing will become apparent here, one in which Mingus sees both Coleman and the calypsonians as competitors and interlopers. Here, appositional

articulations—however vexed, however burdened by the trace of what they would appose—emerge in (or, more precisely, as and by way of) the space between scenes, in intervals determined by barriers of sound and color. That space moves, inhabits many zones, is inhabited by many times; the groove that is this intervallic inhabitation moves with and along the chartable irregularity of a curved plane (plain) or an oceanic (and interactive rhythmic) feel (field). This irruptive and non-full presence of and in the interval takes the form of an anticipation and a medium; the before and interiority of an outside as magnifier, as amplifier; the shadow of inhabitation as a thing that conditions apprehension attenuated by disappearance. You come upon these inside-outside things, these bootlegged, black-market things, in the midst of thinking about stolen life: the general equivalent who materializes as rough translation and rough translator; the smuggler moving (messages between) stolen property; the anarchic methodological constant; the emanation alive in every essay. In this essay, the thing is German conductor Wilhelm Furtwängler, in all the non-full, non-simple blackness of a certain mediate, conductive brokenness.

As the acerbic lyrics he throws in Faubus's direction show, in addition to his brilliant musical achievements, Mingus was a genius at showing contempt. My concerns begin with the fact that some of his sharpest rebukes are intermittently and ambivalently directed toward certain key figures in a richly differentiated set of movements called "free jazz," particularly Coleman.[4] When especially intent upon abusing Coleman's musicianship, Mingus called Coleman a "calypso player." Here are two such instances, one from a June 1964 interview with the French magazine *Jazz*, the other recalled in *Tonight at Noon*, the memoir of Mingus's widow Sue Graham Mingus.

> Don't talk to me about Ornette Coleman. There are a bunch of musicians in the U.S. like him who are incapable of reading music and who have his particular approach. Coleman is a calypso player. Besides, he's West Indian. He doesn't have anything to do with Kansas City, Georgia or New Orleans. He doesn't play southern music. He might have come from Texas but that doesn't stop his family from being calypso, the same as Sonny Rollins's. All these musicians have, because of their origins, a feeling that is entirely different from ours. Sonny, at the beginning of his career, had a lot of difficulties. He copied Bird frantically. Now, fortunately, he's found his way and got himself together. To return to Ornette, he can't play a theme as simple as *Body*

and Soul. He belongs, along with Cecil Taylor, to the category of in-
strumentalists who are incapable of interpreting a piece with chords
and an established progression. I remember trying to play with him.
Kenny Dorham and Max Roach were with me that day. We started *All
the Things You Are* but at the end of a few measures Ornette Coleman
couldn't keep tempo or follow the chords. He was completely lost. Let
him play calypsos.[5]

I met Charles Mingus shortly before midnight in July 1964. I'd gone
down to the Five Spot, a jazz club in lower Manhattan, because the
producer of a film I was acting in had commissioned a jazz soundtrack
from saxophonist Ornette Coleman—at least he thought he had
commissioned a soundtrack—and my friend Sam Edwards, who was
working on the film, suggested I check out the scene. . . .

Mingus called for a bottle of Bordeaux—his own, which he'd evi-
dently brought from home—and was standing so close to our stools
that, as he drifted into wine talk with the bartender, I stole a glance at
his eyes. They were large innocent eyes, I thought, vulnerable and ques-
tioning, deep brown amused eyes that darted about the room while he
remained fixed on his conversation with the man at the bar. I decided to
ask Mingus whether he'd seen Ornette Coleman, the musician Sam and
I were looking for, whose free style of playing was still causing disputes
among jazz fans.

"You mean the calypso player?" Mingus replied scornfully. He looked
at me with curiosity. "You his old lady?" he asked.

"His mother?" I said. I hadn't the faintest notion what he meant.

Mingus laughed. "No, baby, I mean his woman, his lady."

"He's writing some music for a movie I'm in."

"You in a movie?" He seemed surprised. "With those teeth?"

Now I laughed. "It's an underground movie," I said. "They're not
fussy." A missing tooth in the back of my mouth was hardly visible—
certainly it had never been singled out by a curious stranger.

"Isn't your daddy rich?" Mingus persisted. I looked sideways at Sam.
He was sitting straight-backed and noncommittal, staring at himself
in the mirror across the bar. I imagined he was waiting to see exactly
how far down this communication failure was headed.[6]

At the edge of the spiral of musicians Probe sat cross-legged on a
blue cloth, his soprano sax resting against his inner knee, his afro-horn

linking his ankles like a bridge. The afro-horn was the newest axe to cut the deadwood of the world. But Probe, since his return from exile, had chosen only special times to reveal the new sound. There were more rumors about it than there were ears and souls that had heard the horn speak. Probe's dark full head tilted toward the vibrations of the music as if the ring of sound from the six wailing pieces was tightening, creating a spiraling circle.

The black audience, unaware at first of its collectiveness, had begun to move in a soundless rhythm as if it were the tiny twitchings of an embryo. The waiters in the club fell against the wall, shadows, dark pillars holding up the building and letting the free air purify the mind of the club.

The drums took an oblique. Magwa's hands, like the forked tongue of a dark snake, probed the skins, probed the whole belly of the coming circle. Haig's alto arc, rapid piano incisions, Billy's thin green flute arcs and tangents, Stace's examinations of his own trumpet discoveries, all fell separately, yet together, into a blanket which Mojohn had begun weaving on bass when the set began. The audience breathed, and Probe moved into the inner ranges of the sax.

Outside the Sound Barrier Club three white people were opening the door.[7]

According to Mingus, Coleman exhibits a harmonic ignorance that is manifest as an inability to navigate the music's spatiotemporal structure. The origin of these faults is double: idiomatic strangeness and technical incompetence. He doesn't know where or when he is because he comes from the wrong place, is of dubious, Antillean origins even if he is, in fact, from Texas, even if he migrated, like Mingus, to New York by way of Los Angeles. And so Coleman starts to fold, bending toward the center, the absolute singularity of an inescapable point or beat. He loses force, loses drive, spiraling to nothing, to confusion. He can't keep up, can't return and so the very figure of the black musical centrifuge stands in for what Mingus despises under the rubric of the centripetal, the concentrique. Coleman's music exhibits the deathly gravity that goes with being out of the loop, outside the circle of occult musical understanding and interpretive im/possibility that Frederick Douglass associates with knowledge of slavery, that Mingus associates with knowledge of the South, that Henry Dumas associates with an embryonic collectivity, born of a range of exiles, that is in part defined by the impenetrable attrac-

tion it seems to hold for a kind of hipsterism that Dumas fictionalizes and Sue Graham Mingus autobiographically records.[8] But what if such rootless rootedness is the *deliberate* aesthetic effect and affect of wanting out? When does the decaying orbit of centripetal force itself become a kind of centrifugitivity? How would one know the difference? More precisely, how would one inhabit such eccentric, such impossible, ground? This is the essential question concerning the radical in general and black radicalism in particular—its comportment toward a center that is, if not nothing, certainly not there. But the question of such comportment cannot be dealt with by avoidance, no matter how vexing any or all particular addresses of it have been or might be. Moreover, the absent but determinate centers of such structures are multiple. There are many impossible origins toward which we must comport ourselves; this is what might be called—in the full force of each of these terms—the question concerning the scored, scarred, richly internally differentiated, authenticity of blackness. Mingus's vexed, jealous, intolerant, ambivalent, beautifully ugly attendance to this question—his out inhabitation of the center of the circle—is, therefore, of great interest precisely because of its troubled and troubling nature. From the broken and unbroken circle (of slavery) to the vexed structures of musical emancipation and subjection; from Little Rock Central High to the outskirts of town; from (Sweet) Home to Harlem: "the thought of the outside," in Michel Foucault's terms, is bound up with the centrifugal, the fugal, the fugacious, the fugitive, the "destination out," in Nathaniel Mackey's terms.[9] The experience of the (sparkle of the) outside that resurfaced, according to Foucault, "at the very core of language" occurs in relation to an upheaval that is authentic however much it is broken in the performance—at the core of language and everywhere else—of blackness.[10]

Mingus's anti-calypsonianism is all the more problematic if thought in relation to the vast range of his Afro-Latin moods and modes, his Spanish tinge and turn and dinge, as Jelly Roll Morton + Robert Reid-Pharr might say, his *cante moro* or *cante jondo* as Mackey might say (after Federico García Lorca).[11] Mingus's spatioaesthetic chauvinism had to do with what he heard as a rhythmic and temporal structure whose vernacular linearity could be said to bespeak both idiomatic singularity and elective bondage. Such dismissal of the vernacular, which moves by placing its features under the sign of the Caribbean, is all the more complex when seen within the context of Mingus compositions such as "Wednesday Night Prayer Meeting," "Los Mariachis," and "Haitian Fight Song"—songs whose titles and musical character reveal a profound engagement with southern U.S. and Caribbean

Afro-diasporic vernaculars. At the same time, the supposed harmonic and rhythmic deficits of calypso and free jazz mark a more general deficiency that Mingus hears in Afro-diasporic music when compared to Euro-American concert music. Sometimes it seems as if Mingus is in search of a certain capacity for freedom in music that is to be found either in European development or Afro-diasporic primitivity, but neither in some combination of these imaginary poles nor in their deconstruction. And yet Mingus's proper musical home is precisely this interstitial, interarticulatory space that "neither" or "naught" signifies. This is to say, among other things, that the nationalist discourse on jazz is generally structured, above all, by a deep ambivalence. The way out of the limitations of jazz turns out to be nothing other than the way back into those limits that constitute its absent ground. There are two rhetorical strategies apparent in Mingus's discourse on those limits: one is the spatial chauvinism glanced at above; the other is a kind of spatiotemporal antifoundationalism in his musico-theoretical discourse out of which emerges the term *rotary perception*.[12]

Brian Priestly argues that Mingus's practice and theory of "rotary perception" begins to emerge in an experience of the frontier, in the vexed circuits of politico-economic, aesthetic, and sexual desire that mark the U.S.-Mexico border, its cycles of conquest and conquest denial, its Afro-diasporic traces and erasures. Mingus's *Tijuana Moods*, an album recorded in late July and early August 1957, just a few weeks before the National Guard had to be deployed in order to escort nine black kids into Little Rock Central High, replicates that circuitry. Of one of the signature tunes from that album, Priestly writes:

> *Dizzy Moods*, apparently conceived while driving to Tijuana, was described by Mingus before it was ever recorded: "Try a song like Dizzy [Gillespie]'s *Woody'n You*, for example, and make some changes; fit a church minor mode into the chord structure," and in fact a bluesy phrase in B flat minor is reiterated throughout the D flat circle of 4ths that constituted Gillespie's original A section (based on the sequence of Fats Waller's *Blue Turning Grey* and *I've Got a Feeling I'm Falling*). Mingus' B section, however, is in 6/4, but phrased in such a way that the 4/4 time-signature is still felt subliminally and it may be that the idea of adapting this polyrhythmic approach (hinted at in the C sections of [Mingus' composition] *Pithecanthropus*) surfaced after the trip to Tijuana, since it is a fact that Mexican popular

music is typically in multiples of three syncopated by multiples of two.[13]

Priestly then quotes Mingus's long-time drummer Dannie Richmond on the rapport they developed "in negotiating such novel terrain for jazz":

I could see that [Mingus] stayed completely on top of the beat, so much so that, in order for the tempo not to accelerate . . . I had to lay back a bit. And, at the same time, let my stroke be on the same down-beat as his, but just a fraction behind it. . . . So that, when I would play on the 2 and 4, and sometimes switch it around to 1 and 3, he liked these different kind of changes that were taking place between the two of us. And I think it was when we first started to play something in 6 that we knew the magic was there, and that we could within a second be out of the 6 into a smashing 4/4 and not lose any of the dynamic level that had preceded it.[14]

This rapport was cemented, according to Priestly, in the nine months of intense collaboration in Mingus's Jazz Workshop before the recording of *Tijuana Moods*. That period came to a kind of climax when Mingus said to Richmond: "You're doing well, but now suppose you had to play a composition alone. How would you play it on the drums? . . . OK, if you had a dot in the middle of your hand and you were going in a circle, it would have to expand and go round and round, and get larger and larger. And at some point it would have to stop, and then this same circle would have to come back around, around, around to the little dot in the middle of your hand."[15] What's at stake here—by way of Tijuana's magic circle and broken market, by way of Mingus's self-described massive appetite for sexual and aesthetic control, his location of Tijuana as a key point on the circuit on which those appetites were indulged, and his identification of Tijuana with his experience and understanding of his own self-described hybridities—is Mingus's sense of the play of the centripetal and the centrifugal in this early formulation of what he comes to call "rotary perception."[16] This new approach to negotiating the circle and its border emerges from another border experience, from a music whose idiomatic specificity Mingus has to learn in order to achieve or more definitively to claim the kind of grounded eccentricity he desires. This is where the resingularization of the Afro-U.S. musical idiom (which we'll come to understand as an example of the reconstruction of techniques of *feel*) takes and is taken by the time of Mexican celebration. But this is accomplished

within the context of Mingus's otherwise distancing and denigrating remarks regarding another Afro-diasporic music.

Those remarks are inseparable from the emerging discourse on "rotary perception." That discourse is one of marketing as well as of a more "purely" musical exigency. Mingus invents terms meant to compete with those that were being attached to free jazz, especially to the music of Coleman, the calypsonian. His intervention is intended to announce a musico-theoretical advance as well as to attract the critics and the women, thereby fostering a dual seduction at the sound barrier. As Priestly shows, Mingus's most well known exposition on "rotary perception," which occurs toward the end of his autobiography *Beneath the Underdog*, comes from an interview that was ghosted into an article in a British journal called *Jazz News* in July 1961.[17] The article's formulations on "rotary perception" come right after a diatribe against John Coltrane, and other members of the jazz avant-garde, whose innovations Mingus felt he had anticipated with a rigor that proponents of the new thing never approached. In *Beneath the Underdog*, Mingus's explanation of "rotary perception" comes in the midst of a seduction scene at the start of a romantic relationship, a scene reminiscent of Mingus and Sue Graham's initial encounter. The denigration of Trane, Ornette, or, more generally, free jazz in calypso terms is part of a courtship ritual that also includes the codification of a new musico-theoretical formulation springing from a diasporic practice that crosses borders for its (im)proper articulation, and which has its origins in a desire that is both discursive and commercial. As we'll see, critics and historians of Trinidadian history and culture, like Gordon Rohlehr and Harvey Neptune, are helpful in placing Mingus's comments on Coleman within the context of the marketing of calypso in America. Mingus is fighting a battle against two sets of invaders. These formulations on "rotary perception," then, are inextricably linked to the dismissal of Coleman and calypso. And, as Priestly intimates, the dismissal is always accompanied by a trace of indebtedness:

> When I first introduced the name to the press, I admit it was only a gimmick like "Third Stream." I was tired of going hungry and I wanted to catch the public ear but, although the word was a gimmick, the music wasn't. . . . Swing proceeds in one direction only—but this rotary movement is, of course, circular. Previously jazz has been held back by people who think that everything must be played in the "heard" or obvious pulse. . . . [Previously people regarded the notes as having to fall

on the centre of the beats in the bar, or at precise intervals from beat to beat like clockwork. Three of four men in a rhythm section would be accenting the same pulse].... With "rotary perception" you may imagine a circle round the beat. [This is necessary because when you are playing you visualize this. It's not parade music or dance music. If you imagine the circle, then with a quartet formula each member can play his notes anywhere around the beat. It gives him the feeling that he has more trace.] The notes can fall at any point within the circle so that the original feeling for the beat is not disturbed. If anyone in the group loses confidence, one of the Quartet can hit the beat again. [The pulse is inside you, only to *remember* the beat is important.][18]

Again, this passage, as Priestly points out, is something like a rough draft for what goes on in *Beneath the Underdog*. You'll notice, though, refinements at the level of a certain insight into the possibilities of intra-ensemblic antagonism in jazz performance:

There was once a word used—swing. Swing went in one direction, it was linear, and everything had to be played with an obvious pulse and that's very restrictive. But I use the term "rotary perception." If you get a mental picture of the beat existing within a circle you're more free to improvise. People used to think the notes had to fall on the centre of the beats in the bar at intervals like a metronome, with three or four men in the rhythm section accenting the same pulse. That's like parade music or dance music. But imagine a circle surrounding each beat— each guy can play his notes anywhere in that circle and it gives him a feeling he has more space. The notes fall anywhere inside the circle but the original feeling for the beat isn't changed. If one in the group loses confidence, somebody hits the beat again. The pulse is inside you. When you're playing with musicians who think this way you can do anything. Anybody can stop and let the others go on. It's called strolling. In the old days when we got arrogant players on the stand we'd do that—just stop playing and a bad musician would be thrown.[19]

Throw the bad musician like a horse throwing a bad rider, a bad possessor. Refuse by way of induced confusion. The bad rider is not rhythmically self-sufficient, is radically distant from the complex inside/outside relation to the circle taken up by the ones who know. The ones who know are protected from a certain decay that standing on the beat, that occupying the

center of the circle, ensures. The bad rider, on the other hand, succumbs to that disciplinary cadence and, in so doing, fails to know the relation that he signifies. But why link calypso, with its supposedly insistent groove and putatively simple harmonies, with the rhythmic fugitivity and atonal errancy of free jazz, modes of dissidence and dissonance which elsewhere Mingus lauds and which his music both prefigures and emulates? And why do it by way of both nationalist and regionalist discourse even as one engages in critiques of the most egregious and brutal forms of American regional-nationalist vulgarity? Mingus's work is partly an intense—one might say typically modernist—activation of the desire for both advance and nostalgia. The freedom that would allow unfettered musico-structural development is tied to the forging of minimal—which could be construed as primitive—musical forms. In the end, however, we'll see that Mingus's idea of "rotary perception" corresponds to musicologist Shannon Dudley's description of the "interactive rhythmic feel" of calypso (the very music Mingus denigrates) in particular, and Afrodiasporic music in general—where cometric accents coexist with the contrametric; where those accents can be both audible and inaudible.[20] Against the grain of his own nationalist assertions, Mingus is after the discrepant drive of an international—as well as intranational and, even, contranational—musical ideal; a spatial universality that manifests itself as rigorously enacted and interarticulate temporal differences.

In comparing Wilhelm Furtwängler's and Arturo Toscanini's divergent modes of conducting Beethoven's Fifth Symphony, Herman Rapaport opens up a couple of lines of inquiry that I will try to explore, lines having to do with Furtwängler's intuitions regarding Beethoven's temporality and Toscanini's "Heideggerian" intuition regarding the thingly character of Beethoven's works. I want to think the relationship between thingliness and multitemporality, between these and the new politico-aesthetic dispositions to come. This will touch and trouble a certain discourse on nation and idiom that has much to do with Mingus's conflicted cosmopolitan desire. Rapaport writes:

> What is entirely inimical is Furtwängler's correct intuition that in Beethoven there is no unifying tempo for any of the movements but that each of the phrases exists in a temporality unique to itself. In other words, there is no unified musical heading, but a non-finite proliferation of multiple temporal idioms that the conductor conducts as just so many hegemonic references. It's precisely in this acknowledgement of another temporality, never before disclosed in the history of mu-

sical conducting, that Furtwängler crosses the limit line of the mercurial or the merely mad for the sake of encountering what Derrida calls the right-to-philosophy, a heading other than the heading in which we thought we were being directed. It is in this new heading that Furtwängler anticipates an entelechy that is very reminiscent of Derrida's advent of democracy in that the particular is not at all simply submerged in the general. It is here, furthermore, that ironically the most tainted great musical performances in human history bear out Adorno's criteria for greatness in modern music: the refusal of the individual unit to meld into the general context while finding an inevitable niche there all the same.[21]

A discourse on the relation between jazz and democracy that moves from Ralph Ellison to Hazel Carby will have to be teased out and carefully read in order to move, along with Rapaport, on a trajectory that allows an understanding of this tainted music—"conducted by Furtwängler in 1943 in Berlin at a gala concert where high-ranking Nazi officials were present"—as "the fruit of evil," but that recognizes that music's indictment, as well as its justification, of its origins precisely at the moment when it would seem to claim, in the most problematic ways, idiomatic or national specificity. Rapaport's question concerning the politics of musical heading or musical idiom, the manifestation and disruption of heading in musical time, occurs by way of his revisiting the historical encounter/agon between Furtwängler and Toscanini.

In comparison, Toscanini, whose music is the fruit of good [as a function of his refusal to perform for Nazis and his leaving Nazi-controlled Europe for "the land of the free"], appears to be much more confining and dictatorial. His music refuses the kind of atomization and alterity that would allow for a proliferation of hegemonic references. If Toscanini has a philosophy, it is one of regimenting and of ranking, a philosophy of bringing phrases and audiences in line with a work whose truth is the occurrence of a conversation or debate that could take place anywhere among anyone. It is in that regimentation of music as a kind of cultural and political "tutti" that the arrival of a democratic moment can be glimpsed. For Toscanini, however, this heading can only be reached if Beethoven is de-transcendentalized or cut down to size. The excesses of the particulars must never be allowed to escape the grasp of a generality or mediocrity that restricts and contains. For

those of you who would like definitive proof of this tendency, listen to the long-withheld recording of Toscanini's 1949 performance of Gershwin's *An American in Paris* where any hint of swing has been carefully suppressed, a suppression that in the past has led to accusations of a decidedly un-American agenda on Toscanini's part. It would be here, no doubt, that the race question can once again be raised on the shore of another heading.[22]

In thinking Toscanini's suppression of swing in Gershwin as, at once, a national and racial question and in thinking swing as the irruption of the interior temporal alterity *and constituency* of the work, Rapaport erects the frame of a bridge that would traverse the space(s) between time(s), (racial/national) idiom(s) and thing(s). If this suppression of swing is indicative of a kind of impoverished temporal understanding of Beethoven, then perhaps the temporal divide that separates the European and African diasporas was the occasion and possibility of a range of articulations and encounters that might have made for another history altogether. We'll return to the possibility of such idiomatic as well as historical recalibration by way of calypso while recognizing that Toscanini may well stand in for a specific European conceptual deficit with regard to the complexities of *European*, as well as African and Afro-diasporic, musical time. In the meantime, as Rapaport argues, "it is already not hard to see that the question of musical headings would be interesting to pursue from the standpoint of the right to make art in terms of a cosmo-political context."[23] He then veers toward a consideration of the philosophical in Furtwängler and Toscanini:

You may have already wondered if Toscanini was, indeed, quite as poor a philosopher as I have made him out to be. In fact, Toscanini shares a Heideggerian insight about art reminiscent of a famous sentence from "The Origins of the Work of Art." "Beethoven's quartets lie in the storerooms of the publishing house like potatoes in a cellar." That "all works have [a] thingly character" (of course, this is not all Heidegger has to say on the matter) was, very much, the philosophical heading under which Toscanini and his followers have been conducting music. What Toscanini hated, above all, was the metaphysical heading of music—the idea that the music is "something else over and above the thingly element." Here we should be aware of the metaphysical/anti-metaphysical headings under which Furtwängler and Toscanini found themselves, something that would change their performances

greatly in relation to how we would estimate them. When Heidegger tells us that "The art work is, to be sure, a thing that is made, but it says something other than the mere thing itself. . . . The work makes public something other than itself; it manifests something other; it is an allegory," he is raising an issue that Toscanini wanted to demystify, the notion that the work must manifest itself as something *other*—that it manifest itself as having an *other heading* or course than the internal headings of the musical phrases. Provided we can imagine Toscanini playing a certain Heideggerian kind of Beethoven, a Beethoven as earthy as a dry sack of potatoes in the root-cellar, but by no means representative of one, we would then have to start asking questions about whether Toscanini and Furtwängler were actually headed in such different directions after all, since the hegemonic philosophical point of reference would be a slice of *German* philosophy that would bring the two conductors under somewhat of the same aesthetic heading.[24]

This same aesthetic heading is where idiom and thingliness would converge, though immediately one is called upon to move, by way of Heidegger, toward another consideration of the thing or, if you will, toward the other that is already in the Heideggerian conception of the thingliness of the work of art. That the thingliness of the artwork is bound up with its being made bears a significance that will only intensify when the thingliness—the vexed history of commodification, objecthood, and "the natural"—of its maker is also considered. A line of objections—a phrase of objection—remains here to be traced. That time line, such phrasing, intimates that which is over and above the thing is *in* the thing, is the essence, in fact, *of* the thing. This is to say—after Heidegger and Rapaport and, necessarily, in another register— that the work is over and above itself, is other than itself, and that that other heading is the exteriority that is given or is possible only by way of the internal headings of the musical phrases in all their canted singularity. To deny the exteriority of these interior turns as an object of critico-performative desire is to foreclose any possibility of inhabitation of the work, any possibility of sounding, of following the thing's internal headings, its internal differences, those multitemporal, nonunified, subliminally felt, unbound hegemonic references. What Rapaport hears and abjures in Toscanini is what Mingus hears and abjures in the military regularity of certain iron-systemic rhythms in jazz performance, which could either be thought of as suppressions of swing in what passes for swing or as a dry and congealed thingliness in violation of the

very essence of the thing—an absence of meaning, if you will, that requires a transcendence of swing. If *this* is swing, Mingus seems to be saying, then it never meant a thing. Meanwhile, Rapaport suggests that this "divisibility and overlapping of musical headings" that he has begun to investigate by way of Furtwängler and Toscanini, Heidegger and Derrida, might "point towards a deconstruction of a Eurocentric horizon—perhaps even the Eurocentric itself—that would exceed the unifying determinations of, say, the dialectical stability of Eurocentric versus the post-colonial."[25] Rapaport further suggests that this deconstruction will have required the recitation and analysis of another story, that of the violinist, and "ravishing beauty," Anne-Sophie Mutter. It strikes me that Mingus's theory and practice brings another beauty into the mix as a kind of deferral of Rapaport's critical odyssey: Calypso. What has Calypso to do with the music—and radical thingliness—of other times? This is a question concerning the spatial politics of the groove. Such politics is also always a sexual politics.

Why will Ornette Coleman come to occupy the place of this seductress who makes you wait, who makes you lose or change your heading? How does Mingus register, and how is he disrupted by, an arrhythmia that is driven by and toward the postcolonial? How does calypso interrupt the iron idioms of something that is called swing in ways that Mingus both loves and hates? This all has, also, to do with thinking the harmonics of swing. Can we think the cantedness—the circularity, even—of calypso's dissonance, a wandering irresolution that Mingus hears in Coleman as illiteracy, a kind of absence of sanctioned musical reason, a loss of musical self-possession that Mingus elsewhere desires and cultivates? What's the relation between the hidden seductress and the (outside) state of being-lost? There is a certain fear of the islands, of the Antilles, in Mingus's discourse that is, at the same time, contradicted by what might be called his lawless inhabitation of the musical borderlands. In Mingus, the dream of a strolling musical walkabout and the fear of musical homelessness and rootlessness that requires the grounded, pedestrian basics go hand in hand. Like Odysseus, the specter of a final resolution or homecoming only engenders a final refusal of (the right of) return. The refusal leads Mingus repeatedly to Mexico—in search of a kind of rapacious, imperial life and, later, during his fight with Lou Gehrig's disease, in search of a kind of respite, some non-commercially driven deferral, and then acceptance, of death—and then to the Ganges, where his ashes were scattered in the hope of the most radical return as nonreturn, the reincarnation of a lovebird. This international reclamation and disavowal of national idiom

marks the cross-section of a circuit worth exploring: Trinidad, India, Mexico, the United States, Germany. One must discover now the other thingly character—the multiple temporality and interiority—of the market as well as the artwork. This is a history of migration, interior invasion, excursion, and return, of what Sarah Cervenak studies under the rubric of a necessarily circular, necessarily broken, wandering; the occult instability of the (intra- and inter)national market: to be for such communism, the democracy that lies before us, such liberation of surplus, is no simple being against regulation.[26] This is at the root of Mingus's rootless ambivalence in all of its determined aggression.

Meanwhile, it must be considered that people rebel against the beat like they rebel against understanding, reason, law, and especially those modes of control that masquerade as abandon. But what's the relation of the beat to that *other* reason, that more complex interinanimation of law and imagination? And how do we deal with what Furtwängler, Rapaport, and Daniel Barenboim might get to as the imperceptible errancies and delays of the beat and its reason, understanding, law? This is a problem or question concerning the line. Here is Barenboim in a passage from his recently published conversations with Edward Said that address Furtwängler's mutable time. I juxtapose them to a couple of excerpts from Karl Dietrich Gräwe's description of the organizational effects and choreographic affects of Furtwängler's conducting style. The passages concern imperceptible variation, the internal differentiation of the simultaneous and a certain interinanimation of groove, circle, and hand in Furtwängler's mode of laying down the law.

Furtwängler believed implicitly in the fact that it was not only permissible but necessary to have certain fluctuations of tempo, not only to achieve the expression of each individual molecule but, on the other hand, paradoxically, to achieve the sense of form, in order to have the ebb and flow. You needed to have these imperceptible fluctuations in order to achieve the sense of formal structure. Obviously, they have to be imperceptible. This means that one of the main principles of making music is the art of transition.[27]

There has never been a dearth of critics to find fault with Furtwängler's straggling entries or his unstable tempi. (Toscanini called him *"il grande dilettante."*) An orchestral musician claims to have counted how Furtwängler's baton, describing a jagged line in its descent, beat 13 times like an irritated seismograph. [Like the irritated seismograph

that is Erwartung.] The orchestra then managed, yielding to the suggestive "overkill," "to find its entry at some point." If one listens to the sound documents Furtwängler left behind, one will notice that the instruments rarely enter together: some dare to come in "too early," others finally succumb to the force of gravity and "fall into" the chord. The result, however, though at the cost of a wafer-thin lack of synchronicity, is a sonority of exceptional luminousness, warmth, fullness and weight.[28]

How did Furtwängler conduct? His high-raised right arm made him look like the incarnation of a *Jupiter tonans*. How did an orchestra sound under Furtwängler? This question touches on some essential considerations. Threatening gestures and demands for metrical rigour were not his way. Instead his right hand described gentle, circular movements, like the shaping, modeling hand of a painter or sculptor. He did not chisel at unyielding stone; he gave form to a soft, malleable substance, and it was always a product of the moment, binding, yet subject to revision, an *ultima ratio*, but valid only for the momentary act of music-making.[29]

The soft circularity of Furtwängler's fitful starts, his falling into the beat as if under the influence of some kind of disrupted gravity or broken curvature, offers a clue about that locale where rhythm, tempo, and a kind of durative simultaneity begin to merge in and as improvisation. Errancy is crucial here—performance is, or is marked by, what elsewhere Mingus denigrates as Coleman the calypsonian's supposed confusion or lack of confidence. But while Mingus's figure of the illiterate outsider is a variation on the historic devaluation of the thing's supposedly lawless incapacity to intend, Barenboim's reflections on Furtwängler associate such errancy (or, in his terms, plasticity) not only with profound concentration but also with the evanescence of performance. Note, also, that immediately following the recording of the passage on "rotary perception" in *Beneath the Underdog*, an unfortunate British critic asks Mingus about British jazz, about whether the British can play, to which Mingus makes a reply based on unjustifiable notions of immutable, untransferable, and irreducible idiomatic difference that quickly crosses into a justifiable rant on the racial economics of jazz. The difference, by the way, between Mingus and Barenboim is that Barenboim believes national idiom is real but transferable. Mingus's resistance to such "cosmopolitanism" is, on the one hand, strategic and economic and, on the other hand, violated constantly by his own compositional and performative practice. This is to say

that Mingus's procedure is all about the courting of such errant eccentricity, the vexed resistance to a regulation that he must honor. This requires our attunement to the expression, in Mingus's errant, immigrant, fugitive law of movement, of his desire for his compositions "to prove how beautifully one can improvise against a basic structure." That desire is constantly given in the evanescent performances of his workshop, an ensemble, a set or class, a thing, realized in things, present at its/their own making or even, one might say, at its/their own conduction.[30]

This means that we have to consider the relation between "rotary perception" and the kind of libidinally saturated image of the whole that Samuel R. Delany speaks of in his autobiography *The Motion of Light in Water*, thereby returning—by way of terrain that Carby explores in *Race Men*—to a kind of rapport between The Music and a complex, dissonant range of sexuality that black musicians flaunt and obsessively deny.[31] This is a question concerning light, where we might consider enlightenment in its relation to what Donne calls "the very emanation of the light of God." Said says, of his first seeing/hearing Furtwängler in Cairo, "it was as if he were an emanation," an impression whose deposed resonance becomes a more than methodological sensibility.[32] And Barenboim speaks of the opening tremolo of Anton Bruckner's Seventh Symphony as the creation of an illusion "that it starts out of nowhere and that sound creeps out of silence, like some beast coming out of the sea and making itself felt before it is seen."[33] This is like Shelley's understanding of the skylark, or a kind of Levinasian insight into the *Torah*—the feeling of otherwise imperceptible natural or supernatural law become sound. It's not to be dismissed for the very real light and heat that it gives off. This emanation is stolen light and stolen life and it is inseparable from a radical spatial politics of the groove. What does it mean to lay with it or in it? To lay with it and to lay out, to refuse or walk away? To lay with something gingerly, with a certain amount of lightness and reticence: is this the detachment of the hipster, as Scott Saul would have it? In the very useful analysis of Mingus in his book *Freedom Is, Freedom Ain't*, Saul links the hipster's detachment with soul and with every solidity of the beat that might be associated with soul.[34] But Mingus's detachment is also from the beat or from its fixity and directness even as he weaves a kind of magic, protective circle round it. He would protect the pulse, like any good bass player, while freeing himself from it, like some impossible extension at the center of a womb-like space. What Dudley refers to—by way of J. Kwabena Nketia—as the "time-line" is a projective linearity that is also a central home, that is at once contained within and

projected from—protected by and protective of—the circle, a circle that allows a kind of errant adherence and even makes possible, finally, an adamant opting out unto silence, a meta- (or mega-)exilic departure.[35]

In his analysis of the rhythmic correspondences and differences between calypso and soca, calypso's North American and Indian rhythm–influenced offspring, Dudley uses "the term 'rhythmic feel,' instead of 'beat,' because it is more suggestive of the possibility that many rhythms can combine to produce a distinctive musical sensation." Moreover, in an attempt to "explain the *interactive rhythmic feel* of calypso" not as "a key rhythm around which the music is constructed" but, rather, as "*the consistent musical logic and composite aesthetic effect of many parts which interact together rhythmically*," Dudley moves toward a description of something on the order of a public sphere or workers' circle.[36] The precision of Dudley's description can be traced back to what he characterizes as "early scholars' erroneous perceptions of African music": "Erich von Hornbostel, for example, was puzzled by the absence of a regular pulse in the recordings he listened to and theorized that such a pulse must be expressed not in sound but in the motion of the drummer raising his hand to strike. A. M. Jones drew a new measure line in his transcriptions of *Ewe* music every time there was an accented beat, with the result that various parts of the same ensemble were portrayed as having different, and very irregular meters."[37]

Is the fantasy of the arm-raising event a kind of mirror image of Furtwängler's absent—or, at least, furtive—downbeat, its replacement by the soft, circular frenzy of divided and dividing starts (and fits), the different and irregular temporalities that are the essence of (the) ensemble as Furtwängler knew and Rapaport reiterates (as the restrained but transformative elongations of Gould's second recording of the *Goldberg Variations* demonstrate)?[38] But how did the perception of the absence of a regular pulse in African music become the perception of that same pulse's often overwhelming presence in a certain discourse on Afro-American music that is shared by many musicians and critics ranging from Mingus to Adorno? Meanwhile, though Dudley argues that more careful observation of and instruction in African musical practices revealed that "the Western concept of meter—a commonly perceived, fixed number of equidistant 'main beats,' with a first and last beat, that correspond to a musical period—is not foreign to African music," he is also careful to point out that "the traditional western time-signature" is an incomplete representation of African meter:

What the time-signature description of meter lacks is a way to differentiate between the many patterns of accent that are possible in a musical period. Western listeners and musicians often assume that the metric pulse will be audibly articulated and that certain pulses will be consistently centered—for example, the first quarter note in 3/4 time, the first and third quarter notes in 4/4 time, or the first and eighth notes in 6/8 time. However, Mieczyslaw Kolinski points out that that way of thinking caused Jones to misinterpret *Ewe* music, and he reminds us that even in Western music one finds both "cometric and contrametric patterns" of accent. He asserts that "the interplay between these two types of organization represents an essential aspect of metro-rhythmic structure." Kosinski's distinction acknowledges that consistently recurring accents can be used for more than just indicating the downbeat and weak and strong pulses of the meter. In fact, in much African music the main beats, although they are conceived of (and often articulated in the dancers' steps), are not audibly accented. Simha Arom refers to this phenomenon as "*abstraction de mesure et du temps fort.*" The distinctions made by Kolinski (cometric versus contrametric accents) and Arom (abstract versus audible meter) help explain how African music is understood by Africans to be characterized by regular groupings of a steady pulse, even though that pulse is not always audible.[39]

Dudley continues:

Robert Kauffman sums up the African perception simply and concisely when he says that "Shona musicians . . . use the more dynamically tactile term 'feeling,' to express what Western musicians more abstractly call 'meter.'" Of course, in European music there is clearly more variety of rhythmic feel than what is recognized by the concepts of 4/4, 3/4, 6/8, and so on. It is just that Western *concepts* of meter have generally overlooked this, focusing on the number of pulses, the subdivision, and the downbeat. To illustrate this conceptual deficiency with an example, saying a piece is "in 3/4 meter" would tell much less about its musical character than describing the piece as having "a waltz feel."[40]

Hence, the beauty and importance of Furtwängler: his quickening disruptions and curved multiplications of downbeat are improvised performances against a certain conceptual poverty producing new techniques of

feeling. As Rapaport suggests, his conducting secures for Western concert music that distinction between time signature and accent, and the interplay of temporal and phonic difference within accent, that is of great importance to Mingus and constitutes, on the one hand, what is essential to his understanding of "rotary perception" and, on the other hand, what he seems to refuse to hear in Coleman and calypso, namely, a refusal to hear the absence of a regulatory mode that he both abjures and desires. Mingus thinks that in the absence of a law of movement to break, calypso falls into the random constraint of a death spiral. However, Dudley shows how the maintenance of the circle's integrity requires the legal procedure of an articulated ensemble, what Olly Wilson calls a "fixed rhythmic group" whose "rhythmic feel is not produced by a single pattern . . . but is a composite generated by several instruments that play repeated interlocking parts."[41] No hegemonic single pattern means no sole instrument or player responsible for that pattern's upkeep. There is, rather, a shared responsibility that makes possible the shared possibilities of irresponsibility. More precisely, attuned and passionate response is given both in the capacity to walk and to walk away. While freeing the individual player—say, the bass player—within the fixed rhythmic group or rhythm section from the sole burden of keeping time does constitute a liberation from collective temporal constraint, such escape or animation of the bottom is, itself, an effect of law. That law is a law of (stasis in) motion and emotion, articulated in forced migration and (con) strained revolt, whose truth is uttered in hermetic falsities and falsettos, as the possession and dispossession of time.[42]

This law is a law of genre, or gender, as well. One of Mingus's (and Coleman's) greatest sidemen, Eric Dolphy, called his favorite of Mingus's instruments "The French Lady."[43] And both Duke Ellington and Kenny Clarke problematically assert that the "drum is a woman." The area that drum and bass lay down constitutes that womb-like, family circle of which Dumas speaks, foregrounding a certain maternal responsibility whose fixed circumference Mingus would, at the same time, rupture and redouble by invagination. He strains against a maternal responsibility that he can only abdicate by disruptively confirming. Joni Mitchell, another of Mingus's greatest collaborators, is like a man, Bob Dylan says, because she keeps her own time, is allowed to "tell you what time it is," and burns with that "untamed sense of control" he attributes to old-timey musician Roscoe Holcomb without commenting on the sexual ambiguity of Holcomb's complex, astronomical registers.[44] Such self-sufficient irresponsibility is the province of men. The

rhythm section, on the other hand, is matrical, a locus where metrical antagonisms are mediated, where the regulative and diplomatic force of the mother is always tempered by her criminally empathic breaking of the law she lays down, by her inhabitation of the space where performance and commodification meet. This is to say that this other hand is the independent and untimely same of the one hand; its rhythm is of a sliced section or session, that other time of the ones who keep the other's time if not their own, who let the others take their time, who place time within that impulsive strife of dis/possession that we call music, that breakdown or brokedown opposition located at and as if an irruption of sound recorded by something like an accent meter.[45]

Bearing the constitutive force of catastrophic oppositional failure, Mingus's formulations are an edifice built on the ruins of a legal discourse and legal process, the impossible law and endlessly disrupted trial of the general economy of black maternity. What might be the sexual force of such nurturing? Mingus plays like a (play) mother; she keeps walking, walking away: they touch and go like adjacent variations out of one another's time but bridged by an imperceptibly reminiscent tempo; like the mercantile maternal machinery of a money jungle; like the broken stroll of The ([interactive rhythmic] Feel) Trio; like *The Awakening* into a band. But "these are men!" says William Carlos Williams.[46] Supposedly self-possessive, they're supposed to keep themselves and/in their time. They don't lose time, like the syncopic ones, the ones for whom "swing is '(high lonesome) sound'" reconfiguring synoptic view, the dis/possessors.[47] Imagine the always paradoxical sovereign subject, contemplative in his cell, tortured by the unkept, unkempt time of a musician who is, as it were, outside. The listener loses himself and is unmanned. The listener, speaking aloud, can no longer hear, or bear, himself. This is the contretemps of the soliloquy: having lost myself, subject now to another's time, I speak to myself before you, imploring me to find me. Against the grain of the soloist's proud time, the bass and drum lose the time they keep, holding it right there where they almost lose their way, not doin' no soloin', as The Godfather of Soul demands, 'cause it's a mother (who is impossible, who walks away, ain't it funny how time slips away, "slides away from the proposed," steals away, as life?).[48] So what remains to be considered is something on the order of an extralegal process, a metrical assertion against the law that still exercises an uninstantiable matrical (ir)responsibility that is always before us, moving, still, visible, illusory, like a dot in the middle of your hand, like the drive of a French lady, a black woman, an impossible black mother, in a crawlspace,

a bar, marked by a barricade or a barrier, a club. In the irreducible permeability of the Sound Barrier Club, where things are "cramped and capacious," things are driven.

It is this drive that determines what Dudley calls that particular "relationship between the fixed rhythm and the vocal part or instrumental melodies and improvisations—what Wilson refers to as the 'variable rhythmic group'"—that is characteristic of calypso.[49] Dudley argues that the calypsonian sets off the interaction of fixity and variation by anticipating and delaying the accents of the rhythmic pattern. But Dudley encounters a certain amount of trouble in characterizing that pattern which presents itself with differences often enough to defy the name. This is to say that the singer—the political soliloquist, the (unmanned) man of words—performs variations on a fixity that is always already in trouble. Interestingly, as Dudley points out by way of the work of Rohlehr, in part because of the influence of jazz, many early calypso recordings "used instrumental accompaniment that was rhythmically inappropriate to calypso singing style."[50] This irruption of a certain African American impropriety into the idiomatic specificity of Trinidadian calypso's fixed rhythmic group only redoubles the sense that the constant disruption of the proper is the condition of possibility of rhythmic feel in general. Many calypsonians from Lord Invader to David Rudder sing of "the American social invasion," on top of the American rhythmic invasion, which is, it turns out, just another singularity from within a diasporic time that is constituted by the geopolitical disturbances of invasion and im/migration that it is most properly understood as constituting.[51]

This spatial politics of the ruptured groove, of the broken circle, corresponds to those "rhythmic nuances of the calypso singer" which are born of an originary and formal impropriety.[52] In this sense, what musicologist Charles Keil calls "participatory discrepancies" might be best understood as transcendental clues leading to a more accurate sense of idiom as a range of anoriginal differences. In turn, the groove might be best understood as a circle of such differences in which the players might be "in synch but in and out of phase," as Keil puts it; where the music comes fully into its own as something other than itself.[53] Rapaport, Barenboim, and Said all get into the groove of Furtwängler's Beethoven. In a way that is the same, and radically different, "rotary perception" is swing's "originary displacement" (to use Nahum Dimitri Chandler's phrase), swing's Afro-American/Afro-Caribbean/Afro-Eurasian eclipse.[54] Swing is, in other words, an international incident; the groove is not the groove; jazz is not what it is and as it is it is it is. The music instantiates

the broken circle, the brokedown (public) sphere, the indecipherably break-
ing cipher, of black international fantasy.

Consider the grooved, fantastic circle and its (spatial) politics as some-
thing along the lines of what Mary Pat Brady, in an echo of Cherrie Moraga,
calls a "temporal geography."[55] Brady's criticism is indispensable to a proper
understanding of Mingus's border work, his linking of musical influence
with a mode of sexual tourism not unlike that which he decries when it takes
place on the Central Avenue of his heyday. That criticism is animated by
a critical awareness of the way the border marks and helps to instantiate
and perpetuate a collaborative process of imperial expansion that Edward
Spicer calls "cycles of conquest," the imperial and counterimperial strife that
is both between the United States and Mexico and within them in their own
shifting scales and contours, strife that long predates 1848 and the signing
of the Treaty of Guadalupe Hidalgo and that continues to trouble the forced
stabilities that larcenous pact was supposed to ensure.[56] To be aware of this
history and truly attuned to its challenges—even as one acknowledges the
gross asymmetries of this border strife; even if one is primarily and legiti-
mately driven by a critical and political desire to resist the current hegemonic
force of all kinds of U.S. imperial desires in their necessary articulation with
what Brady astutely describes as erotic-imperial paranoia—raises certain
overwhelming questions for the study of Mingus and of jazz. Can a politics,
aesthetics, and erotics of liberation be forged from the ongoing construction
of an identity that is based, on the one hand, in displacement and the re-
sistance to displacement, and, on the other hand, in imperial conquest and
exploitation and the establishment of bourgeois personhood, however in-
flected by bohemian style? Must revolutionary subjectivity also be geomet-
ric, geographical subjectivity? If it must, how will it successfully detach itself
from empire's spatial obsessions? How are the complex disarticulations and
rearticulations of space and subjectivity productive of theoretical insight and
political possibility?

Brady addresses these questions that are, in her work, partially animated by
the fact that (1) *mestizaje* (and its partner, in an uneasy and complex relation-
ship, *indigenismo*)—as scholars such as Herman Bennett, Martha Menchaca,
and Maria Josefina Saldaña-Portillo have shown—was a fundamental part of
the Mexican colonial and imperial projects even as it now has been made to
operate within the framework and in the service of profound anti-imperial and
anticolonial desire; (2) discourses of the border—across a vast range of his-
torical articulations—constitute something like a spatialization of mestizaje;

(3) the traversing and transversing of the shifting, bridge-like (non-)terrain between the United States and Mexico—or the more literal (in that they are more extensive in their metaphorical force) spaces between Aztlán and the Valle de Mexico or Pacific Palisades and Watts—is that spatialization raised to the level of somatic and discursive critical method.[57] Brady is interested in claiming that method for insurgent political and intellectual practice, and her work offers a rigorous exemplification of that method—the deconstruction of a state-sanctioned imperial mestizaje meant to work in the service of political homogeneity and colonial indigenismo that violently imposes itself against the fugitive political force of nomads like the Apaches; the mobilizing reconstruction of the rich differentiations of the mix; and the critical deployment and displacement of origin (or something, again, like "originary displacement"). This movement—the most salient particularity of Brady's critical discourse of the border, in particular, and space, in general—is of extreme value to African American expressive cultural criticism. A profound discourse of the cut(, the groove and of their corollaries, the bridge and the circle) animates that strain of the African American tradition that Cedric Robinson calls black radicalism.[58] Something akin to a continuing excavation of the Mexican *afromestiza*—whose erasure is always attenuated by the insistent and irrepressible trace of her constitutive, migratory force (to which Bennett, Menchaca, and Kevin Mulroy attest) for black radicalism in particular and radicalism in general—is a project to whose theoretical foundations Brady makes a great contribution.[59] Mingus's music also contributes to that project though work like Brady's is required in order to listen to Mingus against his grain so that his contribution can be heard. Such work makes it possible to imagine—indeed, demands the imagination of—the border and the cut, more properly, as interinanimate, so that blackness is understood as an irreducible mestizaje (the mix as its condition, not its negation) whose inhabitation is a nomadic bridge; and as the internal differentiation and external transversality of what Robinson calls "the ontological totality."[60] Brady's work is something like a cornerstone of the span that would connect, say, Brent Hayes Edwards's analysis of "the practice of [African] diaspora" with Rafael Pérez-Torres's reading of "the refiguring"—and/or Genaro Padillo's reading of "the uses"—of Aztlán.[61] The articulation of Aztlán and the African diaspora, amplified and distorted originarily by originarily distorted Euro-American (and, for that matter, Asian American) voices and forces, sounds like Mingus and forges, however fleetingly, what Matt Garcia might call "a world of its own." Mingus's disavowal of the Caribbean can't be properly un-

derstood without taking into account the vexed productivity of his musico-sexual "romance" with a Mexico that will always have been both more and less than itself.

It is no mere coincidence that the erotic-imperial paranoia that marks the United States' and Mingus's relation to Mexico can also be said to character-ize U.S. relations to Trinidad. The incursion of U.S. power into colonial Trin-idad's geographic, social, and psychic space turns out to have been the vexed field in which a certain Afro-diasporic international contact was played out. That contact, at least in part, took forms such as this:

> Around 9 P.M. on Friday, April 16, 1943, a storm of sticks, bottles, and stones sent residents of Basilon Street, Laventille, scurrying under their beds. The source of the missiles, neighborhood folks would soon find out, was a group new to the community and, indeed, new to colo-nial Trinidad: African American soldiers. Helmeted and bare-chested in some cases, and bearing weapons in nearly all, the black men who belonged to the 99th Anti-Aircraft Regiment of the U.S. Army had set out on a seek-and-destroy mission in one of Port of Spain's most infa-mous slums. The objects of their pursuit were the community's self-proclaimed "robust men," young, predominantly Afro-Trinidadian males whose unabashed hostility and alleged hooliganism scandal-ized "respectable society" in the British colony. How many "robust men" the marauding members of the 99th found remains uncertain. What is clear is that during the course of the night, these soldiers wrought serious property damage and assaulted scores of neighbor-hood men. In their wake, black Americans left broken windows and dented walls, and, by the end of what outraged municipal representa-tives condemned as a "wave of homicidal fury," twenty-four local men, including four special reserve police officers, had to be hospitalized.[62]

Harvey Neptune shows how a marauding band of African American sol-diers, perhaps in response to threats and acts against their safety and that of some of their local female companions, sought out and attacked some of Trinidad's "robust men." The "robust men"—angered not so much by the loss of "their" women to the seductive powers of Yankee soldiers and their "Yan-kee dollar" but, more precisely, by the troubled decisions through which local women asserted an attenuated sexual autonomy in the face of local mascu-line control—acted out a specific ambivalence toward black American sol-diers and local Afro-Trinidadian women to which those soldiers responded

in ways that were also deeply ambivalent, ways that both reflected and re-fracted the American schizo-imperial imperative to liberate by destroying.[63] On the one hand, according to Neptune, Trinidadians and other Caribbean peoples who immigrated to the United States viewed black Americans as the highly constrained victims of a particular and extremely violent and debilitat-ing mode of racism to which they had not been subjected; on the other hand, Neptune argues, Afro-Trinidadians were impressed by the militant resistance to racism among black U.S. soldiers—manifest in the many clashes between black and white soldiers that local blacks witnessed (with pleasure when the black soldiers came out on top)—even though those soldiers were operating in their work and in their leisure by way of the force of massive neoimperial state power directed against and within Trinidad. Indeed, that power was solicited and welcomed by British colonial administrators precisely because it might also serve to suppress the political mobilization of the island's emer-gent nonwhite working class.

Neptune allows us to understand, then, that the presence of black soldiers from the United States produced oppressive and liberatory effects, both of which were both embraced and rejected by Afro-Trinidadian national mas-culinity. Afro-Trinidadians laid claim to certain protocols and performative styles of African American masculinity that could be deployed in challenging the slightly more subtle forms of white supremacy that served as the founda-tion for the colonial order. But when the performances of African American masculinity—augmented by the privileges of American military power and the force of the Yankee dollar—were directed toward Afro-Trinidadian women, now constituted as objects of liberation and mastery (which is to say desire), Afro-Trinidadian men also laid claim to styles, protocols, and rhetorics that would bespeak a national identity distinct from (American) blackness.

The possibilities of diasporic contact and solidarity were always struc-tured, then, by a complex system of intramural and extramural antagonistic hierarchies, a condition that has now only become more pronounced and more articulated. Neptune's work leads him toward the question of whether the black soldiers who spread around the "Yankee dollar" induced—or, more precisely, aggravated—that special kind of proprietary, homosocial, national misogyny that can be associated with, say, the German racist hysteria over the occupation of the Rheinland by Afro-diasporic soldiers in the Allied forces after World War I and the birth of the mixed-race *Rheinlandbas-tarde*, or with the complex exchange of resentments between northern and southern black Americans, soldiers and nonsoldiers, in communities adja-

cent to U.S. military bases that Amiri Baraka's novel *The System of Dante's Hell* represents in the chapter "The Heretics."[64] One point, of course, is that chauvinism is neither the exclusive domain of the U.S. component of the diaspora nor absent in the internal relations of that component. The other point is that what can be dismissed too easily under the rubric of chauvinism is determined by the striated resistance to a complex of invasions and expansions. A complicated kind of interinanimative trouble is marked by the rough historical coincidence of Lord Invader's musical anticipation and rearticulation of the Laventille uprising (both of which are enabled by the very invasive militance—something on the order of a pre-occupation of rhythm and romance—against which they were directed) and Furtwängler's dissident and dissonant inhabitation of the German musical tradition against those who would claim that tradition (and the unfettered right to expansion that the tradition is supposed to ground) by way of the very ritualized performance that his downbeat's broken, circular script initiates and disturbs. At the same time, both in spite of and because of this kind of trouble, the intranational and transnational nature of anticolonial, antiracist struggle is made much more clear, leaving us with much to emulate and correct and many questions to ask.

One such question is this: What identificatory claim is Lord Invader making in the chorus of "Crisis in Arkansas"?

Please take off that black bow tie—lay-oh!
And that black tuxedo,
You callin' us names, yet you wearin' black,
Please take off everything black off your back.[65]

Consider that Lord Invader invokes blackness by way of his rhythmic and phonic play on the color black. Mingus's reference to blackness is, as it were, implied. However, Lord Invader's multisyllabic irruption of accentual-metrical difference breaks and makes new musical (rhythmic/syntactic) law in a way that Mingus would valorize. Consider also that Lord Invader moves strenuously toward another arrangement of the social law as well, in his critique of U.S. domestic racial policy. In his lyrics he asserts his opposition to Faubus and, more generally, to a reactionary apparatus whose ethical and juridical dispositions were symbolized by U.S. President Dwight D. Eisenhower's tardy response to the illegal obstruction of the students' entrance into Little Rock Central High. Mingus was, at first, prevented from any such verbal assertion of any such political opposition; Columbia Records

suppressed his lyrics for "Fables of Faubus." It was not until a year later, when he (re-)recorded the "Original Faubus Fables" for Candid Records, that his protest could be heard uncut.[66] But even Mingus's rerecording never approaches the canted but explicitly identificatory claim on blackness—which simultaneously constitutes the repeating ground and anarchic disruption of the song's universalizing claims—that animates "Crisis in Arkansas." One could argue, furthermore, that the complexity of the variable rhythmic group in "Crisis in Arkansas"—led by a vocal performance whose accentual richness is the dissonant effect and affect of lyrical political dissidence—is the aim of Mingus's agonistic approach to "fixed" rhythmic performance as well. Lord Invader packs syllables into every measure with a precision that manifests one moment as abundance, the next moment as economy, an interinanimation of more and less that bespeaks musical and political fugitivity. The (sound of the) oppositional emergence that both prompts and responds to the ongoing state of racial emergency is always non-full, always non-simple, always on the run and not (fully or simply) on the one.

Amiri Baraka and Samuel R. Delany have both explored what might be called the political feelings that attend an escape that is somehow both from and within the musical bar line. In "Time Considered as a Helix of Semi-Precious Stones," Delany aligns such fugitivity with the specific political insurgence of singers who move between worlds on the tracks of an underground migratory circuit, while Baraka, particularly and repeatedly in *Black Music*, pays special attention to the way Coleman exemplifies the irruptive musical liberator's challenge to time and tune.[67] Lord Invader's escape is manifest, however, as a kind of overactive cometric and contrametric inhabitation to whose strict criminality—for instance, the intensified negation and irruptive rhythmic feel of the two equally necessary instances of "off" in the chorus of "Crisis"—Mingus aspires, redoubling it to ever more anarchic effect in "Fables":

> Oh Lord! Don't let them hang us.
> Oh Lord! Don't let them shoot us.
> Oh Lord! Don't let them tar and feather us.[68]

Such out-of-time resistance to—such scarring of—scansion is laid down with the open deliberateness of a secret agent and with such an agent's demolitionist and abolitionist intent against the very instruments and locale of (mean) time. But Mingus's disruption of regular meter can also be understood as bearing the trace of subjugation to both commercial and aesthetic regulation. One form that commercial regulation took was the U.S. record-

ing industry's attempt to circulate, and to determine the popular reception of, calypso as an imagined alternative to the political energy animating World War II black American music. However, Lord Invader's music reveals the deep political affinity at the very heart of the imagined alternative. Mingus and Lord Invader share a political aesthetic that seeks to deploy strenuous rhythmic and lyrical resistance to and within self-imposed regulatory forms in order to facilitate flight from externally imposed regulation. Such flight is the ongoing performance of a shared diasporic legacy that is always articulated in close proximity to intradiasporic conflict. African American musicians' persistent denigration and distancing of Caribbean rhythms and sonorities and the deployment of those same elements in the service of Caribbean disavowals of an African American identity that is conceived as both dominant and abject, intimate a complex, many-sided whole.

The lines of stress and lines of flight that animate the Afro-diasporic set, the Afro-diasporic gathering, compose a terrible richness. Why must Mingus's neoabolitionist drive, or the King of Ghanaian highlife E. T. Mensah's pan-Africanist musical and political impetus take the form and/or lyrical content of calypso? Why is radical political desire all throughout the diaspora so often manifest as ever more complex reconstructions and deconstructions, recoveries and concealments, of sonorities, rhythms, and sensibilities derived from a home that seems to withdraw from every return? Why does Fela Kuti's insistent assertion of African idiomatic specificity against the neocolonial force of state-sanctioned corruption and violence move with the complex in/direction of a Bootsy Collins bass line? What are the conditions of possibility and maintenance of a kind of permanent and unassimilable dissidence and dissonance, and why is it that such a formation seems destined to find its fullest articulation not only against but by way of forms and resistant deformations that seem to confirm African American cultural hegemony in the diaspora? How do we account for the popularity of the aesthetic and political force of this permanent dissidence when it emerges from the United States? Has this specific dissonance, which is both national and antinational, which was born in ongoing modes of accumulative exclusion that are unique in their severity and bred in what had been and continues to be a radical detachment from power, attained hegemony not only by way of the circulatory system of an unprecedented cultural imperialism, but also because it continues to bear the trace of a radical, anticipatory opposition to state power that constitutes the fundamental element of an identity?

What's at stake here is the question of comportment toward the irreducible and constitutive specificity of a blackness that always manifests itself against the black-*Americanism* that it manifests itself as. The abstract and imagined space of internationalism, transnationalism, or the eternally congealed and disappearing object/s of hybridity, with all the appeal of every other general equivalent, are not the same as a federation of disrupted locales. However, though it is tempting to say that internationalism or diasporism have become teleological principles run amok—false and empty universalities whose excesses align them with imperial, neoliberal capitalism as an ideal and as a set of commodities—such a claim would not justify some easy disavowal of the international, the diaspora, or, for that matter, the universal or the teleological. An irreducible utopics of The International is still to be desired, against all positivisms, against any vulgar reduction to the empirical encounter however post- or anti-imperial that encounter might be or appear to be, even if no one can locate it anywhere other than in its disrupted and disruptive locales. Meanwhile, the disrupted and disruptive locale recedes and exceeds; aggressive, improvisational assertions of a certain teleological principle bring this into relief so that New York or Port of Spain or Lagos are understood as that which The International and its feelings make possible. At the same time, locale disrupts any crystallization of teleological principle: The International is in that it is in the local—the only and infinite possible space (effect of an irreducible deictic bond or bind) for that impossible place, the Internation. The International markets itself in the very disrupted locale that is disruptive of The International; landscapes and markets, mountains and things, make accents and (time) signatures. And it's not difficult to point out complexities, crossings, and antagonisms—the point is what to make of them—just as it's not enough to say this or that is an instance of internationalism. So that if this or that particular instance is understood as an irruption of internationalism, this is interesting only in that it self-*destruktively* raises the question: What is The International? It is a question that is inseparable from a couple of others: What is blackness? What is black Americanness?

The irreducible and constitutive specificity of blackness-as-black Americanness; the irreducibly vexed specificities of blackness in Afro-diasporic internationalism or in what is valorized or hoped for in the new comparativism: both are at issue here. Violence to these specificities, done in the name of black American exceptionalism, intradiasporic hegemony, the black-white binary, or their most viciously legitimate critique ought to be resisted. This is all just to say that it should still be permissible to study the disrupted

and disruptive locales/objects of blackness-in-black Americanness, which is what I think I'm doing when I listen to the John Donne/David Rudder/ Mary Pat Brady Trio. Moreover, such study is not only permissible but also imperative because it makes possible some more rigorous address of the real question, namely that of the (constitutive force of blackness in the anti- and ante-American, musico-democratic assertion of The Black American) International. This question—which concerns what Akira Mizuta Lippit might call the open history of the (objection to) "inalienable wrong"—might also complicate legitimate critical and theoretical disavowals of "states of injury" and their relation to the putative degradation of left politics or to the inability of left politics to think and enact new political dispositions.[69] Perhaps identities forged in severe injury might have something to do with a kind of persistent resistance to (states of) power and to taking power that not only will have clearly borne a deep attraction to those who remain excluded from power, especially when others have taken power in their names (i.e., the general constitution of what is called the postcolonial), but also will have served well the task of forming the genuinely new comportment, the out-from-the-outside thing, that is the aim and object of musical and political fantasy. Such fantasy constitutes and is constituted by rigorous analysis of the relation between blackness and the politics and aesthetics of a certain claim on dispossession that will have animated the range of musical homelessness with which I have here been concerned. This dispossession, this refusal, this objection—in all of its spatiotemporal complexity, in the full range of its irregularities, in the objects and events of the vast range of sharp locations that link and differentiate Mingus and Lord Invader—is intact as sung, strained, scripted, articulation; as a choreography dedicated to the criminal movement of hips; as the free, rhythmic, de-centering preservation of structure. (Ornette Coleman called it "The Circle with a Hole in the Middle." When Mingus covered it, in spite of Coleman and himself, it called to him, was revealed to him, was performed by him, as "The Circle with a [W]hole in the Middle.) It is, therefore, productive of new singularities (which is to say new ensembles). Blackness is the production, collection, and anarrangement of new singularities (which is to say new ensembles). Diaspora is an archive (gathering, set) of new things productive of new things (which is to say new ensembles).[70] The Charles Mingus/Lord Invader/Wilhelm Furtwängler Ensemble plays the radical spatial politics of the broken circle, the radical temporal politics of the broken groove. It's the New International of Rhythmic Feel/ings.

The Phonographic Mise-En-Scène

1.

For Theodor Adorno, the graphic reproduction of operatic performance means that the primary scene of audition has shifted: from the theater—and the telic determinations toward which the natural history of the theater tends—to the living room, where people gather to listen to what they no longer concern themselves to perform. The phonograph allows the vagaries and vulgarities of the visuality of (operatic) performance to be held off or back by an auditory experience whose condition of possibility and whose end is the illusory recovery of something literary—and thus essentially visual. What remains is to begin an attempt to see and hear what might be gained by moving through the opposition of the denigration of the recording in the discourse of performance and the denigration of performance in the discourse of classical musicology. This attempt is made by way of the 1993 recording of Arnold Schoenberg's monodrama *Erwartung*, starring Jessye Norman as the opera's single character, *Die Frau*, with the Metropolitan Opera Orchestra under the baton of James Levine.[1] It is an attempt that has required reading with and against Adorno—which is to say listening to and for the sound that works in and against him.

It would be difficult to overstate the importance of writing for Adorno, who understands the graphic as an interinanimation of drive and affect essential to aesthetic experience, whether it be film (wherein montagic constellation approaches writing) or music (whose authenticity is established in a mode of audition that simulates composition, thereby sanctioning a practically literary displacement of the musical performance in favor of the musical work). Nevertheless, as essential as writing is to Adorno's idea of the aesthetic, as central as music is to that idea, phonography presents a

problem for Adorno to the extent that the complex scene of writing/reading/rewriting that emerges in the interplay of audition and composition is mediated, if not re-staged, by means of mechanical reproduction, even if such mechanical reproduction might at some point make more feasible a form of structural listening that will have reestablished composition's priority by sharpening the constitutive fantasy of composition's originary moment.[2]

This is all to say that Adorno is critically aware of the tangled interaction of writing and reproduction and its production of another, more fundamental, double bind. On the one hand, the reproductivity of writing confirms the central distinction between technique and technology upon which stands whatever singularity is embedded in the internal structure of the work even as it marks another distinction between original and copy. At the same time, writing is perceived as that which delays or defers any immediate reference of the copy to the original, an immediacy upon which, say, film depends unless it adheres to a grapho-montagic structure that is at once essential to and immanently critical of cinema.

To defer the immediacy, to disrupt the representation, of the object: this, for Adorno, is the true essence of film, of music, of art. Or, to put it in another way: art must shift its representative function away from the object and toward subjective experience. For the cinema, subjective experience is given, as it were, in montage; and to the extent that dissonance is most properly understood as deferral, as a disruption of immediacy-as-resolution; and to the extent that abstraction is, too, the holding off, as it were, of any simple and immediate experience of the object and of its story; and to the extent that this deferral or disruption or, just as well, this indeterminate extension of expectation can be understood as a kind of rupturally rhythmic, asynchronous suspension better known as syncopation, then we can understand the central importance for modernity, its aesthetics, and its politics of the ensemble of montage, dissonance, abstraction, and syncopation that animate the phonographic mise-en-scène.

The hybridities of the circus and of burlesque, which Adorno dismisses due to what he terms their "venerable roughness and idiocy" in one of his "Transparencies on Film," are best understood as the interstitial sloughs wherein the autonomous arts each in their specific singularity falter.[3] These locales of inarticulacy, spaces marked only in and as the warping, broken, and breaking articulation of objects, only in and as the site where one comes upon or encounters the object, are also the hybrid *modes* of what Michael Fried disparagingly characterizes—in its mid-twentieth-century manifestations in

the plastic arts—as theater.[4] These hybridities are the structured and structuring origins of hybridities; they are the district, the bottom, the side, the (cut) Cuba Addition, the terry, the plain as well as the "process of dilution and bastardization" where misalliances of all paresthetic and un/natural (or radically natural) kinds come or come up or are come upon.[5]

Adorno valorizes montage as writing, the sensuous theorization of the interval, while denying, even as he acknowledges the undeniability of, whatever emerges—precisely as theoretical sensuousness—from a certain lingering in, or from whoever object lingers in, the interval. Whoever this object is is not just what she is—the apparatus, the *dispositif*, her invented and philosophical sensing is the anorigin of our modernity. In the particular instance that interests me right now—one which cannot be seen not to operate at and in the audiovisual convergence of musical composition, phonography, the animaterial and animetaphoric trace of cinema and the fantastic *Gesamtkunstwerk(lichkeit)* of opera—the object's name is Jessye Norman, born and raised in, erupted out of, the respectably asymptotic outside of the terr(itor)y of Augusta, Georgia.[6] Meanwhile, the intervallic breaking of the flow is the flow's condition of possibility and this, of course, is both good and bad. In the end, we are interested in the objection to (that is also the constitutive objection of and in) the story—the mellifluous off inside the drama; the montagic, dissonant, syncopated abstract; the criminal disruption of narrative; the grapho-reproductive improvisation of narrative; the black performance of narrative; the irreducible trace of (slave) narrative. The dramatic quarters of narrative is where we're lingering now in this, in our, modernity. The portable dark continent, not even all that far back in the woods.

2.

Access to the seeming remoteness of such seemingly wild space is made more possible by recognizing that, for Adorno, the graphic reproduction of operatic performance means that the primary scene of audition has shifted as well: from the theater—and the telic determinations toward which the natural history of the theater tends—to the living room, where people gather to listen to what they no longer concern themselves to perform, where the reproduction of performance is brought to give notice to what the new technologies of reproduction make performance no longer able to reproduce, where the stereo (and the television and all their digital accoutrements)—now even more than in Adorno's time—eclipses the piano as the piece of furniture

most iconic of bourgeois domesticity and accomplishment, where "through the curves of the needle on the phonograph record music approached decisively its true character as writing."[7] Thus the phonographic mise-en-scène, because of and despite the structuring degradations of the culture industry, is revealed to be the most authentic site of a mode of "structural listening" that approaches reading, one where development (or its deferral or disavowal) and the closed totality of the work become the objects of a kind of ocular-linguistic musical perception in which music's textual essence comes to light. As Rose Rosengard Subotnik puts it, this kind of structural listening "makes more use of the eyes than of the ears," though, for Adorno, the scene of phonographic audition comes to constitute something like a prophylactic against the degradation or waste of musical substance that is always given as a danger of the ideological spectacle of operatic staging as well as the irreducible materiality of sound, of the musical moment.[8]

Adorno's valorization of the auditory phonographic relation to the literary experience of the score displaces the effects and affects of sensuous visuality that had seemed an inescapable by-product of musical performance in general and operatic performance in particular. This is to say that the condition of possibility of the revalorization of sound is that its new phonographic medium makes possible—by way of its erasure of itself as medium or as the medium of a medium, the vehicle of sound; and by way of the repetitive listening which it allows—a more proximate relation of the experience of music to its essence as writing. Sound comes back but only by way of its graphic overwriting, underwriting, *Ur*-writing. The phonograph enables the illusory recovery of an architrace. At the same time, the vagaries and vulgarities of the visual are held off or back by a phonography whose condition of possibility and whose end is the illusory recovery of the essentially literary—and thus essentially visual—experience. That experience—literate or "structural listening"—is imagining composition: the listener's impossible inhabitation of the imagination of the composer in order to discern those structural intentions upon which the interinanimation of individual and universal autonomy is supposed to rest.

What remains is to begin an attempt to see and hear what might be gained by moving through the opposition of the denigration of the recording in the discourse of performance and the denigration of performance in the discourse of "classical" musicology. So I've been preparing myself for Norman's and Levine's recording. That preparation has meant reading with and against Adorno—which is to say listening to and for the sound that works in and against him.

3.

Schoenberg calls *Erwartung* the representation "in *slow motion* [of] everything that occurs during a single second of maximum spiritual excitement, stretching it out to half an hour."[9] Adorno describes the work in this way:

> The monodrama *Erwartung* has as its heroine a woman looking for her lover at night. She is subjected to all the terrors of darkness and in the end comes upon his murdered corpse. She is consigned to music in the very same way as a patient is to analysis. The admission of hatred and desire, jealousy and forgiveness, and—beyond all this—the entire symbolism of the unconscious is wrung from her; it is only in the moment that the heroine becomes insane that the music recalls its right to utter a consoling protest. The seismographic registration of traumatic shock becomes, at the same time, the structural law of the music. It forbids continuity and development. Musical language is polarized according to its extremes: towards gestures of shock resembling bodily convulsions on the one hand, and on the other towards a crystalline standstill of a human being whom anxiety causes to freeze in her tracks.[10]

I'm interested in the convergence of music and writing, duration and discontinuity, at the scene of literate audition and will attempt to justify and properly pose the following questions: Can we locate the body or, more generally and precisely, fleshly materiality, at the scene where performance, recording, and audition converge? What's the relationship between phonography and bodily inscription? How do the corporeal, visual, and tactile markers of racial and sexual difference shape the phonographic mise-en-scène?

If the seismographic register that is *Erwartung* comes fully into its own not on stage but only in the fully equipped living room, undetermined by the pre-scriptive primitivity of embodied performance, it is liveness in and as its somatic manifestation that has caused this deferral. Therefore, for Adorno, it is imperative that the spectacular experience of the performing body be disrupted in a scene of auditory reading that stages the protection of the aesthetic and of subjectivity from the very sensual, ideological, and objective impurities of style, theatricality, and performance that make the aesthetic and subjectivity possible. In the case of *Erwartung*, the subject will have been protected by the breakdown of the subject's line. That paradoxically prophylactic rupture is sutured, as it were, by a phonographic structural lis-

tening "that, when successful," according to Subotnik, "gives the listener the sense of composing the piece as it actualizes itself in time."[11]

This solicitation of the temporal coherence of the subject of musical experience—that appears as the imagined composure of the composer—is the moral, so to speak, of *Erwartung*. The restoration of the subject will have been made possible by the subject's having been broken by waiting. If, as Susan McClary puts it, "tonality itself—with its process of instilling expectations and subsequently withholding promised fulfillment until climax—is the principal musical means during the period from 1600 to 1900 for arousing and channeling desire"; and if the subject stands in as an effect of the regulative channeling of aroused desire; then *Erwartung*, or expectation, can be understood as the knell of a new moment in musical history, the moment when disruptive atonality troubles the twin essences (development and a resolved, even resolutely coherent, totality) of the musical tradition and the mode of subjectivity that tradition helps to form and deform.[12] The discontinuity that goes with the interminable extension of the moment is nothing less than the rupture of development that is development's last resort, a rupture that phonography underscores.

4.

The evolution of Adorno's attitude toward phonography marks something like a path to the last resort. In his 1927 essay "The Curves of the Needle," Adorno writes:

> Talking machines and phonograph records seem to have suffered the same historical fate as that which once befell photographs: the transition from artisanal to industrial production transforms not only the technology of distribution but also that which is distributed. As the recordings become more perfect in terms of plasticity and volume, the subtlety of color and the authenticity of vocal sound declines as if the singer were being distanced more and more from the apparatus. The records, now fabricated out of a different mixture of materials, wear out faster than the old ones. The incidental noises, which have disappeared, nevertheless survive in the more shrill tone of the instruments and the singing. In a similar fashion, history drove out of photographs the shy relation to the speechless object that still reigned in daguerreotypes, replacing it with a photographic sovereignty

borrowed from lifeless psychological painting to which, furthermore, it remains inferior. Artisanal compensations for the substantive loss of quality are at odds with the real economic situation. In their early phases, these technologies had the power to penetrate rationally the reigning artistic practice. The moment one attempts to improve these early technologies through an emphasis on concrete fidelity, the exactness one has ascribed to them is exposed as an illusion by the very technology itself. The positive tendency of consolidated technology itself to present objects themselves in as unadorned a fashion as possible is, however, traversed by the ideological need of the ruling society, which demands subjective reconciliation with these objects—with the reproduced voice as such, for example. In the aesthetic form of technological reproduction, these objects no longer possess their traditional reality. The ambiguity of the results of forward-moving technology—which does not tolerate any constraint—confirms the ambiguity of the process of forward-moving rationality as such.[13]

This is a problematic that concerns narrative, where what is encoded as the interplay of photography and lifeless psychological painting is more properly understood as the audiovisual locus of stolen life. Moreover, the entire problematic of intolerance of constraint, in its positive and negative forms, is at stake here—power/capital's intolerance of constraint, the slave's intolerance of constraint. We'll see how this concerns the relation of *Erwartung* to the photographic silence of the servant girl (the apparatus's shy relation to the speechless object) even as it is also about the shrillness of her scream. This is about the convergence of new technology and speechless object, screaming servant girl, unreproducibly reproduced and reproductive singer, the pregnant, *mater*ial individual and her event. It is also about the criminalization of forward movement that is irrevocably bound to the scream, to chromatic-libidinal saturation, to the end that is, at once, infinitely deferred and hopelessly premature.

Meanwhile, in the 1934 essay "The Form of the Phonograph Record"—as he did seven years earlier in "The Curves of the Needle"—Adorno figures phonographic records as "herbaria" that provide the shrinking sounds (of a music whose performance is already understood as the somatically degraded copy of a scriptural original) with a kind of archival space, an audiovisualized display like some kind of auditory equivalent of the diorama.[14] Music falls into an analog of naturalistic oil painting, where a kind of scientism or

positivism lies inherent in the technical form. But even as Adorno decries the muting privatization that is forced upon music by the emergent technologies of the nineteenth-century bourgeois era, the necessarily mutational force of an essentially graphic form/medium arises for him as a positive value insofar as it makes possible a more genuinely literary musical experience. The strife between eye and ear bears complications and ambivalences that remain.

This struggle between two ways of valorizing the muting of music is paralleled by two ways of valorizing the emergence of music as a private experience. The complex relation between the private, the individual, and loneliness is unique and necessary to Adorno's way, despite the rich annoyance of his particular mode of provocation. A glancing, antipathetic engagement with pregnant stillness and profligate shrillness lets us get at the sexual dimensions of the ensemblic barrier to the last resort:

> The relevance of the talking machines is debatable. The spatially limited effect of every such apparatus makes it into a utensil of the private life that regulates the consumption of art in the nineteenth century. It is the bourgeois family that gathers around the gramophone in order to enjoy the music that it itself—as was already the case in the feudal household—is unable to perform. The fact that the public music of that time—or at least the arioso works of the first half of the nineteenth century—was absorbed into the record repertoire testifies to its private character, which had been masked by its social presentation. For the time being, Beethoven defies the gramophone. The diffuse and atmospheric comfort of the small but bright gramophone sound corresponds to the humming gaslight and is not entirely foreign to the whistling teakettle of bygone literature. The gramophone belongs to the pregnant stillness of individuals.[15]

> Male voices can be reproduced better than female voices. The female voice easily sounds shrill—but not because the gramophone is incapable of conveying high tones, as is demonstrated by its adequate reproduction of the flute. Rather, in order to become unfettered, the female voice requires the physical appearance of the body that carries it. But it is just this body that the gramophone eliminates, thereby giving every female voice a sound that is needy and incomplete. Only there where the body itself resonates, where the self to which the gramophone refers is identical with its sound, only there does the gramophone have its legitimate realm of validity: thus Caruso's uncontested dominance.

Wherever sound is separated from the body—as with instruments—or wherever it requires the body as a complement—as is the case with the female voice—gramophone reproduction becomes problematic.[16]

Here, the fact that the female voice is tainted by the bodily presence that it requires in turn taints the phonograph that requires the very body from which it promised to liberate us. Moreover, the degraded nature of the form is tied, as we have already seen and will see again, to its incipient visuality. And while phonographic records are "a virtual photograph of their owners, flattering photographs—ideologies," commodities that come to embody, in their portrayal of a pseudocultured ideal, something like the absence of individuality that characterizes its consumer, there remains, again, a kind of memorial hope that Adorno derives from the record—the dead phonographic object, in and despite its petrification, reification, commodification, and submission to the degradation of possession, is invested with a life that would otherwise vanish.[17]

In this sense, at this moment, Adorno begins to think more seriously the record as a kind of writing, as letters from the dead that mark the condition of possibility of an auditory augmentation of the musico-literary experience called structural listening. This is finally and fully elaborated, in light of the development of the technical apparatus's temporal capacities, in the 1969 essay "Opera and the Long-Playing Record" where Adorno writes: "The entire musical literature could now become available in quite-authentic form to listeners desirous of auditioning and studying such works at a time convenient to them."[18] The long-playing record "allows for the optimal presentation of music, enabling it to recapture some of the force and intensity that had been worn threadbare in the opera houses. Objectification, that is, a concentration on music as the true object of opera, may be linked to a perception that is comparable to reading, to the immersion in a text."[19] He adds:

> The ability to repeat long-playing records, as well as parts of them, fosters a familiarity which is hardly afforded by the ritual of performance. Such records allow themselves to be possessed just as previously one possessed art-prints. But there remains hardly any means other than possession, other than reification, through which one can get at anything unmediated in this world—and in art as well. . . . LPs provide the opportunity—more perfectly than the supposedly live performance— to recreate without disturbance the temporal dimension essential to operas.

. . . Similar to the fate that Proust ascribed to paintings in museums, those recordings awaken to a second life in the wondrous dialogue with the lonely and perceptive listeners, hibernating for purposes unknown.[20]

Indeed, hibernation, here, is quite obviously meant to facilitate a structural listening whose loneliness moves in some perfect correspondence with the loneliness of the composer, especially Schoenberg's loneliness, embodied perhaps most purely in *Erwartung*, in relation to which Adorno writes, in his 1948 *Philosophy of Modern Music*: "That the anxiety of the lonely becomes the law of aesthetic formal language, however, betrays something of the secret of that loneliness. The reproach against the individualism of art is so pathetically wretched simply because it overlooks the social nature of this individualism. 'Lonely discourse' reveals more about social tendencies than does communicative discourse. Schoenberg hit upon the social character of loneliness by developing this lonely discourse to its ultimate extreme."[21]

But why is this loneliness "of city dwellers totally unaware of one another" best understood from within the singularity of the phonographic mise-en-scène and out of the crowd of the concert hall?[22] Is there a new or another understanding of the sociality of loneliness embedded in certain qualities of the black voice that Adorno elsewhere dismisses? Does the troubled voice, the voice that is both more and less than complete, resocialize the iconic loneliness of the phonographic mise-en-scène, its auditory extension of composition and its suppression of spectacle, even as the trace of operatic staging irrupts forcefully into phonographic audition by way of the racial-visual language that is indispensable not only for a critical engagement with opera in particular and Western music in general but for any account—anecdotal, theoretical, empirical—of the social and, above all, psychological extremity of loneliness as well? This is a question to which I'd like to turn, precisely by way of the disruption that it implies.

5.

Such disruption—wherein the development and coherence of the (musical) subject is suspended within a fearfully crowded solitude—is one way both to describe and theorize what Schoenberg called "the emancipation of the dissonance."[23] Dissonance, as Charles Rosen understands it, implies neither "disagreeable noise" nor the necessity of two notes being played together. He writes:

There is nothing inherently unpleasant or nasty about a dissonance: insofar as any chord can be said to be beautiful outside of the context of a specific work of music, some of the most mellifluous are dissonances. They are even to most ears more attractive than consonances, although in one respect less satisfying: they cannot be used to end a piece or even a phrase (except, of course, if one wants to make an unusual effect of something incomplete, broken off in the middle). It is precisely this effect of ending, this cadential function, that defines a consonance. A dissonance is any musical sound that must be resolved, i.e., followed by a consonance: a consonance is a musical sound that needs no resolution, that can act as the final note, that rounds off a cadence. Which sounds are to be consonances is determined at a given historical moment by the prevailing musical style, and consonances have varied radically according to the musical system developed in each culture. . . . It is not, therefore, the human ear or nervous system that decides what is a dissonance. . . . A dissonance is defined by its role in the musical "language," as it makes possible the movement from tension to resolution which is at the heart of what may be generally called expressivity.[24]

Rosen argues that dissonance, precisely in its irreducible relation to the problematic of development, is fundamental to musical expression; Schoenberg and Adorno imply that such expressivity is, necessarily, written; and Subotnik shows that what allows for the disruptive and anticipatory force of music-as-writing is the reduction of phonic materiality and the submergence of the spectacle of the performing body. The traditional mise-en-scène of operatic performance is thus abdured by Adorno, not only because it causes the ignorant to mistake sound for music but because it degrades music with the visual thereby enacting that vulgar hybridity that Michael Fried calls theater. The phonographic mise-en-scène that Adorno desires is a scene of subjection in Saidiya Hartman's sense of the term;[25] it is the locale where the ambivalent and timeless sublimity of the musical aspiration for "freedom under continued unfreedom" is continually played out.[26] But what if the unfreedom that covers freedom is precisely that state of affairs that is characterized by the impossible forfeiture of a haptic materiality that is understood to be tainted by madness, blackness, and femininity?

Adorno's criticism of jazz reveals that for him the body, in its material objectivity, is always nothing other than that irreducible substance that must be reduced precisely by way of a discursive pathologization of sensually experienced racial and sexual difference. Elsewhere, it might be possible to show that such pathologization is a, if not the, central teleological principle animating the Kantian line—wherein natural history subsumes natural description in a way that will have had major implications for the dream of a sociologically and philosophically informed musicology—that Adorno's work critically extends. For now, it is imperative that we recognize that the phonographic mise-en-scène of subjection is the erstwhile staging of a sensual and substantive reduction whose failure is revealed always and everywhere by the material trace—in Adorno's writing of and on the music that he loves—of the music that he loathes.

An anticipatory materiality discomposes the composer and his most faithful structural listener, writing and reading them in their most immediate graphic relations to a music that turns out to have existed only in the faithfully disruptive, disruptively constitutive occupation of it by the irreducible materiality of pathologized racial and sexual difference. Such invaginative piercing is decisive for, indeed generative of, a musical event that takes place at the articulated combination of atonality and atotality. Jessye Norman's performance within the phonographic mise-en-scène is the recording of this illegitimate birth, offering up something like a renaissance of the dissonance where rebirth and liberation converge, one carried in the change and trace of a kind of crossing over, a translation of the body from unfreedom to freedom. Her phonographic re*mater*ialization of *Erwartung* disrupts discontinuity with the radical force of an objective and objectional continuance, thereby requiring a reconfiguration of the concept of writing as that which occurs where performance and recording converge at the site of a *bodily* inscription. Unsuspecting in his office, den, or living room, Adorno is being written (on) and read by the syncopated vagaries of an un/broken line for which Schoenberg's composition is an ambivalent medium. I'd like, now, to begin an approach toward something like an unnatural descriptive history of this operation, one that takes into account Rosen's understanding of dissonance while expanding it in order to be able to consider every micrological scar on the surface of musical *récit* and recitation, ones that occur not only in the movement from note to note but in the internal differentiation and multiplication of every tone.

6.

At the end of *Erwartung*, at the very edge of expectation, Rosen describes an effect—in lieu of tonality's climactic resolution and the structural or formal assurance it gives—in which all the tones/notes in the chromatic scale are given, at various speeds, as something like that "dense interlock of competing energies" that Sandra Richards has noted as correspondent to the deferred but foundational presence (or, perhaps just as precisely, the suppressed but resistant trace) of Ma Rainey in August Wilson's *Ma Rainey's Black Bottom*.[27] In *Erwartung*, as in Wilson's play, what will have been overlooked as "the unwritten, or an absence from the script [or score] is a potential presence implicit in [an always already phonographic] performance."[28]

I want to think this potential performance in its relation to the so-called black sound in opera that moves, mysteriously, like some kind of photophonographic haint tautology. The sound is sometimes visually figured as a certain aural duskiness, smokiness, or huskiness and sometimes characterized, by way of taste and/or touch, as rich and velvety. Often associated with or understood as the trace of an ineradicable and collective pain, it's then figured as a plaintive quality where the plain in plaintive goes all the way back to the plexed, cut, cutting augmentation of what Cedric Robinson calls the "ontological totality" whose preservation is the essential task of black radicalism.[29] The black voice is also figured as deep and this is both spatialized by way of a set of metaphors of meaning, truth, and history (as opposed to surface, as opposed to any absolute newness) as well as anatomized (wherein the sound is tied to a kind of deep-throatedness that is sometimes translated as a function of training but has often been linked to supposed anatomo-biological specificities of black bodies). Some just call the black voice mellifluous, which brings to mind Rosen's assertion that some of the most mellifluous sounds are dissonances. On the other hand, the ugly beauty of the low and the guttural are coded as black whether coming from a black singer or not.[30]

One wonders whether Adorno had an understanding of the relation between opera and blackness that was as fully formed as the following thoughts he offers on the relation between jazz and blackness in his 1936 essay "On Jazz":

> The relationship between jazz and black people is similar to that between salon music and the wandering fiddle players whom it so firmly

believes it has transcended—the gypsies. According to Bartók, the gypsies are supplied with this music by the cities; like commodity consumption itself, the manufacture of jazz is also an urban phenomenon, and the skin of the black man functions as much as a coloristic effect as does the silver of the saxophone. In no way does a triumphant vitality make its entrance in these bright musical commodities; the European-American entertainment business has subsequently hired the [supposed] triumphant victors to appear as their flunkies and as figures in the advertisements, and their triumph is merely a confusing parody of colonial imperialism. To the extent that we can speak of black elements in the beginning of jazz, in ragtime perhaps, it is still less archaic-primitive self-expression than the music of slaves; even in the indigenous music of the African interior, syncopation within the example of a maintained measured time seems only to belong to the lower [social] level. Psychologically, the primal structure of jazz may most closely suggest the spontaneous singing of servant girls. Society has drawn its vital music—provided that it has not been made to order from the very beginning—not from the wild, but from the domesticated body in bondage. The improvisational immediacy which constitutes its partial success counts strictly among those attempts to break out of the fetishized commodity world which want to escape that world without ever changing it, thus moving ever deeper into its snare. . . . With jazz a disenfranchised subjectivity plunges from the commodity world into the commodity world; the system does not allow for a way out. Whatever primordial instinct is recovered in this is not a longed-for freedom, but rather a regression through suppression.[31]

What's the difference between the phono-political weight of the dispropriative event of servant girls singing—the performance of fugitive music—and the full content of the reconstructive musical moment—when abandonment is sublated, rematerialized, transubstantiated in and by consoling protest—that constitutes the impossible end of *Erwartung*? That the latter is given only in its alignment with the other, hidden tradition that the former embodies is a relation whose suppression sometimes seems to be the most essential function of Adorno's music criticism. The recovery of that line in Schoenberg's music makes necessary what Subotnik might have called post-structural listening. But such listening will have already been anticipated not only in the very music that Adorno dismisses but also in the style of his

dismissal. Adorno never talks as cogently about the interplay of development and stasis, or even development and regression, as when he speaks of it in relation to blackness, to femininity, to black femininity in and as jazz. It's as if the music that "is not what it is" is revealed to be—both in the violated maternity of its elusive but irreducible blacknesses and in the dis/possessed materiality of its undeniable hybridities—not only the essence of *Erwartung* but also Adorno's primary object *and* aim.

The scene that I have been imagining (or the imagining whose preface I have been writing), in which Adorno listens to the irrepressibly visual, haptic presence of Norman's recording (wherein one is not only denied, by the reproductive apparatus, immersion in the large-scale musical-theatrical space that Adorno likens to a "magic circle [placed] around both artist and audience that neither can escape," but where one is instead confronted by the fugitive thingliness of a black performing body and all of the historico-musical material/ity that it bears), is the condition of possibility of that revelation.[32] Adorno is interested precisely in the flight from that circle but is profoundly troubled—to the point of the most stringent denials—by the fact that that scene is located where the story of disenfranchised subjectivity falling from the commodity world to the commodity world is displaced by a convergence of personhood and audiovisual thingliness that takes flight (fantastically, magically) within that circle. Such flight from within the circle is the animating mark of music Adorno reads and thereby produces without discovering, amplifies without hearing.

You have to be used to the work of discerning value in that which is most degraded, a kind of work which, even in what he might think of as its highest form, Adorno would have seen as obscene, as having been determined totally by the obscenity, finally, of being seen, the obscenity of a degradation which is at once ordinary and spectacular. Such discernment, such seeking, is the task toward which *Erwartung* tends, a task written onto the voice that strains to see, the voice that a necessarily social vision strains toward the figuring of a nonexclusionary ensemble, as mise-en-scène turns to *mise en abyme*: "*Oh, bist du da . . . ich suchte.*" (Oh, there you are, I was looking.) Norman sings with the knowledge of an object in search of some*thing* that she is, with a trouble in the voice that theatricality lets us see, a trouble that is at once of and before the extended encounter that structures the historical drama we now inhabit.

Someday I'd like to be able to make somebody see and hear the objectional and ontological sociality of the black voice, where being black is only

being black in groups, where not only the group of blacks but the group as such is given as an object of a specifically politicized fear and loathing precisely because of their collective and disruptive seeing. Adorno's problem is not so much with disenfranchised subjectivity as with the abandonment of a specifically individualized subjection, the sidestepping of the dialectical snare of a freedom that exists only in unfreedom. That abandonment, as given in jazz, is aligned by Adorno with the music of "the new objectivity." Though any relation jazz has to that movement is minimal, certainly jazz moves within the history of a resistant, however commodified, objecthood, the history of an aggressive audiovisual objection that constitutes nothing other than the black and animating absent presence of *Erwartung*, the black thing that Adorno wouldn't understand, that Norman's objectional audiovisuality animates or reproduces with each encounter. Blackness, which is to say black femininity, which is to say black performance, will have turned out to be the name of the invaginative, the theatrical, the dissonant, the atonal, the atotal, the sentimental, the experimental, the criminal, the melodramatic, the ordinary. It is and bears an aesthetic of the trebled (troubled, doubled) seer's voice disturbed by being seen and seeing up ahead where escape, crossing over, translation will have meant the continual reanimative giving—unto the very idea of freedom—of the *material*.

Liner
Notes for *Lick Piece*

I have this classic music background. I still love Beethoven, I still love Bach,

I still love Brahms. You look at my record collection and there's . . . I hope I

don't have any Stockhausen—but you know, everything else, Ravel and Ave-

naise. They're there because they were great musicians, they were good com-

posers. The problem that I had with how they were perceived or how they

were presented in a concert hall had nothing more to do with the music or

what they were trying to do. It was much more about society—who's sitting in

the first row, how wavy is the hair of the conductor, does he wiggle his rear end

well, you know. And all of these marketing things . . . really have nothing to

do with the music. . . . My three operas—*Madame Butterfly, Carmen, Tristan*

and Isolde—all three in one hour! Some people think of it as persiflage but it's

not really that. It's a tribute to them but reduced and pointed in a different

direction so that "ah, that's what it was about. It's not about how much you

paid for your ticket or if you are in the royal box."—**BENJAMIN PATTERSON**,

Ben Patterson Tells Fluxus Stories (From 1962 to 2002)

Music Discomposed

Nineteen sixty-four was a big year in the history of what Rebecca Schneider
calls "the explicit body in performance." Carolee Schneemann's *Site* and *Meat
Joy* follow her actions for camera of the previous year, *Eye/Body*. These per-

formances are centered on a new mode of self-presentation in which the nude female body enacts a resistant reanimation of the aesthetic/sexual object. The sensed becomes an artist in her practice, in disruptive continuance of her trial. Is Benjamin Patterson allowed—or is he, in fact, required—to take up and adjudicate this cause? There is a double operation that Schneider aptly theorizes and describes, which renders Schneemann both eye and body, both subject and object.

> In *Eye/Body* Schneemann was not only image but image-maker, and it is this overt doubling across the explicit terrain of engenderment which marks *Eye/Body* as historically significant for feminist performance art. Though there are possible important correlatives that can be resurrected from history—such as, as some suggest, the proto-performance of nineteenth-century hysterics—in *Eye/Body* Schneemann manipulated both her own live female body and her artist's agency without finding herself institutionalized as mentally ill. Instead, she found herself excommunicated from the "Art Stud Club." George Maciunas, father of Fluxus, declared her work too "messy" for inclusion.[1]

Is that operation available to Patterson, particularly when he dons the worn mantle of the artist in appearing to make explicit another's body but not his own? After Schneemann, to be clothed is to be recognized as having staked a kind of claim, at the convergence of the explicit and the implicit. The claim is illegitimate not only because the brutal authority of its object—the power to expose—has been exposed but also because Patterson's assertion of it must remain unheard and invisible. The unrecognizability of the black male artist is part of the general constitution of the atmosphere—we'll call it the art world—within and out of which Patterson's work emerges. He stands, in that world, as a prefigurative variation on Adrian Piper's mythic being, whose accompanying Kantian cartoon bubbles set off a body whose inherence in an assumed bareness of life renders it explicit even when it is clothed. Anticipated by Schneemann, whom he anticipates, Patterson is subject to a double exposure. Overexposed, in the glare of the nothing that is not there and the nothing that is, he disappears.

Something remains, however; not just a photograph but also the ghost it captures (or the spirit that animates it). Patterson's *Lick Piece* was performed on May 9, 1964, at Flux-hall, George Maciunas's New York City loft. Peter Moore's photograph of the event becomes an event when accompanied by

its inadvertent caption, Letty Eisenhauer's recollection of its precipitation, which is primarily composed of the performance of her explicit body, which Patterson arranges in obscurity, as imposition.

I was jolted into a new appreciation of the work of Ben Patterson recently when I was made aware that a performance piece, *Lick*, which I had long attributed to Bob Watts, was really the work of Ben Patterson. Because the piece was performed nude, and was in the intimate yet publicly accessible surroundings of the Fluxus Canal Street loft, it was likely that Watts had to persuade me to do the performance. *Lick* was presented on a very hot summer (or spring) (May 9, 1964) day. My naked body was sprayed with whipped cream and the audience was invited to "lick" it off. The cream curdled or melted and ran in disgusting rivulets off my steamy body. My embarrassment and fear that some stranger might actually lick me probably also contributed to my overheated state. I don't think anyone in the audience volunteered to lick the cream off. . . . Ben and Bob demonstrated, but neither of them pursued the task with vigor. *Lick* may have been one of the culminating pieces in my history as an art world nude and in the Dada-Fluxus tradition of poking fun at the formal art convention of painting/sculpting the nude body and perhaps taking Duchamp's *Nude Descending a Staircase* a step further. This piece was only a "pubic hair" away from being a "blue performance," presenting as a public action a possible intimate portion of the sex act during a sexually conservative period.[2]

Unseen, unrecognized, bare in its clothing, in performance, the hypervisible instrument is in position, has a plan, an open secret bearing more than eye/I can see, more than sound can bear, of other musics. (See the Fluxus ear in profile, naked in the disregard it suffers and enjoys, arranging the performance.) Schneider reminds us that in Schneemann and Robert Morris's live version of Édouard Manet's *Olympia*, the black maid is out of *Site*. In something like the same place, at something like the same time, Eisenhauer mistakes Patterson for Bob Watts's assistant, such convergence requiring us to consider what the maid made as well as the relation, which will have been insubordinate to that between artist and object, between artist and servant. In Patterson's case, by way of an old-new musicopoetics of service that underwrites and undermines the attempt to rebehave an already behaved nakedness and thereby become an artist, an eye, an I emerging from an Other, the explicit body prepares, offers protocols, knows the score:

cover shapely female with whipped
cream
lick
. . .
topping of chopped nuts and cherries
is optional

As Phillip Auslander argues with regard to all the foundational figures of the Fluxus movement, Patterson is a musician.[3] His best-known early works, *Paper Piece* (1960) and *Variations for Solo Bass* (1961), as well as more recent works like *The River Mersey* (2002) and *Surveying Western Philosophy Using China Tools* (2003), bear this out. There is an ethical and aesthetic obligation, then, to play back the photographic record. *Lick Piece* is one of those Fluxus works that seems always to have been more in the vein of performance art than music in what can be taken as its visual, tactile, gestural, and culinary displacements of sound. But it is precisely by way of the gestural and the culinary, which intimate that Patterson's concerns rearticulate some crucial formulations of Bertolt Brecht regarding the nature of opera, that the sound of Patterson's encrypted claim is revealed, as a kind of surprise.

Lick Piece's claim to a place in the history of opera is staked by its update, more than forty years later, in Patterson's discompositions of *Carmen* and *Tristan and Isolde*, which render asymptotic the seemingly remote trajectories of Brecht and Schneemann. This proximate nonconvergence moves by way of intersection: consider the multiple positions that Patterson takes up on stage. He conducts. He composes. He cooks. He consumes. He is consumed. He serves. Focus is shifted—intermittently, glancingly—from the bodies (which is to say the questions) that he poses. One of those bodies is his, which remains explicit though it is not nude. The explicitness of the black body, the explicit body's blackness, is not only about the way a certain lived experience can be said to bear the traces of bareness; nor is it encompassed in what it is to bear the only black body on site or on stage or in the room or in the frame. For what is also brought into relief is a kind of dynamic facticity, an "impossible purity," that the irreducible interplay of blackness and femininity bodies forth.[4] Does the black (who is, by illegitimate definition, never legitimately an) artist, in his composition of the female nude, also bear the bare sexuality that he exploits? Is the sheer corporeal fact of sex centered only on her figure? Is the artist transported outside of the sexuality that her exposure rearranges? Or does his black body remain in a reductive

hypersexualization held in the danger of his own arranging hands? One way to look at it is that Manet and his model and her maid and her cat occupy different worlds and different times. If, by contrast, in *Lick Piece* Patterson and Eisenhauer cohabitate, however temporarily, on the border between public and private, theirs is a criminal occupation, a dangerously black as well as blue preoccupation. The racial mark is emphatic but unremarked in Eisenhauer's recollection. Perhaps it's because she couldn't have known that Patterson was both composer and conductor when he was posed as a servant like Olympia's maid, helping her to prepare for visitors, within the tableaux's narrative frame, which is broken again by another of its constitutive elements. In reality, it is Bob Watts who helps Patterson help Eisenhauer so everybody but her can help himself. Who could have known? When Patterson takes the stage, music is discomposed and discomposes. Insofar as the servant was already there, helping to prepare the eye/body's active repose, discomposition is given, anoriginary, best understood as a kind of anticipatory refreshment.

Musical theater turned off Broadway at Canal Street, so it could get something to eat. Letty Eisenhauer has a recipe in the Fluxus cookbook. Right down the street someone named Richard Eisenhauer designs and patents food warmers. Lick it up. I mean, look it up. Google is a kind of gumbo, a (web)site gag with endless permutations. It's easy to overindulge. Does too much whipped cream make you gag? It's messy. Did *Lick Piece* make Maciunas laugh, or is it too deformed by the kind of messiness he hated, the kind that got Schneemann kicked out of Fluxus, which she helped to start?[5] There's a relationship between messiness and gagging, between the gag and the gag reflex, between Fluxus and reflux, destructive re-creativity and aesthetic indigestion. Fluxus traffics in acidity and corrosiveness. Messiness is its messianic, maniacal double gesture. The expression, through Patterson, of "female creative will" against, and therefore with, Maciunas's will, disseminates overexposure, radiates overheating. *Lick Piece* must have made Maciunas laugh, a recurring event that Patterson describes as a hacking cackle that more often than not led to an asthma attack. *Lick Piece* must have made Maciunas gag. He couldn't have thought it was funny even though the gag became "[his] litmus test for determining which works by whom would be included in a Fluxus performance or publication."[6] Why was it that Schneemann turned out to be insufficiently funny, too serious? Or was it that her seriousness was too funny, too piercing, too scary insofar as it was always already poking fun at the (wrong) man, which is another good way to start some mess? Schneemann certainly thinks it is fear that drives Maciunas unsuccessfully

to try to gag her. He would have thrust something in her mouth, to keep it open and thereby silent just as he thrust absurdities down the throat of the art world, as Patterson implies. To prick, to wound, to make a thrust. To be a prick. To resist being pricked, though when one is pricked, one laughs to the point of gagging. Eisenhauer speaks of "George's need to control or to work with artists who were as constrained as he was[, which] governed not only the artworks produced for sale but also the performance of the scores. Ay-O's *Finger Boxes*, neatly engineered and executed to fit into a briefcase, are a good example of George's aesthetic and his personality: pristine on the outside but with a surprise—obviously sexual and potentially sadistic—when you poked a finger through the opening. . . . George did not like messes." Did *Lick Piece* make Maciunas laugh? *Lick Piece*, too, is more than meat joy. The gag, as Patterson employs it, is more than "just a *persiflage*." It's a gig, a jest, on gest, some notes, on gesture, on Google, on YouTube.

You Can Help Yourself, if You Take Too Much

Giorgio Agamben writes, by way of Gilles de la Tourette's descriptions of the syndrome that would bear his name (and by way of an unfinished text of Honoré de Balzac's called "Theory of Bearing"), about a European bourgeoisie that had, by the end of the nineteenth century, lost its gestures. The loss of gesture is all bound up with the loss of sense. Both, in turn, are bound to a double imposition: revolutionary agent of its own decay, the bourgeoisie loses itself (its sense; its gestures) in being itself. Itself insofar as it acquires itself, in loss of itself insofar as it constitutes itself by way of acquisition, the general catastrophe of the general equivalent sets what Peter Brooks calls "the melodramatic imagination" to work in an attempt to recover the sacredness that regulative understanding constantly endangers. For Brecht, opera's particular interinanimation of *melos* and drama is the gestic/gestural medium in which this game of lost-and-found is serially played, replayed, long-played, if you will, like a record.

But what if the loss of gesture is more rigorously imagined as gesture's quickening, its internal differentiation, an enriched sounding and a continual initialization of the sacred? Giorgio Agamben speaks of bearing, of carrying or carrying on, of gesture as enduring, as the emergence of pure means without end, of the human as pure mediality. Gesture, then, is the communication of communicability as, for Brecht, the theatrical activation of gest makes possible a movement from the realm of entertainment to that

of mass communication. What characterizes gesture, Agamben adds, "is that in it nothing is being produced or acted, but rather something is being endured and supported. The gesture, in other words, opens the sphere of *ethos* as the more proper sphere of that which is human. But in what way is an action endured and supported? In what way does a *res* become a *res gesta*, that is, in what way does a simple fact become an event?"[7]

This indexes a movement in the photograph of the explicit body in performance that goes against the grain of its having been posited, of her having been posed. Apposition is given in the form she bears, in bearing that moves and sounds, in stillness and silence. It steps across the distance between pose and gest, bridges the gap between gest and gesture, like a cinematic event, an operatic happening. But this is to say that what is at stake is not simply a reclamation of lost gesturality but something Brecht might recognize as that rich internal differentiation of gesturality that he speaks of as gest or, more precisely, as social gest. A certain fugitivity of the gest/ure will have already been remarked in apposition, as it awaits its music, in impure mediality, for an irruption of that seemingly held, seemingly stilled, irregularity (which Brecht associates with jazz and with what he calls "the freeing of the Negroes," but which is figured more precisely when blackness and escape combine to form the name of the general itinerant). This racialized irregularity moves, now, not so much as what Brecht might have called gestic music or the music of social gest, but rather by way of a necessarily flavorful advance, something Miles Davis called social music, which is what Patterson discomposes, like a virus in Wagner's finite score, like a form of life whose active minoritization actually constitutes the principle of finitude.

Brecht avows his antipathy to the culinary by staging and inducing gluttony. Eating too much whipped cream, for instance, will have been always in bad taste but it can be put to use insofar as it exemplifies and exposes the bourgeoisie's self-consumptive jones, which can be traced in opera's devolutionary arc.

> *The Magic Flute, Fidelio, Figaro* all included elements that were philosophical, dynamic. And yet the element of philosophy, almost of daring, in these operas was so subordinated to the culinary principle that their *sense* was in effect tottering and was soon absorbed in sensual satisfaction. Once its official "sense" had died away the opera was by no means left bereft of sense, but had simply acquired another one—as sense *qua* opera. The content had been smothered in the opera. Our

Wagnerites are now pleased to remember that the original Wagnerites posited a sense of which they were presumably aware. Those composers who stem from Wagner still insist on posing as philosophers. A philosophy which is of no use to man or beast, and can only be disposed of as a means of sensual satisfaction. . . . We still maintain the whole highly-developed technique which made this pose possible: the vulgarian strikes a philosophical attitude from which to conduct his hackneyed ruminations. It is only from this point, from the death of the sense (and it is understood that the sense *could* die), that we can start to understand the further innovations which are now plaguing opera: to see them as desperate attempts to supply this art with a posthumous sense, a "new" sense, by which the sense comes ultimately to lie in the music itself, so that the sequence of musical forms acquires a sense simply *qua* sequence, and certain proportions, changes, etc. from being a means are promoted to become an end.[8]

Sense totters and is then absorbed in sensual satisfaction. The absorption of sense—of a philosophical, dynamic, daring element—leads to the acquisition of another one, a value that will have been, as it were, intrinsic to opera as opera. At stake is the relation between self-indulgent sensuality and fetishization, the illusion that art is or could ever be for its own sake. Sense has been absorbed by sensuality; content has been absorbed by form; operatic innovation produces a pale afterlife of sense in the form of a purely formal self-reference or, perhaps more precisely, self-regard. When opera acquires another sense and then posits that acquisition as always already its own, it asserts the acquisition of its form as an absolute value and the acquisition of a certain fetishized sense of itself, of a sense of itself as (its) sensuality, of that sensuality as the form that opera is, that opera has, and that opera takes. This complex—wherein acquisition and element, sense and sensuality, blur—disturbs and therefore reveals a deeply regulatory and fundamentally Kantian impulse in Brecht, one whose roguish object is the nonsense that turns out to be irreducible in opera, the cantian irruptions or Kanted flights that constitute its form while deforming its content. But the deformation of content need not be understood as either its absorption or its death if one can imagine that the one who is disposed of as a means of sensual satisfaction, the one who is posed, posited, but who troubles the already given content and the already assumed agency of composition, is a philosopher; or, perhaps more precisely, that insofar as there is philosophy it moves only in

and by way of her impossible, impossibly sounded and sounding movement. Hers is an elemental philosophy of anacquisition, of that essential value of the outside that cuts and augments suffering and enjoyment. Her apposition of the pose from its interior, moving theatrically against a range of absorptions by way of the operatic gest/ure of the working girl, is social gest in social music, which Patterson's performative, compositional conduction discomposes.

The convergence of content and pleasure is terrible. It is the cause and the cost of flight. Therefore, Brecht must risk the scandal and the regression that attends pleasure. Brecht will, as it were, allow himself to be absorbed by pleasure; he'll have whisky or you'll know why. Such absorption will have been both submission and release, a self-sending that is carried out in the interest of salvation, by way of being-consumed, within which the necessarily disagreeable, whose excessive flavor must be in bad taste, puts itself forward as a kind of pharmakonic capsule meant to poison the glutton that consumes it. A more subtle realization of the structurally necessary relation between enjoyment, flight, and resistance that the culinary brings to life is, for Brecht, nothing more than capitulation to the degraded and degrading hedonism of the bourgeoisie in the form of false innovation. Brecht is prepared to let us wallow in enjoyment in order to kill it; Patterson moves in and against his wake.

The Opera's Not Over . . .

Phonic materialization is a visual, gestural, theatrical affair accomplished through a set of repeatable operations performed and interpreted severally, separately, every time. Music is an encoding and deferral of phonic material that is embedded and embodied in phonic materialization. The knowing enactment of this interplay of dematerialization and rematerialization is Patterson's métier, though more generally, Fluxus occupies, is preoccupied with, the precarious balance between bare materiality and unsparing dematerialization. Music's bare life, its mere materiality, is, further, poised between gesture and the culinary, as if the rougher and more vulgar senses are the most likely locale of the likeliest and severest threat. More matter, less art? No. Because matter is only ever art's delivery system. Deployed in the interest of such delivery, opera is perhaps the most vulgar art form of all, born in and by the vernacular, delivered gesturally, by bodies more likely than not to be out of all compass, hyperbolic, hyperphysical, nonsensical. Opera

always threatens, in the delivery of its material, to deliver nothing more. For the refined, who see art's ultimate refinement in dematerialization, opera is an embarrassment. The bourgeoisie, who may or may not adhere to this particular understanding of refinement, are willing to pay for it in any case.

In advance of such embarrassment, the most radical movements toward dematerialization are the ones that are most bound to the material. Patterson not only enacts but also celebrates this paradox, reducing opera to its most base and basic elements. The materiality that insisted in and on such performance is in the air or, more precisely, in the airlessness of cyberspace, digitally recorded and disseminated but never by way of the transferable solidity of the compact disc or the DVD. You can see for yourself on YouTube.[9] The difference of this opera is in its being seen and seen again. Lip-smacking, mouthwatering, the hyperbolic body made explicit, fully detached now from the sound (production) that would have justified such embodiment. There to be consumed, enjoyed, and nothing more.

What led Conceptualists and Fluxists to dematerialize the work was, precisely, the intensity with which the work had been given over to and disappeared by the valuation of what was always immaterial in and to it. Aesthetic acculturation, as Piper discusses it, tends toward dematerialization, but so, too, does the resistance to it.[10] The critique of aesthetic value (or, more precisely, the critique of bourgeois aesthetic valuation) disappears but for a kind of *retrait* of the material. This insight—sense's oscillation between the lost and the found—is continually given and enacted in the work$_2$—the setting to work of the work, the working on or over of opera. The explicit invisibility of the servant is, too, a kind of dis/appearance. Within the strictures of an ethics of dematerialization, Patterson dis/appears. He reemerges in republication, in enactment, in repertory, by way of the recording and its digital and cybernetic reproduction—the paraontological remains of his performances take the form of a sifting of and through remains, a continual serving of leftovers, of fucked-up, funny, generatively unfunky licks and pieces of licks. Matter is art's embarrassment; enjoyment is its shame. This double illegitimacy betrays so much of what is valorized under the rubric of Fluxus, which moves within a disingenuous forgetting of this fact, which is, in turn, disingenuously and sometimes profitably forgotten. There was a Fluxus show at the Hamburger Bahnhof, but Patterson's train never made it to the station. There is a structure of recognition in the retrospective— there was this man who did some things, made some things, or was involved in a particularly resonant and interesting mode of making whose methods

and processes of fabrication never left us with anything ready or present-to-hand. There is, at the same time, a profound ethics of preparation—in the absence of something made, on the performative outskirts or against the phonographic backdrop of the ready-made, Patterson works to make things ready. His is an aesthetics of preparation; his privileged genre is the recipe, in which the combination of stringency and extravagance sometimes achieves a kind of lyricism. At bottom, within and against a certain tradition of the inhabited and abandoned bottom, where bassists walk and walk away, Patterson cooks, prepares a table for us, a phrase resonant in its demand that we prepare ourselves and in the fearsome imposition of its constantly renewed offer to prepare us.

It's not so much that there is a thin line between licking and consumption but rather that there is a thin line between their interinanimation and a devouring that leaves nothing intact. But is anyone left intact? This is a question concerning the culinary-musical pleasures of the lick and what it prepares in and for us. The virtuoso bassist (fore)plays for us, the lick obstinately returns from variation, and we are prepared to make something out of nothing. But why extend this sacrificial economy just for the sake of a point you have to make? On the one hand, he prepares some food for us; on the other he prepares it for himself, so he can eat in front of us. The careful preparation is on stage in Patterson's *Carmen*. The director as stagehand, performer, prop, asks us to consider the long, unbreakable connection between music, sex, and food. The musical material, ennobled by its dematerialization, is rematerialized as dessert—there is no question of nourishment or necessity. Patterson conducts from onstage, after serving as stagehand. The characters present themselves in and by way of a gift of material that the players bear to the conductor's hand. This transaction is staged but detached from the music that constitutes that staging's background. The music is not played in the orchestra pit but played back offstage, as if Patterson put a photograph on the phonograph. The music is the material trace of a prior transaction. The players give themselves over to be blended, discomposed.

When opera becomes emphatically, self-consciously culinary, it also becomes more emphatically visual. Staging, and consequent revisions and invasions of the stage, predominate. The music is reduced to backdrop, décor, which is what Adorno would have the long-playing record remedy. But Patterson deploys the LP and its compact variant to render visuality ever more insistently, not in the interest of a non-visual *cum* structural listening (in which the visual experience to which the music is made subordinate is

eliminated so that the music itself can be seen and not heard) but rather in the service of a total subordination of the musical material so that it can be given, now, as staging. Opera replaces the spectacle of exertion in concert with staged gestures that are both detached from and driven by the music that is produced in the orchestral pit. Now the kinetics of musical production is rendered more remote by mechanical reproduction. Reproduced music brings unproductive gesture into relief. In this counterproductive mise-en-scène the senses become conceptual in their practice. The sensory apparatus is recalibrated. Or, rather, it's as if by way of Patterson we can now go openly to the opera for what it is that we always wanted: something to enjoy. The asceticism that attempted to separate music from food and that, more generally, wished to protect hearing from the contamination of the other senses and which had to use a kind of conceptual visuality to do so, thereby undermining its own project, is hereby relinquished. The end of this open enjoyment is the revaluation of means, which you can almost taste when the bassist puts some flavor in your ear, which you can feel when the hegemony of the end, of the one who lives in the exclusive zone that ends inhabit, which they have accumulated, where they accumulate, where they exercise possession's brutal imperatives, where they are exercised by owning, where they await exorcism, having paid the highest possible price for their ticket, crossfades to black.

Because he is a DJ, Patterson is able to distinguish ownership and enjoyment. Because he is a bassist, for whom the lick is, therefore, basic, Patterson plays on and in and with the persistence, our repetitive consumption, of the profane fragment, the culinary musical moment, the stock pattern or phrase that always tempts and sometimes fills in the open possibility of social life that attends the instrumentality to which such impure means consent. Patterson's solo variations act out in that opening, as if virtue and virtuosity—now that the bassist stages himself in the feminized locus of a culinary transaction, in the interest of a pleasure that is neither productive nor reproductive—are breaking up just to let you know that all along music was drama, a theatrical symposium on the general antagonism. *Lick Piece* extends the discomposition of the lick—and the lick's discomposition of the work—begun in *Variations for Solo Bass*, repeated with differences in *Paper Piece*'s torn ostinato of tearing, and revived in *Carmen* and *Tristan and Isolde*'s reflexive, refluxive commensality. Patterson, Fluxus's practically unacknowledged remainder, is given to festive, obstinate rupture of the familiar. He reconstructs Schneemann's *Site* specificity and regifts the puritanical indulgence Brecht confers

upon opera. Enabled and disabled by the thing he would correct, rearranging the submissive aggression to which he aggressively submits himself, having consented to become the more-and-less-than-singular instrument he abusively prepares, Patterson performs the messy, irregular, earthy methods and processes by which violence overturns itself.

Rough Americana

At the beginning of the eponymous first track of *Rough Americana*, pianissimo effects involve machines in acoustic music's old project of soothing.[1] Electronic hush and calls to hush extend that project however much noise without signal is said otherwise to operate. A roar is preceded by a faraway approach to melody and, after a minute, channel switching commences: percussive transfer to sustained, but glottal, hum; beaten string to an orchestral sample of lost, paradisal engines. It's not that every sound is in *Rough Americana*; rather, every sound is possible there, here. DJ Mutamassik's and Morgan Craft's improvisational performance, recorded live in Brooklyn in 2002, moves within a tradition of the extraordinary in that it reinitializes such possibility even as it is radically ordinary in its emphatic rendering of the everyday beauties and brutalities of a global sonic field structured as much by war and migration as by the constant insistence and celebration of locale. This music is driven by the tension between its assertion of a new and unenclosed musical commons and its depiction of the sounds that attend the ongoing politico-economic enclosure. Does the genre of work that works like that have a name? Black Music, I guess, which is all, which is the all something called *Rough Americana* could ever have hoped to be. I am greatly tempted to call it Great Black Music, ancient and futurial, for the questions it raises. Those questions, of course, have to do with how and what *Rough Americana* sounds. Does its sounding of an idea of who and where we are (by way of what these musicians call "electric black improvisation" or "Afro-Asiatic roots and technology music"), its assertion of another mode of sociality breaking out of and into already existing social life, sound good? Does it sound good in or because of or in spite of that assertion and those ideas? Does sounding good matter now? How does the matter of sound matter now?

In raising these questions, *Rough Americana* bears a collusive and corrosive abstractness that faithfully disrupts the programmatic content, the

doctrinal accompaniment, that has constituted the historical impetus of black music, whether that music is characterized as an expression of sorrow or its corollary, freedom. Moreover, it carries and (dis)articulates the terror and delirium of enjoyment, of the party, the set, which is to say the constraint that paradoxically is that historical impetus. The incorporated divergence or broken fold implied by "(dis)articulates" is fundamental in music that gets with a program of refusal by refusing to get with the program. It expresses the most radically authentic possibility in the tradition by radically challenging the traditional ground for any claim for or to authenticity. It does so by way of broken thread and rough beauty. The music sounds good and it matters that and how it does.

Consider the history of what has been done to strings in America: pulled, broken, frayed, bent, yanked, plucked, twisted, fingered, thumped, thumbed, rubbed, burned, fuzzed, tuned, plugged, tied, bitten, bottle-necked, box-car'd, mail-ordered, masturbated, remastered, they've been suspended between leeway and seizure all for an open set of sounds. Wire is tacked to a doorframe. Minutemen and cannibals twang and warn. Strings have been loved toughly like God loves the poor; and roughly, for the sake of reproduction. They've had to tolerate disinvestment and unfair trading. Giving props to the improper but always subject to veiled conventions, they've been claimed by me and the devil and whomever else. Often taken for evidence of roots and rootlessness, they've been mobilized in the doing and undoing of root work. They've been party to many illicit deals and seem to keep getting people into and out of various jams. People break words to them. People make breaks with them. Now Morgan Craft opens this ensemble of open sounds and soundings by pulling stunts with them. Stunt guitar is like big air guitar, on the half-pipe, no engine, with somebody else's wheels. The materiality of his imaginary playing is shocked and amped so that a whole history of enabled technical disability comes out as a whole new surprise virtuosity.

But stunts happen against the backdrop of a blank screen against which a constructed background is projected. Sometimes the stuntman seeks escape from the soundscape that is newly mixed for him; sometimes he accepts its embrace. The broken chastity of marriage is intact and definite in *Rough Americana*. Mutamassik turns the tables on the very idea of the rhythm section, singly reenacting it by way of sub-division, as multiplicative incursion. What she brings to the mix is the mix but her mélange is an effect of trouble, of violent effects. The tracks of every stunt are successfully taken beyond their extremes to failure. What the track numbers indicate is not a new song

but a portal between sets of scenes and series of illumined phrases that are gathered in the formation of a soundscape already given but composed, found but recombined, fugitively performed and on the run from preformation. Mutamassik is the working archivist of a way-out soundscape, a soundscape in which ways out are the essence of its code, a sound(e)scape. She lays groundwork with a phonics of calculated wandering while the itinerant, acrobatic guitarist, riding in and out of blinds, is looking for a home. The oldest song—of flight from settlers and settling in the hope of some other settlement—is serially, collaboratively found and renewed in *Rough Americana*. The liberated zone within which the songcatcher would move is, however, virtual. The ubiquity of the military helicopter, as much as Stockhausen's helicopter quartet, preaccompanies this music as if in surveillance of a set of effects that call it into being. The one who would move within and re-create this soundscape does so critically, hastily, and with a kind of thrift (manifest in the creative re-fusing of whatever fragments remain of whatever oppressive wholes one might have destructively refused) that shows up as extravagance in a work that is not (simply) one.

Rough Americana contains massive, but also microscopic and microphonic, interplay between pause and incursion, and the breaks between units are small un-uniform models of a larger break that Mutamassik and Craft enact. "Air Raids" most emphatically questions the logic of track divisions, pointing to the status of *Rough Americana* as continuous composition. This is to say that the breaks between tracks—some of immeasurable thinness, others whose thickness and color approach the notion of a border—are part of the composition. This is not to say that the idea of the track is disrespected, that tracks are not laid down. On the contrary, the composition is given by way of that nervous, nervy non-self-possession that seems to attend the state of being musically possessed, letting us know that such train-like, trane-like brokenness—the chased, chasin' (chaste, chastened) fugitivity of something running both from and after something—is the condition of possibility of both continuity and composition. This bridge is not natural but engineered, so that the helicopter, rather than silence, announces another track change. When the helicopter arrives, "Granma Dearest" begins. With slips of melody underneath, the chopper sounds too good to fly. Lower to the ground, the city sounds beneath. Interrupted phone call interrupts, then Cecil speech scratch Pickett to the closing jail door punctuation of "74M3." But attempts to identify the samples, to enumerate a set of multicultural, transnational building blocks, when the most important thing is the ruined, reconstructive disposition of the

ensemble, don't matter. What's at stake, rather, is the profligacy of the break within a serialized persistence, imposed by the conventions of the album/CD itself, which makes its own deliberate approach to the idea of "the work." This sustained, collaborative break (that is composed of breaks) worries development, totality, time, and the very nature of the operative unit within and out of which something is presented that seems constantly to defy and disrupt the very idea of the unit (scene, song, phrase, note).

But any analysis of the break in *Rough Americana* must be mixed (and this fact must constantly be remixed, which is to say reiterated) with the realization that its experiments in the architecture of sound are possible only by way of a massive condensatory drive. *Rough Americana* also revolves around the paradox, which Adorno identifies with Webern, of total construction as a means of achieving immediate utterance. This interplay of distillation and elaboration is fundamental to the unsettling and resettling of the (musical) unit. This music moves—which is to say that a new musical form and a new articulation of time emerge—by way of profligate interruption within an orgy of musical moments. Concentrations of impurity serially interrupt and entangle one another. Americas—loved and hated, loved and left, entered and hated, stolen and loved—are jagged; distilled but unfiltered, their anoriginal flavor depends upon proximate impurities. Uncut Americana is given by way of mergers and acquisitions as well as cuts and breaks. This is the composed brokenness of the rough cut. This music erupts from the deadly social life of way more than a thousand cuts and an endless series of incorporations. Somewhere here but up ahead of us, this music is one thing with many things in it that compose and undo it for the common good. There's a certain amount of dreaming (musically pre- and posttraumatic syndrome [grouped signs and events; composed things and symptoms]) in *Rough Americana*. It's an expression of stress that salvage, recovery, and invention situate against the placebo of old, bad, inaccurate, imperial news.

Sampling is, therefore—and again in Adorno's terms—the ultimate, off-scale "little heresy," marking the return of the extended, twisted, broken musical moment, where the high resolution of the edge is internal to and multiplied in every broken unit. Each rupture of each arbitrarily determined, deliberately given track delineates another mode of cut pleasure, a frayed satisfaction of rubbing or, even, of maceration, as in the Arabic Antillean blur of "Calaloo" enacting the eclipse of melody by rhythm, the eclipse of rhythm by slur, by unnotatable *nere*. At the same time, poised in the way a bridge is immediately before collapsing, this music expresses the violence

of things fitting into a new, because newly destroyed, place. The beat's compromised ability to withstand the agitation it engenders is further troubled by outside agitators as well. "Amid Debris" is funk for nervous times, giving about one hundred seconds of conventional dance before requiring parts of the body to fly off in response to unforeseen complications. The implications of Jimmy Nolen turn out to have been disruptive all along. This insight is made possible by Mutamassik's and Craft's research, which shows that black (reconstruction) music is a music of ruins.

"Memphis USA" sticks with those funky disruptions that cut and redouble b-boy sensibility. Riley King was a Memphis DJ before reinitializing a long stint of pre-stunt guitar begun on a porch in Indianola, Mississippi. The edge of Tennessee is one of two sites serving as Craft and Mutamassik's spatio-temporal musical coordinates, gateways to different deltas, different changes, different ancient resources. *Rough Americana* could be said to initiate a new, transatlantic musical discourse of cotton when "Memphis Africa" asks if disturbed minimalism is better known as black madrigal. Its rearranged copresence of sonic instances confirms this soundscape of juxtapositions, this seascape of changes. Who you next to? Who you rub? Who ran into you? Who you running from? The sense of being allowed, but not to cohere, is given in this alternation between etiolation and metastasis of form. So that when "End" gestures toward some kind of coming (non-)full circle, the listener can only conclude, before starting over again, that the reprise is meant to indicate an open sore. The necessity of this cut conclusion, which *Rough Americana* constantly utters, is inseparable from its orchestration which is, itself, so complete as to necessitate this other set of questions regarding the impossible being of what we listen to again, now, and have been listening to all along—the music of another common tongue, another common logic, another (natural and unnatural) common law.

When sonic extremity comes out of clash, embrace, and the mix/marriage of the break, then whatever retentions, abdications, augmentations, and amputations of whatever authentic anti-, sub-, and/or extracultural assertions—independent of the history of false universalities—make it possible and necessary to look for what one has come upon again, as if for the first time: the new thing, the other thing, the black thing that it takes a certain madness of "the work" to understand.

The New Black Music is this: find the source and then open it.

Nothing, Everything

The poor . . . refers not to those who have nothing but to the wide multiplicity of all those who are inserted in the mechanisms of social production regardless of social order or property.—**ANTONIO NEGRI AND MICHAEL HARDT,** *Commonwealth*

1.

I'm here to testify not only to Thornton Dial's greatness but also to the fact that he didn't come from nothing. Mr. Dial has something to say: nothing will come from nothing, speak again. Speak, so you can speak again. And then he speaks again in this highly wrought, well-wrought, overwrought iron, filled with urge and air and flowers and bones like the animated skeleton of a fantasy Babbage couldn't have, a trip Turing couldn't take, the *différance* engine/touring machine that Mr. Dial designs, builds, and swings in immanent critical transcendence of privative brutality. When Mr. Dial speaks he flows; his syntax is textural, its internal space occasioning infinite navigation there and in your head, where you can dance and make things, make frames for permeation and breathing, for the cultivation of volunteers, of flowers that come up through our bones to work steel, this whole thing really keeps us workin' our mind, *A Monument to the Minds of the Little Negro Steelworkers*.

2.

You can think about Mr. Dial within a specifically black Marxist frame and problematic but also within the context of certain radical aesthetic and social interventions made over the last forty years in Italy that fall under the

rubrics of *arte povera* and *autonomia operaia*, both of which, insofar as they also make something new, something else, out of Marx's innovations, can be situated in relation to the question of a nonoppositional relation between wealth and poverty. Because he wields the hammer that they were thinking about when they said hammer and sickle, hammer and hoe, Thornton Dial also works the ground and surfaces of social theory, and this is neither accidental nor a function of individual genius, however much Mr. Dial emphatically asserts and makes visible everything anyone ever thought they meant by appealing to that notion. Mr. Dial as a black worker in the deep South, moving down the line described by Hosea Hudson, the great black Marxist labor organizer and strategist who spent time in and around the magic foundries of Birmingham, Alabama, and its environs; and introduced, in another register, by the pathbreaking historian Dianne Swann-Wright who talks about those richly improvisational practices of family planning, of more than familial making, that blacks engaged in after "emancipation," reconfiguring given understandings and valuations of wealth and property, ownership and dispossession, having and giving, through a general, communal socioecopoetics that she indexes by way of an old, undercommon phrase, "a way out of no way"; and introduced in still another register by Deborah McDowell, the brilliant black feminist literary critic whose memoir *Leaving Pipe Shop* thinks and illuminates the ordinary heroism that serially appeared in and as the working class black social life of the neighborhood in Bessemer, Alabama, that she and Mr. Dial each provisionally called home and will have never been said—in having left—to have left behind.[1] Consider the way labor unrest and worker insurgency, mutual indebtedness and supposedly impossible common sociality, animated Pipe Shop. These elements were a big part of the noise, the background radiation, out of which everything emerged, as the light of a material breath.

3.

The autonomist aesthetic thrust of black radicalism is something liberation theologians call a "preferential option for the poor." But this demands that we ask, after Michael Hardt and Antonio Negri's formulation: What is it that the poor, the ones who have nothing, have? What is this nothing? What comes from it? These questions require some consideration of a social economy of dispossession, the social circulation of wealth that is manifest in poverty and indebtedness. The poor are the ones without credit, but they are

indebted to one another. They make a preferential option for one another in an infinite series, an incalculable web, of small acts of claiming and reclamation, conviviality and commensality, that constitute the renewal of—and the resistance to whatever attempt to suppress—their sociality, the everyday and everynight making of the ones who work from can't see in the morning until can see in the morning. These were the folks whom my grandfather, much like Mr. Dial, called smart. I used to think that smart, in this usage, was simply the opposite of lazy, but I have come to understand that what he meant was that the people who get up and go to work every day get up and go to school every day. Here's where the question of poverty and the question of things brush up against the question of study. Consider Pipe Shop not only as enclosure and relegation zone but also as refuge and university. Its inhabitants are the keenest dialecticians, Brecht would say. They study change; they are preoccupied with generativity in its irreducible relation to decay. But what belongs to the poor, to the refugees, to the ones who study change? Samuel R. Delany says that in order to have a transition you need to be armed: What is the armature, the arsenal, of the poor, the ones who, in having nothing, have everything? This question is inseparable from the reconfiguration of a fundamental ontological question. How is there everything in, how does something come from, nothing? How can something, how can some things, be in and out of no things, be in and out of nothing? What is the relationship between something and nothing that animates our understanding of poverty, of the vernacular, of the common, of their insurgent force, of their (de)generative, doubly incalculable wealth? Consider that we live within the history of a double violation: the denigration of things and the coincident devaluation of people that are carried out at the conjuncture of what is supposed to be their reduction to things and that is supposed to be their exaltation above things. We have to linger, art requires and allows us to linger, in the exhausted, exhaustive space between something and nothing, nothing and everything, so that we can begin to understand again, how the interrelation of wealth and poverty is all bound up with the question, which is to say the study, in things, of nothingness and thingliness. But to move along this trajectory I have to alter the testimony I bear; can I strip myself down to nothing's social and absolute fullness and be a monument to Mr. Dial's (and all the things on his) mind?

4.

Mr. Dial allows us to ask, and it is to him that the question ought to be directed: Where can the work of (re)creative thinking be done in the midst of the commercial enclosure of the art world, in the vocational enclosure of the university, in the ideological enclosure that one might call, even though both of its terms need radically to be called into question, the intellectual's public? The ascriptions of "self-taught" or "outsider" are expressions of desire and anxiety that redouble the structures of deprivation-in-privilege to which they react. The long self-imposition of austerity (which conceptualism/minimalism/pop reflect and to which they respond, sometimes beautifully, as if by accident) in that narrow slice of the intellectual and artistic milieu that delusionally thinks of itself as central is the perennial inhabitation of a crisis. Sometimes it seems like we are trapped in the correspondence of this assumed legitimacy of exclusion and precarity (in which enclosure is exercised as a kind of right and disposability is understood to be an essential quality of every earthly inhabitant). This is why we are so fortunate that Mr. Dial extends a sociopoetic tradition of studying the eloquence of things. That he is able to see that eloquence as depth, texture and syntax, and visually and verbally to amplify the macrophonic assemblage that we call the world, illuminates a certain problematic of lessons, in which how and where he pursues this deep, rigorous, advanced learning is all bound up with what he passes on to those who are willing to attend. The capacity to discover/invent things—which is to say things of beauty—is not only something with which Mr. Dial is richly endowed but is also one of his fundamental and enduring themes. He is concerned with material and sensual emergences (of light, flashes of eye/spirit, glints, echoes, cutting acts of speech that cut speech in the interest of its formation) and with their subsequent fades and traces. Mr. Dial's studies of the interplay of the informal and form are evidence of his rigorous training in both. Out of that training, but ongoingly in its midst, as well, Mr. Dial works and speaks a whole other ecology of the thing, of the abundance of things in the refusal of whatever notion of the disposable. This is another essential theme in his work. One might speak of the biodiversity of that work—of a kind of uncut imaginative generativity that studies generativity; a generativity of the thing, *de re*, that is inseparable from its degeneration and regeneration—where such speaking puts *ex nihilo* to rest. So Mr. Dial works words, too; his work is of the word, *de dicto*, serially letting us know that there's no such thing as nothing, as the out-of-nothing, as

making something out of nothing, of making a way out of no way. Mr. Dial makes things out of things. There are things and he is educated in their eloquence. Mr. Dial allows and urges us to think the impermanence, the extraordinary evanescence and ephemerality, of the indisposable (of that which was not made of, and will not disappear into, nothing) as a kind of undercommon divinity. That his works may someday fade or fall apart, *not into nothing*, but rather into the informal, deformed, enforming somethings that they were and never were (which is to say into the general condition of possibility that we call the life cycle, the re-cycle) is a massive, incalculable source of comfort-indisturbance. In these works, the richness of the informal is given to, but not suppressed by, form. Someday, someone, something will make some thing, some one, some day, out of the fragments of (the) everything that Mr. Dial has made. But what will be made then, what will be made again, what will be remade again and again, is where and when some thing will emerge as the anarchic principle of creativity in exhaustion, the reanimation of the *ex nihilo*.

5.

That's why I'm here to testify not only to Thornton Dial's greatness but also to the fact that he comes from nothing, out of nowhere, somewhere so old and new that it's beyond impossible, a maternal persistence in distanced birth for which we have no data. He comes to let us know that there is such a thing as nothing, such a place as nowhere, such a way as no way. He comes with nothing but things, nothing but lore, nothing but remnants clothing the nakedness that is proclaimed in unflinching disenchantment by the ones who (know what they) are supposed to know. But the thing is, things speak the nothing that is, that other presence, that underpresence, which is not only an object and an engagement and a space to be studied but also a mode and a plain and a place of study, where unknown things talk among themselves despite periodic disturbance from surveillance and its all-but-disembodied questioning.

—What are you talking about?
—Nothing.

Pipe Shop, as McDowell luminously remembers it, is an institute for advanced study; in Mr. Dial's serial reconstruction of it, Pipe Shop is left and borne, in and with the improper richness of the poor, who have something, who have everything, in having nothing but the mechanisms of social pro-

duction, in which they are inserted, in which they are, which they are. Alongside the question of the preservation of Mr. Dial's studies is the interminable inquiry that they preserve (even in the relatively immediate question of their decomposition; even in their incorporation of the fact and question of the animate and interinanimate decomposition of normative works and normative selves; even in the relay the more-than-impossibly eloquent make—by way of their irruptive, disruptive, recombinant, poetic force—between something and nothing): the paraontological totality.

Nowhere, Everywhere

Over the last five years, having previously had few opportunities beyond those of his own devising to show his work, the range and force of Theaster Gates's visitation has been startling. His sculpture and installations, his performances and urban plans, bear a kind of weight, bring a kind of noise, that, in having come from everywhere while appearing to have come from nowhere, require us to consider what and where everywhere and nowhere are. Neither utopia nor dystopia, as they are generally conceived, this other, outer, interspace requires constant searching and research. A scattered commonness of light and air and ground, everywhere has generally been precisely where art criticism doesn't look for its objects; everywhere *is* nowhere, a literal absence of location, in the art world. But everywhere is precisely where Gates's critical artistic practice is located. In the middle of nowhere, on the south side of Chicago, his hometown, the sweet home of homeless everywhere, in a newly made row of abandoned houses, in unhoused collections, in objects registered neither as lost nor found, in the everyday grandeur and ungroundedness of crossing, Gates finds impetus for, and evidence of, *making*. If you listen to his visionary music, its cosmological groove forming sacred, earthly space, on tour but lodged in the seeming impossibility of a monastery in Kyoto, Mississippi, where absorptive chant and quickened moan dislodge one another in a whole new investigation of nothingness, of what it is to come from nothing, of what nothing is that it could be come from and come upon with such generative restraint that neither Nishida Kitarō nor Frantz Fanon could have imagined it because they would have had to imagine it together; or if you look at his long-sung, dark speculation on Dave the Potter—nineteenth century South Carolina slave become twentieth-century Wisconsin cryptographer—manifest as performances of thrownness in centering that coalesce into the amplified history an auctioned vessel can hold; then it becomes possible to feel that making.

Gates's institute and archive, his juke joint and temple, is *The Dorchester Project* (2009), where an old two-story building is serially cut—in contrapuntal echo of Gordon Matta-Clark's deconstructive and culinary impulses—and remixed into the library, tea shack, and general headquarters of the ongoing symposium. This is the site of *Glass Lantern Slide Archive Relocation* (2009)—an exorcising exercise in redistribution that entailed the transport of the University of Chicago Art History Department's glass slide collection "for reuse as performance material, research and speculation" into space the university had defined itself against in a long history of incorporation and exclusion.[1] Gates places the *weight* of this act manifest in things among the list of its methods and materials, causing us to muse, perhaps most fruitfully, against the backdrop of certain ballistic, hypercussive, x-terminative formulations, on relocation as aesthetic assertion. It's as if his Uzi weighs six tons or, more precisely, that he deals in the surreptitious publicity of pirates, once thought to be the enemy of all, but now recognizable as students of friendship. Indeed, *The Dorchester Project* resonates with an already constantly given architectonic shift of study that Gates had begun to explore and extend in the series of meals that his retrospective avatars the Yamaguchis serve in *Plate Convergence*. By the end of such real and imagined evenings something—food, feeling, the nation, the earth under our feet—had been moved because Gates's work is concerned with moving and being moved across town or water or international boundaries, through identity barriers and restrictive generic definitions, over impassive and impassable spatiotemporal divides. It is difficult to come straight at the massively articulated, secretly inscribed libretto of a totality of work whose plane is so vast. Can you walk right at another horizon? Perhaps a curve, or a fold, is the only possible approach to the general field of constraint and dispersion that are emblematized in new sculpture such as *In the Event of Race Riot* (2011), objects in which the iconic apparatus of racist crowd control, updating a long history of water terror that stretches from the Gold Coast to the Leeward Islands, from Birmingham to Birmingham, are themselves enframed by black aesthetic insurgency. Considering the coiled, winding dislocation where Gates is coming from—Chicago, Iowa, Cape Town; America, Japan, Africa—this necessity of bent approach seems likely. Work and the playful disruption of the work such as he delivers allows and requires you to rethink your self and its origins.

And that's all good, since diaspora's nonarrival continues in all its terrible beauty. Can our sad anticipation of repair be given now to the new departure that's been waiting for us? Can we make a move(ment) that is also

an open and internally differentiated inhabitation—a general antagonism, a place where you expected someone else to be, given in a bunch of little irruptions of being there together that are never simply enough? How to sustain? M. NourbeSe Philip, echoing Gavin Bryars, echoing the unnameable renamed and their phonic remains, says sound never disappears in water.[2] Her cryptanalytic immersion in the exhausted, mute, mutating language of animate cargo muffled by socially dead captains marks and extends this persistence. Worrying Olaudah Equiano's line, violently reciting its unbooked passage, Philip takes the juridical silencing of incidents and injuries deep and off the market into antenarrative, interesting insofar as it is of the ones who are without interests, the ones who, therefore, cannot have (a narrative). Fugal palimpsest. Fugued amnesia. Centrifugitive motet. These are irreducible motifs of black study in and of dispersion, in diffuse concert because, as Philip says, "I couldn't go back down to that ship by myself."[3] Rakim says back to the lab to replay that utterly naked declivity, the brutal process of recombination in the experiment we claim and suffer. We were sent—by history, Lorna Goodison says—not to be a single being, and David Kazanjian has established that we are flashpoints in the water, in the blessed inassurance and joyous profanation of Little Walter's sacred harp, misshaped note as the informal, to be read and misread at sight, in the ongoing mishappening, where (il)legal record, manifest, and log become our saturated hymnal.[4] "Do you remember the days of slavery?"[5] The impossible recalling that question's urgent contemporaneity implies and demands is given, somehow, in that there is "underneath this English another language floating."[6] Mass, mas, drone.

The movement Philip groans—the undercommons, the underlanguage, underground, underwater, which is the people's macrophone—wants to know/make the relationship between form and instability, when the informal becomes a form of life precisely insofar as it is where forms of life come from. There is an ecology of unaccountable self-positing, unaccountable because what's more and less than self, disposed and without position or deposition, makes this positing in refusing being bought and sold. The logistics—the analogistics, the ecologistics—of the unaccountable population is barely audible, given only in distortion, which is our plain of code. The way a certain burned-out house or broke-down truck is packed in and against the wave of general deployment, depression, dust bowl. A boxcar full of mutual pillows of zonged (zaumed) song that Steven Feld feels in a creek or in Accra.[7] An echologistics. A metoikologistics. If the literary has been traditionally reserved for the anti-ecological, if it is aligned with the sovereign even when

poised in/as the non-space between the sovereign's democratization and His endless trial, then Emily Dickinson and Harriet Jacobs, in their upper rooms, are beautiful.[8] They renovate sequestration, designing, as Maurice Wallace teaches, the new public interior of a supernatural historicity that black art's acceleration of the material marks in and as massive and diffuse production.[9] Its corrosive, prolific regeneration takes the form of an open set of containers, renewing the shipped's fascination with the ship that goes back through Philip, Édouard Glissant, Jacobs, Frederick Douglass, Equiano, and beyond. The Superdome, the temple, the row house, the project, the shack, the crawlspace are each a kind of vessel. The body is a vase, a pot, an evanescence of eccentric thrownness. To get at the openness of these carceral apparatuses of refuge, these dungeons of flight, these holds for fantasy, is the vocation of the ones who have been po(i)sed between exclusion and withholding, the ones who Brecht says study changes, the flightlings who work fugitive memories of superhydration in the sound of down and out avowing its own making and unmaking and remaking.[10] At stake is a general economy of imprisoned passage, an ante-epistemology and paraontology of the excluded middle from which nothing is excluded, it's non-vulgar time given in the eloquent vulgarity of everywhere out of nowhere. Passage is the common underground, given in movement's constant miscegenation of force and voluntarity, of the modes of regenerative interaction that hold bodies and populations together by tearing them apart. The poetics of passage are everywhere, out of nowhere, even out of black Chicago's migrant field, with its emissive heaviness and changed flavor, its ungovernable binding and charged color, its weakness and its strength.

This particular occasion of Theaster Gates in London comes in the aftermath of a set of sharp provocations emerging from the field of Afro-diasporic cultural studies. Crucial questions regarding the efficacy of popular culture and/or mass intellectuality—and, more pointedly, the placement of the range of U.S. particularities in the history of (black) Atlantic humanity and humanities—have been asked by a generation of brilliant scholars moving in the wake of Paul Gilroy's emphatic and persistent interrogation.[11] What would it mean, will it ever have been possible, to be central to, or to authentically body forth the diaspora, its disciplines and discourses? Can centrality and authenticity be, as any diasporic centrality and authenticity will have had to be, predicated on irreducible marginality? How would such interplay move? How would it operate and what would it make possible, even in the field or out of the depths of its inhabitation in ongoing, radical interdiction?

What will it have meant for such centrality and authenticity—either in their impossible actuality or in the rejection of or resistance to whatever enunciation of the very ideas—to be taken to stand in for the poor, in general, even as it is also taken to stand in for the rich, in general? The paradoxical nature of these questions is not meant to indicate that such convergences are impossible; rather, what must be discerned is what such convergences mean or, in their specific absence, what the phantasmatic ascription or assertion of such convergences mean. What is it—here, now, in a world of modern blackness—that Black America indicates?

Gates's love of collections (and divisions) makes it more possible to address these questions. He moves in the calculated drifting and promiscuous repetition of an experiment that is concerned with one incalculably differentiated thing: the fetish character of blackness and its open secret. He does so by way of an extended, multisensorial investigation of a specific field of inhabitation given in a vast archive of things. The informal precision of their coalescence is given in that resistance to catalog and category that marks the extra-American blackness of certain blacks in Chicago. That social field is Gates's curriculum. If this local abstraction moves us further along in the general gathering of dispersal that is called black art and black life, it is not because of its centrality and authenticity but is, rather, because of its specific enactment of the marginality and minority that is the central and authentic feature of blackness understood as a general, generative principle of differentiation. Blackness is the name that has been assigned to difference in common, the animaterial inscription of common differentiation, which improvises through the distinction between logical structure and physical embodiment. Physical embodiment is not this or that skin color or body shape but haptic graph. Logical structure is not this or that determined or determinate discursive frame but common informality.

The S-curve marks, with the kind of pleasure that is troubled from before the very beginning, therefore troubling beginnings and therefore still good, Gates's richly various movements and inhabitations. The crossing of water of and in his work is in mutual accompaniment of an internal dispersion in local (American) space. His place-making, thingly arrangements of things in unlikely gardens, all under the general atmosphere of having been taken *for* nothing in the ongoing, general (mis)calculation *of* nothing, moves to recognise and amplify unacknowledged wealth. He moves and makes things in and out of things that are of this first nothing the elixir grown, plotting and planning an incalculable multiplicity of ways in and out of no way. Some-

thing keeps on coming out of nowhere, as in the Black Monks of Mississippi and their extraBuddhist anaBaptist dirge, that cuts the difference between cabin, jug, and body in new, topoietic valorizations of container and instrument. Gates experiments in new habitable tactilities: (unannotated, atonal) scale in rough brick grain inside and out to be walked around (in) (and out of). As things make the space they are and the space they in, as London is the place for me insofar as it is isn't, expatriate calypso and punked-up ska, the music of Zanzibar, and of Tunis, and of the townships, and of the Kalakuta Republic, the African pan, the pan-African thing, that loving strife, that serially extracommunicative sound of the excommunicated, of the Delta's profane ministers and sheikhs, on top of the world they are under, unresolves into an ode to nothing, the immeasurable means of an ongoing throwing of ends and beginnings. I'm interested in the b section, the exclusionarily included middle, the bridge. B is for blurr, for the seriality of an extra r, dividing movements like a fantasy, like Theaster Monk's mood.

Gates keeps (not) arriving to tell us that the black history of monasticism in Chicago is theatricality in the wind. Traveling players extend a coenobitic drama of moving, of the moved, up 61 Highway. The south (side) is the serially dissed location of such dislocation. On the outskirts of or even underneath diaspora—which seems, in its more or less official formation, to have been all but ceded to eternally prospective homeowners—remains a certain commitment to wilderness, to wilder equal daughters, equal sons, whose out situation is set aside in the normative Atlantic relay. The conflict between the water's edge and up the country is all up in everybody. Sometimes, it's just the way some folks say theater, thee-ā-tuh, theaster, the actor, the actor slash director, the speculactor, that post-Boalian loop and plan and conduit and vestibule. There's a curve, a function, that won't stop, keeps getting deeper, as constant potential interplay between exponentiality and saturation, crescendo and decrescendo, plural and curl, theactive, thelonial reverb of incalculably small beginnings, more but without majority, approach but without climax or seizure, this constant irruptive unfolding of planning. *The Dorchester Project* works this way; *Plate Convergence* works this way—as field and feast for black study, for the university of abandon, an old-new massive intellectual fête of dispersed word and flavor given again and again in the growth, the evangelical permeation, of a population, how it sustains and revives, how it survives contingency and removal and occupation, its preoccupation with opening and renewal, in an interminable drama of contact. Chicago has seen this before in the counterprojects of the projects; in East Garfield Park's or

Grand Crossing's or Maywood's or Mayfield's advanced doo-wop seminars and revolutionary breakfasts; in the small acts, minor strains, and new angled arcs of critical making, tearing shit up in the general rupture; in difficult caresses theorized and distributed in velvet lounges, where Muhal Richard Abrams and Fred Anderson are maudmarthian dandelion farmers in the antipresidential legacy of communal organizing. Gates speaks about what it would mean to be a good citizen of Chicago; but it seems to me that he becomes something other than a citizen, detached from political ambition and, more generally and more importantly, from the political as the exclusionary field structured by citizenship's necessary anti-universality. He is, however, a mobile inhabitant, joining in agitation other inhabitants who have been committed, intellectually, spiritually, aesthetically, to another inhabitation. Lading is in our nature, says this anarepetitive sound, with a phonoaberrant *h* in it, just so you always remember that it always sounded like something. Theaster Gates, cultural planner, is an anti-, antecitizen of Chicago, where what's happening is that it hasn't happened yet, where the dispersed disrupts (in) her terribly beautiful dispersal.

Disruption takes the form of architectural hair. Or the face become color field—skin become fabric—whose broken, undulate, textural surface defies livery's insistent flattening in aggressive looks constructed by the unseen, under surveillance. But even after some extended meditation on the antifoundational nature of our makeup, it's hard not to believe that we are byproducts of a theory of the beautiful. Who must be stupid because she is black, who must be unfeeling because she does not blush, may, under the unbearable burden of this constraint, this difficulty in not believing, turn to a life of imitative refutation. Becoming black might then be seen as this extended performative argument held in the way we carry ourselves in fashion shows, with the help of Fashion Fair, in the interest of a self-fashioning that was always only structured by the scandalous interplay of physical appearance and philosophy. What Gates gives us is some sense of the tension between normative cosmetic statements designed to reveal, once and for all, the truth about us and an antiepistemological paintedness generally understood to be the idiom of dark ladies in the modern world; between fugitive, decorative sociality and political struggle's state-sanctioned, state-imposed decorum; between aspiration for a place in the world and exhaustion by and of the very idea of home. All this tension, which Fanon insists we consider in its irreducible muscularity, comes down, also, to matters of style, of style's in-

surgencies, whose incalculable generativity is also what is indexed by the term *diaspora*.

This is all to say that the interplay of vindication and insurrection, which Gilroy centers in the African American cultural and social milieu, is part of a general history of common dispersion. It is to say, moreover, that this interplay need not in its turn inexorably propel social theory toward another analytic oscillation between consumption and citizenship made possible by the acceptance not only of (a certain conception of) markets but also the state as natural arrangements that work "according to the specifications of orthodox economic [and political] theory."[12] We are left to consider precisely what anarrangements might be intimated in performances of and through consumption and citizenship, as well as vindication and insurrection, by the noncitizens who bear the mark of being-consumed, who bear the trace of an ongoing insurrection that can never be vindicated within the "legal" terms and structures of the administered world. Neither (African) American hegemony nor its transatlantic, north Atlantic staging can exercise full control over arrangement's continual improvisation. This anti–state of affairs is no less insistently, disruptively emergent because intradiasporic relations are now, as they have always been, mediated by the brutal forces that initiate the violent policing of the general dispersal, the general antagonism. On the one hand, because media exert the power to determine, we must consider, along with Gilroy, "that African American culture now contributes directly" to "the brand value and identity of the United States" as it sinks further and further into the depths of the imperial viciousness and venality that seems to be the *telos* encoded in its settler colonial origins.[13] On the other hand, because the domesticated structures of possessive mediation are constantly unmoored by the imaginative habits of the shipped, we must exceed Gilroy's grudging concession that "there may still be things to learn from the US acceptance of 'race,' providing that it is accompanied by an acknowledgment of the damage done by racism and does not become a blank resignation to the effects of racial hierarchy" in order to move toward a richer understanding of the dense, richly internally differentiated theoretical inhabitation of blackness in African American culture that is too easily misunderstood as "acceptance" of or submission to "the foundational absurdities of U.S. race talk."[14] As Tavia Nyong'o sharply asserts, by way of Denise Ferreira da Silva's massive theoretical intervention, "in dispelling race from its improper place in the order of the human sciences, casting it into disrespectability along with sorcery, alchemy,

and other bait for the credulous, we consolidate that much more firmly the protocols of scientific rationality," running the risk, thereby, of forgetting that "the protocols of science gave us race as an invidious distinction in the first place."[15] One need hardly add that the scientific discourse in question shares with the United States a claim upon European origins that is supposed to sanction, in turn, their status as official and definitive, particularly in the context of Gates's metacuratorial intervention which has, as its primary motives, the ongoing discovery of what is singularly terrible and beautiful in the (African) American example and the displacement—at once temporary and continual—of objects in order "to captivate and lure, seduce our audiences into a zone of cultural engagement, allowing the British community to reflect upon what these signs and symbols might mean in the context of British history."[16] Under circumstances designed "to leverage [Gates's] greatest readymade to simply present form and content, allowing people to dig into these histories and make connections where they make sense," what will the gallery now become? Will the White Cube readily be (re)made by the strangers who engage in the black poetics of make-up, or recombinant imaging, each in their own vexed, leveraged mediacy, each in their irreducible necessity to the unfinished project in which extralegal vindication, convivial insurrection, and alternative inhabitation still animate one another?[17]

Theaster Gates will mess you up if you let him. Theaster Gates will make you up if you let him. He facilitates your submission to your own critical imagining, with others. *On Black Foundations* is an antifoundational assertion of an antefoundational reality: that we mess and make each other up as we go along. This simultaneously deconstructive and reconstructive social poetics is restaged again and again in Gates's objects and engagements. The discovery is in unlikely places by way of the kinds of ominous public/private partnerships—the corporate entanglements and mercantile impurities—that stripe and striate modernity and its erstwhile subjects/citizens. Is Gates's present work exemplary of what Gilroy calls the pursuit of "the expansion of African American access to capitalism's bounty"?[18] Is the present writing nothing more than a misunderstanding structured by a dream "of the system's overthrow"?[19] Or is Gates's work productive of precisely that rich, insistent, antiracist, common, communist meditation on "the interpretive significance of slaves having themselves once been commodities"?[20] It strikes me that Gates's art not only both requires and begets further dark speculation on the matter of dark speculation but also that it stages the planning, by revealing the history, of the open institutions in which such theory thrives—

not in the reactive negation of reification, however justified and necessary such a maneuver seems, but rather in the refusal to fall for the ruses of incorporation and exclusion that say all we can and should desire is citizenship and subjectivity. Gates sounds an epitaph for that desire in alternative longing that loudly keeps its own apostolic counsel. Look at the open, secret, sociopoetic ceremony he keeps finding nowhere, everywhere!

Nobody, Everybody

What if we could detach repair not only from restoration but also from the very idea of the original—not so that repair comes first but that it comes before. Then, making and repair are inseparable, devoted to one another, suspended between and beside themselves. Harold Mendez makes changes, out of nothing; flesh, out of absence. His work, which is more + less than that, more + less than his, calls us to that suspense, to the contemplative frenzy of detail, the general meadow of invention, the generative movement of the *pre*. In this regard, like Francis Ponge, his dictaphonic caress of things, colder than absolute zero, more + less than that, more + less than his, is analyric lysis, the slides and cross-sections, the burning life of a thousand cuts, sounding the absolute look; like Terry Adkins, he recites when he installs, and passing through is our audition and rehearsal, more + less than that, more + less than ours. Off, in and out of your own words that are not your own, right now, which is always before us, repeat after me repeating after him what you must have been saying all along since here you are: the work is at prayer; we are at prayer in the work; in response, we call the work to prayer. To pray for the repose of the general practice of repose is an underconceptual veer from the history of art in order to take the way back into that history's ground, under that ground, under its skin, at play as the surface burrs, feeling its immeasurable depth, skin underneath itself, all up under that, which is deep, which is the ascendant bottom, where the propositional content of the preposition is nothing but noise, on, off, in, out, over, under, through, fray, merge, fringe, verge, pore, duct, surge, yeah. Surface everywhere and nowhere, if this is who we are, to pray the anoriginal repair.

What if we could prepare, as seal and tarry, this waiting? Fleshwork's gest and bearing multiplies the veer, as geistic feel. If you look closely, through the solid, one given and taken away as some's partiality, close enough for the arithmetic of the definite and the indefinite to explode into skin's transfinite

diamonds, then it's some work going on. Then something unfixed is fixing to happen and there's an image of something getting ready to take place. Something getting ready to get made and unmade out of nothing up in here. Some fabrication up in here waiting. A vestigial picture of fabric's event. Preparation shines in suspense, the degenerative and regenerative sight and sound of things, *de re*, the real, unsettled rim. Trying to prepare the edgework, the anaprepositional surfacework, the underconcept and anechology of earthwork, so we can pray. Wrapped in this radiated weave of sackcloth as prayercloth, trying to prepare the cold, the freeze inside and out that quickens prayerful looking slow as dreamwork. So close to who we are. We're so close to where we are. Close edge, he says. How can we make amends? The sound of the call to prayer is strand. Look closely through that solid border. To show the composure of this coldness is cold fire. Had the price of looking been blindness, I would have looked, he says. Everybody's there. Nobody's there, he says. They occupy. We are preoccupied in an unavailable resort, he says. The civil butchery of its knives and textured sequestration, where the walls leave marks and the doors are just the memory of doors, because see how far outside we are inside? In dreams, he says, I look closely through the block through which they look through us. Surface is deep, he says. Plane is thick and rough. Certain facts (blackness; its variously lived experiences; its undercommon dispersal; the epidermal and its vestibular folds, jewels, veils; our haptic devotions; the chapped chapels; the particular church; the beautiful concert; the terrible consort; the gold, brutal variations) bear this. Bear this out. Carry this out, improperly, he says. We who can't wait keep waiting on this ongoing advent of texture. We who are nothing, we who have no one, can't wait for you to learn how to wait for it. We who have nothing hold it in reserve. We're at your service. We can't wait for this impatience to repair. Our look is cold, so cold it's cool and bears no judgment. So cold it burns and won't belong, no word is bond, we're all so close, we're all right here, outside your jurisdiction, criminal in the work and out of phase, at prayer, in preparation, of repair. This is the airy ground that he keeps working, herald on the mend and off the edge.

Remind

I rode up to the Forest Houses from Soho in a limousine called *Precarity*. The night before I'd been stopped and frisked in the lap of luxury. The way they say sir is worse than the way they say nigger. As property, I was properly protected and therefore more than tired. I didn't think I needed the reminder, but their questioning, that interplay of menace and popo theory, was a slave ship. So by the time I got to the *Gramsci Monument* I'd already been there, in the grave of all that's nothing, for a while. I mean, I'd been reminded, even before I got to the reminder, so I could rub and be rubbed in the remainder, which surplus thieves and zombies can't remember. Their shiftless shit is automatic. Their shit is our automatic transmission. So we have to slow down, to remain, so we can get together and think about how to get together. What if it turns out that the way we get together is the way to get together? I mean, and this is an analytic proposition, not many of which are actually necessary, that everything is everything, which is a Donny Hathaway formulation, which is something more + less than the world is all that is the case. We came to rest on the outside. There probably ought to be a Wittgenstein Monument but you couldn't get from there to the earthly and unearthly thing Gramsci's anarchic ark gets you to, as bridge to and away from itself, as its own kicked-away ladder, its own exhausted hegemony.

Monuments are meant to put us in mind of something. To be put in mind is a strange construction. To be reminded, to have something brought to one's mind, to have something put in one's mind, is articulated as one having been put in (the) mind of the thing of which one is reminded. With regard to the *Gramsci Monument*, I can speak, strangely, of having been put in (the) mind of the house in which I was raised, of my old neighborhood, of my lost friend, smiling, who came to find me there (in Cubie, in Hialeah) and my memory serially conceived as autonomous transportation to what is no longer or to what was never either here or there. Still, what remains, undeniably, is having been moved. I was writing before I arrived, as arrivant in constancy, in the hold, held in the rub. Moved by what had drawn me there,

which is also what had sent me there, still arriving there, where I had never been, prodigal in this immediate and overwhelming sense of having been there, poor in the spirit in which I am sent.

Now that it's gone, into a more + less than material part of the matter it reminds, I wonder about the tense of *Gramsci Monument*, which is a *Monument to the Minds of the Little Negro Steelworkers*, which is a Thornton Dial formulation. Is and was are blurred, not resolved, in its dismantling but also in the fact that it was there before it was made. There's a profanity, which we just always mean to practice, given in this hard-wrought poetics of rough-hewing, that misshapes our ends. It lies ahead of us, passage to what it puts in mind. Remember that it hurts more than anything to say this. The ark(estra) is an ark of bones, a ship of fools. Do you remember or are you that memory? The revolutionary madness of the work, transmitted as aroma, in the relay between smoke and provision, is *nostalghia*, a village mobilized in ruins.

Thomas Hirschhorn calls the *Monument* a paradise. If I had been there more, if I could have kept being there, which is something I have kept wishing for, I would have come to know it as paradise, too. Paradise is a place where we exercise the hopes and dreams of paradise. The *Monument* was a bridge to and away from itself. The utopia parkway of the South Bronx, with its own articulate boxes, marked, as if plywood's rain-softened yellow fade were a clear window, anaredactive covering of a dandelion insurgency, which is a Gwendolyn Brooks formulation, which begins another way of seeing that it lets you see, the sepulchral transparency that makes things clear. The job of resurrectors is to say good morning. Give me some dap and roll it away.

We walked the boards of an open poetics, a mountain blacker than black, brown and blue as New York out of school. If you need some, soul, come on, get some, which is a James Brown formulation. We *been* here. Can you be open to saying that? Claim your (under)privilege. "Being present is crucial." Presence, having interrupted presentness to release it into the air, returns in this walking, along this pathway, the bridge that isn't crossed but inhabited, whose preoccupations are shared in unshared authorship. Thomas, this ark disrupting arc, your arkestral unsharing, makes me want to recover sharing from you for you. Come get some more of these differences we share. Are differences our way of sharing? Let's share so we can differ, in undercommon misunderstanding. Our undercommonness is that we have no standing. That's all it is, that's where it's at, in the open we keep making.

The paradise of the unfinished community, beloved in the way it loves its flesh, damned in the way that only flesh is damned, is the paradise of the

informal. Paradise is form's emergence in experimental exercise, in disruptive practice, when we greet each other in exhaustion, our limited subshine in prayerful agreement, in "the incredible agreement of Erik Farmer," which is more + less than hegemonic hum. It's like the space of sharing is instantiated in the space between sharers. It's like that space is open secrecy. We miss, we dodge each other's understanding, a general feint we give and take in the absolute ensemble of proximity, in the projects, of the celebrants, originally of the mass.

The little abduction, in which I immediately become trivial, and the black site's off-site comfort: this is a contradiction called loneliness, having been secreted, held incommunicado, right in the middle of the world, until Danny and Max and Bob and Rich and Greg and Diedra came to watch with me for a while, and then it was more and less than black enough to arrive, to remember things that let the sunshine in my memory, and here come my lost and found friend, smiling, to remind me that loneliness *been* gone. Theodor Adorno writes about the loneliness of the ambulatory city-dweller and Giorgio Agamben, more closely attuned to the physicality that contains and transports solitary reverie, ties that loneliness to a loss of gesture. But all this depends on where you're walking. I knew the arrest of my downtown wandering was a tangle of anomalies—not supposed to be down there, not supposed to be down there in the way I was down there—but in the novelty of my being down there what comes into relief is that where I was was not where they usually arrest us. This kinda shit happens every day, yeah, but not downtown so much as way uptown where I had come, now, so I could feel more free. Against the grain of the fact that I couldn't choose it, there was an enchantment I'd chosen. In the forest there was a kind of magic city.

Multiplicative identity was anchoritic up in there. Against the false generality and absent generativity of citizens talking to one another, there were outside voices inside. The library wasn't rigged for silent reading. There was a transliteration of combs and house shoes. An amplification of notebooks and things were given in that it would never occur that they should be for everyone because they were for anyone. We begin contemplative life, which is momentum in repose, refusal's monument to itself in being moved against moving, as a pattern of tremendous trees or Davy D's unbudged needle. The daily recording of practice has become our practice—of prophecy—itself. Let's see how it would be to live the way we live. Let's make a refuge, which we refuse to settle, for which we refuse to settle, within which we can enjoy the refuge to which we've long been given. In being visited, in our ongoing

defiance of loneliness, maybe they'll leave us alone. But I don't even know how long before I got there this was written. I just want to remember something to you, to put you in mind of something. This is just something to put on your mind, which is a Curtis Mayfield formulation. There was a kind of shimmer. I wish I could make you hear it as a kind of hush.

Amuse-Bouche

You came to see human bodies tonight, but she said this is "holy work and it's dangerous not to know that 'cause you could die like an animal down here."[1] She was talking about making dances—pacing back and forth across bridges, riding up and down the block, selling loosies on the corner, walking in the middle of the street. The hazard of movement, of moving and being moved, of knowing that we are affected, that we are affective. There's danger, too, in the very fact of this reminder, even if it's just a taste, of what you haven't seen. The maternal is a radical exteriority the eucharistic consumes. Time and again and out of time we're lost in the re*mater*ialization of this loss, another invaluable impersonation done gone, sometimes of natural causes, sometimes in refusal of naturalization. That's when he (I mean that man, you know, the man, the one, the one who looks like everyone and no one, as you know) tries to control the more-than-human by calling it less than human. The quasi-autobiographical modalities of our story, of however many years a slave, which try to render thingliness relatable, model this regulation precisely in seeking after it. Relatability, which is subjection's scene, the romantic subject's haunt, is the naturalization of what can't help but be a docile body. It comes to light as the production of corpses on or underneath the thoroughfare. The only way to come through this *bildung* in the service of destruction and rebuilding, that contract, that contact, that refusal of surrender, is to extend the ante-autobiographical modalities of our story. Our consent to be inseparable, our constant escape from what our constant escape induces, even from time even when we're on it, requires us to live in danger.

So may I offer you something? Something rich and strange, an abundance, but on a plate so small it's not even a plate; a spoonful, really; just a mouthful, just enough to taste, just for a moment, the alchemical magic, the terrible and beautiful and immeasurable richness and impurity of a train or a streetcar or a sidewalk held in the flavor of solfège, in simultaneously

encrypted and decrypted composition, sung until it can be tasted, that taste made music from *embouchure* to *batterie*, hand to mouth, in ongoing haptic incident and percussive hors d'oeuvre. If you've never been offered something like this before, I can only imagine your frustration at being enjoined to imagine dance before you can attend to it; and by way of this intangible offering from so far away; and by way of something which is, if not quite nonsensical, moving by way of the wrong sense. The synaesthetic reach is probably too little and too much: a proprioceptive failure—a sharp disorientation—appears to be immanent as well as imminent. Nevertheless, beyond the bonds of taste, feel how much of dance—of the chorographic, choreographic life you've been living and are living and are about to live right here, right now, in this bearing that we can't quite get—there is to be tasted in and by way of Samuel R. Delany and Cecil Taylor.

She opened her mouth, feeling her tongue's weight on the floor of her mouth, the spots of dryness spreading it, and tasting the air's differences, which marked not the air's but the tongue's itself.[2]

When I was in the Conservatory, there was a Southern woman who taught English the first year that I was there. . . . She was talking about Tennessee Williams, and she was talking about *Streetcar,* and she said, "The language in that play, there are sections of that play that are so good," she said, "that I could actually taste it." . . . Mother always had me reading. Mother spoke French and German and brought Schopenhauer to me when I was eleven years old, but that was something else— that was—you didn't have a choice there with Mother. Boom! That's the way that went. But here was this woman who just said this, and I heard it. And her emotional dedication to a word—I said, "Wow, that's my dedication to music. You mean it's possible to have that kind of dedication to another art?" So, that.[3]

Moved movers amid the intensity of the pas de deux my offering asks you to imagine, Delany and Taylor are bound in what Denise Ferreira da Silva would call the affectability of "no-bodies."[4] Bound for that embrace, they hold, in their openness, to its general, generative pattern. Openness to the embrace moves against the backdrop of exclusion and the history of exclusion, which is a series of incorporative operations. This is how openness to being affected is inseparable from the resistance to being affected. Dance writes this push and pull into the air and onto the ground and all over the skin of the earth and

flesh that form the city. The words of these moved movers have something specific to do with dance, and I want to talk about that specificity as an interplay between walking and talking, between crossing and tasting, between quickness and flavor. Their words and work form part of the aesthetic and philosophical atmosphere that attends the various flows and steps that have taken place in and as New York City over the last fifty years, especially downtown in the serially and simultaneously emergent and submergent dance space between two churches, Judson and St. Mark's. I want to call upon this history of devoted heresy, of transgressive congregation, because, as with most of what we know of atmospheres and their conditions, the astral air and gritty fluid Delany and Taylor have long been circulating, rich with the mineral, venereal, funereal character of New York's paved soil, its palpable, haptic aroma, the way it gets rubbed into and out of yourself and others in the jam and crush that tends to mess and mix up selves and others in the grand, eccentric compound improvisation of the city—because that kind of knowledge, our knowledge of all that, our capacity to think in and with our inhabitation of all that, is too often suppressed in crowded, solitary busyness. It takes a lot to feel yourself walking around, mouth open in wonder and/or desire, as eager to taste as an Arkansan, or an Oankali, out looking for where the dragons might be.

Genitals, buttocks, nipples, tongue all seemed so insistently present inside Sam's mouth and twenty-four-hour-worn suit. Once, well back before dawn, when the train windows were still black and the other passengers slept, he had stared at one white round glass, thinking of the moon, when, at once, he'd stood, to bring his mouth closer and closer, as if to kiss this night light at the aisle's end, pulling back only when the heat about burned his lips.[5]

Yoruba memoir other mesh in voices mother tongue at bridge scattering Black.[6]

We shared an apartment for a while, and I had the opportunity to watch him practice, and his practicing revolves around *solfège* singing. He'll sing a phrase and then he'll harmonize it at the piano and then he'll sing it again, always striving to get the piano to sing, to try and match this feeling of the human production, the voice, in terms of pianistic production so that it gets the same effect. Cecil's trying to get the vocal sound out of the piano, and I think he's achieved it on many

occasions. You can almost hear the piano scream or cry. It's worked for him.[7]

In their shared preoccupation with bridges and their variously creative use of cantilevering; in their questions concerning the architectonics of the graph, and of the graft, and even of the grift; in their investigation of the trick's subsocial emergency, the aesthetic and sexual imagination's passage between lawmaking and lawbreaking, the centrifugal range of holistic difficulties that mark the relationship between the bridge and a kind of engineered, sculptural, and machinic thingliness that fleshes forth history, that juts or walks or gets walked out into history as a kind of manufactured outcropping or as out speech, that speaking out into history that animates queer performance, black performance, and their convergence, Delany and Taylor reveal that dance is the city's mother tongue. The bridge marks, because it also is, where crossing over crosses over into smuggling, a transportation of lost and found desire, lost and found matter, both of which move in constant escape. The bridge's errant merger of rant and merge is given in the audiovisual logisticality of the cry from Edvard Munch to James Brown; but concern for it must be registered in close attention to the mouth—to the feelings of words and sounds on the tongue, the taste of herbs and roots and cream and flesh and glass, the bridge where the tongue rests—and to the fingers, too (another transfer within song toward tactile, percussive lyricism) and to the variously good and bad feet that carry them. The passages above allow for that further investigation as does the use of solfège as a pedagogical tool by Taylor's teachers and, then, as a pedagogical-compositional tool by Taylor himself. Consider dance as a matter of mouthfeel as well as footstep (of a song, or story, the physical-chemical reaction that occurs when the idea is sounded, a birth effect given in combinations of *soufleé, saveur,* and *savoir-faire*). The essay I'll never write would have been an ode to *la* and *mmm.*

That's the soundtouch of an aberrant cruise inside the straight line, which uninstalls directness in interior paramouric curve or cave or cant, sticking out from itself but slant as a kind of gesture, in a kind of dedication, where the senses have become theoreticians, where aesthetic experience is a literal and literate transfer of substance. Between the oral and the aural there's some commerce at the level of taste: material tactility, material event, material inscription. In *Just above My Head,* this is what James Baldwin is after between Arthur and Crunch: circuits of lyrical emulsion and theoretical image. Knowledge of this dedication is given by way of parental—but please,

in the interest of another movement, of *mmm* and all it stands for, of the general and pansexual maternity that animates materiality, indulge me if I say *marental*—lesson and lesion and loss. There's a kind of violence to black/queer maternity that deals in the liberatory force of endangerment. Toni Morrison speaks of a certain extremity of this force but its mundanities—not necessarily any less spectacular—animate the tradition she extends. The hazard is abandonment, which is inseparable from the grace of abandon. Delany and Taylor speak (of and in) this movement.

My mother died when I was, like, thirteen or fourteen.[8]

After my father died, I went into analysis. It was Sullivan analysis, a kind of analysis that built on the theory of interpersonal relationships. The analyst would help steer your course. There is a relationship between the analysis and my music, even though it's hard to define. The fact is that, being a musician, I had put a lot of things into music that music itself was not able to resolve. That is, music is the creation of a language out of symbols, of sounds, sounds that cannot be spoken and therefore create a kind of personal isolation. If there are problems that music cannot answer wholly, you either have to have friends whom you can trust not to destroy you with whatever you give them of yourself, or you have to go to a neutral source, and that is what analysis was for me.[9]

When I came out of school, the first thing that I did was to walk down 125th Street and listen to what was happening. And it took me maybe a month before I started digging. That was the beginning of, like, the other education. I mean the participation in, and the doing of, the thing.
 . . . (I try to imitate on the piano the leaps in space a dancer makes)[10]

The dance, I think, had its results on his [Taylor's] playing because a lot of his playing depends on body motion, especially the fast playing. He does things with a speed that most pianists, if they heard it on a record, would say, 'How does he do that?' It has a lot to do with the rhythmic flailing of his arms or his ability to move his body back and forth like a pendulum from one end of the piano to the other so that he can put his hands in the proper position, and I think his interest in the dance has a lot to do with that.[11]

"My father died of lung cancer in 1958 when I was seventeen." This is just not a sentence that, when an adult says it in a conversation seven or a dozen or twenty years after the fact, people are likely to challenge.

And when, to facilitate my Pennsylvania scholars, I put together a chronology of my life, starting with my birth (April Fools' Day, 1942), that sentence, among many, is what I wrote.

I don't remember the specific letter in which one of them pointed out gently that, if I was born in 1942, I could not possibly have been seventeen. In 1958 I was fifteen up until April 1 and sixteen for the year's remaining nine months. Various researches followed. . . . Finally, in an old Harlem Newspaper, a small article was unearthed that confirmed it; my father died in the early days of October 1960.

I was eighteen.[12]

In October, almost exactly a year after my father's death, Marilyn miscarried. She recuperated in my sister's old room at my mother's apartment. Two or three weeks later, she got a job as a salesgirl at B. Altman's department store. Let go even before New Year's almost immediately she got a job as an editorial assistant at Ace Books.

Probably within a week (certainly no more than ten days), after a set of obsessively vivid dreams, I began what, not quite a year later, would be my first published novel, *The Jewels of Aptor*.[13]

On a chill, immobile evening, during a midnight November walk, through a window in an alley adjacent to the Village View construction Marilyn glimpsed two or four or six naked people—multiplied or confused, in a moment of astonished attention, by some mirror on the back wall, as the window itself added a prismatic effect to the bodies inside, gilded by candlelight or some mustard bulb—before they moved behind a jamb, or she walked beyond the line of sight, the image suggested proliferations of possibilities, of tales about those possibilities, of images in harmony, antiphon, or wondrous complementarity. Once, when I was gone for the night, she went walking— and was stopped by two cops in a patrol car, curious what a woman would be doing out in that largely homosexual haunt—on the Williamsburg Bridge. It was a time of strained discussions in our tenement living room, in the midst of which a bit of plaster from the newly painted ceiling would fall to shatter over the mahogany arm of the red chair.[14]

My father died when I was sixteen, when I was eighteen; my mother died when I was, like, thirteen or fourteen; when I was thirty-seven, but I was thirty-eight, my mother and father died. Note the temporal confusion of a loss that makes you move, that puts you in motion, bearing you out onto the city streets. Delany writes of an abyss between columns waiting to be bridged, itinerant flight through soffit and cistern, where one enters into another scene, into contact, in which one becomes more and less than that. Taylor's autobiographical narrative pylons, the burred, felt precision of the recollection of marental loss, move in their relation to Delany's. Then the music becomes self-analysis, improvisation taking over the function of a certain distance, where private language and personal gesture move from solipsism to the social. There's a thinking of the kinetic thing that Taylor engages—the participation in, the doing of, it. There's a theory of illicit exhaustion and insistence that he gives, coming out of an experience of the ordinary in and as movement like a feel *Trio A* or some undercommon *Caminhando*, Yvonne Rainer and Lygia Clark channeled in asymmetrical, off-stride walking and cutting, hip flaneuses returned to get deep in the tradition of the everyday thing, a thin-curved slice of life, a fugitive trench, an almost interminable *tranche*. This is the general dance project we share tonight, supernaturally; this is solfège by Duke Ellington, his suite for Alvin Ailey, a bridge over *The River*'s repercussive cascade, the music of things worn, strummed but also beaten, to airy thinness, in nothingness, as indiscretion.

Yet Cecil Taylor has no compunction about transferring to jazz any innovations that might be useful. He opened his section of a December, 1963 Jazz Composers' Guild Concert at New York's Judson Hall with an improvisation for tuned piano. Strumming tuned piano strings is a device rarely used in jazz, and it is obvious that all those blues chords and chord changes, rhythms and melodies that have been the definitive substance of jazz could not be played in any recognizable way on the inside of a tuned piano. But the piece was well received by the jazz-oriented audience, and Cecil, who feels that he has only one music, whether it is played inside or outside the piano, and who regards himself as nothing but a jazz musician, did not feel that he had compromised himself in the least. Buell Neidlinger described the performance: "I don't find any of the sounds Cecil makes on the inside of the piano at all similar to John Cage or Christian Wolff or Stockhausen or Kagel. I know he's heard all that music, but the implements that he

uses to play the inside of the piano are nothing like the ones that they use. For instance, he uses bed springs, steel mesh cloth, things that he lives around. And like those cats are using rubber erasers, corks, felt mallets. Cecil's is a much more metallic sound, very brilliant, but the Western cats soften the piano down.

"In the Judson performance I played the sustaining pedal and the keyboard and Cecil played the inside of the piano. It was fabulously successful, but it was entirely improvised on the spur of the moment—there was absolutely no rehearsal of that at all. On that tune there was just the drums and myself, and I was able to reach under the piano with my left foot and play the bass at the same time."[15]

In that other essay I would have been more delicately emphatic in approaching this exhaustive collection of approaches. When Taylor says you can't just walk up to the piano any kind of way, when Delany details a history of the broken world in calculated, but nevertheless incalculable, drifting, a dance is being danced from which a range of composition is improvised. Opening the piano recalibrates swing; it's another way, in and in extension of the tradition, of organizing sonic energy. Something is given in this penetration of the instrument that is allied to orchestral song and dance. A ritual of approach is already given here that culminates in performance with Min Tanaka on the street that time, in refusal of the tonic, outside of Tonic, in what they used to call Loisaida, and then this last time in Kyoto, that long, slow, felt, sensed, anarepetitive inhabitation of our fallenness and our flight. What's the difference that Neidlinger hears and senses in these encounters of penetrative, penetrated objects? Taylor's implements are everyday objects, "Things that he lives around." Canted, this is the bridge Delany lives around, where matter and desire are lost and found in mist and mystery.

Usually when the moon lingered toward the day torches were not set out, and he'd be able to see all the way across the bridge, into the market square, to the glimmer on the water that plashed in the fountain at the square's center—as long as the stalls and vending stands were not yet up.

But tonight, to fight the fog that now and again closed out the moon completely, the torches had, indeed, been lit. As the cart rolled onto the bridge, waist-high walls at either side and clotted shallows beneath, the weak fire showed the crockery shapes under the lashed

canvas; then firelight slid away, leaving them black. And the bridge thrust three meters into dim pearl—and vanished.

He cuffed the ox's shoulder to hurry her, confident that the old structure was the same stone, bank to bank, as it had been by day or by other nights. Still, images of breaks and unexplained fallings drifted about him.[16]

On —th Street, just beyond Ninth Avenue, the bridge runs across sunken tracks. Really, it's just an extension of the street. (In a car, you might not notice you'd crossed an overpass.) The stone walls are a little higher than my waist. Slouching comfortably, you can lean back against them, an elbow either side, or you can hoist yourself up to sit.

There's no real walkways.

The paving is potholed.

The walls are cracked here, broken there. At least three places the concrete has crumbled from iron supports: rust has washed down over the pebbled exterior. Except for this twentieth-century detail, it has the air of a prehistoric structure.

At various times over the last half-dozen years, I've walked across it, now in the day, now at night. Somehow I never remember passing another person on it.

It's the proper width.

You'd have to double its length, though.

Give it the pedestrians you get a few blocks over on Eighth Avenue, just above what a musician friend of mine used to call 'Forty-Douche' Street: kids selling their black beauties, their Valiums, their loose joints, the prostitutes and hustlers, the working men and women. Then put the market I saw on the Italian trip Ted and I took to L'Aquila at one end, and any East Side business district on the other, and you have a contemporary Bridge of Lost Desire.

It's the bridge Joey told me he was under that sweltering night in July when, beside the towering garbage pile beneath it, he smelled the first of the corpses.[17]

Transfer is hard life. The history of approach is terrible in its ongoing removals and violent translations. Unnatural causes burden every step you take. In the city, under the bridge, tonight, murder animates the history of dance, so you have to turn enjoyment to refusal and be open to the things

you live around. How are you getting home tonight? Pretty soon it'll be time to go out into the pearl.

She said, if you're ready to be less and more than human, to be nobody, to have no body, to claim the nothingness that surpasses understanding, then recognize and move against the killing even if you think it's not you that's killing or being killed. We study noncompliance with civil butchery. X and 'nem were walking in the middle of the street. What can we do to match that danger? Abandon flown in and out of abandonment, dance is the risk of movement. Dance is movement at risk. Noncompliance is contact improvisation. He's trying to kill this ongoing walking down the street together. He's gone, unburied angel, and we are anti-gone, against the times. We study the sacrament of self-defense, which is fulfilled in the persistent practice of what we defend. Always already less than human, we're more than human in public. Evidently, there can only be one human at a time. Humanity is antisocial, evidently. Calm the tumultuous derangement and mow your lawn, he said. You can be human by yourself but black don't go it alone. It's a social dance, unruliness counterpoised between riot and choir, and our melismatic looting is with child, sold all the time, but never bought. Our numbers are queer, they won't come out right, 'cause we keep moving like simple giving in the remainder. The human is never more or less than one. More and less than one, we're walking down the middle of the street. We study staying unburied in the common underground. Don't let him humanize us. Don't forget about X and 'nem. We an' dem are more and less than that. We an' dem and X and 'nem a-go work this out. We've made some other plans. Your mama's baby's flesh will raze the city. In that crossing, in the rub it bears, we'll raise the city. We are the engine that will raze this city. What neither begins nor ends is that we are the engine that will raise this city. On Earth, where we read the worlds he makes in force against song and dance, we are instruments at work and play, in touch and taste, of tongue and roof, for mouth and bridge. Just a taste, and our amusement, and it's gone. This is our invitation to dance—out of nothing, till there's nothing at all.

Head Collective

0.

In the hope of renewing the antiprofessional profession and professoriate of deviance, where certain sly growls and sweetly devoted cuts of pedagogical irascibility-in-love sound the deepest commitment to insurgent study, let's move in the prolific distinction between the city and the commune that animates these passages from the *Grundrisse*.

> With its coming together in the city, the commune possesses an economic existence as such; the city's mere *presence*, as such, distinguishes it from a mere multiplicity of independent houses. The whole, here, consists not merely of its parts. It is a kind of independent organism. Among the Germanic tribes, where the individual family chiefs settled in the forests, long distances apart, the commune exists, already from *outward* observation, only in the periodic gathering-together [*Vereinigung*] of the commune members, although their unity-*in-itself* is posited in their ancestry, language, common past and history, etc. The *commune* thus appears as a *coming-together* [*Vereinigung*], not as a *being-together* [*Verein*]; as a unification made up of independent subjects, landed proprietors, and not as a unity. The commune therefore does not in fact exist as a *state* or *political body*, as in classical antiquity, because it does not exist as a *city*. . . . The commune is neither the substance of which the individual appears as a mere accident; nor is it a generality with a *being and unity* as such [*seiende Einheit*] either in the mind and in the existence of the city and of its civic needs as distinct from those of the individual, or in its civic land and soil as its particular presence as distinct from the particular economic presence of the commune member; rather, the commune, on the one side, is presupposed in-itself prior to the individual proprietors as a

communality of language, blood, etc., but it exists as a presence, on the other hand, only in its *real assembly* for communal purposes; and to the extent that it has a particular economic existence in the hunting and grazing lands for communal use, it is so used by each individual proprietor as such, not as representative of the state (as in Rome); it is really the common property of the individual proprietors, not of the union of these proprietors endowed with an existence separate from themselves, the city itself.

. . . Now, wealth is on one side a thing, realized in things, material products, which a human being confronts as subject; on the other side, as value, wealth is merely command over alien labour not with the aim of ruling, but with the aim of private consumption, etc. It appears in all forms in the shape of a thing, be it an object or be it a relation mediated through the object, which is external and accidental to the individual. Thus the old view, in which the human being appears as the aim of production, regardless of his limited national, religious, political character, seems to be very lofty when contrasted to the modern world, where production appears as the aim of mankind and wealth as the aim of production. In fact, however, when the limited bourgeois form is stripped away, what is wealth other than the universality of individual needs, capacities, pleasures, productive forces, etc., created through universal exchange? The full development of human mastery over the forces of nature, those of so-called nature as well as of humanity's own nature? The absolute working-out of his creative potentialities, with no presupposition other than the previous historic development, which makes this totality of development, i.e., the development of all human powers as such the end in itself, not as measured on a *predetermined* yardstick? Where he does not reproduce himself in one specificity, but produces his totality? Strives not to remain something he has become, but is in the absolute movement of becoming? In bourgeois economics—and in the epoch of production to which it corresponds—this complete working-out of the human content appears as a complete emptying-out, this universal objectification as total alienation, and the tearing-down of all limited, one-sided aims as sacrifice of the human end-in-itself to an external end. This is why the childish world of antiquity appears on one side as loftier. On the other side, it really is loftier in all matters where closed shapes, forms and given limits are sought for. It is satisfaction from a

limited standpoint; while the modern gives no satisfaction; or, where it appears satisfied with itself, it is *vulgar*.[1]

That distinction allows Karl Marx both to define property (with the serial, locomotivic intensity of a runaway tenor man) and to distinguish it from wealth. Moreover, that distinction's offspring—the difference between personhood and citizenship that grounds Marx's critique of the abstract equivalence of bourgeois subjects (in the delusional isolation of settlement, enclosure, propriety, home), which is nurtured in the appositional rub of personhood and thingliness afforded by a kind of deviance from and in Marx's elucidation of the commodity (its fetish character, its secret, its relation to the very idea of a general equivalent)—is poised to grow into the rough beauty of the "real assembly." We ought not be able to keep from imagining the real assembly—the gathering of things in the flesh, of fantasy in the hold—as the fecund caress of earth/commune/school/lab/jam/(collective) head, where the performed devotion of calling and responding in anarrangement refuses every enclosure of its resources.

To speak of the thing that is before the city—as the previousness of a rigorously imagined contemporary projection of an insistent, departive turning over of soil and blood and language—is to engage in something that wants to be called sentimentalism while asking you to remember that sentimentalism is the aesthetics (which is interinanimate with the extrapolitical sociality) of the unfinished project of abolition and reconstruction that is our most enduring legacy of successful, however attenuated, struggle; and that sentimentalism is too often and too easily dismissed by students and devotees of power, especially in its connection to what they dismiss as identity politics (where such dismissals are always hypercritical of [nonmale, nonstraight, nonwhite] identity while courteously leaving politics to its own uncriticized devices. To be interested in the rematerialization of wealth as something outstripping, even as it is constitutive of, limited bourgeois-imperialist forms and modes is to think such rematerialization as an anticolonial complaint for the anarchic, undercommon) permeation borne by what would have been outside, where we work and work out the poetics of our beautifully ugly feelings, as Thelonious Monk + Sianne Ngai might say. To be interested in this subtensive irruption is to be concerned with what a genuine anticolonialism might be.

My teacher, Masao Miyoshi, studies and extends this subtensive irruption by way of architecture's vexed instantiations, its mixture of tragedy and

utopia, its interinanimation and repression of work/thing/play/image. Operating at the intersection of performance and architecture, at performance's disruption of architecture, its bringing to bear on architecture an outside/r, Professor Miyoshi is concerned with the rupture of restricted economies, those privatized sites of public exclusions in which the naturalized limit, like some retroactively indeterminate wall or door of houses that are imagined to have built themselves, bespeaks a mode of rationality that would posit the externality as something other than either the effect or object or victim of surreptitiously intentional nonintention. Exterior things pierce naturalized economic exclusion, envelopment, and exploitation, thereby initiating the work of abolition and reconstruction: on the one hand, they body forth antagonisms; on the other hand, and deeper still, in discovering them, inventing them, making three- or four-part inventions and interventions in or on them with the outside human voice of city nature, they intimate the general antagonism, the general economy.

Reflecting on the (anti-)aesthetic experience of the immediate peripheries of Taipei, Tokyo/Yokohama, and Seoul, Professor Miyoshi considers the outskirts of these intensely localized communes in capitalism's newly reglobalized space as monuments to an accumulative drive that marks the derivation of the proper from the commune. He also notes that while they are erected with the ironic capitulation of a certain mode of architectural genius, these communities are often characterized by residents and tourists alike as drab, sprawling, unattractive working- and middle-class slums. However (or, perhaps more precisely, therefore), Professor Miyoshi's reflections turn toward the life that is both embedded in and escapes these city edges (as the outside that allows the very constitution of their centers), which is symbolized by the merry playing of children and the everyday work of their elders, something Marx gestures toward in the presupposition of their activity, which is represented as individual property by way of the power that is vested in, and invested by, enclosed commonality and which is, before that, in the double sense of before, the thing that underlies and surrounds enclosure. Professor Miyoshi's complaint, a recording with differences of the beautiful music that emerges from and as assembly's serration, helps illuminate the city's underconceptual, undercommunal underground and outskirts that Marx (re)produces without discovering, in and as the very essence and emanation of his phrasing. Professor Miyoshi is finely attuned to the collective dissonance and logic of irreducibly economic existence, "the universality of individual needs, capacities, pleasures, productive

forces, etc., created through universal exchange" that is persistently *lived* as wealth in the commune, as the project of the project(s). Which we wrap around ourselves as a kind of shawl, since we are poor (in spirit).

Professor Miyoshi's attunement takes the form of a question: How do people live in the absence of that infinitely expandable list of "amenities" figured as "necessary"? But one might also put it this way: How do people live in the absence of the attractive? Or one could even ask: How do people live in the absence of any point of attraction? Life, in the very fugitivity of the working and playing that escape whatever might have been experienced or theorized as its own bare self, turns in this turning, divisive, recollective run of questions, demanding the pivot Professor Miyoshi enacts. Moreover, his veered inquiry is aesthetic however much it might seem that that aesthetic has been liquidated or overcome or avoided in its constant throwing of itself beyond its categories, as Duke Ellington + Sianne Ngai might say. Implicit in this step/run/fall/dance is something essential to the general structure of complaint. It is a need that will have been inseparable from capacity, pleasure, productive force given in exchange's irreducible sociality, the contrapuntal anarrangement of its collective head. That pivot, where life's exhausted beauty initializes the questions concerning its absence that appear to be its antecedents, is this: Is there something on the order of a life of attractions, which might be thought in relation to an architecture of attractions, a life and an architecture of attractions in the absence of any point of attraction?

This question assumes the necessity of the aesthetic dimension of anticoloniality.

Moreover, its occasion, Professor Miyoshi's occasion, demands that we consider the sentimental pedagogical aesthetics of the curmudgeon, whose enduring message to his students is "Always complain!" and whose critico-celebratory feelings make possible an investigation of the relationship between what some combination of José Gil and Kevin Lynch might call the theoretical image of the city and something Samuel R. Delany intimates as a submerged and negative inscription of its prefigurative gathering on the underside of a mediating surface or lens, (in)sight made (un)available by the motion of light in water.[2] What is this image of the thing that happens when a limited form (the city of attractions and its attendant, etiolated notion of wealth and necessity) is stripped away? Maybe you have to be a curmudgeon to ask questions that bring the world and the city—their geographical delineations and historical divisions—into play by way of the question of the thing, this indexing of the commune and the earth that anticipate and sur-

vive the end of the city and the end of the world by placing them under the disarranging pressure of performative study. The thing itself is also brought into play in such questioning. The thing-in-play, in turn, turns toward the question of (the) work, the work in play, the work-in-progress, which, for Professor Miyoshi, leads to the problematic clash, if you will, of two utopias or, more precisely, the eclipse of (a modernist) one by its (postmodern) other. As he writes:

> Architectural discourse, like that of city planning, is inescapably uto-
> pian. Possibly because a completed building no longer belongs to its
> architect but rather to its buyers and users, architecture is only fully
> itself while it is a blueprint under construction and thus still address-
> ing a future condition. This future most preoccupies us during phases
> of violent cultural change. How can an urban building relate to the
> changing demands of a city? How can a city respond to its "global-
> ized" economic needs? Such questions occupy a major portion of the
> architect's and city planner's thoughts. Yet the future of a building and/
> or a city is necessarily negotiated with the dominant powers, those
> who manage and administer as well as own and dictate. The dreams
> of those who organize and direct are increasingly transnational and
> corporate.[3]

The rejection of modernist utopianism around 1970 was probably un-avoidable. In the past two decades in particular, the social contradic-tions built into bourgeois capitalism were too brutal to contemplate in a single, seamless context. For culture industry employees, the choice was either to convert these contradictions into disjunctive fragments or to dissolve the materiality of the contradictions into linguistic games. The best example of the former strategy is the sharp division of all knowledge into disciplines and professions so that no one can gain an inkling of totality. Each sector is mandated to develop exclusive terms and methodologies as if it could successfully seal its autonomy. (*To-talization* is perhaps now the dirtiest word in the academia of indus-trialized countries.) An example of the latter strategy is a reassertion of linguistic and discursive priority where material obstructions such as poverty, suppression, and resistance are decomposed and erased in abstract blurs and blobs. (Hence, the popularity of terms like *hybrid-ity* and *discourse*.) Both are gestures of surrender and homage to the dominant in the hope that culture employees might be granted a share

of the corporate profits. So-called global capitalism is a supremely exclusive version of utopia, to which "intellectuals" ache to belong.

Actually, global economy is merely a maximum use of world resources via maximum exclusion.[4]

For Professor Miyoshi, the eclipse of modernist architectural utopianism is signed by the demise of mass public housing projects that, no longer an object of planning, have become objects of demolition. The utopian nature of architecture is tied to the utopian nature of city planning; however, the utopian is the in-progress, the in-playness of the thing, the (art) work, the planning away of the city into, and which is also enacted by, the real assembly or assemblage that is present outside and underneath the city's absence. To ask the question concerning that thing is to bring the outside so deep inside that it cuts that opposition until it can't be seen then cuts where it was. Such questioning engages in a thinking that is something other than the detached contemplation that occurs in detached houses or isolated huts. It is, rather, the anaprojective poetics of the projects and it effects a kind of inhabitation—directed, in this case, toward the problematic of inhabitation, where building, dwelling, and thinking go together in ways that reveal how Martin Heidegger's most characteristic sound is often, finally and surprisingly, a recording of a specifically Marxian music. This inhabitation is a movement that Miyoshi characterizes as outside architecture. More specifically, he speaks of a rematerialization of architecture that would constitute its genuine eradication, rather than a doing away with its utopian displacements. Part of what's at stake is that these utopian displacements might very well be the way into a resistance to state power and its conception of private wealth.

I think of a more literal and less cerebral eradication of architecture: to bring architecture around to the material context, to the outside space where ordinary workers live and work with little participation in the language, texts, and discourse of architecture.

Modernism—with all of its ills—was at least mindful of those left outside architecture. Urban workers had their housing projects, though ugly, unlivable, and finally useless. Today's industrial cities eliminate those rational monstrosities and, with them, homes for vast numbers of people. Las Vegas has a steadily increasing population of homeless people, but no one remembers to mention them. In the streets of Kawasaki and Keelung, on the other hand, there are still homes

and apartments, however hideous. Whether they are inhabitable or not should not be hastily decided—especially by those who do not live there.

We cannot return to modernism. We do, however, need to think about shelter and workplaces for anyone, anywhere, and indeed, "anywise." How we live is finally not that important; that we live is . . . Perhaps, instead of building guilty conscience into aesthetically, theoretically, intellectually admirable but useless shapes and forms, we might stroll in the streets of Kawasaki, Keelung, and Puchon (west of Seoul) and learn how people live in these "filthy" and "uninviting" places. There may be more life there than in architecture's patronage houses, where the patrons are not always more satisfied or more comfortable than the residents of these streets.[5]

This outside and insovereign place can be thought more literally by way of the theoretical image with which Professor Miyoshi begins: that of children playing on the streets, outside the project, outside the dismal house and its antisocial science. They play outside architectural discourse, too, with extreme subcommunal enjoyment. The ones who live and work and play outside the modernist architectural structure are Professor Miyoshi's object here, but there is, deeper still, a rigorous mode of study that animates his words—a project mode that is thoroughly theoretical, intellectual, and, above all, aesthetic, and which is enabled precisely by the curmudgeonly "rejection" of these. Professor Miyoshi recognizes that the city is where life escapes but that recognition is already embedded in a thinking of the undercommons, the (under)commune, against and outside and before the city. He thinks outside the city in the interest of what will have surrounded it just as surely as he wants to think and inhabit an architecture whose rematerialization makes it an architecture outside architecture. Outside as in before, of the attraction against attractions and amenities, of attraction in the supposedly unattractive, whose music is discomposed by the curmudgeon, the outsider, the *metoikos*, the fugitive, the exile, the hermit, the complainer. The attraction of the unattractive moves in another ecology. Where else can that thinking occur now but at the edge of the (image of the) city? How might we persist as a scar at the underedge of the university, which wants to be the economic engine of the urban apparition, which wants to police the apparitional *polis*, which would enclose the essential gift that animates and undermines it? How do we renew the presence that turns the absence of the city and the

university inside out? How can we access the breath and (en)lightning that remains of Professor Miyoshi's *destruktive* and devoted inhabitation? These are questions for my friend, José Muñoz.

1.

At bottom, above all, in the heart of it all, on the outskirts of it all, for José queerness is its own deliciously filthy and uninviting utopian project, one whose temporal dimensionality is manifest not only as projection into the future but also as projection of a certain futurity into and onto the present and the past, piercing their previous arrangement and administration. Queerness has a spatial dimension for José but only insofar as it is located in displacement, at sites that are both temporary and shifting, in underground, virtual neighborhoods, ephemeral, disappearing clubs, and ordinary, everyday venues broken and reconstructed by extraordinary everynight presences whose traces animate his writing with the sound and feel—as well as the principle— of hope. Like Heidegger, but wholly against Heidegger's grain, José inhabits the convergence of "ecstasy" as spatiotemporal derangement with "existence" as stepping in and out of time. He studies study's performative appearance in and as the social life of the alternative. He knows that sometimes the alternative is lost. That sometimes it has to get lost. That sometimes the alternative is loss. To be or to get lost might be neither to hide nor to disappear. Similarly: to lose, to relinquish, or to veer away from—even if within—a given economy of accumulation: José thinks this in relation to, or as a certain disruption of, property, of propriety, of possession and self-possession, of the modes of subjectivity these engender, especially in fucked-up, Locke/d down, America. Inappropriateness such as José's—which is his, and his alone, because it is not his, because he gave it to us from wherever he was and gives it to us from wherever he is—remains undefined by the interplay of regulation and accumulation that it induces.

Consider (which is to say feel, which is to say dig) Kevin Aviance (deviance and essence, the trace of another scent and gest and groove) as José approaches (which is to say dances with, which is to say grounds with) him— accursed share and shard, cracked vessel of essence-in-motion, counterfetish instantiating the critique of possession that only the dispossessed can make. Such consideration isn't easy. In their mutual approach, José and Aviance become something else; something else becomes them and we have to try to get beautiful like that. That beauty is hard, brown, black, black brown

and beige, tinged with the sadness that attends our, and that keeps us, moving through the ongoing history of brutal enjoyment to get to what survival demands that we enjoy. José says that on the way to that—in the slow, inescapably lowdown path of our escape—we critically rush the impasse of our fetishization, the sociosynaptic (log)jam that keeps us from becoming instruments for one another, which is our destiny. What José knows about Aviance is what we also know about José. If the force of the counterfetish is lost in the Roxy, lost in all the various pragmatisms whose asses José kicked, lost in Marx though he, at least, as Louis Althusser might say, produces the concept that José came to discover; if the "fetish, in its Marxian dimensions, is about occlusion, displacement, concealment and illusion," then it can also be said to be about loss or to be the lost.[6] The fetish is representation of loss or of the lost. The condition of possibility of this necessary representational function is loss. Heidegger might say that the fetish, or the counterfetishistic property of the fetish, tends toward unconcealment, *aletheia*, truth. He would say that unconcealment has concealment at its heart, which we recognize in the anarepresentational content that is borne, the ephemeral and performative energy that is transmuted and transmitted, when Aviance and José dance their queer, spooky pas de deux at a distance. What Marx figures as subjunctive we now know to be actual. This is to say that José neither reads nor interprets the rematerialization of dance; he extends it, becomes part of the ongoing rematerialization that is (its) performance. This is a migrant curve evading straightness and its time. This is the counterfetishistic, redistributive, performative, gesturally perfumative content of José's writing, which theorizes loss as the instantiation of another condition of possibility: the prefigurative supplement of loss that deconstructs and reconstructs identity, that reproduces a personhood at odds with, or radically lost within, the accumulative-possessional drive; the future lost in the present, fugitive of and in the present; our subterranean movement; the shard of light we share.

José—whose irreplaceability is given in that he was movement in collaboration—sheds that light on and with Aviance. They remain as "queer ephemera, transmutation of the performance energy, that also function as a beacon for queer possibility and survival" so we can see ourselves, both descriptively and prescriptively, as the history of abnormative in(ter)vention.[7] We have to see our everynight selves like that everyday, until the party becomes The Party; and though we're not party to this exchange, because we're not, we feel it, because it moves through us when we feel (for) one another. The ones who don't see the gravity of this have never been on, let

alone under, the ground. Such grounding, such approach, is José, flying. The velocity of his escape remains in (f)light, as what we fight with and for. See, if Aviance and José hip us to the notion that ephemera mark the ongoing production of (a) performance whose origin is always before us, then every vanishing point signals the inevitability of a return, even if it's just in the way we get up tomorrow, even if our loss makes us not want to get up, because tomorrow we'll see that the one we lost has left us something to help us find him. Deeper still, way before the end, the ephemeral counterfetish will either make the bosses beautiful—multiply perspectival, contrapuntally out, in re- covery of what's lost in the stiffness of their stride and minds—or destroy them. Now that Professor Miyoshi and José are, along with Marx, lost and found, improperly dispersed in us, it's our job, our animated and animative labor, to bear that, to be borne by that, to keep being reborn in that—so we have to keep on playing.

2.

One of Professor Miyoshi's most important and celebrated works, "A Border- less World? From Colonialism to Transnationalism over the Decline of the Nation-State," is reprinted in *Politics-Poetics: Documenta X—the Book*.[8] In this reprint his words are juxtaposed with photographs of Lygia Clark's work or nonwork or work-in-progress or performance or thing or play *Cabeça Coletiva* (Collective Head). There is, in particular, what the editors identify as a picture of *Cabeça Coletiva* moving or being moved down a street in Rio de Janeiro in 1976, out of or in withdrawal from Clark's authorship and control. It's like a float into which people have entered or, somehow, returned as if in exile from exile; a float like a hat that a group of people wears; a hat like a garden that a bunch of people cultivate; a garden like a living that a congregation serves; a living like an artwork that a curacy disperses. It is work at play in the city on the order of a theoretical image (à la Gil and Delany, on the one hand, Lynch and Fredric Jameson, on the other) of the city that is outside and before the city, the city of displacement now given as the axiomatic primitive of a new ecology, a general economy. It marks attraction in the absence of the attrac- tive, friendship in the absence of the amenity, moving in what André Lepecki might call an extension of Clark's own (non)performative "withdrawal of her body's presence," where withdrawal might also be understood—as in Gil and Eleonora Fabião—as complication: body turned through absence into pres- ent paradox, secret divulged in secretion.[9] What forty years earlier in Kansas

City they might have called a (collective) head arrangement moves down the street in Rio as and on the way to what Clark would call an empty fullness, the "*vazio-pleno*," that anti- or antesubjective no-thing-ness of the plenum that displaced *carioca* Denise Ferreira da Silva illuminates in her special and general theories of the no-body.[10] In the dispersive, differential gathering of the project, the projective work, the resonant instrument and collective head walking hand in hand in a field of feel, an approach toward a social physics of psychical flesh is practically imagined as an undercommon precedence of the city, before (and up ahead of) the nation-state, its local antecedents and its global residue. Such rematerialized, transportive, anarchitecturally anarranged utopianism constitutes a nonexclusionary urban plan, structured by communicability rather than relation, in acknowledgment of an already given and incalculable wealth.

It turns out that the end of "Outside Architecture" echoes the end of "A Borderless World?": "Los Angeles and New York, Tokyo and Hong Kong, Berlin and London are all teeming with 'strange-looking' people. And U. S. academics quite properly study them as a plurality of presences. But before we look distantly at them and give them over to their specialists, we need to know why they are where they are. What are the forces driving them? How do they relate to our everyday life? Who is behind all this drifting?"[11]

Now what's the relation between these strange-looking people, these outsiders, these *metoikoi* and the ones who are outside architecture in their own homes, the ones dancing in their collective head, like Lygia Clark or Ornette Coleman or Kevin Aviance? What is the nature of this before of the distant look, a thinking antecedent to detached contemplation? Direct examination is distinguished from distant look, from the distancing of political actuality and the detached contemplation of people in/at/as work-in-play. The before of the distant look is an inhabitation, an assembly, a public thing, that is nothing, finally, if not aesthetic, that is driven by nothing if not the intensity of a whole other payment of attention. Inhabitation, here, is immediately a question of drift. To think those who are outside architecture alongside the "strange-looking" people is to consider the universal exchange of extraordinary lives. The question of the architecture, economy, and ecology of our down-and-out commonality is the song-like question of the earth that is also, and immediately, the question of art to the extent that it is bound not only to the ability to inhabit the differential but irreducible totality but also to deal with the mobile jurisgenerativity of dwelling. The collective head always complains, always sings together; the collective head is coming-together,

way on the outskirts of town. To complain is to sing with that communist sound to which Professor Miyoshi and José are attuned and which they amplify and extend insofar as their work is an open installation, the thing you live in and play in and play and wear and are.

When Professor Miyoshi and José encounter one another in the call for the art/work/play/thing of a queer, utopian, futurial anarchitecture—not (just) as something sculptural but in/as irreducible presences of improper, impersonative flesh in all its thingliness and earthly inhabitation—they are calling for and also joining a rematerialization of wealth, of what we ought to treasure in what is always here, the future in our present that is beautiful however unheard or unappreciated. He calls for the actuality of what is often feared in artistic presencing; for an architecture of what people outside architecture, outside the house and the city, outside citizenship and subjectivity, outside settlement and sovereignty, do to all of these by living; for an architecture set up to receive aninstrumental, anarchitectural doing, thinging, thinking; for a communal, anarchic, textural environment that is ecological, social, and personal. This is also to call for a necessary reconfiguration of economics—beyond the rapaciously incorporative incorporealities of what Randy Martin calls the "financialization of daily life"—so as no longer imperiously and imperially to exclude, by way of the most violent calculations of forced and rationalized inclusions and in/corporations, externalities (not just unaccounted for costs but also irreducibly originary material benefits), in their undercommon and erotic indebtedness.[12] It is in the interest of unsettling, of the unsettled who are without interest, that Marx, Miyoshi, and Muñoz walk the resonant bridge between the city and the commune. I once heard Professor Miyoshi speak, with a mixture of understanding and impatience, of Edward Said's need for art, which he understood as a tendency to veer away from the urgent necessity to concentrate on the economic. But José lets us know that attunement to the economic, where the economic is an irreducibly edgy anoriginarity that Marx would call the commune, leads immediately to the aesthetic so that the need for art will manifest itself materially, as the rematerialization of wealth that Marx also calls for by way of his production, if not discovery, of the commune, his undercommon making and joining of the real assembly. What emerges is an aesthetic of material wealth and beauty that also allows discussion of the ugliness by which it is permeated. The aesthetic's improper home is the curmudgeon's inappropriate office, the bitch's loving fierceness, which is what we should have been treasuring all along. We move, along with Marx, Miyoshi, and Muñoz, in

anticipation of rearrangement, in step with anarrangement, as if remotely performing Clark's collective head arrangement, her anoperatic offering of the subrepublican public thing, and Aviance's ongoing project of the broken vessel, his projection of its immanence and emanation, the outside we live (in), our making and joining and renewal of the real assembly.

Cornered, Taken, Made to Leave

3.

Some ideas I've been working around: (1) I can no longer see discrete forms in art as viable reflections or expressions of what seems to be going on in this society. They refer back to conditions of separateness, order, exclusivity, and the stability of easily accepted functional identities which no longer exist. For what a posteriori seems to be this reason, I'm interested in the elimination of the discrete form as art object (including communications media objects), with its isolate internal relationships and self-determining esthetic standards. I've been doing pieces the significance and experience of which is defined as completely as possible by the viewer's reaction and interpretation. Ideally the work has no meaning or independent existence outside of its function as a medium of change.—**ADRIAN PIPER**

These remarks will make sense only within the general assumption that the Atlantic slave trade and settler colonialism (in themselves, which is also to say in the traces of the insistently previous but anoriginal displacements and emplacements they bear) are irreducible conditions of global modernity— that is, of the very idea of the global and the very idea of modernity. These ideas include and project modernism, which is also to say postmodernism. They include and project this institution (i.e., the museum, this museum), which includes, in turn, the enactment of our interinanimate inhabitation

of and escape from it, which is eventually to say, more generally, the entire structure of the proper—appropriation and expropriation, proprioception and aproprioception, propriety and impropriety. When being-in-the-world is who you are, and who you are is what you own, and what you own is where and when you are, then what it is to have been taken and to have been made to leave, which marks again and again the already inexhaustible vestibule of what is known and lived as the exhausted, is the beginning and the end of the world. We study passage in overcrowding. Dismembered, dissed nonmembers, having dissed membership, we attend (to) the plenary, as indiscretion.

4.

Cornered, on the corner, cut, cur(at)ed, a coat hook for some headphones, to listen to a language you don't have. Is listening to a language you don't have like looking at a face you don't have? I don't have Arabic, so I can't even know for sure if it is Arabic, but there's a fuchsia circle around her face and this crowdedness fades. Inshallah comes as beautiful recognition without subject, then fade, my life is in front of me. What's in front of me when she says my life is in front of me, then fades? Sandi Hilal, is every plaza roofless? Is this an outdoor corner? Can this be an outlaw corner? This is about the difference between being in the corner and being on the corner. Image remains—but on the crushed stool, in the glossblack ground, in the low mirror of Samuel Barry's "Imagination, Dead Imagine," in Judith Beckett's Quad, its ratic, phenic echo—to live the open corner like Miles Davis, in passage, in refusing to pass, or let shit pass. This chor(e)ographed view, held in crowded, crowding blackness, objection's glaze and favor, the accidental ensemble, digital fade's loss of already lost color to that wind in the image, a breath upon her face unsettling it, moving it in stillness, in dark and shimmer, enjambed varieties of effacement in composure, abjection's gaze and flavor.

5.

Of passage: how to think in preparation, never to have been prepared. A way of organizing until the general reorganization, which is what's going on. I'm waiting for my supercession even when it comes in the form of disregard or, merely, extravagantly, of attention, of caressive attentiveness. I came in search of a work and found a general aphanisis not in but through the ruined forms of appropriation and institutional critique. Separate but equal,

held in and given by a black op, its open secrecy, Johanna Burton and Darby English inform, are formed, are in formation as articulate tell in and out of their intentions.

For quite some time, it seems, artistic dialogues regarding criticality— by now a go-to, if also often doubted, rhetorical marker for unflinching engagements with and examinations of culture—have revolved largely around its precariousness or, more aptly, its likely demise. Indeed, two of the most prominent strains of critical practice in postwar art, appropriation and institutional critique, are by many accounts exhausted today. The former is typically posited as an operation, a kind of technique for displacement, first understood to radically lift the veil of images and idioms—extracting sign from syntax to dispel cultural myths—and allow viewers to recognize their own place in a constructed representational field. Yet with this operation considered today most often in a formal vein, images so "liberated" from their original settings are commonly regarded as utilized in the service of cultural amnesia, in the name of the perpetually circulating sign. As for institutional critique, which is by contrast largely considered a kind of articulation—an instance in which cite and work meet, with the latter making evident the ideologies and infrastructures of the former— even its protagonists and champions have lately posited the genre as a thing of the past. . . . The artist Andrea Fraser would in a 2005 essay underline the degree to which institutional critique and its techniques necessarily had to be understood as "institutionalized" themselves— belonging to a celebrated passage in art history regarded by many as bolstering figures of authority more than dismantling or problematizing them in any substantive way.

Regarding such assessments, however, it is useful to consider how *criticality* is in fact consistently under duress. The term is a moving target, historically attended by questions regarding what it *is*, whether it can be sustained, and, moreover, whether it inadvertently fuels the very entities it aims to combat.[1]

To demand that an image or thing convey people problems—that's a lot to ask of an image or thing.

We could tell the stories of these practices in another way—say, by proposing a genealogy of appropriation and institutional critique *that also writes* the history of a shift in the valences of form construction.

But such a history would need to leave a lot of room for aspects, even criteria, of art that the critique of institutions often seems quite eager to set aside. Another, utterly defining element of what Wilson, Steinbach, and Williams had to do to create these works was the notably unfussy, differently intentional act of putting stuff together. You take something and set it next to something else in order to pose, but not necessarily to answer, a question about their relationship. You do this not because on its own it's a particularly interesting thing to do but because, *as a context*, art gives things-in-relation a capacity to inform that no other framework can. What becomes of analysis and interpretation when description, without which neither can proceed very far, foregrounds the relationship—the condition of besideness—that is the sine qua non of critique made manifest as art.[2]

On the one hand, the corner where site and work converge in and as displacement; on the other hand, good fences make good neighbors, so let the work reclaim itself in our descriptions, which must be recognized as an uptight, updiked, held back, holding form of love. That systemic, necropercussive regularity is a dead giveaway; one hand knows what the other hand is doing, then tells, *le pas de deux de l'informateurs*. But setting metacritical curation and its metaphysics of individuation aside, *what if curacy is overcrowding and scarring*, not knowing and more than knowing, in total darkness, so that the work, which is, in any case, mad in and mad about not being one, remains unseen? Blurred portrait, mugged mugshots (Galton + Lombroso + Eakins + Muybridge + Smith + Fanon), amputation and the range of echo it induces: spooky resonance, phantom hapticality, haptical sociality, communicability's constant contact in missed communication. Network failure.

6.

Verge: the distinction between separate and fuse is maintained in collapse.

7.

The demand that a conveyed thing convey (because an image is a thing; a thought, a word, is a thing: this is a matter, the matter, of poetics—contra weak theories and surface readings), because all things do is bear, carry, convey one another into no-thingness, is oppression to the one who would

be free of every burden, the one who wants his artworks that way, too. On the corner, there might be another ethics of social support. The works care for, cure (cut + heal + season + preserve), curate one another in shared unselfconcern. Contact improvisation is their paraontological massage.

8.

Rub my ears. Why headphones but not blinders? Why protect phonic integrity in accord with all this transverse, anareflective haze? English speaks of putting stuff together. Perhaps this lets us speak, more precisely, of how stuff goes together. Things go together in support of one another so thoroughly that the memory of the thing fades to black, nothing, in dry, exhausted wind. This is the strong theoretical deconstruction of the very idea of one and the very idea of an/other. Overcrowding, overflowing, my cup, my plate, too much of not enough, abundant rupture, enformality and enarticulation overflown away.

9.

Blackness isn't a people problem; it's the problematization of the people. Black study—which is to say blackness: the preoccupied breath of the ones who have been taken, who have been made to leave—is the medi(t)ation of things as, breaking and remaking every law, every bond, they shimmer in the absolute disappearance, the absolute nothingness, of their sociality. English says, "As a context art gives things-in-relation a capacity to inform that no other framework can." Perhaps that which remains obscure in his phrasing can be otherwise performed. It's not about things being beside one another; it's about the very idea of the thing being beside itself, touched in an absolute and enformational nothingness. Insofar as blackness is not just one name among others for this condition, and precisely to that extent, blackness is the subject of every artwork. The question of whether or not the experience of art is a private experience comes into relief against this backdrop, and as the limit, of English's critical endeavor and perception. When he valorizes description, it seems as if he's saying that the answer to the question is no. Deeper still, normative art history, which English exemplifies and seeks to renew, is predicated not only on the essentiality of description but also on what Paul Guyer—interpreting Kant, who Clement Greenberg, English's most elemental precursor, calls the first modernist—says is "the intersub-

jective validity of taste."[3] This supposedly intersubjective validity, which description confirms and enacts, is, I think, what Michael Fried calls "conviction": the art historian's categorical imperative to assert that the work he judges to be great must be great for anybody. Of course, a vast range of brutal qualification determines who is understood to be "anybody" (as opposed to nobody), but the issue on which I want to focus now concerns this problematic of intersubjectivity. I am concerned with how it is that intersubjectivity can, and indeed must, be aligned with (the privileges and privations of) private, transdescriptive experience; with how it is that English's invocation of Robert Frost's oft-cited adage—"good fences make good neighbors"—helps us understand the intensity of the interplay between solipsism and the ordinary negation of sociality, the antisociality, that undergirds an experience of art that is simultaneously normative and impossible.

10.

The question of the privacy of the experience is all bound up with the question of the privacy of the work. Besideness implies discreteness, the separation whence spring the various beauties and uglinesses of articulation. I want to consider, for a moment, that besideness is antisociality masquerading as what it negates; that intersubjectivity is solipsism held and enacted within the immeasurable, because nonexistent, free-space of the public-private field. Just as antisociality masquerades as sociality, so description, within normative art history, is meant to stand in for and to instantiate the transdescriptive loneliness that ensues when anybody, in his abstract and exclusionary equivalence with anybody else, takes it upon himself to tell you what he sees, insofar as whatever it is that he sees is always only "gross effigy and simulacrum" apprehensively attempting to apprehend itself in the mirroring artwork. Meanwhile, it remains for us to consider the dis/appearance of things-in-relation into nothingness. Implied, here, is that we must or can use the language of things to get to nothingness-in/as-sociality.

11.

When English places thing and image in a quite particular association with one another he does so against the grain of Ludwig Wittgenstein's emphatic insistence (as reported by Rush Rhees) on the difference between them, and on the difference between the various grammars with which we would attend to them:

We are tempted to use the grammar which we use for a word designating a physical object—we are tempted to use this grammar for words that designate impressions. In our primitive language most substantives relate to some physical object or another. When then we begin to talk of impressions, we have a temptation to use the same kind of grammar. . . . Our craving is to make the *grammar* of the sense datum similar to the grammar of the physical body. That was why the term "sense datum" was introduced—it being the "private object" corresponding to the "public object."[4]

When Wittgenstein says, also, that "it seems to people unavoidable to hypostatize a feeling," it tempts one to consider that the interplay between the artwork's form and the art historian's conviction that description mediates between that form and its viewers is not only best characterized as hypostatization but is also best understood as the necessarily failed structure of public-private rapprochement.[5] The essentially impossible relation between things, in failed correspondence with the essentially impossible relation between anybodies, turns out to do its most important work in guarding the border, necessarily fictive, between anybodies (supposedly bound to one another by the intersubjective validity of their taste) and nobodies (held together in the fantastic and terrible hapticality of their flavor).

12.

Just as Wittgenstein recognizes the futility of wishing for some absolute separation of (the grammars of) sense datum and object (impression/image and thing), it's probably futile for us to wish for some absolute separation of relational things and nothingness-in/as-sociality. Perhaps Piet Mondrian was also teaching us this, more or less simultaneously: that it's ok to use the grammar of representation as long as you recognize the various problematics that attend that use and, above all, as long as you recognize not only that the operative relation is neither that between image and thing, nor that between thing and thing, but that between things and nothing—that what's at stake is not held in the nexus of representationality in/as relationality but in a certain haptical sociality which, in some incredibly cool ways, the experience of this show helps us to produce. The overwhelming, Althusserian question concerns how and by what mechanisms we can move from production to discovery. How do we conceptualize this haptical sociality when we remain be-

holden to or held by the grammar of relation-in/as-representation? Another way to put it is that the Althusserian question allows us to move through an Althusserian problematic or, at least Althusser's oft-referenced way of thinking and valorizing articulation, "articulated combination," his translation of Marx's particular inflection of and upon Gliederung. I'm listening for an enarticulate murmur—the informal noise that attends enformation's and deformation's constant undoing of information.

13.

The relation between image and thing, given in the relation between image and viewer, is taken away, as it were, by what the viewer must recognize as the material thingliness of the image. Strangely, this rematerialization of the image, even in artworks that purport to be interested in and to instantiate the dematerialization of the object, is shut down when the viewer fails to recognize his thingly materiality in all the fragility of its figuration. This is to say that the problem, again, isn't so much the interplay of reflection and representation; it is, rather the displacement and suppression of an imaginary and temporary relation between things (viewer and artwork) by an imaginary and endless nonrelation, masquerading as relation, between images. This is what arises when the viewer thinks of himself as form rather than as substance. Alas, English is unconcerned with relations between things either within the artwork or between the artwork and the viewer. He is concerned, rather, with the impossible relations that obtain between forms, that general field of antisociality that is best described, again, in the adage "good fences make good neighbors." The best neighbor is the one who remains unseen insofar as to see him is to see yourself. Meanwhile, the concept of relations between things, even as it is inevitably and hopelessly lost in description's transdescriptive signal, might prepare us, in its fictiveness, for the burly, airily affectable present—the catalytic indiscretion that ruptures (even against Piper's grain) the very idea of (inter- and intra-)subjective aesthetic experience—that being-cornered keeps on giving.

Monsters

Enjoy All

14.

I was never quite stopped short by an individual work in Mike Kelley's massive retrospective, but I was continually stunned, disturbed, and overjoyed to be walking around in the midst and mist and remains of a mystical/monastic practice, his intense and palpable devotion, which had to have been an everyday thing. The closest I came to the kind of "objectifying encounter with otherness" that some folks think is the hallmark of genuine aesthetic experience was early on, when I was momentarily held by a few works that, among other things, place Kelley, or show Kelley emphatically placing himself, within the canonical trajectory of Western art history. Paused before Kelley's *Odalisque*—a late Kandorsian epiphenomenon, exiled from the neon'd city, laid out as muted ground control, a burnt-out remnant that vertical, monumental super man left behind—one becomes aware of the operation in which blackness and the reclining nude brush up against one another in mutually asymmetrical service remixed by fire. In the midst and mix of all this color it's the black(ness) in Kelley's art that I'm drawn to, as if the spectrum's citizenry were mere prosthesis, accessory, or trim, like some punkish, mohawk purple topping off the traditional hardcore black on black in black. The richness and diversity of Kelley working, his trial, his pilgrimage, comes to a head in black, which pierces the diversity of his world like shards of behavior behaved many times. I want to see if I can figure this out. Obviously, all this stuff is about the way we live. On the other hand, paused before *Horizontal Tracking Shots*, one is given brutality backstage at the color field. Hans Hoffman turns out to have been your daddy and your daddy turns out to have been Mr. Gradgrind. Black. White. (and in). Color. Later, color comes back way too terribly beautifully in the rest of *Kandors* (Kal-El's hometown, some undetroited under and overdetroit that lies hidden in Los Angeles as Los Angeles's alternative, like far east Melrose's Guatemalan storefronts or far south Central's far east

Mississippi thump) as Hoffman's revenge or retreat. Retreated Hoffman is different than retweeted Hoffman, evidently, and Kelley gives us an extra unhealthy helping. This is a recalibration and redistribution of what's bad for you because it seems as if Hoffman is kitschy now, and not just because Kelley says "Beauty can only be Kitsch." This is something all bound up with the thwarted black queerness, or queer blackness, of a little kid in *Horizontal Tracking Shots* dancing, having induced terror by dancing, having succumbed to that terror, the white family as this tight, fucked-up little ball of Oedipal blowback. There's a rainbow on the other side of this that's different, now, having been tained. I mean that the rainbow can mean this other thing now that it's backstage, in resonance with the patchwork of *Half a Man* and that *Rainbow Coalition* of AfroWigs. I want to see if I can figure this out, too, because whatever else it is *Rainbow Coalition* is also a disavowal—a residual, and carceral, and merely twice-behaved flight. Maybe we can think a little bit about Mike Kelley and/in the history of art even as we also talk about Mike Kelley's commitment to the idea of the work. While what I love and value in Kelley is what strikes me as his serial failure to keep that commitment, I still have to acknowledge that he might have been pissed not only at my joyful inability to be, or my militant resistance to being, absorbed by his individual works but also by my attribution of that inability and/or resistance to him and to what I think is great in his practice, in the general idea of practice and in the particular confluence of practice and performance evident in our inhabitation of the atmosphere within which his works appear and disappear.

15.

It feels like everything, or if not every thing every idea, was preserved. But even if it's only a feeling, I want to make an argument for what's absolutely invaluable in it. There's no trash in monastic practice. There's a massive critique of the very idea of trash, of disposability, that is given to the ones relegated to the heap. This is how there's an empathy still waiting to be confirmed between Thornton Dial and Mike Kelley, artists who work on the backs of things. They would have had something to talk about. In the absence of that conversation, Mike Kelley remains one of the greatest artists ever of how fucked-up shit is, one of the most capable of the mutual infusion of this terrible serrated monolith, and the message it induces, with beauty (which is kitsch, Kelley says; which is bad for you, evidently). But in the absence of that conversation, this is mad boy art. I know he hated that bad boy shit so

let me say, more precisely, that this is mad white boy art, this is privilege art, which it pains me to say, because I hate the word *privilege* more than I hate all the presidents of the United States, except the ones in that band, whom I merely loathe. That this conversation between Dial and Kelley must have taken place is only partially, only peripherally, an Iggy Pop question. Refuse to believe in the non-meeting of two monastic, anArkic practices, one supposedly schooled, the other supposedly unschooled. On the one hand, Mike Kelley and Sun Ra shacked up in Unde(r)troit, or Kandors or whatever city in Saturn; on the other hand, why move to Los Angeles when you can move to The Magic City? Look: *Pay for Your Pleasures* is presented in the colors of post-hippie reaction. Post hippie-reaction is, actually, a Kantian formation; he hates the swarmy, shmeary, kitschy, geechie gooiness of the Anabaptists; and black folks are so ugly that everything they say must be stupid. And the critical Kant, the genius Kant, doesn't refute but follows from this. So I really do mean to say that Kant formed the post-hippie reaction, in his own port city, as a regulation of Romanticism, in ways that Goethe echoes and Kelley posterizes. Kant says, "The imagination, in its lawless freedom, produces nothing but nonsense and must have its wings severely clipped by the understanding." Goethe says, the imagination is criminal, is our enemy; in its piracy it is the enemy of all; its monks should be visible only in mugshots, as mughosts haunting a rogues gallery, and only after a donation is made to the victim's families or to the family, which is, in general, the victim. It's an incorporative reaction; it's a restrospective, guilt-ridden disavowal of the stuff you can't do without. Having taken advantage of what the imagination affords, it's only right to feel bad about it. Again, I'm trying to approach Kelley within the history of art, from which Dial is excluded, in order also to consider what happens when Dial and Kelley sit down and talk with one another.

16.

Insofar as Kant is the indispensable, seminal theorist of subjectivity, which is the residual and programmatic phantasm of post-hippie reaction, he is also the indispensable, seminal theorist of white flight. When folks talk about white flight, especially with regard to Detroit, which is the kind of hypercapitalist, decapitalized and decapitated anticapital of white flight, people often, even usually, talk about it as an abandonment whose effects were primarily visited upon the ones, and the place, that was left behind. White patriarchy leaves impossible-to-live-with black maternity behind to fend for herself and

her kids while He upgrades His quality of life. When I say that Mike Kelley is one of the greatest artists ever of how fucked-up shit is I mean to say that he refuses the usual paradigm. He shows us constantly how fucked-up white flight was for the children of the redomesticated, the renaturalized. (Just so you know: in my understanding, white flight is something that you don't have to be a person who is called white in order to do. At the same time, being a person who is called white, and deeper still, being a person who answers to that call and accepts the various coupons that go with so answering, apparently makes white flight a harder thing to flee.) I feel that when I'm walking through this exhibition, I am walking through a clinical installation of the imagination in white—which is to say brutally regulated, segregated—flight. What's deep is that what remains overwhelmingly and undeniably palpable in this installation is the beautiful and generative impurity we're all supposed to be running from. I think that's what I was trying to get at when I was saying that every idea, if not every thing, is in there. (That) mass does the work of undermining the individual works, of rendering them absent or, deeper still, present in a "differentiated indiscreteness" (to borrow a phrase from my friend Laura Harris), inducing its own empathic madness. At the same time, what undermines and underwrites how fucked-up it is—even in its self-aggrandizing, self-consumptive privilege—to be forced to be white is this other thing that actually constitutes, in my view, Kelley's most fundamental material, even if it's never very explicitly conceptualized. It must have been a tremendous burden so faithfully both to bear and to resist. I wonder if he ever had a chance to talk to anybody about it.

17.

There's a racial and sexual economy of kitsch. What if we consider, to the point of love, what it is not so much to be mugged, or to have one's conviction extorted, but rather to be hugged and to have one's affection caressed, by these blurred, substitutive demonstrations, these sculptural commodities who speak, thereby animating the general installation, like my old student Dan, who never bothers people at the museum, but who just had to say something to me, for which I'm so grateful, even though it was in precisely that violation of protocol which demonstrating objects are made to induce and enact. Kitsch is a slur. You can't take the valuation it imposes to heart. *Kitschen* is a verb that means "to smear." Kitsch is a slur conferred upon the slurred. It's not just in-between, not just the locus of theatricality or performance that violates

the subject's discretionary self-possession; rather, it undermines the very idea of the in-between, the buffer, turning the border into the projects. Art predicated on the critical mobilization of kitsch kinda hates itself, is always trying to distance itself from itself, to flee itself, its own materiality, its own impurity, which is its beauty. In order to deploy its own devaluation it has to accept it, which is to say it has to accept the theory of value upon which that devaluation is founded. And this is a genuinely fucked-up situation, particularly when folks start giving you lots of money for it. Nevertheless, the conceptual apparatus that carries this devaluation also carries that other thing, the unslurred slur that "kitsch" can't bear, the no-thingness that blackness has come to name, and from which whiteness flees. To move through Kelley's long and general installation and pilgrimage, to inhabit and enact his ongoing performance, is to demonstrate something that is, in the end, in excess of objection or of being an object. He talks about what it means to be in the performance, to get the feel of an ephemeral logic, the feeling of a structure, the haptic goings-on that animate a practice that crumples the prescriptive and/or restrospective opposition between sense and nonsense. We're musical sculptures walking around in his composition, which gives us a chance to make something happen even against the obsessive way he's always showing us, maybe against his own will, that he has a reason for everything he does in his art. Dominated by the concept he seeks to dominate, Kelley makes a space for us to perform unscripted resistance. With all due respect to the curators of this show, Kelley's practice is and remains a devotional curacy, which is why the following question is so terrible, and beautiful, and insistent. What if the idea of complexity, which Kelley reveres, and the idea of the work, to which Kelley adheres, are incompatible? Well, he gives us a way, which is kinda like a place, to live with that. Having exposed the brutalities of racial capitalism, Saidiya Hartman and Cedric Robinson also let us know that there is an error, a miscalculation, in the terror of enjoyment's vicious economy. It's like we have to enjoy all monsters in order to destroy all monsters. *Mobile Homestead*, Kelley's first foray into what is called, but what is rarely, public art maybe even gives us a way to Detroit all monsters, as if turning around on Michigan Avenue in search of magic hidden in a long-ass manmade drought, in fugitive reversal of white flight's chainganged mobilization, might be the way we learn to enjoy ourselves, our monstrosity, our criminality, our imagination, when the ridiculous schools they throw us into before throwing away the key don't just stage but actually domesticate and naturalize white flight as the sovereign imperative of the subject citizen.

How do we unlearn that shit in the interest of learning how both to destroy and to enjoy? I don't know that Kelley ever figured that one out completely. I don't know that anyone has. It's certainly way deeper than just checking your privilege, which is truly fucked up since privilege is ubiquitous and since eventually your privilege kills everything, including what you thought was you. But it does feel like he's on the way, or that he's more + less than one of the more + less than ones who pave the way, to figuring something out. Discovering this has been a pleasure and I'm not gonna pay for it.

Some Extrasubtitles for *Wildness*

It is Christmas Eve in the year of Huitzilopochtli, 1969. Three hundred Chicanos have gathered in front of St. Basil's Roman Catholic Church. Three hundred brown-eyed children of the sun have come to drive the money-changers out of the richest temple in Los Angeles. It is a dark moonless night and ice-cold wind meets us at the doorstep. We carry little white candles as weapons. In pairs on the sidewalk, we trickle and bump and sing with the candles in our hands, like a bunch of cockroaches gone crazy. I am walking around giving orders like a drill sergeant.

Somebody still has to answer for all the smothered lives of all the fighters who have been forced to carry on, chained to a war for Freedom just like a slave is chained to his master. Somebody still has to pay for the fact that I've got to leave friends to stay whole and human, to survive intact, to carry on the species and my own Buffalo run as long as I can.—**OSCAR ZETA ACOSTA**, *The Revolt of the Cockroach People*

18.

The Revolt of the Cockroach People begins with the repression of paratheological swarm and ends with the release of paraontological rub. The Brown Buffalo has to let himself be let go by trickle, bump, and sing but you can

already see an Organizer's detachment from the general anabaptism he presumes to call to order. What is the price of reveille when that mustering, in being against the church and the state, is also against the slur? What if organizing wears out welcome, because welcome is always slur and swarm? There's an air of the broken world—and revolutionary geology predicts this waft in time, this disruptive plume, insurgency's panache—that just keeps on tearing shit up and swirling it around. And it seems like there's always someone who can't help but ask how to survive intact in and as that solidity of waste and shame that comes at the expense of spirit. Wu and Acosta get us to the threshold where that question is called to disorder. It turns out you can walk from St. Basil's to the Silver Platter. That nearness makes them seem so far away (from one another and from us) but there's just yesterday from here, which is no distance at all, let alone what it is we think distance usually implies. Just out of place and time in gathering, in Los Angeles, where if you can walk you might as well fly. You might as well warp time, not seize it but give it seizures, animate it, let it quicken, loose its tongues. That's what happens below the history of churches—in fallenness, a club arises. Disorder is our service, our antidote and anteroom, our vestibule without a story. We can't survive intact. We can only survive if we're not intact. Our danger and saving power is an always open door. Our venue is mutual infusion, the holy of holies in the wall, glory in a kind of open chastity, where the explicit body reveals itself demure in disappearance. Unenforced, slid, venereally unnatural and convivial, we claim slur against drill and document. Confirmation of the flesh is queer and evangelical. Our host is the para-site St. Basil's rejected, a sustenance of brown commonality in anecclesiastical reformation. *Wildness* serves *Revolt* with grace and style; it reveals the urge to revel that is devotion's drive. To fuse the relation of devotion, revelry, and revolt is to be welcomed into the temple. The alternative chapel is dispersed as soul. Are you experienced? Have you ever been experienced? Have you ever been welcomed? Well,

19.

the general antagonism of evening is our advent. Blür twilight, anacrepuscular fade to violet, almost royal. Everynight life on a bed of fire. The oracular brightness is a bouquet of storefronts—mortar, care, savioral hue. Did they really bring the wildness to you or did you bring it to and in and out of one another? You say, I keep them safe but I'm not safe. We're all at play here,

we're all part of it, we all complement. *Love bade me welcome: yet my soul drew back, / Guiltie of dust and sinne. / But quick-ey'd love, observing me grow slack / From my first entrance in, / Drew nearer to me, sweetly questioning, / If I lack'd anything. // A guest, I answer'd, worthy to be here: / Love said, You shall be he.* You shall be she. What shall we be? They taste my meat when I am slow and empty. They want to feel. I won them over. They want to fill. Feel her retreat, his recess, hystera, her borrowed time, his time turned inside out, her night routine. We are preoccupied and so we throw a party. Shade raises shade, nor will our sun renew. These ruins that you see were once a monument. Stitched together, to be seen as many ways, and shards of night inside me. Night shades inside me. A family comes inside me. It's not all family inside me. Welcome, musical quartz! Welcome, Tejano Tenor! Welcome, Bustamental! Welcome, remixed missish Missy! Welcome, Brown Buffalo! We witness anecdotes at the door. Our strange habits of assembly are unestranged. Irregular assemblage is our regular market day. Transformers play our geisha syndicate. Our low-class conspiracy is nonperformed performance. There's another university of earth and we sound better in chiffon. We just look better when Tuesday and Friday be Sunday every night. All we have to do is please the time. We stir in accord with the undergroove, dissonant and animancipated. This is escape from the war for freedom and it ain't nothing nice. It ain't nothing nice. It ain't nothing nice. In love, in luxuriant necessity, base community is a practice of continually relinquishing a whole buncha shit that's s'posed to be basic. Sometimes, the refusal of self-determination is a drag. Luckily, the refusal of self-determination is in drag.

To Feel, to Feel More, to Feel More Than

20.

Ben Hall has a kind of evangelical obsession. Some joker gave him something and now he wants to give you some. See if you can see and hear and feel certain passages in and of a collective head arrangement, as if Lygia Clark were touring with a territory band.

21.

Now I have one radio-phonograph; I plan to have five. There is a certain acoustical deadness in my hole, and when I have music I want to feel its vibration, not only with my ear but with my whole body. I'd like to hear five recordings of Louis Armstrong playing and singing "What Did I Do to Be so Black and Blue"—all at the same time. Sometimes now I listen to Louis while I have my favorite dessert of vanilla ice cream and sloe gin. I pour the red liquid over the white mound, watching it glisten and the vapor rising as Louis bends that military instrument into a beam of lyrical sound. Perhaps I like Louis Armstrong because he's made poetry out of being invisible. I think it must be because he's unaware that he is invisible. And my own grasp of invisibility aids me to understand his music. Once when I asked for a cigarette, some jokers gave me a reefer, which I lighted when I got home and sat listening to my phonograph. It was a strange evening. Invisibility, let me explain, gives one a slightly different sense of time, you're never quite on the beat. Sometimes you're ahead and sometimes behind. Instead of the swift and imperceptible flowing of time, you are aware of its nodes, those points where time stands still or from which it leaps ahead. And

you slip into the breaks and look around. That's what you hear vaguely in Louis' music.

I went toward the microphone where Brother Jack himself waited, entering the spot of light that surrounded me like a seamless cage of stainless steel. I halted. The light was so strong that I could no longer see the audience, the bowl of human faces. It was as though a semi-transparent curtain had dropped between us, but through which they could see me— for they were applauding—without themselves being seen.

"May I confess?" I shouted. "You are my friends. We share a common disinheritance, and it's said that confession is good for the soul. Have I your permission?"

"You batting .500, Brother," the voice called.

There was a stir behind me. I waited until it was quiet and hurried on.

"Silence is consent," I said, "so I'll have it out, I'll confess it!" My shoulders were squared, my chin thrust forward and my eyes focused straight into the light. "Something strange and miraculous and transforming is taking place in me right now . . . as I stand here before you!"

I could feel the words forming themselves, slowly falling into place. The light seemed to boil opalescently, like liquid soap shaken gently in a bottle.

"Let me describe it. It is something odd. It's something that I'm sure I'd never experience anywhere else in the world. I feel your eyes upon me. I hear the pulse of your breathing. And now, at this moment, with your black and white eyes upon me, I feel . . . I feel . . ."

I stumbled in a stillness so complete that I could hear the gears of the huge clock mounted somewhere on the balcony gnawing upon time.

"What is it, son, what do you feel?" a shrill voice cried.

My voice fell to a husky whisper, "I feel, I feel suddenly that I have become more human. Do you understand? More human. Not that I have become a man, for I was born a man. But that I am more human. I feel strong, I feel able to get things done! I feel that I can see sharp and clear and far down the dim corridor of history and in it I can hear the footsteps of militant fraternity! No, wait, let me confess . . . I feel the urge to affirm my feelings . . . I feel that here, after a long and desperate and uncommonly blind journey, I have come home . . . Home! With your eyes upon me I feel that I've found my true family! My true people! My true country! I am a new citizen of the country of your

vision, a native of your fraternal land. I feel that here tonight, in this old arena, the new is being born and the vital old revived. In each of you, in me, in us all."[1]

22.

If one is human, as a matter of sheer biological determination, then to feel *more* human, which is given only in the experience of having been made to feel *less* human, is, in fact to feel *more than* human, which is given, in turn, only in the experience of having been made to feel *less than* human. What if the human is nothing other than this constancy of being both more and less than itself? What if all that remains of the human, now, is this realization? What if the only thing that matches the absolute necessity of remaining human is the absolute brutality of remaining human? Is there any escape from the interplay of brutality and necessity? Serially excessive of itself in falling short of itself, brutally imposing the necessity of its retention as the only justification and modality of its retention, the human is only ever visible as the more than complete incompleteness from which it cannot quite be seen. Invisible Man marks and is the blindness and insight of this impossible point of view. Invisible Man can't quite see when he tells us how he feels; and when he tells us how he feels he does so by way of a paradox that is contained by the very feeling it cannot quite approach. All we know about what it is to feel, to feel suddenly that one has become more human, is that it is to feel immeasurably more than that. The immeasurable, here, denotes every earthliness that remains unregulated by human distinction and distinctiveness. At stake is the sheer, slurred, smeared, swarmed seriality of mechanical buzz, horticultural blur, geometrical blend, an induced feeling's indeterminate seeing Ben Hall musically instantiates in his art. Let the gallery's held logisticality explode into the Brotherhood's improper displacement. Give a sign. Shake a hand. Dance.

23.

Charismata—the gift of spirit of which Cedric Robinson and Erica Edwards teach—is conferred upon the one who cannot see by the ones who see him, in their hearing of him, in their bearing of him, in the touch of their eyes, in the brush of their ears, in the sight and sound of their open, lifted hands. It's as if he fades into their senses, them, the ones who in being so

much more and less than one can only be figured by science as the mob. To be held in the mob's embrace, in the wound and blessing of their shared, accursed sensorium, is to be made unaware of one's own invisibility—to feel, to feel more, to feel more than, to feel more than I feel, I feel. Can you hold one another tonight in the blur, so that one and another are no more? A table is prepared for your common unawareness, for the disinheritance you might not know you long to know you share, the share you're blessed to share right now that only unawareness of yourself will let be known. Invisible Man had withdrawn, if only for a moment, into the external world, which responsible subjectivity rightly understands to be no world at all in the brutality of its wrongful attempts to eradicate it. Adrian Piper, pied, in motley, blind, silent in her consent not to be single while, at the same time, loud, and felt, in the intensity of her confession, has been led to lead us out of the art world and into this exteriority with that same pentaphonic song Armstrong was always playing no matter what song he was playing. No matter what song he is playing, they are the ones who are not one who are playing it. That's what this entanglement of Ben Hall are playing. You have to excuse their grammar. DJ Crawlspace's repercussive counterweight is stairwell, in golden light well, in sound booth, in reverberate hold. That Armstrong plex, given elsewhere in Hall's *Some Jokers (For 5 Turntables, basement, ice cream and sloe gin)*, regifted as Paolo Freire, vocoded, digitized into uncountability by an unaccountable sonority Freire now would recognize, is the undercommon instrument whose instrument we'd like to be. In the glow and blur of the collective head's collective embrace, more precisely and properly valued in its fuzzy disruption of valuation, in its radical unbankability, in its inappropriable impropriety, light and sound *are* the materiality of our living, the basis of our revolutionary pedagogy, the ground of our insurgent, autoexcessive feel.

Irruptions and Incoherences for Jimmie Durham

24.

The propensity to dance in America is both corrosive and preservative, both uncountable and accumulable. There's a genocidal braid of sets of qualities and instances that can't be seen as one another's originals that might just be an object you can change. Certainly, it's an object that's always changing. The alternative is everywhere as air, and we're careless with what we breathe and how we breathe, hence this massive problematic of use, which is a kind of worship, if you can change without improving. If we embrace obscenity and contradiction, just in the way we move with them, it's not only because sometimes the terror of resisting earthly terror feels good, it's also because the terror of feeling good is not optional. There's a cloned, drone-like two-faced officer, a doubly-unconscious coin made out of any impossible body, money made out of untroubled performance and unalloyed critique, who says "privilege" and then, when you turn him over, "precarity," while acting like the realities these words are meant to index can be separated because, evidently, you can't see two sides of your art-historical self in the mirror. The piety of not thinking that is given in acting out this one-sided two-sidedness is surreptitiously piped into the general reservoir of normatively thought-ful bullshit, making it ever more noxious. Minted, self-assertion sways like a bunch of empty uniforms, shows like Calvinist branding on disavowed flesh, sounds like screeches, tweets, and chidings simultaneously pseudo-politically and hyper-politically marketing the suffering that exceeds being bought and sold, that can't be calculated because it can't be individuated or packaged in a tranche of torture-backed, countercaressive securities. Such critique is an interminable citizenship test in the world its performers say

they want to disappear. They dance, too, harder and faster, precisely because they are the ones who are supposed to know. They negate everything, with neither joy nor pain, and we are left with them, because we are them, watching them arresting what we are, because that's what we are, suspended between the careless negation of what we are and the careful affirmation of what we are. Is that what we are, is that what we are, this propensity to dance given in the terrible imperative not to celebrate?

25.

Is Jimmie Durham an artist? The legitimacy of his claim to the category is undeniable if he just wanted to be somebody, to the extent that any such claim can be legitimate for anybody, if there is some body, if there is any body. And it's just as undeniable that in his enactment of the category he simultaneously refuses its imperative to preserve itself in separation. To be an artist, in Durham, for Durham, is not to be one, as well. To suggest that he works, or that he is in movement, or that he is movement against the separate single being of the artist is to suggest a more general resistance to severalty, to what one might call, in echo of what the Dawes Act cruelly echoes, the allotment of identity, which Durham is constantly, which is to say endlessly unsuccessfully, escaping. Maybe Jimmie Durham is an activity. Maybe Jimmie Durham is a practice. Showing that we are not what we are, that we are not, that we are; saying that to say that is to affirm we as the persistent, militantly preservative practice of no-thingness, of the inveterate changing of every object and every nation, of an open-ended sculpturing of every exhaustively open end, Durham re-presents we as a matter of thought the prison church of privilege and precarity tries but fails to interdict. That we as cuts we are just enough so we don't have to worry about being-consistent or being-coherent is what we study, is all of how we come to nothing in study, finding more than everything in the findings we make. The practice persists, is preserved, only insofar as it is open, radically non-exclusionary, insistently improper in an overturning that laughs at itself to keep from crying. The vast range of violence the ante-national international perpetrates on the verb *to be* in the unholy name of the nominative case of the first-person plural pronoun is a clue that is, at once, both immanent and transcendent.

26.

What we be trying to talk about all the time, amongst and against ourselves and all up in the air and under the ground and water, is antegrammatical—a general beyond of the analogy, whose very invocation remains a kind of sterile double entry. The hold, the trail, the trailer, the project, the general antagonism—all that's just the mobile locus of an intensification of every feeling, which is why the way the alternative survives the ongoing genocide— even though the ongoing genocide kills every last body it makes—is so unfadeably chorographic and choreatic, manifest in a dance of vicious colonial mapping and nervous anticolonial muscularity. And all that's special about this or that exclusion, this or that death, is the general refusal of this or that exclusion, this or that death. If the notion that this or that modality of suffering is special requires disavowing the intensity of the entanglement of privilege and precarity (when that entanglement is so crucial to our necessary comportment toward the open end of world and time) then special needs to get let go in a continual enactment of that ceremony we keep finding, where being singular plural is dispossessed in a plain of sēms.

27.

Celebration lets being-special go, but under an absolute duress. Escape from the struggle for freedom is required. Celebration in art can't be redemptive because what we have to celebrate is so immeasurably small and large. Art asks how to hand on or hand out the feel and the sense of that against the grain of aesthetic theory's tendency to call the authorities in itself on itself. If I could only get myself to police myself, aesthetic theory wistfully sighs. In lieu of that, the ascription of radical irregularity is the ground not only of art's exclusion but also of the exclusion of every practice of the alternative, which is what we are. We have to celebrate the offness that's been writing on us, which we accentuate in nonperformances of nonportraiture, in we as, as in how we be pretending to be Rosa Levy. We on in putting on, in nothing, which turns out to be all red and black in the absence of the artist, her pencil stache and juicy lips, Duchamp's interminably descending rock bottom. In overloading an already overcrowded rogue's gallery of self-portraiture, Durham makes it seem like art might actually be able to rewrite itself out of making pictures of its selves in severalty all day long. Maybe we write ourselves out. Maybe that's what we are, he says, when we as like that

28.

To ask the question of how we get past the imposition of severalty and the self-portraiture that is its imperative and residue is already to bear something more and less than the artist's way of being. For the artist is given in severalty, beholden to what Durham calls the state's violent "immortality," which comes into relief as a spectral projection against the backdrop of patterns of exile and return, of precedent postresidential resistance to the brutally perennial settler state, which proliferates in a bunch of little states of settlement, found(ed) by artists in flurries of anti-loisaida self-picturing on the death march from urban village to east village.[1] "'We are parasites of the rich,' an artist friend of Durham's once said."[2] In recounting that passively aggressive self-assertion, Durham teaches us that severalty is where racialization and aesthetic theory converge. The individuation of the artist is a kind of massacre. And so we seek out the landed blessings of the landless, neither as a repertoire of countermeasures nor a collection of countersubjective standards but just because to want to dig the transverse earth is what we are. We as this changing object called object changers.

29.

This is all about land and use, but it's also all about language and/as material. Does the artist own the materials he uses and, in so using, improves upon? Does the poet own his language and, in so owning, purify the language of the tribe (as T. S. Eliot once said in a beautifully fucked-up western called *Four Quartets*)? On the other hand, is there a work of dispossession in Durham, of resistance to severalty, and even of a resistance to sovereignty given past the claim upon it and moving on in and as a violent unsettling that is at once earthly and divine? If there is it's only insofar as the work of dispossession cannot be contained. It places the artist, having come into his own in and through allotment, in grave danger of having to suffer the immeasurable grace of his disappearance, of her dispersal. See, I'm interested in the work and feel and material presence of dispossession, disappearance, dispersal, and disbursal in Durham's art, which is not his, and I'm thinking that this is something as palpably, audibly, flavorfully visible—as spirit, as breath, as irreducible and ineradicable aroma—in the objects he changes, in the changing of himself as object, and in the objections his changes raise and play not only on the very idea of objecthood itself but also on subjectivity, the

object's evil twin, its 'evilly compounded, vital I.'"[3] That's why it's so cool and crucial to check out the itinerary of his thinking on use, on development, and how it turns not only in his writing on artist-driven gentrification but also on the problematic of the very idea of the artist and his world. Durham moves, is on the move, his indigent indigineity in voluntary exile from voluntarism's slough and epicenter. But what's at stake is not in the way he carries himself or keeps carrying himself away; what's important is the way he carries his selflessness, the way he keeps changing that object, like a mobile sculpture in the act of its own making and unmaking, wrapped in the mantle of its own dismantling, continually asserting this refusal of self-assertion, constantly refusing representation and self-representation with a particular wave, an emphatic and insistently gentle kind of greeting and goodbye. The presence of the one who says here I am in not being here is dispersed and more and less than full, given in the air and dirt and water and flesh of a whole other, pre- and postcolonial mathematics. In this old-new math, it's not about figuring out ways to count the uncountable. It's about standing together, in refusal of standing, in praise of all. And let's say that for right now, for just this moment, that the name of all is Jimmie Durham. Now, I'm not saying that we are Jimmie Durham. That's a beautifully terrible thing to say. I'm just saying that in saying that the name of all is Jimmie Durham I'm saying that all don't quite add up. Jimmie Durham practices (the theory of) nonnumerical material.[4]

30.

Dense and airy earth, let's rearrange the neighborhood again, in curacy. The earth has a future at the end of the world right now. Right over here there's a museum for durational art formed in walking by panthers of care on a wingtip cruise. There's a vast unincorporated evangelical mission of blur. We trying to get people to practice and people already been practicing. They already knew but maybe just didn't feel it or didn't let it be a bright feeling, a way of strolling glow mutuality. When shift happens we notice the duration of the living. "The music is happening, I don't need to play," Monk says. Duration in Durham is like *Mary Lou's Mass*, monks say, while walking down the street as art taking displacement. Charged with the uncollectible, the museum will have taken aim, like a society for community safety, a defense mechanism of absolute openness for aesthetical Cherokees. Durham's durationally extrarational art wants to be beautiful, a certain lack of coherence in creativity

and the social process, that ongoing interruption of naturalization that we keep waiting for, the museum as a bunch of lumpen parties, a serially intergalactic swarm of midnight jams. The beautiful that's inseparable from the terrible, that's too nasty to be sublime, to flavorful to be tasteful, to syncopic to be fixed, too red, blur and black for things to persist in residence. The state is a mechanism for the monopolization of violence, its placement in or under reserve, in and as the strict regulation of generativity. And western thought and culture has been the place where this monopolization is theorized and defended, in the name and by way of sovereignty, self-possession, and self-determination. Freaked out over the generativity that destroys order, troubled by savory metastasis, underconceptual cancer, pre- and postconceptual sensing, not grasping but letting go in ripped up anapprehension, embodied viscera sense inevitable fade while the earth laughs sunlight.

31.

Bricolage is too charming, Durham says, too comfortable to keep close, too closed for the necessary discomfort.[5] So how do you go from pleasingly putting lots of things together to having nothing quite add up, to letting nothing be so thoroughly in the work that a certain unworking of the work gets done? The work of letting be the nothing in the work that undoes the work till it and the artist are eased with being nothing. The museum of that is walking around in exile and humility, endlessly having to have something to say for itself so it can help you make you strange to yourself. Estrangement, here, is all up in the rub or glance, not in the work, because to be strange to yourself, to be able to have been disabled in the museum, to walk in but not walk out (as you), and then to walk on, aesthetically, is to be unable to have found the work. An eccentric little piece of nothing gestures to the work's not being there. It's like if you can't see it then you can't see yourself in it. Indians love his work, Durham says, because they don't look at it. He says they have no use for it and perhaps it is in this that the work is useful.[6] Out of this nettle, danger, we pluck this flower, safety, which is way too terribly like picking all the goddamn cotton in the world. There's this problematic of how to refuse and to refuse, as well, their refusal, which often takes the form of fusion, of being collected in exclusion, of being brutally, violently wanted—in a libidinal economy of absolutely have to have—when absolutely no one wants you. Because the One can't want these explosive, "eccentric little pieces of nothing," these tchotchkes made for money by the ones who refuse to be money, these little bits of steal-

ing in stolenness.[7] Viciously, this has all but all been admitted. To let in is to confess where to incorporate is to deny. The whole thing is radically untenable and then there's the fact that we have to take responsibility for it. Europe is our project. America is our thing. You have to say that a million times before blowing them up becomes a necessary option. Jimmie Durham laughs, repeat after me.

Black and Blue on White. In and And in Space.

32.

Steve Cannon is a light, primordially black. Wallace Stevens is a wall, primordially white. Primordial black is blue. How blue can you get? Black. So your mind needs to go all wintry to see the nothing that is there through the nothing that is not. Understand this as a play of presences, not absences—or of presences held within a general absence that is, in fact, not there. It's winter but it's Sunday and the fire's already been lit. The nothing that is not there appears, but only from its own perspective, to surround the nothing that is. Attempts at a general imposition of this confusion occasion fusion and refusal. But here, now, the vacuity that is all but not there, the emptiness that so brutally and so generally makes its absence felt, is not our concern. We are after the absolute presence of blur. Blueblackblur is our concern. In anticipation, David Hammons concertizes our curacy and curation, at our entry offering us blue flashlights in a brilliant bowl. In (re)viewing Hammons's *Concerto in Black and Blue*, Cannon tells us the lights keep going off.[1] In this blindness, which is really an intermittence of shade, we dip our hand into the well for the luminescence of holy water. To come and see if we can see is a blessing, a table art prepares for us and prepares us for, more through less. If the world is a hustler's automobile, white on white in white; or a jar making wilderness slovenly and, then, unmaking wilderness; then the agile galleries of Earth are otherwise, even in light romance, as clusters of darkened church and open cell. There are holes and there are wholes. Ours is the deep midnight of category's beyond.

As Cannon says, the question that eventually, inevitably, Hammons brings to mind is what did we do? Nothing. Walk the streets. Knock on a door. Disrupt the supply chain of cigarettes. You have to do nothing to be so blueblack, which

is why there's a practice of silent destruction and itinerant grift in Hammons's work. It is as if, at once, in his radical invisibilities, he were as Ras as Monk, as Rinehart as Iceberg Slim. The blur he invokes, which is also his material, requires us to think hard about the difference and the relation between *in* and *and* in space, in the break that lies there between blue and black, as if it were something between blue and black, as if nothing were something between, as if the lie of something between could lie itself into being some blank surround. *And* implies *out*, as in outside, as in some thing, across some silent but emphatic line or border, that can then be linked, in the absoluteness of its singularity, to some other thing. *In* implies immersion, or even entanglement, and that's a whole other thing than the matter of things and their others. Blackness in Hammons's work is a matter of blue, surely; the matter is, as Leonardo says, "without lines or borders, in the manner of smoke or beyond the focus plane." Hammons's performed, participatory sfumato—black so deeply in, rather than and, blue, that blueblack is neither its word nor its concept but the old-new expression of its diffuse gathering of differences— announces a profligate tradition of steps to the side of compositional line, so that what Édouard Glissant calls *l'improvisible* is continually improvised. And the trick, of course, is this refusal of border under the constraint of border's constant imposition. *In* can't simply act as if *and*'s segregation, however unreal, doesn't produce absolutely real effects. *In* can only proceed surreally in *and*'s insistent, overbearing absence. This false ubiquity of absence, manifest as the proliferation of borders, must be radically and improperly misunderstood. What if we start acting like whiteness is not the surround but an inventory of snowballs suitable for wholesale distribution? Immeasurably aggressive, isolate flecks are harvested, processed, and submitted to their own restricted economy. The bliz-aard in which black's entanglement with blue is held in obscurity marks an atmospheric condition in and from which Hammons is constantly escaping; one aspect of his technique is to facilitate blueblack's fade into one another with such recalcitrant blur that it's hard to see up in (t)here. At stake in this concerto is not only counterpoint but also chromatic saturation. Sfumato bends toward deep song and, in the fashion of Ornette Coleman, we stop playing the backdrop and start playing the music. As Cannon says, blueblack haze or blue in green, Miles's microphonic whispers, come to mind; consider the trumpeter's absolute proximity to quiet, where how you sound is transmitted in how you look. There's a problematic of smoke and fume, an imperative of toning down in tuning up, intensification given in practice, as preparation, for solicitude in mutational silence.

There's a certain irony and violence in muted speech, at service in the pe-
culiar refusal of servility that flourishes in wine and urine-soaked hallways,
people pissing in the stairs because they just don't care because they care
too much. This is also blueblack, which is to say anaconceptual, art's, aus-
tere and lonely office. James Baldwin, Melle Mel, Robert Hayden—they all
sound this as a way of making space against the edge of color. The problem
of blackness and its relation to the concept is something toward which Can-
non gestures in the attention he shares with Hammons, approaching the
amazing and immense relation between beauty and nothingness, between
the material and the meditative. It is as if Cannon sees that Hammons has
been postcinematically producing all those experimental films Baldwin mor-
bidly dreams of making in the preface to *Notes of a Native Son*. Hammons's
findings work the devil in a way Baldwin speaks to, a way that requires hav-
ing pop-eyes, frog eyes, mama's eyes, Bette Davis eyes—not so that you can
see in the dark but, rather, so that you can look through all the blinding light
of the storm we been in so long. You have to be, which is to say deal in, what
the enlightened called ugly. Being black from head to foot will have been dis-
tinct proof that what Hammons says is stupid fresh. What he sees and shows
is all but all blueblack and beautiful in the shaping and packaging of snow
or in the immersive blackening of the gallery wall, that nonrepresentational
capacity that is supposed to allow all representation to take place.

Perhaps the operations of conceptualization and critique in the art/
political world and in (the aesthetic sociality of) black life are mirror im-
ages of one another. At which point *Concerto in Black and Blue* is the in-
finity room in which our fallenness takes flight? It is a retreat into sensory
overload, not deprivation. There's too much light and soon there will be too
much sound. Black stains lack with boom in blur; white is strewn with reflec-
tion, continually soiled with some of this funky soul we got here. One can
only hear these things in underillumination, Cannon reminds us, his vision
augmented and properly amplified in impairment. What he encounters and
describes in Hammons's work is the illumination, grand in being spare, of
his own inhabitation, a revelation in opacity that undermines the tendency
of the orator to tell it like it is. It ain't is the point, so how do we live with
that, he asks, reminding us that Hammons reminds us "that art, at its best, is
about beauty, and contemplation, which often means that it is about nothing
at all." What it is to be about nothing at all is not to be. Side by side beside
themselves, black and blue in white is an ignorant man again, knowing noth-
ing, not knowing anything and everything, the snow(ball) man, a junk man I

know, a man of vision, who supplies us with wire and sockets. Hammons has a mind of winter and, as always, as Ralph Ellison knows, as Gil Scott-Heron sings, it's winter in America. America has always got the blues, he sings, and in his eyes, which are her eyes and ours, our story is the story of America in that general absence of a story that someday might allow us to be eased with being more + less than one. It's strange in this snow-white village, which one comes to know having been interred in violent welcoming, where listening to Bessie or Billie in the relative emptiness—in the furnished and oppressive enlightenment—of a hole, one comes upon the open destination of the color we choose. Same ol' same ol' up here down there. Same in blues, he says, with a certain amount of nothing. The Soul of John Black says, I went down in the hole to see what I could see. When I got down in the hole, wasn't nobody but me. I can't see, he said, unseen. Somebody turn the light on, he said, nobody but him down there. Luckily, there's a junk man, lowdown in his own supply, 1369 snowballs sold, like lightbulbs, for the illusion of light they give off. The black light, the fugitive information, the radiation in winter, is detected only by way of another mathematics, a future metaphysics for which Hammons's work is epilogue, in absolute refusal of the principle. Ellison's whiteout his proliferate lightbulbed snowballs, optic and monopolated, are the poems of our climate, as a graffiti'd, blueblack Sharpied, Christina Sharpened Wallace Stevens might say. Our climate doesn't change. Nothing is nothing neither here nor there. What do we do with all this newly fallen snow? The jar, the bowl, its cold arrangement of flowers, that whole art thing, art's response to the weather, but if winter doesn't end for us here how do we respond when "the evilly compounded, vital I" is neither our birthright nor our inheritance, on this relay from uptown to downtown, the train of the kicked around, blue train, blue mood, black whole sun? That unlimited finitude that Richard Iton calls the black fantastic is Hammons's palette and subterranean pied-à-terre, reverberate with echoes of that phantasmagorical riot and irruption and implosion and retreat at the end of *Invisible Man*, that near drowning in carnival and bullet precipitation. Neither the ending nor the beginning is happy. Born in burial; a detached and empty hood; an empty, hanging noose and lonely mourner; a chalk outline with a piece of chalk in hand. What did the artist do to be so alone? Nothing but feed back to us a concerto. Let's see if we can see how to roll the stone away. David Hammons is a soloist, primordially blue, primordially none.

Blue
Vespers

33.

Because we are in a state of constant mo'nin', the upper room is our concern. If David Hammons's *Concerto in Black and Blue* is our vestibule, Chris Ofili's *Blue Rider* is our serial vehicle, bearing us as it bends toward itself, devotional space in midnight blueblack daylight again and again. When critics speak of the vibrancy of Ofili's colors, his unashamed decoration, it is as if, secretly, pigment were some dangerous shit since to be reminded of the material by its presence in the work—and, therefore, to be reminded of the work's irreducible materiality—is in blatant violation of a Kantian reminder to forget about shit like that. Color doesn't take place, but it does matter. There is neither settlement nor event in blurred mattering. Its dawning twilight gathering is space-timeless. Blueblack matters no matter where or when. Its topological gravity has a sociopoetic logic. And if there's a writing (not) (in) between—suspension moving through inverse prose in celebration of a critical mass, in preservation of a celebratory space—then Ofili's work is such writing's exacerbation.[1] I just want to devote myself to that, to be touched by that disturbance, to feel its quickening power. I can't handle it, can't grasp it, can't quite reach it but it's precisely that aeffect, that getting to in being gotten to, that I'm after. I mean to say that I am after that but also that "I" is always and only ever after that, as emanation, as emissary, as evangelist. Maybe to be within reach is the imprecise way we have for reaching out, in our speech, to what it is to have been reached. I still be reaching—thinking about, as well as experiencing—a tensing, sensing the aspect of a muscularity not under control, searching for an all-encompassing outside I'm caught up in. This whole problematic of the (not) (in) between is an old obsession to and by which one is given as a kind of legacy. It's this givenness of (the) one, which is best understood as this given awayness of (the) one, that the problem of $_{n/i}$between, of not being in the between, brings into relief. But I'm digressing from a digression I haven't made yet.

I wonder what Frantz Fanon would think of Ofili's colors, their intensity, their unapologetic flavor. From tension, from an occupied kinesis only to be relieved or placed in release in an overturning of the settler's political order, that I'd rather think of as a kind of anticolonial muscularity moving against the grain of every political order—based as they are in fiction of the regulative/ regulated body—is it possible to move with or in the grain of the fugitive play of flesh in constraint? What's between such more than voluntary movement and Ofili's insurgent chromaticism, his antinomian shade and ruffneck hue, especially when all that color is distilled in/as his blue(s)? First of all, when I say distilled I mean to say blurred. I mean to say bluesed—moved: slurred: shifted: shined: differed: suffered: grafted: (choreo)graphed: grifted: thrown: enthralled: if not by some three-person'd God then certainly by Trinidad's nightshade bacchanal. I mean to say blacked—not out, but lit, as if being illu-mined in this way came only in answer to a call that was, itself, a response; or maybe lit and out, lit out as if for some territory or as if part of some territory band, maybe the Blue Devils Walter page conceived in his secret visitations to Paramin. What I'm after in all this is what happens when you go to that holodecked church up on the third floor. You go up there to join a movement, to see what movement feels like when you inhabit the changes.

This absolute and incalculable precision and precedent of blue in blur is all you could ever want to talk about tonight and every night, which will have only been to keep on asking after the richness and complexity of black(ness) in Ofili's work. In asking after Glenn Ligon's asking I can't keep myself from say-ing that Ofili's work is so black it's blue. It's hard not to tarry with the ensemble that's forming (in) my mind: Ofili, Fanon, Ralph Ellison, Louis Armstrong constitute a quartet within a larger plain. Ben Hall sits in, as an arranger. That multistereophonic shmear, its caressive crash, is Hall's *Black and Blur*, his staging of *Invisible Man*'s underground *mas* or masque: "I'd like to hear five recordings of Louis Armstrong playing and singing '(What Did I Do to Be so) Black and Blue'—all at the same time."[2] My perversion of this fantasy is Ligon lovingly tormenting Fanon with five video screens replaying this. Isn't it hard not to think that Armstrong's performance of "Black and Blue" in Kwame Nkrumah's presence and in his honor at the celebration for Ghana's foundation as an independent state is that to which Fanon obliquely indexes, in "On National Culture," as the prototypical "jazz lament hiccupped by a poor, miserable 'Negro' [which] will be defended by only those whites be-lieving in a frozen image of a certain type of relationship and a certain form of negritude"?[3] Sometimes I think placement of Fanon under such duress is

necessary prologue to a new kind of contrapuntal, pan-African groove, some blue rhapsodic panorama given in and as ensemble's beautiful division and collection, whose venue is the sunset chapel where *The Blue Riders* hang, all for you, as Extra Terrestrial Mensah said. Go see if you can hear them in the space they make, as that space makes them, our Crepuscule with Ofili. This is what Brent Edwards calls diasporic practice. We could also call it diasporic prayer.

34.

This turns out to be a series of letters I'd better not send. I'm procrastinating my way into writing what I'd promised to deliver. I've had to move by that indirection because I want to take the promise back, should never have made a promise to write an essay that Ligon has already written way better than I could have ever hoped to do. I'm trying to write my way out of it by digging into its epigraphs, looking for something in which I am immersed. I'm caught up in the middle of something, like Bobby Womack. I wish you didn't trust me so much. I've been (not) (in) between for a while.

Remember that Piet Mondrian show at MoMA in 1995? That wasn't the first time I got utterly messed up at an art museum. I think the first time was at the Fogg, was actually a series of first times with Pierre-August Renoir, *Gabrielle in a Red Dress*, every other day for at least a year; but even after it messed me up I didn't know it was possible to get messed up like that; the Mondrian was the first time I understood a little bit about what was happening to whatever it was I thought was me, but way before that there had already long been that buzz, that blur, that swoon in red shade, red shift, sent moving toward a moving away all held in blue entanglement. Then, at the Mondrian show, there was this amazing nonarrival at unfinished, condensed, explosively multi-matrilinear seriality, the amazingly, beautifully jooked joint called *Victory Boogie Woogie*, Mondrian's transblackatlantic thing, the thing that lets you hear that supplemental, elemental "a" he dropped from his name, Mondri*a*an, like a held or hidden note, letter pressed, paint over tape, painted over, taped, taped over, scratched, dubbed, overdubbed. To continually approach a work whose absolute madness constitutes a radically embracive sending messed me up; I'd been sent, turned, turned out, made out of turn, never to return. Deeper still, *Victory Boogie Woogie* still sends what's left of me—dispersed, disbursed, all through its folds and creases, on the way

to *The Blue Riders*. Now, I'm trying to get at getting to, something seeing those paintings softly and insistently imposed. They really got a hold on me, got to me, held me, threw me, got through to me and through me, in that space, that chapel, that new upper room they (re-)made. It's like a culminating propulsion into I don't know what. To have arrived at nonarrival. It's this seriality, our common seriality, I would sing (about) if I could live the love that I sing about. I keep getting sent to church is what I want to say; sent to being sent again, sent by color in search of color, sent serially prospecting for the color. Not series the way they want to make you think about it; this thing is a beautiful violation of privacy, a mashed-up, improper cultivation, an underhistory of art Ligon initiates in his channeling of Goethe: "The colours which approach the dark side, and consequently, blue in particular, can be made to approximate to black; in fact, very perfect Prussian blue, or an indigo acted on by vitriolic acid appears almost as a black."[4] To sit with this a while is to consider that the history of art is a history of violence. How can you not be happy to live that violation, but how else can you describe what induces us to inflict upon our minds the shift from shade to shade? There's a personal trajectory, worked by a whole problematic of edge, that trauma describes more accurately than dream: Renoir, Mondrian, Adrian Piper, Tshibumba, and on, in just these last months, to the disruptive accompaniment of blur's—or blurred—facticity when Judith Barry's video relinquishes integrity in a dark corner of the Hammer or when Mike Kelley's work (whose chromatic intensity prepares you for Ofili's) bleeds all over and into itself, or selves, or residue, in a temporary contemporary cavern in which the shift from shade to shade, in lieu of the objects or spaces that are supposed to have borne them, is all I see. Out of the blue, out from blue, on blue's darkside, Ofili calls us to prayer.

This is a series of letters that asks, can we speak of an arrival at seriality itself? This would be to speak of an arrival at seriality's irreducible indiscretions, the riotous generativity that worries the line, as Cheryl Wall might say, into its unnameable existence. Seriality's monkish, spherical dimensionality—volume turned up on an already golden, broken, distended, unended circularity. An insistent seriality, its (re)turn, all the concomitant blue blurring that goes with that. A seriality of the not-in-between, the unenclosed. Ofili's work shows this entanglement—seriality's curved indiscretion. I better deviate from the original plan. I would feel bad about it if I didn't feel so good about it.

35.

What if we begin with the black and blue premise that it is a terrible thing to have been given a face? I want to say that the face is a function of enclosure. *So black it's blue* is usually a thing one says about someone's face, but very rarely to it. What if everything, every fall, every torture Fanon collects under the rubric of epidermalization, belongs more fundamentally and properly to another process we might awkwardly call envisaging? I mean, in this term, to indicate a very particular modality of imagining and contemplating, one given primarily as a mechanics of (facial) recognition, an ethico-phenomenological event best understood as the continual imposition of a murderous gift. Imagination is regulated in and by such recognition; our existence is unrecognizable if we could only imagine it. So if I consider Ofili's *Blue Riders* as extensions of his *Afromuses*, a virtualization of portraiture arisen in and out of the depths of an underground upper room that has, now, become Chris of Manchester's *Showings*, his Moored, unmoored, unanchored, ananchoritic visions, is this too far-fetched? Is it too much to hear in Mahalia Jackson's eternal recurrence an impossibility of black portraiture we might want to get at? It bears something of the divine, materializing an iconography. Perhaps there's a portraiture that disrupts the face, and the face to face, while calling us to prayer? Ofili shows us an imagining that is happily less and gloriously more than envisaging. He does this by way of entangled seriality; the upper room cannot possibly be abandoned. Crepuscular Trinidad, that anasatanic, Trinitarian blue, night and day, twilight, 'tween, that 'twe'ensong Ligon beautifully approaches, the scandal of the material given in an application of paint to flesh, nothing in between.

When Ligon reports Wittgenstein as having said there is no intermediary between color and space, it is tempting to say there's none between color and material, either.[5] Perhaps the paint, the pigment itself, is what, and all, there is. Blue is in that it matters toward an animaterial impasse—a certain facticity, even tactility, and also motility of light, its spontaneous movement, its quantum, particular velocity, its short, anivolitional wave, an impassioned, reflective greeting we receive so we can ask: Where is it? Does it matter? And these are the questions Ligon wants to make us want to ask, as if blue's mattering were a matter of location. Doesn't the materiality of the pigment itself mediate between color and space, light and location? Doesn't it mediate them, and the distance between them, away in its own running away? Isn't blue a fugitive pigment? Doesn't it fade (to black)? Ligon says blue is

a bitch; it won't stay; moreover, blue don't care when you pack your own bags; blue ain't even thinking about sunrise. See what blue has done? Pigment calibrates a material's reflectivity and capacity to absorb. Air scatters radiophonic spray. And then it turns out there are all these layers—colorant, binder—till nothing but middle's registered, bottomless medium's boom, vehicle in the tension it induces, riding, giving pigment a ride, taking reflection for a ride, but bound and in suspense, but somehow fugitive when suspension fails, hits bottom, so blue is already in green, on the way to what it's in, that modality of herbaceous mood, depressive mangrove, metamorphic plant in early mourning, post-blue's lumpen swerve. They knew you were gonna start saying that shit so they started signing lazulic roughness at great expense to the theory of color.

This is Maggie Nelson:

54. Long before either wave or particle, some (Pythagoras, Euclid, Hipparchus) thought that our eyes emitted some kind of substance that illuminated, or "felt," what we saw. (Aristotle pointed out that this hypothesis runs into trouble at night, as objects become invisible despite the eyes' purported power.) Others, like Epicurus, proposed the inverse—that objects themselves project a kind of ray that reaches out toward the eye, as if they were looking at us (and surely some of them are). Plato split the difference, and postulated that a "visual fire" burns between our eyes and that which they behold. This still seems fair enough.[6]

Wow! To see a work of art in twilight, that ongoing disruption and deferral of the total. Monk plays, monks play, and I consider how my light is bent. Prolepsis is conceptual motility, a thought provoked by senseless sense, enacted in senseless ritual's inveterate sensuality, disorder's tendency to blue, this blackness, which is not prophecy but description. How blue can you get? Prochronic blue. The bluer the berry, the sweeter the juice. We *been* gone, *was* gone when we got here, that inveterate forward flash of nachel blue, that senseless sense of what *been* there 'cause it *been* gone, subjection's prey in prayer, entangled, exsensed blue, brushed grammar, blue grammar's swarmed, schwärmereitic anasyntactic mood.

36.

What if they changed the name of Paramin to Paraman? Check out Earl Lovelace in *The Dragon Can't Dance*:

In truth, it was in the spirit of priesthood that Aldrick addressed his work; for the making of his dragon costume was to him always a new miracle, a new test not only of his skill but his faith: for though he knew exactly what he had to do, it was only by faith that he could bring from these scraps of cloth and tin that dragon, its mouth breathing fire, its tail threshing the ground, its nine chains rattling, that would contain the beauty and threat and terror that was the message he took each year to Port of Spain. It was in this message that he asserted before the world his self. It was through it that he demanded that others see him, recognize his personhood, be warned of his dangerousness.[7]

We could pretend to self-assert, but what if carnival is this other thing? There, gone, blue philosophy just gon' be proleptic, projective, anticipatory, improvisational. This is Judith Butler working an encounter between Mladen Dolar and Louis Althusser that puts us right at carnival's edge:

Dolar underscores the inability of Althusser's theory of ritual practice to account for the motivation to pray: "What made him follow the ritual? Why did he/she consent to repeat a series of senseless gestures?"

Dolar's questions are impossible to satisfy in Althusser's terms, but the very presuppositions of Dolar's questions can be countered with an Althusserian explanation. That Dolar presumes a consenting subject prior to the performance of a ritual suggests that he presumes a volitional subject must already be in place to give an account of motivation. But how does this consenting subject come to be? This supposing and consenting subject appears to precede and condition the "entrance" into the symbolic and, hence, the becoming of a subject. The circularity is clear, but how is it to be understood? Is it a failing of Althusser not to provide the subject prior to the formation of the subject, or does his "failure" indicate only that the grammatical requirements of the narrative work against the account of subject formation that the narrative attempts to provide? To literalize or to ascribe an ontological status to the grammatical requirement of "the subject" is to presume a mimetic relation between grammar and ontology which misses the point, both Althusserian and Lacanian, that the anticipations of grammar are always and only retroactively installed. The grammar that governs the narration of subject formation

presumes that the grammatical place for the subject has already been established. In an important sense, then, the grammar that the narrative requires results from the narrative itself. The account of subject formation is thus a double fiction at cross-purposes with itself, repeatedly symptomatizing what resists narration.[8]

Let's make a narrative about resistance to narration. Let's make a narrative of passage—a story too blue to be true, or believed; a passage too terrible to pass up. All rituals are not the same. Why is prayer different than speech? Maybe it's because prayer, if it's real, implies neither addresser or addressee. Maybe prayer is (not) (in) between. Maybe prayer is that there's nothing between us. Maybe there's nothing between black and blue, no relation of existence between blue and gone, just that blur black leaves when it comes and goes before the subject. Blue comes and goes before the subject. Blur comes and goes comes before the subject. There's another kind of prayer, another modality of devotion, another devotional mood, given in the black indigeneity of ceremonial indigo. We are (in) the general prayer just like we are (in) the margins, the wilderness, the social. We are (in) the insistent previousness of the we. We precede. Blue abides. Where? Gone. This problematic of blue's place, that it has none, in a movement of infusion and surrounding. Where's the sky start? We are in it, this border. We blue.

In lovely blue the steeple blossoms
With its metal roof. Around which
Drift swallow cries, around which
Lies most loving blue.[9]

This is Friedrich Hölderlin's variation on a theme by Ligon. It lets us consider more fully, more literally in relation to Wittgenstein's suggestion, which is to say beyond the location of the paintings, of the spaces they are meant to represent, just what it is to say that there is no relation of existence between color and space. Is to say that there is no relation of existence between them the same thing as it is to say there is nothing between them? Lovely blue's braided infusement embraces things, and the embrace is a kind of annihilation, but not the kind we're usually enjoined to fear, just the kind that generalizes the indiscretion in and by which we live. Blue is something (not) (in) between things—a medium, the material within which the pigment is suspended, through which it's transferred, in both reflection and absorption.

37.

It makes you wonder how painting's conceptual work survives its materiality? But this is not merely to repeat the Marxian distinction between the rational and the mystical, which would correspond to that between the conceptual and the material: rather, let's think about the radical entanglement of all of these, "long before either wave or particle," which brings what will have been isolated under the rubric of the mystical material back into play, precisely *as* medium, or as the refusal of the relation/distinction (not) (in) between not only color and space but also (not) (in) between medium and whatever is mediated.[10] Devotional practice is also given in the way *The Blue Rider* paintings are hung, in the arrangement of light, in echo of The Upper Room. Mahalia's ongoing ascension, her having anticipated Jesus in coming, and in reaching, after Him, is given in and against Thomas's doubting materialism. What is needful in Thomas's doubt, his appeal to the sensual against the grain of the supersensual's strict hegemony, which hallowed, hollow sovereignty is always already trying to establish every time it walks into a museum demanding, "Go some of you and fetch a looking glass." That's the other hand. On the more and less than one hand, some of us want to see not for ourselves. Perhaps it is this insistence upon the sensual that sustains us in the flesh. The blessing must be taken for a wound so that the wound can be taken for a blessing. That's the artistic gesture that cannot be reduced or denied, that it's all got to be seen or felt, that massive concert of seeing, feeling, tasting, breathing, hearing that Christian iconography can't get past which is revealed in its need/tendency to represent the wound, to ingest at the wound's convergence of body and blood, that vermillion shock a registration on various altars just to let you know, again, that alteration is the truth in painting, that the truth is given in painting's untruth, not in between, animediate, gone. Materiality, pigmentation, and (un)truth, mess with the supposed interplay of truth, whiteness, and transparency like a birthmark. There's a little heretical contemporaneity, moved, off-stride, in time in being off or out of it, just to let you know that first and last are a brand-new sign. There's a gathering of the entire spectrum in the intensity of this relay (not) (in) between black and blue. There's a runaway ra(y)ve hiding every rising color. All this lets you know that anticolonial chromaticism's anticipatory force ought not be mistaken for blind return. Fanon's ambivalence bears the trace of that mistake. Why can't he share the "poor, misfortunate negro's"

open secret—which is, precisely, given in and as resistance to the irreducible interplay of arrest and relationship?

How to keep this vesperish thing, this echoic atmosphere, this condition of surrounding and infusing, this nonsensical, exsensual ritual, an open secret? How to let the sun inside a refuge? Bob Marley would get back to the hotel room after a show, turn on his portable reel to reel and search the sky for songs like Bukka White. Ofili's pigment, his scattered skylight reflectivity, is the ground for how we imagine the ongoing conversation within which Hölderlin and White become, surround, and refuse one another. Unfallen, Kant remains uncharmed, unable to rise. Fallenness is grace. Suspension is in the material. That's the medium. There's nothing but medium. It's all border. Blue is all black in this newness. Let relation fall out. The term misleads, is grammatically incompatible with the irreducible facticity of entanglement, which these paintings iconize in serial rub. To think blue, to see and feel it, the fact of painting, the fact, the truth of painting, of paint, of pigmentation, is this. This animediacy of blue and black is deep. Another method of truth is given in this fleshliness. Blue is black in this nonexclusion. When color is so reviled, look for color everywhere. Ofili is a person of color. People of color don't quite correspond. Their encountering is objectional, in resistance to objectification. Oblique, appositional, sidelong. If the world is a world of faces, they refuse. Such refusal is devotion. Ofili is the chapel.

38.

What if the body is church's situated disavowal? When Butler says, "The body is not a site on which a construction takes place; it is a destruction on the occasion of which a subject is formed," she takes us *into* carnival's edge.[11] Does, can, an individual life matter? Can we speak of the materiality of "an individual life"? If portraiture assumes an answer in the affirmative, then showing otherwise responds. To say that this or that life matters, that it has value, is to speak, finally, of a radical animateriality as the source of that value and as if it were that value when to attend to value, or to what is said to have value (in its distinctness), is to forget its source. And so we act as if distinctness forgets where it's coming from even as its troubled, troubling experience can only ever occasion the question, what is that *ani*materiality? What if the animateriality that makes a so-called individual life matter is, precisely, that there is no individual life? That blur, given in a failure to interpellate

that too much attention to the failure to indict, erases, is understood by But-
ler even to "undermine the capacity of the subject to 'be' in a self-identical
sense."[12] She hopes that "it may also mark the path toward a more open, even
more ethical, kind of being, one of or for the future," but what if the future
is given more emphatically in what is usually avoided as mere consignment
to (a relative) "nothingness"?[13] This difficult passage requires immersion in
a tradition of massive, studious fête. What is mistaken for the absence of a
tradition, of that tradition, is brought into relief by T. J. Clark operating in a
modality of research that doesn't just move in but also seeks to justify forget-
ting where distinctness comes from and to posit it, rather, as self-grounded,
background(ed) incapacity.

> The look of someone looking at himself looking at the look he has
> when it is a matter of looking not just at anything, *at something else*,
> but back to the place from which one is looking . . . would that do bet-
> ter? Is that what self-portraiture is about? Simple questions in this
> area seem to open onto infinite dialectical regress. And isn't one of
> the things we admire in the best of the genre precisely the effort to
> represent this dialectical vertigo? Isn't that what Rembrandt is doing?
>
> Somewhere in the back of my consciousness I clung to the idea that
> self and other, exterior and interior, immediacy and reflection were
> distinctions that shaped the look I was trying to come to terms with. I
> wanted to resist the distinctions, or at least question them, but I knew
> that the look short-circuited my intellectual defences. It addressed me
> directly. It put me in the place of self. Rembrandt and I—the look was
> our term of agreement—were face to face.[14]

Note that in the second passage, Clark offers commentary on the first
one, given in a previous essay on self-portraiture some twenty years earlier.
Clark wants to resist the distinctions, to resist their naturalness, the sense
that they're not coming from somewhere, but the brutality of having been
brought face to face, this misprision of ethical encountering in which the face
is imposed as both emblem and instrument of serial blur's (of black + blue's)
strict regulation, in which what passes for difference is difference's seizure,
is not the same as the vulnerability that marks/instantiates entanglement.
We do not undo one another; we are this constancy of undoing/redoing, this
generality of antagonism and protagonism that blue seriality induces when
portraiture gives way to mystical and material showing. Clark, emphatically
redoubling what was to be diagnosed, must remain concerned with a no-

tion of space in its relation to the time of the infinite dialectical regress of self-regard. The space-time of the self as spectacle, as spectator, is given as the auto-originary origin that can't be cut, or cut off, or cut away from. Unlike Michael Fried, who understands that place as a site of exaltation, Clark knows it to be a relegation. Rembrandt puts him in his place, which is a terminal condition, even and especially if one desires it, which one must insofar as one is only in this desire. This desire delimits a world, which is not an earth, of faces. Addressability is an epiphenomenal vulnerability, more than terrible because it is devoid of saving power. Clark is in despair. He can't be saved from himself. This despair, generalized, in which Rembrandt's pictures of faces are always "exposing the brain to the world"; in which "the face is the form of the brain in the world"; in which "a face . . . is a machine for exteriorizing—exchanging, universalizing—subjectivity"; in which a face is a machine for universalizing the "I"; in which "a face that encounters itself as an object, be it exhausted or immaculate, is always an ego luxuriating—fully and wonderfully entrenched—in its being-in-the-world" is the despair that accompanies and undergirds recognition. Subjectivity's abject exaltation is a certain shade of the blues.[15]

Clark tries to get at something in "World of Faces" that Butler, in *Precarious Life*, also touches on, in and as an assumption of the additive relationality and isolate bereavement given in "we's" self-fashioning and self-annihilation at address. "One speaks, and one speaks for another, to another, and yet there is no way to collapse the distinction between the Other and oneself. When we say "we" we do nothing other than designate this very problematic. We do not solve it. And perhaps it is, and ought to be, insoluble. This disposition of ourselves, outside ourselves seems to follow from bodily life, from its vulnerability and its exposure."[16]

But there is an anoriginal or anoriginary vulnerability, a vulnerability before vulnerability's coalescence, entanglement's anaecstatic before, that ought not be forgotten, that remains not to be drawn forth but as a recess to accompany fugitive, welcoming twilight. At stake is the infinitesimally small, immeasurably large difference between the arrest and embrace of elusion, an uncapturable allure that precedes itself, that precedes the self, that precedes the body, or bodily life. This irreducible and jurisgenerative precedent— blackness misunderstood if it is merely understood as void; nothingness misunderstood if it is understood as relative, wildness misunderstood if it is understood as wilderness—is *pied, precedent, precise indistinction, an imaginative, improvisatory, previsionary refusal to be envisaged.* What the

face, in its irreducible instability, gives us, is that which is between us insofar as we are always and only in between. The blue-black birthmark that undergirds and undermines every act of portrayal; portraiture's anafoundational betrayal, self-murder, I suppose, because, as Amiri Baraka says, the new black art is this—find the self, then kill it. That's the *Iscariot Blues*. Ofili serially gives us what painting gives in spite of our serial attempts to give that gift away. We are (not) (in) between, beside ourselves in this constant and constantly forgotten setting of ourselves aside. That's all. And here what comes into play for Butler is this problematic of the address, this question of vulnerability, this generativity of imperfection.

> The structure of address is important for understanding how moral authority is introduced and sustained if we accept not just that we address others when we speak, but that in some way we come to exist, as it were, in the moment of being addressed, and something about our existence proves precarious when that address fails. More emphatically, how. So if we think moral authority is about ever, what binds us morally has to do with how we are addressed by others in ways that we cannot avert or avoid; this impingement by the other's address constitutes us first and foremost against our will, or, perhaps put more appropriately, prior to the formation of our will. So if we think moral authority is about finding one's will and standing by it, stamping one's name upon one's will, it may be that we miss the very mode by which moral demands are relayed. That is, we miss the situation of being addressed, the demand that comes from elsewhere, sometimes a nameless elsewhere, by which our obligations are articulated and pressed upon us.[17]

It's important to figure out what's off and asymmetrical and noncorrespondent between "we" and address." *We* has no address, no location. *We's* general dislocation makes addressability a kind of pretense, a kind of performance, as the relay between enactment, embodiment, and indictment. What if (not) (in) between, its dislocation, its ill(ocal) vocality, is flesh's reconstructive deconstruction of address? The address is not what lies between us, like a power line that activates the ends it connects; nothing lies between us; we are (not) (in) between. *Vis-à-vis* is a story we tell whose dominance places us at risk. Butler says that we come to exist in the moment of being addressed; the address, which is to say our addressability, comes first. But whose addressability? We appear to come first; we appear to bear addressability as a kind of capacity

before we are addressed or, as it were, brought into existence by the address. This is Butler's Paradox, which she outlines in *The Psychic Life of Power*. Has she forgotten? How do we preserve? In articulating the paradox Butler reminds us. Maybe we can feel it, enact its ritual, assert that carnival, as a kind of recess, a kind of hollow, a kind of holla we inhabit, that reverberate, nonlocal hello which emits call-and-response as only one terrible and beautiful possibility. The problem we designate, the problem "we" designates, is the indistinctness whence distinctness springs as the all-but-unchecked disaster of generativity's arrest.

39.

In Claudia Rankine's finely wrought encounter with Butler, what remains most deeply for us deeply to consider is not the address or the common and vulnerable collectivity the address calls into existence but rather the trace of a *we* that comes before that, its recess, *nowhere*, a lyric pool Rankine sounds with atonal precision, held within what Erica Hunt identifies as a ruse of address:[18]

> Listen, you, I was creating a life study of a
> monumental first person, a Brahmin first
> person.
>
> If you need to feel that way—still you are in here
> and here is nowhere.
>
> Join me down here in nowhere.
>
> Don't lean against the wallpaper; sit down and
> pull together
>
> Yours is a strange dream, a strange reverie.
>
> No, it's a strange beach; each body is a strange
> beach, and if you let in the excess emotion you
> will recall the Atlantic Ocean breaking on our
> heads.[19]

Nowhere, down here, in dislocation, in Rankine's song and *Zong!* extension, lies what Butler indexes as a chance for interpellative failure, for misrecognition, given at the intersection of decision and complicity, either of

which bespeaks a kind of priority, an existence before the call that is supposed to bring one into existence. She speaks of it as a self before the self, a self that then turns on itself, turns against itself in turning to the law that hails it. But why assume that this priority takes the form of a self, or deeper still, that it takes form at all? Here's where we might begin to think the radical informality of we, the nothing, the blackness that is before, and deep, in the break, not in between. The world and the face are failed project, harsh projection.

At twilight, in the evening, when sense is gone as sense's blur, the sociality generally valued as relatively nothing is given in the full richness of its resistance to valuation. Why impose upon shadow not only the neat dismissal "total darkness," but also, and more terribly and fundamentally, the colonial dishonor of accommodating the work of art and its individual beholder in their locked-down, joint vacation? I hope I'm not just valorizing absorption over theatricality, after all. Clark says it's not about the look, it's about the face. But absorption still implies a separation. Let's not be so conscious of our self-regarding otherness, says Michael Fried.[20] But it's the whole metaphysics of relation and address that is disturbed. It's not that Fried and Clark cancel each other out; rather, it's that they blur. For Fried, absorption is a special, illusory condition that relation makes possible. The art critical condition of conviction manifests what representations of absorption are, themselves, supposed to represent. Nor is the point some Kaprovian blurring of art and life. The point is the blur itself, the celebration of mass, the playing of *mas*, as a phenomenon of indistinctness, of indiscretion, the blood, the blues, the bruise, come out to show them, come out to show them, come out to show them. In the midst of terror, fighting every achievement of loneliness we are constrained to desire, this is the force in performance of the paramen of Paramin, carnival's absolute interval, whose prayer and practice Ofili visually recalls and calls us to tonight and every night.

The Blur
and Breathe Books

40.

I have been studying how I may compare

This prison where I live unto the world:

And for because the world is populous

And here is not a creature but myself,

I cannot do it; yet I'll hammer it out.

My brain I'll prove the female to my soul,

My soul the father; and these two beget

A generation of still-breeding thoughts,

And these same thoughts people this little world,

In humours like the people of this world,

For no thought is contented. . . .

Thus play I in one person many people,

And none contented: sometimes am I king;

Then treasons make me wish myself a beggar,

And so I am: then crushing penury

Persuades me I was better when a king;

Then am I king'd again: and by and by

Think that I am unking'd by Bolingbroke,

And straight am nothing: but whate'er I be,

Nor I nor any man that but man is

With nothing shall be pleased, till he be eased

With being nothing.—**SHAKESPEARE**, *Richard II*

Philosophy, as we use the word, is a fight against the fascination which forms

of expression exert on us.—**LUDWIG WITTGENSTEIN**, *The Blue Book*

"The Blur and Breathe Books." This is a play on Wittgenstein's *The Blue and Brown Books*, notes composed in Cambridge in the early 1930s that are considered preliminary to his *Philosophical Investigations*, a text left unfinished and, therefore, eternally preliminary, at his death and even after its publication. Nathaniel Mackey would call it "premature and postexpectant." The text remains incomplete as a function of a ceaseless worrying, an endless rub, a troubling pregnancy, an obsessive overpolishing that eventually blurs always and everywhere with undoing. Over the past few years, I've been thinking and writing about contemporary art and the phenomenon of blur that sometimes happens both in and between artworks. You could think about it as a kind partition in refusal of partition; a general assertion of inseparability, which nevertheless still moves in and as a ubiquitous and continual differentiation; a breaking or cutting or scoring, if you will. Here, now, in this/ that blur, I'm especially interested in the visual artist/composer/pedagogue Charles Gaines. In the last few years, in Los Angeles, the city where he lives and works, as well as in other cities throughout the country and the world, Gaines's art and music have been displayed and performed in an expanding duo of exhibitions: *In the Shadow of Numbers* featured a selection of works created by Gaines since 1975, focusing in particular on the audiovisualization of number in his work; *Gridworks* re-presents work deploying grids, mathematical operations and multiple layering that had been completed between 1975 and 1989; that show, in turn, spread out in two directions—*Manifestos 2*, in which a nine-piece ensemble played a musical score by Gaines based on a translation of four political manifestos (which scrolled one-by-one behind the ensemble) in which musical notes and silences were assigned to the letters making up those texts; and *Librettos*, which I want to discuss here, a work involving the superimposition of excerpts from the score of Manuel de Falla's opera *La Vida Breve* over the text of another famous political mani-

festo, a speech delivered on April 19, 1967, at Garfield High School in Seattle, Washington, by pan-Africanist political activist and theorist Stokely Carmichael. I will try to focus on a certain resistance to focus in *Librettos* and to move from there to some suggestions regarding aesthetic indiscretion and the critique of sovereignty, questions with which Gaines has long been engaged as a theorist, critic, curator, and even a dramaturg of sorts. All of these roles and their implications are operative in Gaines's *The Theater of Refusal: Black Art and Mainstream Criticism*, a now practically mythic exhibition he arranged at the University of California, Irvine, in 1993, and in the extraordinary essay he wrote for the exhibition catalog. In order to try to talk about *Librettos* I'll have to try to talk about these as well.

41.

At the time of his speech, Carmichael is in the full flowering of his emergence both in and from the leadership of the Student Nonviolent Coordinating Committee (SNCC), a group of young activists crucial to the vast range of dispersed, differentiated insurgencies somewhat misleadingly known as the Civil Rights movement. In his speech, Carmichael brilliantly elaborates a theory of black power that held its own rich and complex critique, rather than denunciation or disavowal, of violence. Meanwhile, Falla, whose opera, first performed in 1913, tells the sad tale of a poor young Roma woman, Salud, whose passion for the well-to-do Paco is unackowledgeable and, therefore, cannot properly be requited. Just as Paco is about to marry another woman of his own social class, Salud interrupts the wedding in order to die at the feet of, and thereby express her otherwise inexpressible ardor and contempt for, the one who can neither deny nor accept her. What connects Carmichael and Falla? And what connects Gaines's staging of their interplay to the history of his concern with letter, note, number, grid, layer? I want to suggest that at issue are some fundamental questions of political ontotheology. In these supposedly separate shows and in the purportedly individual works that make them up, there is a space between the layers, a palimpsestic interval one is always trying to inhabit, a lateral fascination through which attention passes, as the appositional sending of (an) air, an exploratory envoy of breathing. You send air, or you are sent as air through the individual "panel" or blurred unit while being sent through the three-dimensional blurred air of the space itself, the gallery operating normally as a devotional gathering of pilgrims circling inside a square, held periodically by stations that in this case take the

form of hung rectangles, roughly human in scale, relatively flat but standing forth, nevertheless, as an airy thickness. In a series of twelve panels, Carmichael's words, proximate to the wall, are covered by envelopes of plexiglass approximately eight inches thick, upon which is printed Falla's score. This blurring of score and speech and the breathing that takes place in the space between the objects' layers instantiates new musical composition in choreographic performance, a kind of improvisation manifest in movement-activated visual and aural attention that occurs under what might be called temporal distress. I think of the visual-choreographic-musical blur induced by and given in *Librettos* as an entanglement of books in which what it is to quit (pay; clear up) and what it is requit (repay; settle a debt) are all bound up with a politics and an erotics of the incomplete and the unrequited. I'm interested in what can't be finished or cleared up, the unpayable debt, the unaccountable, which is scored in our performance of Gaines's work.

As Carmichael intimates all throughout his speech, along but also over Fanonian lines with which Gaines is certainly familiar, nonviolent coordination is a form of violence, often known by another name, the name to end all names, the name above all but every other name, art. *Gridblur*, to put it another way, is the before-and-after of a radical detonation that places denotation in insurmountable trouble. I have to take some strange detours—not aimless shifts but, rather, strained tracings of a calculated and incalculable drifting—in order to try to show this. For instance, there's something that people call a children's book titled *The Listening Walk*, with text by Paul Showers and images by Aliki. It tells the story of—by inviting us, particularly through its images, to join—a little girl and her father taking a silent walk through their neighborhood, in order to listen, by way of a certain interplay of chance and improvisation that famously worries Stanley Cavell, to the sonic happenings that come into relief as movement blurs into musical (dis) composition. The walk is meant to take at least 4'33," but I've been caught up in a shared obsession with *The Listening Walk* for a lot longer than that, having been constrained serially to reread it, to go through it as if going through a gallery accompanied by my own recitation, by two little boys, recognizing all along that you're not supposed to read it while listening and walking. To be serially unable not to look at it while reading it is to understand that the book substitutes for what it represents; that the substitute defers what it commends. The only way to defend the alternate process is to proceed. Blur is the alternate process, and in *Librettos* Charles Gaines invites and allows us to proceed as we make our listening walk through the gallery, performing

discomposition. Neither Falla nor Carmichael can get you there. Both Falla and Carmichael can't get you there, either. Doubling opens out, rather, onto certain questions, perhaps even past Gaines's own intentions, which are to reveal and also to insist upon a certain proliferation of relations—as if the viewer is activated in relation to the relation that he sees, or makes. This is to align Gaines with what Édouard Glissant calls the poetics of relation, which uncomfortably is prefigured by Martin Heidegger as a problematic of *techné*, whether understood as blooming forth in itself or bringing forth from another. And the questions that emerge from this alignment have to do precisely with the politics and aesthetics of the self-in-relation.

In the Garfield High speech, Carmichael says,

> We want to talk about self-condemnation. Self-condemnation is impossible. Nobody can condemn themselves or no people can condemn themselves. If they do they have to punish themselves. See, if I did something wrong, and I admitted that I did it wrong, then I have to punish myself, see. But if I can keep telling lies or if I can rationalize away my guilt, then I'll never feel guilty. Hmm, let me give you some examples. . . . For us in this country, a clear example of that would be in Neshoba County, in Philadelphia, Mississippi, a honky by the name of Rainey, decides with eighteen other honkies to kill three people. Now the entire county of Neshoba cannot indict Rainey because they elected him to do just what he was doing, to kill anybody who troubled with the status quo. If they indicted him, then all of them will be guilty, and they can't do that. See, they cannot admit that they're guilty. And in sncc we say that white America, the total community, cannot condemn herself for the acts of brutality and bestiality that she's heaped upon us as a race— black people. It's impossible for her to do it. She must rationalize away her guilt. She must blame us or blame everybody else but herself cause if she were to blame herself she would have to commit suicide. My brother LeRoi Jones reminds me that wouldn't be a bad idea.[1]

Our commitment to the commitment that is expressed and renewed in these words requires a reading of their analytic clarity unto and past the point of synthetic blur. Carmichael's anticolonial righteousness requires vigilance against postcolonial, which is to say neocolonial self-righteousness, which turns out to be not just a bad, but a problematically metaphysical attitude. Consider self-condemnation, as Carmichael describes it, as a kind of impossible or, perhaps more accurately, intolerable withering that comes into relief against

the backdrop of a kind of flowering that must be called self-determination—
that coming into its own, as its own, of a people that constitutes the desid-
eratum of sovereignty, whether it is manifest in colonial domination or to be
achieved in anticolonial struggle. But what if self-condemnation isn't impos-
sible but is, rather, constantly given in the impossibility of its relation to self-
determination?[2] What if self-determination and self-condemnation are not
simply the king's but—more problematically, because more precisely—the
settler's and the freedom fighter's twin imperatives? Can the endless oscil-
lation between self-determination and self-condemnation, which might be
said to constitute the conceptual analogs to what Ernst Kantorowicz called
"the king's two bodies," be broken? This might be a kind of preface to what
Huey P. Newton called "revolutionary suicide," even though Carmichael
leads us to this question by way of the fantasmatic self-condemnation of the
kind of contrite white Mississippian that, in the first instance, Newton prob-
ably would not have identified as an ideal revolutionary subject.

It's just that we all know that the contrite Mississippian, I mean the one
who's getting ready to go kill somebody else tonight, is no fantasy. When Car-
michael here associates self-condemnation not only with the admission of
guilt but also with a concomitant submission of oneself to punishment, he
might be said to have overlooked the unseemly presence of self-condemnation
that lies at the heart of the rhetoric of American fallenness, of an original and
originary American sinfulness that turns out not only to be fundamental to
the specific ethic, which one would sincerely love not to call Protestant, that
helps to structure the American ideology but also to a more generally West-
ern cultural alignment of exception and self-conception. In this formation
it is the West's, and in this case America's, capacity for guilt, its predisposi-
tion toward a guilty conscience, that sets it apart. As one of the good guys of
Western philosophy, Emmanuel Levinas, puts it, "There is a kind of envel-
opment of all thinking by the European subject. Europe has many things to
be reproached for, its history has been a history of blood and war, but it is
also the place where this blood and war have been regretted and constitute
a bad conscience of Europe which is also the return of Europe, not toward
Greece, but toward the Bible."[3] Bad conscience is the self's familiar spirit,
accompanying it, as its necessary and irreducible supplement, not merely
as a reaction to the self's enveloping use of force but as, itself, the very force,
the very power that animates relation in and as unbridled use. If this is so,
then what's at stake is not the absence of self-condemnation but its ubiquity
which, when it is understood as essential to the mechanics of continued bru-

tality, is best understood, as in Jean-Paul Sartre's late work, as bad faith. Let's say, moreover, that technically, bad faith is an ongoing commitment to the continuance of brutality that continually bodies forth—in juridical force, in ethical power, in the hard operations that are bound to and by the limits of self, other, and world—a more general and more fundamental disavowal of waiting which is, seemingly paradoxically, in the interest of constant and obsessively absorptive and expansive self-reflection. Often, the relay between the production and the reception of art has been understood and arranged as a theater of such self-reflection, a zone in which what is called consciousness and what supposedly is felt as bad conscience alchemically produce the transcendence and exaltation that the West imagines as exclusionary commonwealth. In this regard, the necessarily partial democratization of sovereignty is, as it were, extracted from art up until the point at which art, no longer concerned with what it feels like to be me, in relation, in the world, unsettles and affirms its space in the in the abolition of self-awareness and the radical disruption of self-reflection.

Gaines folds these questions and the imperative they announce into a kind of showing. In the listening walk, Carmichael's words in your head are halted by the musical notation that hides them from your eyes: you have to read, and so you have to look, so that you can listen, so that you can walk (away), bound to perform in an extra cagey, extraCagean sense of the term. Duration is given in the performance. The time's not set. The relation between depth and surface is reset. There's an unworked thickness, a palimpsestic airing that occurs intermittently, as an ensemble of directives. The space between paper and acrylic is all but traversable. We are barred from it but because of it we are freed from the bar lines or, more precisely, from what bar lines ordinarily signify. This designification is part of Gaines's design. Sign has become mark, in gridblur, which we sight read and perform in a listening walk.

42.

In his speech, Carmichael could be said to spin out a story of love—not quite unrequited but certainly betrayed. The desire to be American marks a failed romance. Does Paco arrive at self-condemnation? Salud achieves self-determination in death which will have turned out to be the only way to achieve it at the moment when someone re-traverses that event horizon. But here, on this side of that bourn, self-determination's terminal condition is saturation in brutally and violently bad faith. Eric Garner, or Michael

Brown, or Laquan McDonald fall into standing. Standing is a kind of fallenness. All the case is, is a fall. That's all the world is. Carmichael can only represent the breaking of that romance, thereby renewing it. In blur, on the other hand, Gaines refuses renewal. In a review of the Los Angeles Philharmonic's 2012 production of *La Vida Breve*, *Los Angeles Times* opera critic Mark Swed writes: "Everything that has to do with Salud and Paco is commonplace overwrought nonsense. Everything *around* (my emphasis) these characters is fascinating."[4] This is interesting. There's a certain advocacy of blur, here, and it's given in a set of excuses for Falla, seen by Swed as a young composer overly influenced by Puccini. Swed is interested in the Spanish fringe around the opera's faux-Italian core. There's a Georges Bizet/Edvard Grieg connection, too. That Afro-Andalusian, under-Norwegian backbeat, an Arabic swerve, a Flamenco stomp, that sweeps Europe as a kind of echo of Orleans made new, its phonic remaking, its Louisiana grunge and Cuban edge and Spanish tinge.

Is musical notation expressed/performed in *Librettos* and, if so, how? Does "serial work progress from one iteration to the next"? Is iteration the name of an action, not a thing? What if looking is an accident you pass through in order to get to reading in order to arrive at looking, which is on the other side of reading? In *The Blue and Brown Books*, Wittgenstein is exploring the notion that meaning is use. Use blurs. I love what appears as the yellowing of the paper in *Librettos*. What if conceptual art is what allows you to love without looking (after, of course, you've been turned, blurred in this regressive mutual eclipse of looking and reading)? When, as Gaines says, "image making becomes separate from an expressive core"/*corps*, perhaps it becomes eccentrically expressive. Perhaps it becomes expressive of no thing, expressive of entanglement, indiscretion, recess. Gaines's work is *recessive analysis*, a tantric Afro-Buddhist diagrammatics. It's not that I'm not ready not to speak of Gaines's imagination; it's that recessive imagination works, makes its impression felt, through Gaines. All throughout Gaines's work there's a blur materiality of shade, of colored number, in number's inexactitude, the way it's always off the beat, as beat's incessant overlap and undertow and undertone and overwork, no matter what. The one is not the one, remember? That Godfathersome, Furtwänglerish slur and slide, grid on live ground, grind, glissed, when "numbers are the subject rather than the formal device that maps the subject," as in Gaines's mathematical disruptions of portraiture. The face is always already in motion. Does portraiture still that? No, the portrait, the landscape, the still life are the picture, rather, animated

precisely by what they cannot still. Then movement is shadow, iteration and seriality in entanglement. Gridwork is indiscrete. Color + Number = Blend. Blur. Breathe. In flight from core expression, things get impressionistic and fugal. The way math and blackness, or aesthetic topology, works in Gaines is this: Shadowed number is a bridge from discretion to slur. Slur rhymes with blur so *Libretto*, whose indiscretions we perform in walking, is something I've come to think of as Wittgenstein's seriality blues, his working out of that haunting that occurs when fascination accompanies expression and you can't do anything about it. What if philosophy doesn't fight against that blur but, rather, in and with it?

43.

Haunting, which we can also think of as a kind of doubling, as a complex bearing that might turn out to be disruptive of personhood in general, as a kind of blur, is taken up in a 2008 collaboration between Gaines and Korean artist Hoyun Son called *Black Ghost Blues Redux*, which is part of the first exhibition I mentioned, *In the Shadow of Numbers*. There, in and as and through the work, Son listens, moving and singing in response to bluesman Lightning Hopkins's call and, in and after the fact of her singing, underneath and off screen, Gaines's response to her response.[5] Solvent and solute are indeterminate in this serialized, surrealized doubling, a fade to black-and-blue blur in a complex of breathing, of cinematic narration's fundament as a kind of layering in aeration, a revelation of charged, changed dimensionality in the dissolve of a thing neither into another nor itself but into what surrounds. There's a social impurity on the move in the relay between internal spatiotemporal differentiation and interracial, audiovisual mix. Acoustic mirroring, here, is an internal as well as external operation, where surge and surgery are interinanimate as a kind of pulse and texture on the screen, an enlivening of it enacted in what feels like a leaving of it. And that's the point: the feeling, not the leaving, so that the leaving is in the feeling—that what's onscreen leaves the screen because it feels like something, blur become rub in an epidermal effect akin to what critic Laura Marks discusses in her *The Skin of the Film* as "haptic visuality."[6] Such visuality is especially prominent, Marks argues, in intercultural cinema's attention to and embeddedness in the ongoing disaster of coloniality; certainly the pairing of Son and Lightning Hopkins redoubled in the pairing of Son and Gaines, occurs against the backdrop of a history of Black/Korean tension in the overlapped field of

social merge where Koreatown and South Central Los Angeles blur into one another, in and as the city's constantly expanding middle, as an effect that both calls and responds to international and domestic neocolonial pressure. The dissolve resolves nothing; there is no easy solution, no phantasmatic melding; but, at the same time, dissolution is not desolation, either. We feel the blur of a general entanglement and the question is, simply, what are we to make of it?

The film's temporality—its manipulation and marking of time in the dissolve, which is not a cut so much as a slide, a *glissando*, in which the ensemble of nonsingle being is differentially revealed—indexes a feel, or a field, of remote audiovisual hapticalities that emerges from/in/as the disruption of sovereignty's proud joy and its fallenness into anxious metronomia. Blurred, unkempt, unkept time is when and where music accompanies, and discomposes, an already strained commitment to visual synchrony. Some of them who serve sovereignty in the very moment of its dissolution, have already been told to go and get a mirror whose capacity to establish the beholder's identity is its own disruption. Others are determined to be the king's friend and so they kill the king. What's at stake here is neither a bringing forth in itself nor a bringing forth out of an Other but a bringing forth out of or against self and Other, a bringing forth in defiance of the metaphysical foundations of relation. To bring forth in the blur, out of the blue, in and out of entanglement, through nonlocality's absolutely nothing—that breath, that anima, that φψσισ—is neither pretechnologically nor antitechnologically but anatechnologically essential: a general, generative, differential repeatability that you could call music, if you decided that you didn't want to call it poetry, depending on which side you took in the wake of their unconscionable, unenforceable divorce. In this regard, it seems to me that Gaines is concerned with a very particular graphic dilemma: how do we score their irreducibly prior inseparability after the fact of their separation? The solution, which turns out continually to be given in his artistic practice, is dissolution.

In trying to think about Gaines's solicitation of the artwork's two bodies, we are allowed to consider what is it for the king to be confronted with the fact of his two bodies, his person and his state (his picture and his shadow, as Lightnin' says and Gaines variously echoes), which together constitute the radical unlivability of a doctrine. The body's general and irreducible doubleness, which accrues to every instance of sovereignty's merely interminable approximation of itself, bears a terminal seriality. Over and over again one is made aware of one's relative nothingness, even when it takes the form of

exaltation's periodic vestibular negation of field and feel. The solution is the self's dissolution, its lapsed, lax, dispersed concentration which reveals, if we can figure out how to pay attention, the anatechnological priority of the dissolve, where the solute won't disappear and solvent can't put itself on solid, self-possessed footing. At stake is the generality of fundamental, anoriginal dispossession. Can we be eased with having, or as Richard of Bordeaux says more urgently and drastically, with being nothing? Can we relinquish the task of recovering the sovereignty we never had, of repaying the debt we never promised? Can we refuse to restate that romance? In seeking to affirm the richly affirmative possibilities that are held in these negations, I'll continue to turn to Gaines, hopefully not too much against Gaines's grain, for what is held in the rich insolvency of his poetics of negative space.

I have in mind a videoepigraph that would betray the fact that I've been trying to get at a certain doubling that occurs between Carmichael and Richard. The dissolve, as it is manifest in *Black Ghost Blues Redux*, as it is produced cinematically in David Giles's BBC television version of *Richard II*, as it is given anacinematically in *Libretto*, gets me to this matter of absolution as and in consent to be touched, to be given in hauntedness, which is inseparable from handedness, the maternal flow(n) or fluid or flood, a radical and general amniosis held, as it were, in the airy thickness of Gaines's objects. What if what we call relation is another (both erotic and libidinal as opposed to self-determinative and self-condemnatory) kind of saturation, so that the term *negative space* actually slanders the pailmpsestic reservoir between the layers of Gaines's three-dimensional sheet music? What if we call it *affirmative space*, a holding in and against the hold, a for(e)given(n)ess: *ab*solution in amniosis? What if what is given in this renaming, this affirmative unnaming, is to see or hear or read or perform the score in or through absolution? A blurred, blue immersion of rubbing, of rubbed string, what Lightning *plays*. A transoceanic feeling of/in passage, our impassivity, our passing through. This turbulence, this antagonism, absolution's absolute dissonance, is given in and as a critique of relation. That's what dissonance is: the note that must be followed by another in itself in and to and as a kind of radical insolvency. Can insolvency, here, mean both that which is in debt and that which also resists the solvent, resists that interplay of solvency and sovereignty? (This is not just what it is not to be indebted but also what it is to resist the power that dissolves, that imposes assimilation, which is, therefore, that which solves, that which determines, that which renders and organizes relationality in accord with a normativity that it legislates, that which sets the terms of

mixture, that thing which wins the game of honor, that which *composes*, the settled and settling score that serially instantiates [the continual establishment of the impossibility of] composition and composure.) What if it's just that sovereignty is the general condition within which relation operates, precisely in and through the particular relation, to which Carmichael alerts us, between self-condemnation and self-determination? Can art be, and show us how to be, something other than a society "structured in dominance"? What if the political is simply the structuring of societies in dominance? If so, can we imagine an ante- and antipolitical art in the interest of the most absolute social and aesthetic insurgency? Against the grain of the very idea of the work of art, how can we imagine the art's insovereign social work? What if it turns out that the general theory of relativity, in a radical entanglement with quantum mechanics for which there is as of yet no math, obliterates the theory of relation? What if physics and sociology are just ways of saying one another when and where art gets to work? Is it possible to ride the waves of Gaines's affirmative space? In leading us to these questions it appears that he knows the score and has a plan. In a violence that is both absolute and gentle, he apposes the theater of self-reflection with the theater of refusal, a theater of differences, given in service to a general and nonsubjective expressiveness, in which, as Gaines once said, "remarkably meaningful things could be produced." We're taken on a walk in looking and listening, in layer, in the elegiac and Lygiac cut of endless *caminhando*, its suspension, in service, in recess, as waiting, as tarrying, in praise, in practice.

44.

Can marginality be depoliticized? This question not only follows from the ones above but also proceeds from the assumption that politics, insofar as it is predicated upon the exclusion and regulation of difference, will have always been the scene of our degradation and never the scene of our redemption, redress, or repair. To ask the question concerning the depoliticization of marginality is to consider that marginality's radically improper place is the social. How can we see marginality as and for the social? This is a question concerning the limit. The one who sets the limit—whose self-image is that of the limit, the standard, the bound figured as the capacity to bind—is said to be the one who exercises the power to marginalize; and while sharp and plentiful focus on the usually deadly modes in which that capacity is exercised remains crucial and inescapable, perhaps it is even more important

to pay attention to how and why it is that the marginal marginalizes itself. What follows from such double vision is a double task—the proposal of an alternative to marginalization *and* an alternative mode of marginalization. Both the vision and the task are undertaken with rigorous and prescient brilliance in Gaines's "The Theater of Refusal" and in Gaines's *The Theater of Refusal.*

What if the theater of refusal were ours, for us, whoever and whatever we are? How might this manifest itself as a profound and illimitable communicability, as opposed to immunity or prophylaxis? And would it move by way of a transgression or eradication of limit or as a kind of proliferation of the limit in and through and in the interest of the surround. Certainly it would go against the flow of what is called the mainstream and its violent relationality. It would be an antiflow or overflow, an undertow or River Antes, that troubles every commitment to the self-as-subject and to the belief that the "the presence of the subject is essential for the implementation of political power" since we might have to open ourselves to the possibility that political power is not at all what we need.[7] These questions are explicit but—deeper still and better yet—implicit in Gaines's essay and in his curacy, in his gathering activity of scholarly and artistic care. In our inhabitation and recitation of those questions we are constrained to imagine, having already enacted, a theater of refusal$_2$, a theater of refuse, a theater of refuse, a theater of the refused, a theater of the refusal of what has been refused, a theater of the left over, a theater of the left behind, a theater of the left, a theater of the (out and) gone.

Gaines violently calls for "a new framework that does not condemn marginality to complicity with power" as gently as if he were calling for nothing at all.[8] He demands and allows us to see the futurial ghost of a marginality in the absence of a mainstream—an antebinary ubiquity of the margin/al which, in being everywhere is nowhere reconceived as general, nonlocal, nonsubjective presence—an immanent aesthetic. When Derrida dreams, in his own gesture at a/voiding the dialectic, of a structure, or a practice of structuring, without a center, perhaps what he sees are certain magical trees, grid worked in and out of itself in a range of anumerical shade, a shading of centric expressivity that does not reverse the dialectic but evacuates it. At stake is a refusal of being given in a generalization of refuge. At the same time, givenness, in its essential difference from itself, in a generative strike against what Wallace Stevens called "the central mind," is where disbursal and dispersal converge on and as a proliferation of verge, edge, tra(ns)versal. There is an affirmation

to be sounded in what is thought of as negative space; it emerges in and as an activity of crossing such that "a less limited construction of marginality" is given in the center's perforation by a population of margins.

Marginality is not a simple theory, but a complex construction of over-lapping social, philosophical, biological and historical ideas. Much writing on the subject is reductionist and essentialist because the politics of the subject almost requires simplification. It almost begs a simpler form, a diagram, perhaps, that will give shape to an impossibly complex machine, a coding that will make the difficult choices for us, to relieve us of the annoying spectacle of its insurmountability.

As I have tried to show, a theory of marginality is part of the lexicon of ideas that frame our world view. It is an old theory, reaching as far into the past and across as many cultures as its parent, dualism. But it is a complex theory, a theory whose purpose is to idealize its subjects.[9]

We must also remember dualism's parent, who is at once both real and imagined: (in/divi)dualism. In *What Kinship Is—and Is Not*, Marshall Sahlins, echoing Roger Bastide's echo of Maurice Leenhardt, speaks of the "dividual person," who is divisble and indistinct, who in refusing the imposition of the body and its limits refuses the city (*polis*) and its limits as well.

In his capacity as a missionary, Maurice Leenhardt once suggested to a New Caledonian elder that Christianity had introduced the notion of spirit (*esprit*) into Canaque thought. "Spirit? Bah!" the old man objected: "You didn't bring us the spirit. We already knew the spirit existed. We have always acted in accord with the spirit. What you've brought us is the body " Commenting on the interchange, Roger Bastide wrote, "The Melanesian did not conceive of himself otherwise than a node of participations; he was outside more than he was inside himself " That is, Bastide explained, the man was in his lineage and his totem, in nature and in the *socius*. By contrast, the missionaries would teach him to sunder himself from these alterities in order to discover his true identity, an identity marked by the limits of his body.

Later in the same essay, Bastide transposed his Melanesian sense of personhood to the African subjects he was principally concerned with, and in so doing produced a clear description of the "dividual person" Bastide wrote of the person "who is divisible" and also "not distinct in the sense that aspects of the self are variously distributed among others,

as are others in oneself." Emphasizing these transcendent dimensions of the individual, he noted that "the plurality of the constituent elements of the person" moved him to "participate in other realities."[10]

Perhaps what it is to refuse the limits of the body is to refuse the limit as regulation in and for possessive individuation and to embrace the proliferation of limits' irregular devotion to difference and blur. But this formulation must bear the fact that even in Bastide the dividual person is given *as* person, as an axiomatic subjectivity whose presence animates whatever intersubjectivity or relationality one wants to proffer. What if there are realities other than that? Facilitation of alterities' flights from binarism's origin in the one requires that an antebinary marginality disrupt any and every (meta)physics of separation. And how we might separate from separation is not a problem for the subject. Indeed, Bastide obscures the insight that Leenhardt elicits. The blur of spirit admits of no personhood, just as art is a constant violation of the artist, the viewer and the work that is the mobile location of their entangled differentiation. At stake is an obliteration of the very idea of the product, the *ergon*, as Kant imagines it, which then disturbs any sense of its relation either to the underlying idea or an external material reality. Don't play the background, Ornette Coleman says, play the music. The nonrepresentational capacities that, John Searle argues, allow representation to take place turn out not to allow representation to take place after all. Representation does not take place; there is no place for representation or, representation's only possible place is in the general dispersal and openness that we call the nonrepresentational. In this affirmative space, in the break, in the blur, in the not-in-between that surrounds the surfaces that surround it, there is an interminable piercing, an unending passing through whose uncountable pleasures are inseparable from eternal middle passage, eternal middle passion.

It's like that time when art + practice appeared and converged on the verge of a set of open books Gaines borrowed, giving eccentric structure to a whole other library.[11] Nobody had to enter the space between the back and the front surfaces of plexiglass because movement in the communicable recess these antebodies made was general, taking the form of a listening walk. And we just weren't even thinking about what the so-called critics were saying. The theater of refusal had become our refuge; the margin without a mainstream is like a river with an active memory. See, part of the trouble is that when we think the margin we think it in opposition to the mainstream, to the river, as it were, when really they are both in opposition to the

border, the boundary, the levee, the dam, the limit in its dual singularity. The margin/al is the water, remembering. The stream, held within its banks, is already a brutal, carceral denial. Toni Morrison gets at this in "The Site of Memory" and Gaines repeats her citation in *Librettos*, whose plexiglass surfaces mark a limit that had already been obliterated by the affirmative space they couldn't contain.[12] Meanwhile, the sociopaths who call themselves the mainstream have produced an image of themselves as a thing in and for itself manifest as trained and regulated plenitude when what they are, in fact, is nothing other than an always already transgressed boundary, or limit, both instantiated, finally, but also figured as (white) skin. So we gotta get it straight. The stream and its constantly changing and changed, transgressive and transgressed, proliferating and perforated margin, which is the essence of the stream itself, are opposed to the limit, the bank, the frame as it is held in the old one-two, that carceral, binary dance. Actually, no: the margin is in this constant, entangled apposition with the stream in its violent disregard of, or sometimes reticent withdrawal from, the very idea of the main. This is a problematic, Derrida might say, of the *parergon*, of the *hors d'oeuvre*. And what's so beautiful about *Librettos* is this constant overflowing of the b(r)ook, just as what remains so immeasurably deep about *The Theater of Refusal* is its abundantly resistant extratheatrical fusion. As Gaines teaches, "Works of art are complex events; their true complexity is revealed in criticism and its attempt to circumscribe the boundaries of art. Criticism idealizes representation and consequently distances the viewer from actuality."[13] This lesson prepares his students to ask, What if the true complexity of the work of art that is revealed in criticism is that art always exceeds the work, not as its absence but, rather, as its irreducibly present madness? What if it's not so much that criticism breaks the work down or undoes it but rather that criticism can sometimes make the work get to work, encourage it to do the work of its own undoing, as in a certain audiovisual walk or wade, an ambulatory tarrying in (ab)solution, an inveterate bus ride conducted by some black and, therefore, marvelously pied piper, say, or an urban pastoral excursion into an endlessly renewed, re*néo*'d green. To deal with the works themselves is a whole other thing, and a radical new understanding of a certain interplay of marginality and limit, not marginality and mainstream, is already given by Gaines, in *The Theater of Refusal*'s second page: "The title suggests that the critical environment surrounding the works of these artists intentionally and unintentionally limits those works, creating a theater of refusal that punishes the work of black artists by mak-

ing it immune to history and by immunizing history against it."[14] In having given us a place to start thinking, Gaines also gives us a place where we can shift and refresh that thinking and its orbit. He shows us that the marginal is misunderstood to be in opposition to the mainstream rather than to the (in/divi)dualized limit; that it is in opposition to a degraded practice rather than to an identity; that it is our task to make an alternative practice, not form an alternative identity. In this regard, marginality is the activity of marginalization which is the river's remembering, its transgressive flood, its jurisgenerative principle. The theater of refusal$_2$ is where we refuse the limit by way of its inseparable differentiation. This is what Gaines is getting at in his critique of the dialectic. Moreover, the work to which he submits himself as artist, in the interest of an unworking, of a general and generative strike, gets at that critique more emphatically and viciously even than certain Derridean or Deleuzo-Guattarian appeals that reify the dialectic of (indivi)duation and relation. Marginalization is radical nonlocality, a double blade rather than a double-edged double bind, that incisively renders provisional even black personhood and the black work of art, insofar as if they are at all, they work a general undoing not only of themselves and their others but also the very idea of others and selves.

45.

I'm sorry if this is all a blur. I'm so used to my own astigmatism that maybe I can't even talk to anybody anymore. To make matters worse, I've never been able to keep my glasses clean. For the last forty-five years it's all been a blur and the dirty lenses Gaines provides in *Librettos* redouble the wounded, blessed assurance of my unsure, double vision. I think I'm seeing what I think I'm seeing, which makes me wonder if I'm seeing what I think. Hopefully, it'll all be all good, in a minute, when I can stop talking to you and start talking with you. Maybe we can go on a whole other listening walk. But let me see if I can finish this one, by way of one last detour to which we might eternally return. I spoke, earlier, in echo yet again of Samuel R. Delany, of "libidinal saturation," which now we might be able to think of as what happens on the bridge of lost and found desire that stretches between seeing things and seeing absolute nothingness, where relation fades in fog and granite, or paper and plexiglass. Between seeing things and seeing nothing, sometimes, when I close my eyes, I think that when I open them I'll see José. The first time I saw him was in the old, unremodeled sixth floor of the Tisch

School of the Arts, when I was giving a talk that was centered on this passage from Delany's *The Motion of Light and Water*, with which, as you'll see, I'm also still obsessed.

> It was lit only in blue, the distant bulbs appearing to have red centers.
>
> In the gym-sized room were sixteen rows of beds, four to a rank, or sixty-four altogether. I couldn't see any of the beds themselves, though, because there were three times that many people (maybe a hundred twenty-five) in the room. Perhaps a dozen of them were standing. The rest were an undulating mass of naked male bodies, spread wall to wall.
>
> My first response was a kind of heart-thudding astonishment, very close to fear.
>
> I have written of a space at a certain libidinal saturation before. That was not what frightened me. It was rather that the saturation was not only kinesthetic but visible. You could *see* what was going on throughout the dorm.
>
> The only time I'd come close to feeling the fear before was once, one night, when I had been approaching the trucks, and a sudden group of policemen, up half a block, had marched across the street blowing their whistles.
>
> It had been some kind of raid. What frightened was, oddly, not the raid itself, but rather the sheer number of men who suddenly began to appear, most of them running, here and there from between the vans.
>
> That night at the docks policeman arrested maybe eight or nine men. The number, however, who fled across the street to be absorbed into the city was ninety, a hundred and fifty, perhaps as many as two hundred.
>
> Let me see if I can explain.[15]

Let me see if I can explain—by deviating, in a way that Delany allows and makes possible, from Delany's explanation. It seems that fear is approached in or as a kind of blur, when the grid, or more generally, the countable is absorbed en masse, into mass, as kinesthetic visibility is felt in movement toward the synaesthetic. In Delany's explanation, he'll activate a psychosocial lens so that he can show and tell us what and how he sees on that night of calculated drifting, when he left his then-wife Marilyn Hacker and their friend Sue alone to read Henry James aloud to one another while he went out to see what he could see. The first time I read, and then tried to write about, this passage it was by way of an early, much-condensed edition of Delany's autobiography.[16] Now that we have access to a more complete ver-

sion I know that what he sees, and lets us see, can only be seen through Hacker's poem "Prism and Lens," and what it seeks to see and record of another night of blurred vision, of focus shifted and then failed. The relevant passages from around one hundred fifty pages earlier in *The Motion of Light in Water* are separated by section IV and an excerpt from section V of Hacker's extraordinary poem:

7.98 In November I got involved in my first major infidelity. You remember the stock clerk whom I'd been bringing home to dinner every night? One evening as I was walking him back home, he paused on the chill corner of Avenue B. He had something to confess to me that he knew would wreck our friendship; but he could hold it no longer. He was homosexual. He *wanted* to go to bed with me

In the course of the whole thing, on the night of Marilyn's birthday, he burst into our apartment, and actually declared to us both, "We *can't* go on like this!"

The unhappiness all around us for the ten days or so of it finally established, however, what became a kind of house rule regarding outside sex: I don't care what you do when you're *not* here," Marilyn finally told me. "It's just how it makes you act when you *are* here I object to!"

It seemed reasonable to me. But over the years it was easier for me to adhere to the parameters of behavior that suggested than it was for Marilyn.

7.981 My affair brought my own writing to a halt (for a week) and produced a sudden creative spurt in Marilyn's: most of the fragments became her poem "Prism and Lens."[17]

I will not lie and say I spent the night
Calmly, ate a light meal, washed my hair,
Read novels with hot coffee by my chair,
then brushed my teeth, undressed, switched off the light.
I came back twice to see if you were there,
and, when you weren't, left, hoping I might
walk off your absence, or walk off the tight
fist closing in my gut and cease to care;
but first I left a note that said I'd gone
walking, and I turned all the lights on.
the glancing lamps reflected my wet face

uncomprehending in a tight grimace.
I walked across the city in the rain,
river to river, then walked back again.
The sun drops quickly. Night rips the green sky.
Pale flares of incandescent mercury
drop limpid pools along the bright expanse
where shadows scatter in a jagged dance
on broken pavingstones and frozen tar,
and scarlet flashes break the light of cars.
Dull gold in dim rooms, figures pause and pass
naked between a prism and a glass.
The lamps along the river, one by one,
spear the dark wings that hover on the sun.

Darkness and moisture settle on my cheeks.
The rain dissolves to close mist in the air.
(You sat back rigid in the easy chair,
your fingers gripped the arms. You would not speak.)
The fog thins out in front of me, revealing
Careening grillwork on a tenement.
(You told me then. I wondered what you meant.
A flake of plaster crashed down from the ceiling.)
The shape of movement comes before the act,
contorts the face into a score of faces,
converts each possibility to fact.
A host of orgiastic angels come
trod me with spurious equilibrium.[18]

. . . Two cops in a patrolcar came
and stopped me by the riverside.
They asked me my address, my name,
and had I thought of suicide.

"I came to watch the morning rise."
They stared in a peculiar way,
and one, appearing very wise,
said there would be no sun that day

and girls should not stay out all night
and roam at random in the park

where deeds too warped for human sight
were perpetrated in the dark,

and midnight cold and morning chill
are detrimental to the liver,
and I had not convinced them still
I would not jump into the river,

And did not seem to be of age
for wandering at break of day
and would incur parental rage,
or else might be a runaway,

or else had fled a husband's house
to finish a nocturnal fight,
confounding the bewildered spouse
in stationhouses all the night.

"I may go drifting anyplace,
lawful and with impunity."
The headlights' glare upon my face
Suggested my majority.

And when the streetlights flickered, I
leaned on the rail and spoke no more
and watched the morning open high
bright wings across the Brooklyn shore.[19]

8. On a chill, immobile evening, during a midnight November walk, through a window in an alley adjacent to the Village View construction Marilyn glimpsed two or four or six naked people—multiplied or confused, in a moment of astonished attention, by some mirror on the back wall, as the window itself added a prismatic effect to the bodies inside, gilded by candlelight or some mustard bulb—before they moved behind a jamb, or she walked beyond the line of sight, the images suggesting proliferations of possibilities, of tales about those possibilities, of images in harmony, antiphon, or wondrous complementarity. Once, when I was gone for the night, she went walking—and was stopped by two cops in a patrol car, curious what a woman would be doing out in that largely homosexual haunt—on the Williamsburg Bridge. It was a time of strained discussions in our tenement living room, in the midst of

which a bit of plaster from the newly painted ceiling would fall to shatter over the mahogany arm of the red chair.

The glance we might have taken at *Richard II* might make you think my lingering with Delany's and Hacker's difficult, wander-struck relationship, is meant, in part, to amplify the separation of king and queen that Shakespeare suggests to be a function of Richard's fascination with, to use Hacker's phrase, "boys who are not boys" and to blame that fascination and the failure of his sovereignty on one another. Most productions play Richard's homosocial waywardness—which Richard himself describes as a kind of unkept time, time out of joint or step or off the track—for all they think it's worth. But in the case of Delany and Hacker it's not all about male spatiotemporal errancy, since Hacker also (a)voids domestic fixity in order to see what she can see. This, too, is a matter of refusal and its inveterate theatricality, the generality and generativity and xenogenerosity of the not-in-between. In *The American Shore*, with regard to Thomas Disch's "Angouleme," somewhere in the unexcludable middle of a long journey through what is, for and with its remains, as its remainder, in search and practice of the alternative, Delany attends to the necessary and all but essentially urban haze of text's refusal and diffusion, which is manifest as re-reading, which turns out to be reading's condition of possibility: re-reading as refusal, as the text's generative and anticipatory discomposition, as the degenerative recomposition of readerly anticipation, as the speculative, disruptive irruption of what is, as is is anoriginally displaced by as, always as if for the first time in blurred glance, in the erotic, palimpsestic volume of reflection in the hold, in turning on and away in turning to, endlessly and without return, adrift.[20] This deconstruction and reconstruction, this dismantling and refashioning, this rereading that insofar as it is as if for the first time staves off the inevitable reproduction of the first time, of a priority that remains sovereign and irreducible when refusal remains unrefused is dispersed, like desire in and for the city. Like Richard of Bordeaux but even more orchestral, Charles of Charleston has come to tell us that Carmichael's and Falla's, Delany's and Hacker's, books are blurred, refused, before we even get there. The question is what can we make of this wondrous, ruptural, mutually interruptive complementarity, the miraculous divergence and nonrelation of shared attention in the gallery of New York, or the galleries of Los Angeles, policed but unenclosed? How do we taste and sound the affirmative space, the air, the breathing of our blurred books?

46.

This is another question for José Esteban Muñoz. I'll ask him when I see him. For now, I can only consult a short unpublished talk he delivered in 2006 entitled "Phenomenological Flights: From Latino Over There and Cubania's Here and Now." After briefly establishing Miami itself, and more particularly its complex and unencompassable Cuban lifeworld, as a text just made for eidetic reduction, where such reduction is, really, and most faithfully, a voluntary submission of the phenomenologist to Miami's rhythms—those uncountable syncopations that proper, normative, self-delusionally sovereign, metronomically and scientistically pseudo-philosophical subjectivity overhears as untimely— Jose begins to describe the intervallic estrangement that structures the native's return to his non-native land.

> I feel home but not home as I prepare to meet my little brother, who is much physically bigger than I. He is already late to pick me up. I prepare to enter the temporality of the Cuban, a belatedness that my friends in New York and elsewhere associate with me, but I nonetheless resent in my kin. I stand in the Cuban diaspora concrete median and commence my wait. I try him on the cell phone, to no effect. I look around me and I notice some of my fellow travelers, lost members of the tribe who have traveled North or West, or just somewhere that is not here, not the here and now of Miami, the world of Miami. Some are students, some artists, some wayward queers who will divide their time between South Beach and their parents' home in suburbs like Kendall. We recognize each other as we recognize the fact that those of us from not here are now here but never here—never in the naturalized time and place of a certain *cubanía*, an everydayness of *cubanía*.[21]

I feel home but not home as I wait for my (big) brother, who is much physically smaller than I. He's late and so I prepare to enter the temporality of the Cuban. In this passage, moving in that line of post-Husserlian phenomenological deviance that stretches from Heidegger to Levinas and Sartre, to Fanon, Derrida and Tran Duc Thao, to Ahmed and Salomon, José teaches us how to solicit the everyday and, therefore, to prepare.

> Facts claim a certain knowledge of the world, a knowledge that fixes things, frames the world in a naturalistic sense. To make such empirical, positivist, or "objective" claims about the world is to presuppose

some sort of epistemological field that "enfolds" the world. To take one's time, or use time itself, outside of some naturalistic teleology, and describe our affective field of perception, that is to "unfold" the world. Phenomenology encourages one to take one's time to observe and describe because to do so is to interrupt a seamless flow of description, and isolate in that seamless flow, as a certain claim about the world but not the world itself, a naturalistic semblance of world. Thus we need to interrupt certain modes of description that do not offer us phenomenology's "unfolding" and merely claim world, which is to enfold it, limit it, foreclose on a horizon of possibility and instead organize things in relation to discourses like science or disciplinarity. It is a problem to simply make claims about the world without really describing it.[22]

Some of us once heard José's mother say that he had some place to get to. But that transport, he tells us here, is aleatory. Having some place to get to means that the arrivant never really arrives. It is, rather, a queer kind of loitering, a kind of cruising, a kind of calculated drifting in and lingering with perception, the way you get to know a city by its rivers, Hacker says, from river to river, echoing Langston Hughes's deferred, montagic dreaming—a looking walk; a listening walk. That's what José's after and he knows, already, that even normative phenomenology can't quite give up its own desire for punctuality. At stake here is a queer phenomenology of perception, a late phenomenology of the feel, one slow enough to be able clearly to see the misty air, the mystery, to sense the blur, and not some normative individuation, as the field from which differences spring.

We consult the blur and breathe books in order more accurately, more rigorously to imagine the surreal and differential inseparability of motion, light, and water. To engage in such study is to effect perception's perpetual deferral of apperception, ordering, assimilation, which often takes the form of catalog or partition. Such study, José says, is "how we engage the world during our lateness." That's what it is to be already late, belatedly early, premature and postexpectant as Nathaniel Mackey is always just about to say again. Never quite either here nor now, either I nor thou, disruptive of relation and its political, metaphysical ground that shifts—in spite of itself, as if a function of a mechanics which it can hate but can't control—between condemnation and determination, our imperative is to keep on describing, and thereby to engage in, the continual unmaking of the world as the earth comes con-

tinually into view. The sovereign turns his cell into the world though the very condition that is supposed to allow that, solitude, is the undoing of what that condition is supposed to provide. He can't wait, wants time ordered and absolutely regular, sovereignty trapped in a deictic prison of its own devising. In describing, in praise, we wait, and serve, knowing also that to describe, as José says, is also, somehow, even to disrupt the seamless flow of description. Is that what phenomenology does or is that what performance is? Is that poetry, or sociology, or physics? The continual fold of unfolding's refusal to enfold. José says,

> To look for essence is not to enfold things in a disciplinary holding pattern. . . . Paying attention to essence and all the ways it disrupts our everyday narratives of things and people is an interruption that needs to happen. *Cubanía* can be an interruption for Latino studies and *latinidad*, as I experience it, should interrupt Cuban-Americaness, on the basis of both the ways these two essences are like and not alike.[23]

Perhaps *latinidad* and Cuban-Americanness blur and breathe one another so insistently that one and another are no more in the persistence of their differences. I think this is how those passages from Delany and Hacker work; that this is how passage and passion work in Hacker and Delany. I think this is how what we call, for lack of a better word, the interplay not in between Hacker's and Delany's old schoolmate Carmichael and Falla, not in between them and Gaines, not in between Gaines and Son, not in between them and Lightning Hopkins, not in between Hopkins and Shakespeare, not in between all of them and all of you and me, not in between all of us and José, works. I hope it is, just as I keep hoping that if I open my eyes I can see what he would say. If I'm being sentimental here it's only in the interest of trying to think, which for a long time for me has been to think with José, our fleshly and familiar spirit here in the affirmative space of the collective head. Here I am, dispersed and shared in this preoccupation of and with the general belatedness, rocking on the diasporic concrete, waiting on the immeasurable and unprecedented differences of my little brother, who always was and always will be bigger than me.

Entanglement and Virtuosity

In October, a couple of weeks before Washington would fly to Tokyo on his first world tour, his father organized a dinner with a group of distinguished older jazz musicians. "When you are chosen," Rickey explained to me, "you need the blessings of your elders." (Reggie Andrews had a more down-to-earth explanation: "Kamasi's about to step into the fast lane, so Rickey wanted him to receive some advice from people who've been there.") This "change of the guard" ceremony took place at the Ladera Heights home of Curtis Jenkins, who runs a business that provides care for disabled children in South Central. In a flight of enthusiasm, Rickey had invited me to attend the dinner. The next day, Kamasi's manager, Banch Abegaze, disinvited me; she said it was for only close friends and family. But she suggested that I stop by later in the evening. . . .

The speeches went on for more than an hour. They were stories of the jazz life, pitched somewhere between sermon and self-admonishment. These elder statesmen were welcoming their friend's son into a very exclusive fraternity, but also warning of the dangers in store. "This really felt like being down South," Newton said. "Yeah, South L.A.," another guest corrected him.

Kamasi listened attentively, speaking only when spoken to: If the young jazz warrior was carrying a weapon, he kept it well hidden. "It takes some of the pressure off to hear from these men who have been down this road be-

fore," he told me later, "since I'm on this journey and I don't know where I'm going." But as I watched him that evening, I was struck by how small he suddenly looked, surrounded by the guardians of Los Angeles jazz. At the end of the ceremony, Rickey Washington faced his son and said: "You have now received the wisdom of your elders. What you do with it is on you."—**ADAM SHATZ**, "Kamasi Washington's Giant Step"

47.

I'm 54 years old. This means that while the music of my childhood is funk and R & B, the music of my adulthood is hip-hop. I've barely written about hip-hop but my work is infused with it. Actually, deeper than that, my work is grounded in it; hip-hop is a foundation of the work I imprecisely call mine. I don't engage with hip-hop so much as I emerge from it, in the same way that there are certain writers and scholars from whose work "my work" emerges so that beyond this or that occasion in which I am thinking or writing about them or their work, there is the general condition and fact of "my work" or "my thinking" moving by way of theirs, as an emanation and maybe sometimes a faithful if deviant reiteration—or, more precisely, resonance—of, rather than a response to, their call. And this is the way it is for me with hip-hop. I mean to say, hopefully more clearly, that if I consider my adulthood to be the time when I really began to try to think about stuff, and when I really began to think about how to think about stuff, then hip-hop is the music that was on when I embarked upon that thinking. It was the background that structured that thinking. So, now, even when I'm thinking or writing about something other, some music other than hip-hop, I'm thinking by way of hip-hop. And maybe all this preparation—in which hip-hop allows and structures my thinking, say, about jazz or chamber music or Afrobeat or samba—is so we can think about hip-hop, now, together.

Once, when I was teaching a class on experimental poetry, I made a casual formulation that I have often made, before and since, and which I still sincerely believe, that Rakim is the greatest rapper of all time. On this occasion, my students looked at me like I was crazy. And this wasn't because at that moment it was most definitely the age of Tupac; it wasn't just because some of them didn't even know who Rakim was, a condition

that filled me with the same kind of horror that is visited upon a classics professor when he sees that his students don't know there was such a one as Virgil. I think the reason they looked at me like I was crazy was that they knew, in a way that could only emerge from hip-hop having been the music of their childhood, that such a formulation, beyond being either wrong or right, was irrelevant. This irrelevance stems, it seems to me, from the sociality of dance, from what it is to have been dancing to the music, and to have one's thinking of and in and with the music emerge from that kinesthetic reality. I have to say that my thinking about hip-hop is pretty much detached from the black sociality of dancing. The music I dance to is Sly, say, much more even than (Eric B & and) Rakim, to whom, in a more sedentary and cellular way, I have been "merely" listening. And I want to make sure you know that I'm not saying that dancing is antithetical either to listening or to thinking or to thinking about thinking. What I'm saying, rather, is that dancing, that immersion in the black sociality of dancing, that living in and as what my running buddy Laura Harris calls "the aesthetic sociality of blackness," is a whole other (collective) head, one that is, in fact, antithetical to the detachment of listening from thinking and from thinking$_2$ and to the alienation that detachment enforces.

Now, when I index the fact of Rakim's supreme greatness, I usually do so by way of (the opening of) "I Know You Got Soul," a song on his and Eric B.'s masterpiece of a first album, *Paid in Full*.

It's been a long time. I shouldn't'a left you
Without a strong rhyme to step to
Think of how many weak shows you slept through
Times up; I'm sorry I kept you
Thinking of this you keep repeating you miss
the rhymes of the microphone soloist.[1]

Think of the brilliant way Rakim announces himself, as if in respectful but firm graduation from James Brown's tutelage, which is musically sampled, and even imbibed, but by way of a mode of distillation the Godfather did not, in the first instance, authorize: it's as if Rakim, a visitor from some anakantian black-lit continent, had kept us waiting too long in our minority, as if we'd been waiting for him and the enlightenment he brings even when or if we didn't know when or if he was coming. In 1987, when this record was released, because by then I'd already started graduate school, and

was already trying to think of myself as a scholar, as a certain kind of intellectual, maybe I was thinking—in ways not unlike a whole bunch of critics at that time who were especially open to Rakim, especially enamored of his own deep scholarship, of what Arthur Jafa might call the self-consciously abnormative way he claimed a kind of normatively scholarly way of being—man, finally hip-hop has produced, out of its intense, shared, undercommon intellectuality, *an intellectual*. And he announces it himself. He is the microphone soloist whose thought patterns, as he later puts it, are displayed on Persian rugs. It is as if, at that moment, he proclaims his own structural relation to his music that is analogous to that which Louis Armstrong's playing so emphatically seemed to have announced with regard to his. This is the emergence of the soloist, the virtuoso, the scholar who might be said to arise from an organic ground of common intellectuality, as a simultaneous representative and negation given in the figure of the one. And what I should say, here, more precisely, is not so much that Rakim is making that announcement but that what he says—or what can have been made to have been said in the isolation of his saying—is what I think I wanted, and still sometimes think I want, to hear *as* that announcement, just as whatever it was that Pops was playing, there's still that gap between what that was and what some of us—in the wake, say, of Ralph Ellison—may have wanted from it. But see, in thinking all this, what I want to say, now, is that all along, hip-hop in particular, and black music in general, is trying all the time to get us not just to want something else but to want differently. In this regard, hip-hop is educational in a sense of the word that Gayatri Spivak once uttered. "Education," she said, "is the non-coercive rearrangement of desire."[2] That's what hip-hop is, that's what the music practices: a noncoercive rearrangement of desire that moves—in a way that somehow obliterates the distinctions between being made to move and wanting to move and wanting to be made to move—in that gap, that break, which is a field of feel in dance, in which the representative itself is negated by way of an overwhelming affirmation. Maybe coming more rigorously, thoughtfully, and phonically attentively to feel this is borne in the difference between being overwhelmed by and always having been held in the communicability of music's kinesthetic force. At which point, what it is, then, is to remember that we always almost all up in something already anyway, a condition for which we constantly appeal to the imprecise language of possession, as when Rakim says, "I know you got soul." We all but all up in something and yet the language of possession and individuated

exaltation holds a little bit of us back from us. The imprecision of the language places an amazing responsibility on us to be more precise in our use of it. And this precision that we seek in the face of and by way of imprecision turns out itself to be a matter, or maybe a function, of dance. The way our mobile, open flesh acts this whole thing out in common bears the sharpness we want the words to follow.

What the soloist says when he appears to have come to announce himself is that it's not about me, it's about us, the social field from which I and you emerge, and to which they recede, like vapor, as the illusory relation that stands for relationality's illusory nature, as such. When Rakim first came out, and folks like me, or folks who at that time I wanted to be like, were busy comparing him to Miles Davis (in part because of his tone, his wickedness in the middle register, his volatility in mid-tempo, his ice-grilled, emphatic refusal to smile), part of what I think we were, and have been saying, was that he brought hip-hop online with ways we had been building to think about jazz, especially, and to a lesser extent, the blues, as a music of nonstandard but nevertheless identifiably intellectual individuation. That's how we had begun to look at and think about Pops, and Bessie, and Billie, and Bird, and so on until what we individuate, in pious recognition, is all but made to fade away. Rakim was The One in hip-hop whom we could place on that trajectory, in that pantheon. But hip-hop, like every other collective instance of differentiation in the history of great black music, ancient to the future, came to remind us, in renewing our habits of assembly, of assembly's indelibly unnatural nature, which might be characterized as a general relativity, an anauniversal and postparticulate gravity to which the relation between relation and singularity is inadequate. The soloist, in this regard, does not announce himself but rather our collective evacuation of the field in which the self is incessantly advertised and, therefore, incessantly degraded. That announcement is what I, for lack of a better word, am trying to hear right now. Even Ellison, in fugitive movement on undercommon ground as opposed to aeronautic solitary confinement, is just about all up in this, against the grain of the very idea of one and many, that singularly multiple imprecision, not in the interest of prophecy but of more + less than phenomenological description.

It's not an accident that one of the greatest (dis)composers in the black radical music tradition's name is (Thelonious, also known—in the Cockney, with reference to his jurisgenerative force—as Felonious) Monk. That name

reminds us of the deep and fundamental monasticism that animates black music, which in turn animates black social life. It's a social practice that is always also a spiritual practice. But it is also fundamentally sensuous, fundamentally material, as Karl Marx, who's all up in almost all of this, too, feels early on: The sensual, the material, is theoretical as well—a practice of seeing, a practice of (anti- and antemasterful) planning, given in a practice of dancing. "Roll back the rug, everybody. Move all the tables and chairs. We're gonna have us a good time tonight." The planning and seeing of the alternative that is manifest in this music is always also given immediately as a socially kinesthetic practice of the alternative. And the alternative is practice in this rich and deep way precisely insofar as it constitutes a mode of defense, the undercommon defense that we provide for us: self-defense as a radically transformative self-endangering, self-ungendering, degeneration of self in regenerative selflessness. When we describe the commune we've been building in defense of our continuing to build it we say: This is our music. Then we give it all away in giving ourselves over to it. We keep dancing so we can keep dancing—that kind of dancing where we be trying to throw our own hands off of whatever it is that people imprecisely call our bodies. It's all a matter of departure and continuity, of entanglement and virtuosity—the soloist's departure from the metaphysics of individuation, the continuation of that fundamental social physics of the music that is the animation of our tradition, the way we keep making the music when we play it, when we cut it, when we mix it, when we move it, when we mark it, when we say it, when we see it, when we hear it, when we feel it, in our practical, sensuous, and spiritual consideration of how we ongoingly theorize the very idea of virtuosity, the very idea of goodness, of the great goodness of life or, more precisely, of the making of a living that is "the aesthetic sociality of blackness." That's the way we pre- and post-anchoritically stay on the scene, like a coenobitically anti-acquisitive chorale, like an "endlessly sudden" next machine.[3] That's how we carry ourselves in our collective breaking and making of rules against the very idea of rule, of dominion, of measure. That's how we make and break the law to bend toward justice. No count, they say, because we are uncountable, because we are the miracle that cannot be accounted for in any science of ownership's brutal double entry. No one, two; no a one and a two; just keep on moving, dispossessively, in the general gift. We know we got soul, we know this is our music, because we got to give it up. Feel we? Long as we're groovin' there's always a chance.

48.

At the point when Washington got the call [to work in Snoop Dogg's horn section], he had been spending most of his time trying to master harmonically demanding songs like Coltrane's "Giant Steps." Now his job was to play apparently simple riffs to "line up with the groove." Playing those riffs, however, was tougher than it looked: Hip-hop was a miniaturist art of deceptive simplicity. "When you play jazz in school, you talk about articulation, but it's a very light conversation," he said. "The question was about what you were playing, not how you were playing it. But when I was playing with Snoop, what I was playing was pretty obvious—anyone with ears could figure it out. The question was how to play it, with the right articulation and timing and tone. . . ."

Snoop was particularly demanding when it came to the placement of notes in relation to the beat, and Washington struggled at first to hear the beat the way Snoop did. After a while, though, he began to discern what he calls "the little subtleties," the way, for example, "the drummer D-Loc would lock into the bass line." He continued: "It wasn't like the compositional elements in Stravinsky. It wasn't about counterpoint or thick harmonies. It was more about the relationships and the timing, the one little cool thing you could play in that little space. It might just be one little thing in a four-minute song, but it was the perfect thing you could play in it. I started to hear music in a different way, and it changed the way I played jazz. Just playing the notes didn't do it for me anymore."[4]

Music was my mother's mother tongue. She handed that to me. I'm a mama's boy, while Shatz makes it appear that Washington is clearly his father's son. Maybe it's not about which music is the music of your childhood. Maybe it's about who was putting the records on the turntable. And yet, I feel the black maternal care Washington's father(s) lavished upon him even as I must also acknowledge the hard limits of that lavishing in the (relative) absence of black women. Given the strictness of those limits, will Washington be able consistently to access black maternity's exhausted, exhaustive care in his own music? To ask this question is to feel, rather than to forget, such attention's miraculous presence in Snoop Dogg's horn section. Meanwhile, having long considered the poverty of my father's absence as a kind of wealth, maybe now it's time to honor the maternal care he lavished upon me, which never

took the form of dispensing wisdom but, rather, manifest itself in what I now know were impossibly tender applications of lotion. I don't know. But what I do know, or think I know, is that the distinction between entanglement and virtuosity is improvised in virtuous, communal, maternal attention to detail—in listening to and for and in detail as Alexandra Vazquez teaches us.[5] This is what Kamasi Washington knows but doesn't activate, discovers but doesn't produce, in *The Epic*. In his admirable insistence upon recognizing the relation between hip-hop and Stravinsky, or hip-hop and Trane, he turns out, precisely by way of the logic of relation, to reify in his own playing and composing—in what he refers to as his return to his own music—a separateness between what now shows up as the music*s*. That separateness debilitates entanglement's manifestation in and as detail. Our anheroic heroes never failed to pay attention to the note's articulation, often unto and over the edge—its over- or underblown blur, its bend in the gravity of our moral arc. They never accepted the distinction between what to play and how to play it. It's strange that what Washington learned in playing with Snoop, to pay attention to the details of articulation and placement, is or seems lost in *The Epic*'s sempiternal return to the unchanging same of an advanced, paternal, messianic guard. The intensity with which Washington claims a kind of patrimonial heritage is deep. There's a powerfully antimatrical aura that pervades the music—a charismatic force that seems, on the surface, to go against the grain of the movement/network to which it is often associated and which association Washington emphatically claims.

Perhaps here Samuel R. Delany's distinction between network and contact is crucial as we consider how it is that maybe this is our father's—as opposed to our mother's—civil rights movement after all. Our mother's movement, in its radical dispersal, in its ongoing and decentralized largesse of *charismata* (as Erica Edwards and Cedric Robinson and Danielle Goldman teach us), was a movement of contact (improvisation)'s small differences, its hand-to-hand rituals of study, its constant practice of the haptical poetics of entanglement that turn out to have been simultaneously the object and the method of—or deeper still the *party* for—self-defense. See, in the insistence with which the founders of the Movement for Black Lives claim their status as founders, even in the sincerity of their refusal of the historical erasure of the contributions of (queer and/or trans) black women to movement, perhaps they lose what movement means just as Washington's music sometimes seems inattentive to the radical force of what Amiri Baraka once called "place/meant." There's a miraculous enactment of appositionality and touch

that is movement's animation *and* that which movement renews, namely black life, which is anti- and ante-foundational, which is neither the subject of nor subject to individuation and (ac)count. In referring to it more simply as dance one arrives at the question of whether or not it's possible to dance to *The Epic*. Adam Shatz says yes—and yet one wonders how and one wonders who. Perhaps there is a choreography of the network that bears its own spontaneities and authenticities confirming the reality of a new collective assertion of personality. It's just that movement's uncollected force— and, for that matter, the constant, genocidal regulation of that force and the injury such regulation still incessantly produces—ain't personal. In seeking to represent what can't be represented, *The Epic* is an exercise in *Bildung* where such self-picturing, such attendance upon the face and, even, upon the name, is inattention to detail. This commitment to personality, which is a recrudescence of the brutal forces of individuation that refused to black matrical ecology the capacity for those terrible incapacities of personality that black matrical ecology refused, remains the crisis of the negro intellectual a little more than twenty years after Hortense Spiller's twenty-five year post-date to Harold Cruse.[6] The insistence on being called the founders of a movement, a claim that undermines the supposed movement's claim on the very term *movement* (which the founders rightly relinquish in saying, now, that it is a network), is an insistence upon personality (already coded, in fact, in the assertion of the mattering of that most viciously carceral of idealizations, the individual life) that doubles down on the patriarchy it is supposed to combat, a patriarchy that its putative soundtrack, *The Epic*, ironically, but also emphatically, claims.

Only two women were present at the meeting that seemed to signal and bless the changing of the guard. What we're left with, then, is the effect, in the music, of a conflict between the murkily sublime and macroaggressive overview of the father and the small, close, beautifully microsensual practices of care that Washington discovered in Snoop's music, though it was also always there in Trane's. Those practices are both extended and undermined in the gathering of old men that Shatz describes in ways that make one simultaneously hope and despair for their reproduction. I want to say there's not enough haptic, differential nothingness in Washington's music—just a particulate fog, maybe given in what it is to be misled by pictures of unpicturable galaxies. In the ordinary blur, ma and mu can't be faded. At recess in the ordinary blue, the shining star belongs to no one. Of course, patriarchal, virtuosic heroism is no more absent in Snoop or Trane or (on a much lower

if more highfalutin frequency) me than it is in Washington. Down here on, and sometimes under, the ground, wishing one could claim that absence is work-in-progress and work-in-presence through the one. All this is just to say that what we love in the music, and what the music loves and cares for in us, is an entanglement in matrical detail that so thoroughly ruptures the logic of individuation/relation/the same and so thoroughly anarchizes the principles of mathematics that it enacts an incalculable falsification, given in the explosion of each of its terms, even of the formulation 1+1=2. On the one hand, there is no solace for the loneliest number; on the other hand, number never applied to us anydamnway. There's nothing epic about this virtualization of virtuosity; the ordinary blur is in the details. Blackness is our everyday romance.

Bobby Lee's Hands

49.

don't lay back on cuts, man

Held in the very idea of white people—in the illusion of their strength, in the fantasy of their allyship, in the poverty of their rescue, in the silliness of their melancholy, in the power of their networks, in the besotted rejection of their impossible purity, in the repeated critique of their pitiful cartoon—is that thing about waiting for vacancy to shake your hand while the drone's drone gives air a boundary.[1] Don't be a ghost, be a spirit, Baraka said, in a movie about white people, the socially dead. Can the socially dead organize their own? What are the socially dead, anyway? This is an ontological inquiry only insofar as it's concerned with what it is, or what it would be, to have an ontological status. What it would be to have an ontological status, and know it, is what it would be to be a white person. In that condition, that particulate dream, which is the eternally prefatory's tired aftermath, one is what it is to persist in having begun interminably to wait on being one. Such a one, that one who is not one but wants to be, is a ghost. How do you stop being a ghost? How do you stop being political in Lincoln Park? One must imaginatively practice oneself away into a whole other mode of service, Uptown's collective head, *speak 'em up and say 'em now.*

For a minute, the mountains in Chicago—having come from nowhere but the gap, from undermelungeonal elsewhere in nowhere in the gap, already more and less than by themselves or as themselves, having brought the modern to the city in Junebug's homily and Preacherman's homeless vespers— had enough of waiting on being white. Sent to this in order to be sent by it, along with all that gathering he carries that always be carrying him, was Robert E. Lee, III. The resurrector, having risen again to serve insurrection, didn't have a slave name, he had a ghost name, so they would recognize him.

It's like in this buried clearing of the afterlife the ministers of espionage are Saul Alinsky and Jackie Mabley, but just for a minute, but you couldn't even time it, and it really had no place, just an irregular displacement of Sabbath in a clearing dug out of a chapel. There's another movie, which is not about white people, of this open secret movement but by the time the watching started, there were more watching, hunting, droning, than destroying and rebuilding. Even the movie couldn't frame it, but for a minute, more than having had enough of being dispossessed, the mountains give away what they would have been, which was held out to them and away from them as what they awaited, ghosts of the brutally unborn in settlement. Giving up the ghost was given in Bobby Lee's exhaustion—in showing, in showing up, his already having given himself away in having come. Sister Ruby couldn't even look at him, at them, at what he and she were doing simply in their presence,

the panthers are here
are here
the panthers are here

for uptown
for anyone who lives in uptown.

We're here for you, we're here to be used by you, he says, deep in the history of the slave revolt. What the mountains were trying to relinquish was not a privilege but a death sentence, continually executed in their own pronounce-ment of it and in their waiting, when the poor interdict an unowned theater of their own. You can't love nobody but the poor, says Bobby Lee. For it is given to the poor not only to be the object of that sentence but also to object to it, in preferment of their own miraculous showing. The generality of that precarity is our privilege, if we let it claim us. What whiteness seeks to sepa-rate, blackness blurs by cutting, in touch. The movie about the movement keeps the secret it reveals. The ruptural caress is on the cutting room floor or, deeper still, underground. His hand waves in exasperation at people laying back on cuts. His hand presses someone's shoulder. Uptown can't improvise without contact, *we not movin', man, let's move, we can't move*. In the cut, laying back on cuts is given to dance in the laying on of hands, *we can't move without you*, and we're on the other side, in sufferance of an already given rupture, in lightly hugging someone's neck just like a shawl. This practice of serrated handing, animation given in the disruption of the dead body's

protection, struggle shared in tousle and massage, message come in touch, having claimed them, having come to be claimed by them, having come out to show them, having come to see them to believe, is how the mountains became Bobby Lee's own to organize, how they became what belongs to what's over the edge of belonging. They had to bear some whole other way of bearing and being borne so they could leave their own (ghostliness) behind, becoming something other than what they were not, something other than what they were waiting on. *The panthers are here, are here, the panthers are here* and, for a minute, the mountains move.

50.

well, he know how to cut yards

For a minute. This interlude in curacy, between a juke joint in Jasper and the Fifth Ward's gardens, is special now because of the richly alternative way some differences are felt. When interlude becomes impasse, then a way out is held in knowing how to cut by touching. *And do you know a lot of people don't know how to cut yards? They don't know how to cut yards. But when he fix it it's so pretty. I love for him to do my yard. But what I don't like about him, he don't wanna take no money.* He cuts yards by touching, by a kind of tenderness sown on every weed, as if he serves at the weeds' pleasure, as if passage is booked in love with the idea of taking her out to dinner. *You can't build no block club by not doing something for folks.* How else can you know who are your own, the owned, the held, the held away, in shoes so they can walk to heaven, which is on the street where they live? Turning left and right toward itselflessness, gently refusing laying back on cuts, knowing how to cut yards, *you go and start chattin'.* There's an endless, insistently previous preview of our work in progress that is held, handed, in touch, in feel(ing) and there's no need to wonder about the ghostly individual and his view. Seeing himself everywhere and calling it politics, he would—in the power of his gaze—be complete and indivisible, out of touch in self-possessed, self-picturing monocularity. Meanwhile, Bobby Lee is this other thing in tactile dispersion, practicing that haptic, active, organic *Phantasie* where one sees, because one is, nothing at all. It's nothing. It ain't no thing. Selflessness ain't about nobility or even generosity. The substance of its ethics is of no account, no count off, no one two, just a cut and then people be grooving. It's not about friendship with others, either. Society is not friendly association with others;

it's friendly association without others, in the absence of the other, in the exhaustion of relational individuality, in consent not to be a single being, which is given in the sharpness of a differentiating touch, in the movement of hands, in *caminhando*. Bobby Lee is another name we give to the xeno-generosity of entanglement: the jam, that stone gas, a block club in a block experiment, an underpolitical block party, a maternal ecology of undercommon stock in poverty, in service, genius in black and blur.

NOTES

Preface

1 Nathaniel Mackey, "Destination Out," *Callaloo* 23, no. 2 (2000): 814.
2 Fred Moten, *In the Break: The Aesthetics of the Black Radical Tradition* (Minneapolis: University of Minnesota Press, 2003).
3 Nathaniel Mackey, *Atet A.D.* (San Francisco: City Lights Books, 2001), 118; Saidiya V. Hartman, *Scenes of Subjection: Terror, Slavery, and Self-Making in Nineteenth-Century America* (Oxford: Oxford University Press, 1997), 117.
4 Hortense J. Spillers, "Mama's Baby, Papa's Maybe: An American Grammar Book," in *Black and White and in Color: Essays on American Literature and Culture* (Chicago: University of Chicago Press, 2003), 206.
5 Hartman, *Scenes of Subjection*, 4.
6 See Denise Ferreira da Silva, "No-Bodies: Law, Raciality and Violence," *Griffith Law Review* 18 (2009): 214; and Laura Harris, "Whatever Happened to the Motley Crew? C. L. R. James, Helio Oiticica and the Aesthetic Sociality of Blackness," *Social Text* 112, 30, no. 3 (fall 2012): 49–75.
7 Hartman, *Scenes of Subjection*, 77.
8 Hartman, *Scenes of Subjection*, 5.

Chapter 1. Not In Between

1 Johannes Fabian (with narratives and paintings by Tshibumba Kanda Matulu), *Remembering the Present: Painting and Popular History in Zaire* (Berkeley: University of California Press, 1996).
2 C. L. R. James, *The Black Jacobins: Toussaint L'Ouverture and the San Domingo Revolution*, 2nd ed., revised (New York: Vintage Books, 1989), x.
3 See D. H. Melhem, "Revolution: The Constancy of Change," in *Conversations with Amiri Baraka*, ed. Charlie Reilly, 214 (Jackson: University Press of Mississippi, 1994).
4 James, *Black Jacobins*, 288.
5 James, *Black Jacobins*, 290–91.
6 James, *Black Jacobins*, 291–92.
7 James, *Black Jacobins*, 314–15.
8 Cedric J. Robinson, *Black Marxism: The Making of the Black Radical Tradition* (Chapel Hill: University of North Carolina, 2000). This text and its author are

brilliant and indispensable. If I say anything of value in divergence from, though never in disagreement with, Robinson it is only as a function of his enabling texts and conversations. This essay is an attempt to linger in the interrogative space he opens around the issues of the lyricism and the origins of black radicalism.

9 Robinson, *Black Marxism*, 382.

10 James, *Black Jacobins*, 391–418.

11 Robinson, *Black Marxism*, 395.

12 Robinson, *Black Marxism*, 394.

13 Robinson, *Black Marxism*, 97.

14 Robinson, *Black Marxism*, 386.

15 Arif Dirlik, "The Postcolonial Aura: Third World Criticism in the Age of Global Capitalism," *Critical Inquiry* 20, no. 2 (1994): 328–56.

16 James, *Black Jacobins*, xi. My emphasis.

17 It's significant that Walter Rodney is able to think an equally unlikely emergence of the proletariat: "Less than three years after being emancipated from slavery, the new wage-earning class was acting in certain respects like a modern proletariat; and the first recorded strike in the history of the Guyanese working class was a success. Leading to the withdrawal of the planters' labor code and the continuation of the moderately increased wage rate." James makes explicit what Rodney implies—the insistently previous presence of the proletariat that strangely inhabits not only the bourgeoisie but the slave masses. Another social ontology, another theory of history, another dialectic is embedded here. See Rodney, *A History of the Guyanese Working People, 1881–1905* (Baltimore: Johns Hopkins University Press, 1981), 33.

18 I am in great debt, here and everywhere in this essay, to Nathaniel Mackey's notion of the sexual cut. See Mackey, *Bedouin Hornbook (From a Broken Bottle/Traces of Perfume Still Emanate)*, Callaloo Fiction Series, Volume 2 (Lexington: University Press of Kentucky, 1986), 30, 34–35.

19 Fabian, *Moments of Freedom: Anthropology and Popular Culture* (Charlottesville: University of Virginia Press, 1998), 76.

20 Fabian, *Remembering the Present*, 6.

21 Fabian, *Remembering the Present*, 9.

22 Fabian, *Remembering the Present*, 17.

23 Fabian, *Remembering the Present*, 21.

24 Fabian, *Remembering the Present*, 267.

25 Fabian, *Remembering the Present*, 267.

26 Fabian, *Remembering the Present*, 122.

27 Fabian, *Remembering the Present*, 122.

28 Fabian, *Remembering the Present*, x–xi.

29 Fabian, *Remembering the Present*, 189.

30 Fabian, *Remembering the Present*, 14.

31 Fabian, *Remembering the Present*, 3.

32 Gilles Deleuze and Félix Guattari, *A Thousand Plateaus*, trans. Brian Massumi (Minneapolis: University of Minnesota Press, 1987), 348.

33 Fabian, *Moments of Freedom*, 127–29.

34 Sergei Eisenstein, *The Film Sense* (New York: Harcourt Brace Jovanovich, 1942), 25.

35 Eisenstein, *The Film Sense*, 86.

36 Eisenstein, *The Film Sense*, 86–87.

37 Eisenstein, *The Film Sense*, 69.

38 Fabian, *Remembering the Present*, 257.

39 Fabian, *Remembering the Present*, 257n17.

40 Fabian, *Remembering the Present*, 258.

41 Fabian, *Remembering the Present*, 258.

42 Fabian, *Remembering the Present*, 258.

43 At one stage in its career, this essay was part of a collaborative effort in which I was engaged with Abdul-Karim Mustapha. I want to acknowledge the positive influence he had on the development of this work while absolving him from any responsibility for its faults.

Chapter 2. Interpolation and Interpellation

1 Theodor Adorno, "On the Fetish-Character in Music and the Regression of Listening," trans. Maurice Goldbloom, in *The Essential Frankfurt School Reader*, ed. Andrew Arato and Eike Gebhardt (New York: Continuum, 1982), 273.

2 Louis Althusser, "Cremonini, Painter of the Abstract," in *Lenin and Philosophy*, trans. Ben Brewster (New York: Monthly Review Press, 1971), 229.

3 Judith Butler, *The Psychic Life of Power: Theories of Subjection* (Stanford, CA: Stanford University Press, 1997), 17–18.

4 Prakazrel "Pras" Michel, with kris ex, *Ghetto Supastar* (New York: Pocket Books, 1997), 149–51.

5 See Butler, *Psychic Life of Power*, 6–10.

6 I must indicate, however briefly, that I am indebted to but deviate from Jacques Derrida's notion of "the becoming-objective of the object." See Jacques Derrida, *Resistances of Psychoanalysis*, trans. Peggy Kamuf, Pascale-Anne Brault, and Michael Naas (Stanford, CA: Stanford University Press, 1997), 31.

Chapter 3. Magic of Objects

1 Randy Martin, *Critical Moves: Dance Studies in Theory and Politics* (Durham, NC: Duke University Press, 1998), 206.

Chapter 4. *Sonata Quasi Una Fantasia*

1 Theodor Adorno, *Beethoven: The Philosophy of Music*, ed. Rolf Tiedemann, trans. Edmund Jephcott (Stanford, CA: Stanford University Press, 1998), 44–45.

2 Eric Blom defines the sonata in this way: "The sonata form in its fully matured but not sophisticated manifestations shows the following main outlines: a single movement in two principle sections, the first called the exposition, ending in another key than that of the tonic. Two main thematic groups make up its material, with room for subsidiary themes and connecting bridge passages. These groups

are traditionally described as first and second subjects. The first is in the tonic key, the second in a related key (e.g., the dominant in a movement in a major key and the relative major in one in a minor key). The second section begins with a development which, as its name suggests, develops some of the foregoing material in new ways, but may also partly or even exclusively introduce new matter (e.g., as in Mozart). This development leads to the recapitulation, where the opening of the movement, i.e., the first subject, returns as before, though possibly with varied treatment; the second subject also appears in the tonic key, major or minor, and in the latter case it is often in minor even if in the first section it appeared in major. All this necessitates a new modulatory transition between first and second subjects. The movement may end in the tonic exactly as the first section ended in another key; but there may be a coda added, either a very brief tail-piece of a merely ceremonial nature or a more developed section which may further work upon the foregoing material, as often in the case of Beethoven." See Blom, *The New Everyman Dictionary of Music*, 6th ed., revised and edited by David Cummings (New York: Grove Weidenfeld [1958] 1988), 712.

3 The run of adjectives I use to describe Gould compose, in my mind, an ensemble whose improper name is blackness. Gould's blackness will have been a kind of ecstasy, the hyperanalytic romanticism of the interior outside, the interior paramour, the metablackamoor carrying in the change, the lawless freedom, of a rough, humming ornament. Gould's blackness might also be thought as a desire operative in the encounter between unfreedom and a freedom drive that manifests itself in escape where improvisation and resistance constitute the tense suspension between harmony and counterpoint. One could also say that Gould's got rhythm, that he's operating in the other's time at that moment when differential tempi marks multiple lines, voices. Finally, Gould's blackness might inhere simply in a certain inability not to betray his origin. We could say, here, that Gould's blackness corresponds to Freud's "phylogenetic fantasy," about which more later.

4 Otto Friedrich, *Glenn Gould: A Life and Variations* (New York: Random House, 1969), 80.

5 Friedrich, *Glenn Gould*, 80–81.

6 François Girard and Don McKellar, *Thirty Two Short Films about Glenn Gould: The Screenplay* (Toronto: Coach House Press, 1995), 40–42.

7 Gould was forty-nine at the time. There is a section in the film, toward its end, called forty-nine. It is another scene of forced female audition, this time with Gould's favored interlocutor, his cousin Jessie Greig. Gould, who often claimed during this period that he was giving up the piano for conducting at the age of fifty, was at this time obsessed with thoughts of his mortality. Schoenberg, one of Gould's favorite composers, who, according to Gould and Adorno, instanti- ates the eruption of counterpoint into new music, was obsessed with numerol- ogy, particularly with the unluckiness of the number thirteen. It turns out that when Schoenberg was sixty-five he feared for his life since sixty-five is divisible by thirteen. A numerologist allayed his fears, assuring him he had nothing to fear this time around. Eleven years later, when he was seventy-six, Schoenberg was warned by his numerologist to watch out for years in which the integers marking his age

added up to thirteen. Alas, that year Schoenberg died. Gould, at forty-nine, had the same fear and, at forty-nine, recorded Beethoven's Piano Sonata no. 13. Gould's morbid numerological preoccupations are treated in Girard and McKellar, *Thirty Two Short Films*, 161–62.

8 It should be noted here, and it is in part the function of this essay to imply, that Gould may well have been sympathetic to Girard's resort to such a ruse. In the liner notes he composed to accompany his recording of piano music by Grieg and Bizet, Gould observes: "The calendar, after all, is a tyrant; submission to its relentless linearity, a compromise with creativity; the artist's prime responsibility, a quest for that spirit of detachment and anonymity which neutralizes and transcends the competitive intimidation of chronology."

What it means to resist such tyranny, to break the laws of serial temporality, might turn out to emerge at that intersection of fantasy and document (where the document could be said to imply both detachment and anonymity), cinema and music, the overtonal and the contrapuntal, that Girard's film occupies. See Glenn Gould, "Piano Music by Grieg and Bizet, with a Confidential Caution to Critics," in *The Glenn Gould Reader*, ed. Tim Page (New York: Vintage, 1990), 78.

9 Glenn Gould, "Glenn Gould Interviews Glenn Gould about Glenn Gould" in *The Glenn Gould Reader*, ed. Tim Page (New York: Vintage, 1984), 318.

10 See Peter Ostwald, *Glenn Gould: The Ecstasy and Tragedy of Genius* (New York: W. W. Norton, 1997), 232–33.

11 See Friedrich, *Glenn Gould*, 184.

12 Glenn Gould, "Radio as Music: Glenn Gould in Conversation with John Jessup," in *The Glenn Gould Reader*, 379. Quoted in Ostwald, *Glenn Gould*, 234.

13 Adorno, *Beethoven*, 26.

14 Adorno, *Beethoven*, 44. My emphasis.

15 Adorno, *Beethoven*, 46.

16 Adorno, *Beethoven*, 47.

17 J. Laplanche and J.-B. Pontalis, *The Language of Psycho-Analysis*, trans. Donald Nicholson-Smith (New York: W. W. Norton, 1973), 314.

18 Laplanche and Pontalis, *The Language of Psycho-Analysis*, 315.

19 Laplanche and Pontalis, *The Language of Psycho-Analysis*, 315.

20 Laplanche and Pontalis, *The Language of Psycho-Analysis*, 316.

21 Sigmund Freud, "The Unconscious," in *The Standard Edition of the Complete Psychological Works of Sigmund Freud*, vol. 14 (London: Hogarth Press, 1953–73), 191. Quoted in Laplanche and Pontalis, *The Language of Psycho-Analysis*, 317.

22 See note 3 and bear in mind the history of the question of Beethoven's blackness, which we could name, by way of an echo of Jelly Roll Morton (and Nathaniel Mackey [and Federico Garcia Lorca] [and Robert Reid-Pharr])—who is also located at the improvisational convergence of composition and performance, *Einbildungskraft* and *Phantasie*, where freedom resides in continued unfreedom, where stolen life seeks to steal away—as the dark sounds of Beethoven's Spanish tinge (or dinge). More later.

23 Laplanche and Pontalis, *The Language of Psycho-Analysis*, 318.

24 This question is prompted not only by the "passing" analogy in "The Unconscious" but also by this famous paragraph from "A Child Is Being Beaten": "Though in the higher forms at school the children were no longer beaten, the influence of such occasions was replaced and more than replaced by the effects of reading, of which the importance was soon to be felt. In my patients' *milieu* it was almost always the same books whose contents gave a new stimulus to the beating-phantasies: those accessible to young people, such as what was known as the '*Bibliothèque rose,*' *Uncle Tom's Cabin*, etc. The child began to compete with these works of fiction by producing his own phantasies and by constructing a wealth of situations and institutions, in which children were beaten, or were punished and disciplined in some other way, because of their naughtiness and bad behaviour."

25 Gilles Deleuze and Félix Guattari, *A Thousand Plateaus*, trans. Brian Massumi (Minneapolis: University of Minnesota Press, 1987), 270.

26 Theodor Adorno, "The Function of Counterpoint in New Music," in *Sound Figures*, trans. Rodney Livingstone (Stanford, CA: Stanford University Press, 1999), 127–28.

27 Edward W. Said, "The Music Itself: Glenn Gould's Contrapuntal Vision," in *Glenn Gould Variations: By Himself and His Friends*, ed. John McGreevy (Toronto: Doubleday Canada, 1983), 48.

28 Leonard Bernstein, "The Truth about a Legend," in McGreevy, *Glenn Gould Variations*, 17.

29 Theodor Adorno, "Bach Defended against His Devotees," in *Prisms*, trans. Samuel and Shierry Weber (Cambridge, MA: MIT Press, 1981), 138–39.

30 Glenn Gould and Curtis Davis, "The Well-Tempered Listener," in McGreevy, *Glenn Gould Variations*, 291–93.

31 Joseph Roddy, "Apollonian," in McGreevy, *Glenn Gould Variations*, 96.

32 Ostwald, *Glenn Gould*, 76–77. Ostwald quotes Gould's "Advice to a Graduation" in Page, *The Glenn Gould Reader*, 6–7.

33 Jonathan Cott, *Conversations with Glenn Gould* (Boston: Little, Brown, 1984), 40–41.

34 Sergei Eisenstein, "A Dialectic Approach to Film Form," in *Film Form: Essays in Film Theory*, ed. and trans. Jay Leyda (New York: Harcourt Brace Jovanovich, 1969), 52.

35 Eisenstein, "A Dialectic Approach," 53.

Chapter 5. Taste Dissonance Flavor Escape

1 See Hortense Spillers, "The Crisis of the Negro Intellectual: A Post-date," in *Black and In Color: Essays on American Literature and Culture* (Chicago: University of Chicago Press, 2003), 433; and Chuck Morse, "Capitalism, Marxism, and the Black Radical Tradition: An Interview with Cedric Robinson," in *Perspectives on Anarchist Theory* 3, no. 1. flag.blackened.net/ias/5robinsoninterview.htm, paragraph 35.

2 Harriet Jacobs, *Incidents in the Life of a Slave Girl* (New York: W. W. Norton, 2001), 5.

3 See Nathaniel Mackey, "Cante Moro," in *Sound States: Innovative Poetics and Acoustical Technologies*, ed. Adalaide Morris (Chapel Hill: University of North

Carolina Press, 1997), 199–200; Saidiya Hartman, *Scenes of Subjection: Terror, Slavery, and Self-Making in Nineteenth-Century America* (New York: Oxford University Press, 1997), 102–12; Harryette Mullen, "Runaway Tongue: Resistant Orality in *Uncle Tom's Cabin, Our Nig, Incidents in the Life of a Slave Girl,* and *Beloved,*" in *The Culture of Sentiment: Race, Gender, and Sentimentality in Nineteenth-Century America,* ed. Shirley Samuels (New York: Oxford University Press, 1992), 244–64; and Daphne A. Brooks, *Bodies in Dissent: Spectacular Performances of Race and Freedom, 1850–1910* (Durham, NC: Duke University Press, 2006).

4 Jacobs, *Incidents,* 87.

5 Maurice Wallace, *Constructing the Black Masculine: Identity and Ideality in African American Men's Literature and Culture, 1775–1995* (Durham, NC: Duke University Press, 2002), 86.

6 Jacobs, *Incidents,* 91.

7 Michael Fried, "Art and Objecthood," in *Art and Objecthood: Essays and Reviews* (Chicago: University of Chicago Press, 1998), 148–72.

8 I want to thank Rebecca Schneider for insisting that the notion of trajectory is worried and must be worried. The broken line/broken circle I am trying to follow here is illuminated by and must go through her work. It is also a privilege to try to work ground that has been broken by Lorraine O'Grady, by Deborah Willis and Carla Williams, by Cheryl Wall and by Jennifer Doyle, whose questions were the initial provocation for this essay. See Schneider, *The Explicit Body in Performance* (New York: Routledge, 1997); O'Grady, "Olympia's Maid: Reclaiming Black Female Subjectivity," in *Art, Activism and Oppositionality: Essays from Afterimage,* ed. Grant H. Kester (Durham, NC: Duke University Press, 1998), 268–86; Willis and Williams, *The Black Female Body: A Photographic History* (Philadelphia: Temple University Press, 2002); Wall, *Worrying the Line: Black Women Writers, Lineage, and Literary Tradition* (Chapel Hill: University of North Carolina Press, 2005); and Doyle, *Sex Objects: Art and the Dialectics of Desire* (Minneapolis: University of Minnesota Press, 2006).

9 See Tera W. Hunter, *To 'Joy My Freedom: Southern Black Women's Lives and Labors after the Civil War* (Cambridge, MA: Harvard University Press, 1997), and Hartman, *Scenes of Subjection,* 17–48.

10 Jacobs, *Incidents,* 54.

11 W. E. B. Du Bois, *The Philadelphia Negro: A Social Study,* rev. ed. (Philadelphia: University of Pennsylvania Press [1899] 1996), 411.

12 T. J. Clark, *The Painting of Modern Life: Paris in the Era of Manet and His Followers* (Princeton, NJ: Princeton University Press, 1984), 79.

13 Willis and Williams, *The Black Female Body,* 36, 44.

14 Willis and Williams, *The Black Female Body,* 45–46. I am also very much indebted, here, to Akira Mizuta Lippit's brilliant excavation, his deep illumination, of the secret, the archive, the *anarchive.* See his *Atomic Light (Shadow Optics)* (Minneapolis: University of Minnesota Press, 2006).

15 Thomas Eakins to Benjamin Eakins, May 9, 1868; quoted in H. Barbara Weinberg, "Studies in Paris and Spain," in *Thomas Eakins: American Realist,* ed. Darrel Sewell (Philadelphia: Philadelphia Museum of Art, 2001), 18.

16 Willis and Williams, *The Black Female Body*, 188.

17 Michel Foucault, *The History of Sexuality, Volume I: An Introduction*, trans. Robert Hurley (New York: Vintage Books, 1978), 140.

18 Theodor Adorno, "On Some Relationships between Music and Painting," trans. Susan Gillespie, *Musical Quarterly* 79, no. 1 (1995): 66.

19 Adorno, "On Some Relationships," 66; Adorno, *Aesthetic Theory*, trans. Robert Hullot-Kentor (Minneapolis: University of Minnesota Press, 1997), 168–69.

20 Adorno, "On Some Relationships," 66.

21 Adorno, "On Some Relationships," 66.

22 Adorno, "On Some Relationships," 66.

23 See Harryette Mullen, "African Signs and Spirit Writing," *Callaloo* 19, no. 3 (1996): 670–89.

24 Adorno, "On Some Relationships," 78. See also Gilles Deleuze and Félix Guattari, *Anti-Oedipus: Capitalism and Schizophrenia*, trans. Robert Hurley (Minneapolis: University of Minnesota Press, 1983).

25 See Akira Lippit, *Electronic Animal: Toward a Rhetoric of Wildlife* (Minneapolis: University of Minnesota Press, 2000).

26 Adorno, "On Some Relationships," 72.

27 Adorno, "On Some Relationships," 73.

28 Adorno, "On Some Relationships," 67.

29 Adorno, "On Some Relationships," 67.

30 Adorno, "On Some Relationships," 69.

31 See Adorno, "Little Heresy," trans. Susan H. Gillespie, in *Essays on Music*, with introduction, commentary, and notes by Richard Leppert (Berkeley: University of California Press, 2002), 318–24.

32 Adorno, "The Radio Symphony," in Leppert, *Essays on Music*, 262.

33 Adorno, "Little Heresy," 319.

34 Adorno, "Little Heresy," 321.

35 Adorno, "Little Heresy," 322.

36 Adorno, "On Some Relationships," 70.

37 Adorno, "On Some Relationships," 71.

38 Adorno, "On the Fetish-Character in Music and the Regression of Listening," ed. Richard Leppert, in *Essays on Music*, 290.

39 Adorno, "On the Fetish-Character," 291.

40 Marvin Gaye, "Since I Had You," *I Want You*, Motown CD 3746352922, 1976. For more on Gaye's performance, see my *In the Break: The Aesthetics of the Black Radical Tradition* (Minneapolis: University of Minnesota Press, 2003), 211–31.

41 Adorno, "On the Fetish-Character," 310.

42 Adorno, "On the Fetish-Character," 315.

43 Miles Davis, "The Buzzard Song," *Porgy and Bess*, orchestra dir. Gil Evans, Columbia Cl 1274, LP, 1958.

44 Adorno, *Beethoven: The Philosophy of Music*, ed. Rolf Tiedemann, trans. Edmund Jephcott (Stanford, CA: Stanford University Press, 1998), 44.

45 Thanks to Ruth Wilson Gilmore for introducing me to Lorna Goodison's poetry and for the rhythm of my title; to Kathryne Lindbergh, Brent Edwards, Bran-

islav Jakovljevic, Marianne Tettlebaum, and Rebecca Schneider for giving me the chance to present and refine this work; to Ed Cadava and Barbara Browning for their comments and encouragement; and especially to Danielle Goldman for her careful editing, caring stewardship, and, especially, for her own brilliant work. This essay is dedicated to Qelsi Qualls.

Chapter 6. The New International of Rhythmic Feel/ings

1 Lord Invader, *Calypso in New York*, Smithsonian Folkways Recordings CD 40454, liner notes by John Cowley, 2000.

2 Charles Mingus, *Mingus Ah Um*, Columbia/Legacy CD CK 65512, 1998.

3 See Paul Gilroy, *The Black Atlantic: Modernity and Double Consciousness* (Cambridge, MA: Harvard University Press, 1993), 1–40. One way to think of this essay is as a kind of response to a more recent intervention by Gilroy, "Multiculture, Double Consciousness and the 'War on Terror,'" *Patterns of Prejudice* 39, no. 4 (2005): 431–43. But how does one respond to the notion that the African American cultural field constitutes a particularly, indeed vulgarly, provincialist threat to a new Afro-diasporic cosmopolitanism and to more general forms of postracial national identity whose imagined conviviality—manifest in the universal desire among a multiracial, multiethnic set of people from Britain illegally detained at Guantanamo Bay for Scottish Highland shortbread—depends upon an avoidance of an American model of multiculturalism that is bodied forth in the African American example? To whom is Gilroy speaking? (Or, in another register, by way of another structure of address, directly to him though I am certain he'll never read this, Who the fuck you talking to?) The question is crucial insofar as much of what Gilroy has written in the last decade seems directed toward the Great Tribunal of Rational Men, The National-Cosmopolitan Star Chamber. I wonder if they listen to him. Gilroy begins by touching on a theoretical problem embedded in the discourse of loss-in-politics that is currently dominated by the mourning/melancholia dichotomy. However, one can discern no sense whatever of any obligation Gilroy feels to theorize loss for himself; no sense of any direction toward an address of the question of how a nation would mourn the loss of its imperial power and thereby work through a postcolonial melancholia that threatens to thrust it into the modes of vicious segregation and exclusion that pass, now, for multiculturalism in the United States. One wonders if it can, in fact, be established that a nation in its entirety, if, indeed, such a totality can itself adequately be established, *needs* to mourn lost empire. Is the mourning/melancholia dichotomy, which seems to tire under the massive weight of the analytic desire it is now forced to bear, even necessary for an understanding of contemporary British racism and xenophobia? This is an interesting question that Gilroy's text requires its readers to ask but that task is, finally, eclipsed by other, more urgent issues Gilroy forces us—or at least me—to address due to the specificities of his critique of American-style multiculturalism. The point is not that I disagree with that critique; if anything, Gilroy is gentle in his treatment of a model in which old-fashioned interracial exploitation and postmodern commercialized assimilation are made to pass for social integration. Moreover,

it is not simply that I fail to recognize the African American culture that I have
known and lived and studied in Gilroy's description, which ranges from brief and
illegitimately totalizing mention of the supposedly world-enveloping mindless-
ness of hip-hop to extrapolations of the entirety of the black political field in the
United States from the mindfully vicious examples of Colin Powell and Condo-
leezza Rice. The point, rather, is that there is a fundamental difference in the
way Gilroy and I think of ourselves in relation to national identity. That there
has always seemed something nostalgically, even melancholically, inaccurate
about the term *African American* is one part of it; but what also differentiates
us is that while Gilroy seems to believe in the personal and analytic value of a
phrase like "We Britons," I could never bring myself—for reasons both affective
and intellectual—to speak of "We Americans." And I experience this neither as
loss nor as implicit acknowledgment of the narrowness or failure of the specific,
anticorporate U.S. multiculturalism to which I would dissentingly subscribe or,
more particularly, of the mode of blackness that I would claim precisely as a re-
sult of a radical, principled rejection of national identity as such. It is heartening
to note that Gilroy sees in black culture, broadly conceived, the seeds of a certain
critique, if not rejection, of national identity even as it is disheartening that the
African American is seen as a regressive countertendency in which the national
is reified. Again, such a formulation depends upon a problematically narrow
understanding of the history of the forms of black life taken up in (anticipa-
tory apposition to) the United States. Gilroy's unfortunate assertions are, to my
mind, a function of his massive underestimation, a practically burlesque inability
genuinely to think the irreducible dehiscence, which is exacerbated by the inac-
curacy and incommensurability of its terms, at the heart of *African American*, a
nonword or nonphrase or nonconcept that ought always to be placed in erasure.
This is how that which is unfairly and inaccurately called African American pro-
vincialism comes to stand in for what is barely acknowledged, beyond the kind of
facile phrase making that now so often stands in for analysis, as the desperately
grasping imperial and assimilative reach of American exceptionalism. This is
how Rice and Powell are offered up as representative African Americans while
Du Bois is presented as a kind of quaint, outdated, etiolated substitute for a
more genuine and effective mode of resistance to the representative. Suffice it to
say that matters are quite a bit more complicated than this. In the end, perhaps
it would be better to have written—for those who think this really matters, for
those who believe in the fantasy of a cosmopolitanism that would be carried
out by spooky actions at a distance in the everyday space-time of human bodies
whose limits remain in spite of the cybernetic powers of the virtual—a record-
straightening informational communiqué titled "On the Transnationality of U.S.
Blackness." On the other hand, the best response might have been a brief ethnog-
raphy focusing on the vast number of multiracial, multiethnic people organized
around the desire for Big Macs in United States prisons. But all I can do is
amplify the admittedly nonconvivial question I addressed to Gilroy above: Who
are you to lecture blacks in the United States, whom you conceive in the most
egregiously undifferentiated way, about their international dissident responsibili-

ties while speaking of "We Britons," and romanticizing the fantasmatic national identity of baked goods?

4 I want to emphasize, here, that the musics in question—jazz, calypso, free jazz—are burdened by their names. Constrained to repeat and revise given musical forms, to redouble and to refrain from the assertion of given political and sexual content, Afro-diasporic musics could be said constantly to perform a kind of antinomian antinominalism. This makes Mingus's nominative gestures, about which more shortly, all the more problematic.

5 Jean Clouzet and Guy Kopelowicz, "*Interview de Charles Mingus: Un Inconfortable Après-midi," Jazz*, June 1964, 27. I thank Brent Edwards for help with the translation.

6 Sue Graham Mingus, *Tonight at Noon: A Love Story* (New York: Da Capo, 2002), 13, 18–19.

7 Henry Dumas, "Will the Circle be Unbroken?" Eugene B. Redmond, ed. *Echo Tree: The Collected Short Fiction of Henry Dumas* (Minneapolis: Coffee House Press, 2003), 105.

8 See Frederick Douglass, *Narrative of the Life of Frederick Douglass, an American Slave, Written by Himself,* in *Frederick Douglass: The Narrative and Selected Writings*, ed. Michael Meyer (New York: Modern Library, 1984), 28–29.

9 See Michel Foucault, "Maurice Blanchot: The Thought from Outside," in *Foucault/Blanchot*, trans. Jeffrey Mehlman and Brian Massumi (New York: Zone Books, 1987); and Nathaniel Mackey, "Destination Out," *Callaloo* 23, no. 2 (2000): 814.

10 Foucault, "Maurice Blanchot," 18.

11 See Jelly Roll Morton, *The Complete Library of Congress Recordings*, disc six, Rounder Records B000GFLE35, 2005; Robert Reid-Pharr, *Black Gay Man* (New York: New York University Press, 2002), 85–98; Nathaniel Mackey, "Cante Moro," in *Sound States: Innovative Poetics and Acoustical Technologies*, ed. Adalaide Morris (Chapel Hill: University of North Carolina Press, 1997), 194–212; and Federico García Lorca, *In Search of Duende*, trans. Norman Di Giovanni (New York: New Directions, 1998).

12 It's interesting to note here that Mingus's fellow transplanted Angeleno, critic and erstwhile drummer and novelist Stanley Crouch, has offered similar criticisms of Rollins recently, to which Rollins has had the opportunity to reply. In an interview with Ashante Infantry, Rollins responds to Crouch's assertion that when he is faced with a young audience "he often resorts to banal calypso tunes." "I completely reject that criticism and I think it was based on the fact that he denigrates that type of rhythm and I don't," said the Harlem-born Rollins, whose parents emigrated from the Virgin Islands. "It's something that I enjoy playing and is a challenge to play, just as much as a lot of the music we play. It's not something I phone in." While Mingus aligns calypso with a lack of musical knowledge, Crouch compounds that formulation by asserting that calypso is also bound up with a lack of musical effort. Ignorance that ends in self-parodic performance and laziness that manifests itself in a performative ease that indexes preternatural cheerfulness are, of course, familiar stereotypes assigned to African-descended peoples, ones that both Crouch and Mingus could be said misguidedly to combat via a kind of intradiasporic

displacement whose circuits of further transfer and return turn out to have been, up to now, inexhaustible. See Stanley Crouch, "The Colossus," *New Yorker*, May 9, 2005; and Ashante Infantry, "Crouching Tiger, Hidden Colossus," *Toronto Star*, June 19, 2005.

13 Brian Priestly, *Mingus: A Critical Biography* (New York: Da Capo, 1982), 84.

14 Priestly, *Mingus*, 84–85.

15 Priestly, *Mingus*, 85.

16 For more on Mingus in Tijuana and for a more general overview of African American/Mexican musical interaction, see Josh Kun, *Audiotopia: Music, Race, and America* (Berkeley: University of California Press, 2005), 143–83.

17 See Priestly, *Mingus*, 124; and Mingus, "What I Feel about Jazz . . ." *Jazz News*, July 19, 1961, 10–11.

18 Priestly, *Mingus*, 124–25, with interpolations from Mingus, "What I Feel about Jazz . . . ," 10.

19 Mingus, *Beneath the Underdog*, ed. Nel King (New York: Penguin, 1971), 251–52.

20 Shannon Dudley, "Judging 'By the Beat': Calypso versus Soca," *Ethnomusicology* 40, no. 2 (1996): 270.

21 Herman Rapaport, "Of Musical Headings: Toscanini's and Furtwängler's *Fifth Symphonies*, 1939–54," in *Thresholds of Western Culture: Identity, Postcoloniality, Transnationalism*, ed. John Burt Foster Jr. and Wayne Jeffrey Froman (New York: Continuum, 2002), 67.

22 Rapaport, "Of Musical Headings," 67.

23 Rapaport, "Of Musical Headings," 67–68.

24 Rapaport, "Of Musical Headings," 68.

25 Rapaport, "Of Musical Headings," 68.

26 Sarah Cervenak, *Wandering: Philosophical Performances of Racial and Sexual Freedom* (Durham, NC: Duke University Press, 2014).

27 Daniel Barenboim and Edward Said, *Parallels and Paradoxes: Explorations in Music and Society* (New York: Pantheon, 2002), 74.

28 Karl Dietrich Gräwe, "Fixing the Moment: The Conductor William Furtwängler," liner notes for William Furtwängler, *Recordings: 1942–1944, Vol. 1*, Deutsche Grammaphon CD Mono 471 289–2, 2002, 7.

29 Gräwe, "Fixing the Moment," 9.

30 Consider the gestural nonconvergence of song and dance. It demands an investigation, which is to say a remixing, of prior tracks and the laying down of some new ones; some movement, down and across ruptured, restricted avenues, nowhere, no place, but not there; some eccentric avenue given and made in being broken in and into and down, uptown, Los Angeles, Arkansas. Movement like this isn't parallel but off and out; tangent as much as crossing; asymptotic, appositional encounter. As soon as we call this line we're on derailment we'll begin to study how all this out root goes. Train circle, then bridge, then fall.
 Butch Morris calls it conduction. (1) "It was at this time [June 1984] that I started thinking more about the combustion, or heat, that the system creates. The communication between eye, mind, and ear, between people—the psychology and imagination. I started to read physics books, primarily to create a rationaliza-

tion for what I was doing and thinking. Here I found 'conduction.' It served dual purposes. One, it served the music-conducted improvisation. Two, it served the physical aspect of communication and heat" (Lawrence D. "Butch" Morris, "First Curiosity," liner notes, *Testament: A Conduction Collection*, New World Records, CD, 1995, 5). (2) "Collective improvisation must have a prime focus, and the use of notation alone was not enough for the contemporary improviser. Free jazz and collective improvisation were grand moves in the history of the music, you can't write this out. I think more than anything, they created more questions and answers to and for the direction of composition for improvisers. The idea that a music's outcome be predetermined (notation) is long a dead issue with me. It is enough for me to know that the musicians who participate in Conduction are there to serve the music we make at the time that we make it, and that they will be served by its outcome. I've seen sabotage in the multitude—and people who want anarchy before they know the law. There is no place for that in this music, as there is no place for that in any other music, art, or culture. Therefore, for this music I look and listen for ensemble players. Ensemble players who can make a decision for the good of the music and its direction" (Morris, "First Curiosity," 5–6). (3) "'Conduction' not only relates the act of 'conducted improvisation,' it is also the electric charge and response from body to body—the immediate transmission of information and result. This is an ancient form of communication that can be used again to further this music (although we see it every day in some form, and if not every day—every spring)." (Morris, "Theory and Contradiction: Notes on Conduction," liner notes, *Testament*, 8).

Heat and memory reforge music as aeffect of service, beyond the absence of "a focus," by way of and through the strictures of objection. On the one hand, a choreographer (Ralph Lemon) speaks of mourning the loss of dances incurred while waiting for dancers; on the other hand, the reproductivity of conduction and its decision, its memory, ancient rite, rewritten book, depends upon the instrument, the musician, the fecundity of insistent things (musicians, instruments).

Conduction #25, Istanbul, Turkey; October 16, 1992. The rhythms insist more intensely with the stringed but flutelike oud: what Dolphy would have sounded like over this much strife, and in it! Now Ragin playing thru it. Rhythm of so much string, strings' translucency is a turbulent field. Content too rich for taxonomy. Irregularities anticipated in the invented but familiar phrase. This is of motherless children. They accent the second syllable because they are disciples.

31 See Samuel R. Delany, *The Motion of Light in Water: Sex and Science Fiction Writing in the East Village* (Minneapolis: University of Minnesota Press, 2004), 291–92; and Hazel R. Carby, *Race Men* (Cambridge, MA: Harvard University Press, 2000), 135–68.

32 Barenboim and Said, *Parallels and Paradoxes*, 17.

33 Barenboim and Said, *Parallels and Paradoxes*, 35.

34 Scott Saul, *Freedom Is, Freedom Ain't* (Cambridge, MA: Harvard University Press, 2003).

35 Dudley, "Judging 'By the Beat,'" 274.

36 Dudley, "Judging 'By the Beat,'" 270.

37 Dudley, "Judging 'By the Beat,'" 272.

38 Check Gould's conversation with Tim Page on the second recording on disc 3 of Glenn Gould, *A State of Wonder: The Complete Goldberg Variations, 1955 and 1981*, Columbia S3K 87703, compact discs, 2002.

39 Dudley, "Judging 'By the Beat,'" 272–73.

40 Dudley, "Judging 'By the Beat,'" 274.

41 Olly Wilson, "The Significance of the Relationship between Afro-American Music and West African Music," *Black Perspectives in Music* 2, no. 1 (1974): 3–22; quoted in Dudley, "Judging 'By the Beat,'" 274.

42 I'm thinking of two late elaborations by Adorno of what he calls the *Bewegungsgesetz*. In the first, he writes, "The object of theory is not something immediate, of which theory might carry home a replica. Knowledge has not, like the state police, a rogues' gallery of its objects. Rather, it conceives them as it conveys them; else it would be content to describe the façade. As Brecht did admit, after all, the criterion of sense perception—overstretched and problematic even in its proper place—is not applicable to radically indirect society. What immigrated into the object as the law of its motion [*Bewegungsgesetz*], inevitably concealed by the ideological form of the phenomenon, eludes that criterion." See his *Negative Dialectics*, trans. E. B. Ashton (New York: Continuum, 1972), 206. In the second formulation, Adorno states, "The semblance character of artworks, the illusion of their being-in-itself, refers back to the fact that in the totality of their subjective mediatedness they take part in the universal delusional context of reification, and, that, in Marxist terms, they need to reflect a relation of living labor as if it were a thing. The inner consistency through which artworks participate in truth always involves their untruth; in its most unguarded manifestations art has always revolted against this, and today this revolt has become art's own law of movement [*Bewegungsgesetz*]. The antinomy of the truth and untruth of art may have moved Hegel to foretell its end. Traditional aesthetics possessed the insight that the primacy of the whole over the parts has constitutive need of the diverse and that this primacy misfires when it is simply imposed from above." See Adorno, *Aesthetic Theory*, trans. Robert Hullot-Kentor (Minneapolis: University of Minnesota Press, 1997), 176–77.

43 Or, as I prefer to call her, Mlle. B:

Mlle. B. was nineteen years old when she entered the hospital in March. Her admission sheet reads:

The undersigned, Dr. P., formerly on the staff of the Hospitals of Paris, certifies that he has examined Mlle. B, who is afflicted with a nervous disease consisting of periods of agitation, motor instability, tics and spasms which are conscious but which she cannot control. These symptoms have been increasing and prevent her from leading a normal social life . . .

Twenty-four hours later the chief physician found these facts:

Afflicted with Neurotic tics that began at the age of ten and became aggravated at the onset of puberty, and further when she began going to work away from home. Intermittent depressions with anxiety, accompanied by a recrudescence of these symptoms. Obsesity. Requests treatment. Feels reassured in company. Assigned to an open ward. Should remain institutionalized.

In his attunement to the interplay of racial archetypography and (rural) metropolitan psychopathology, Frantz Fanon gives access to remainders, both perceived and imperceptible, poised in new musical angles, of the jazz lament and the tom-tom. What if the nervous tic, the involuntary muscular contraction that is exacerbated by the metropole's own migratory exigencies, the trouble of having to leave in order to work and live, were one among other interpretations of a given choreography of racial difference? I have spoken, elsewhere, of how the circle, in Douglass's autobiographical writing, constitutes a border separating interpretive incapacities, of how that constitution is the enactment of an improvisational suspension of interpretation in general and an anticipatory critique of psychoanalytic (or, to be more precise in the case of Fanon, psychotherapeutic) interpretation. Music and movement determine the scene that is, in spite and by way of all protest, a scene, a spectacle. Improvisation emerges at the intersection of the racialized, sexualized beatdown and the phonochoreographic downbeat. The question of which comes first is in perpetual suspense. What it means to enter into a circle or a dance is at stake here. This is to say that the issue is a clinical one. François Tosquelles or, deeper still, Félix Guattari might have imagined the open ward differently, as a band or orchestra. Reassurance is given in the transverse ensemble. Anything is music if it is organized according to certain principles. Latent normativities are troubled by the thought of blackness as a permeable circle of permeable, percussive things in their errant muscularity. There is an annoying intermittence and recrudescence of this liberatory fantasy that liberation is all bound up with fantasy, intermittence, and recrudescence; that blackness is the field or plain of this feel and play, this psychosomatic scene. This young girl's daddy is not rich. The sexual richness of daddy escapes her and Fanon avoids it. But here she is at the Sound Barrier, at the Five Spot, trying to join the circle of the excluded, the sphere of refusal, the gathering underground, on the edge, in the cistern. "'It's especially when I'm working that the tics come.' (The patient was working at a job that entailed her living away from home.)" Certain unguarded expressions arise, as if in response to some music she both hears and plays. "She begins by tapping her feet, and then goes on to raise her feet, her legs, her arms, her shoulders symmetrically" as if caught in the throes of an involuntary conduction, that she enacts, of herself, of the band she is, in these moments of work and stillness, having moved or having been moved. She uttered sounds. It was never possible to understand what she was saying. "This manifestation ended in quite loud, inarticulate cries. As soon as she was spoken to, these stopped."

The psychiatrist in charge decided to employ waking-dream therapy. A preliminary interview had brought out the existence of hallucinations in the form of terrifying circles, and the patient had been asked to describe them. Here is an excerpt from the notes on the first session.

Deep and concentric, the circles expanded and contracted to the rhythm of a Negro tom-tom. This tom-tom made the patient think of the danger of losing her parents, especially her mother.

I then asked her to make the sign of the cross over these circles, but they did not disappear. I told her to take a cloth and rub them out, and they vanished.

She turned in the direction of the tom-tom. She was surrounded by half-naked men and women dancing in a frightening way. I told her not to be afraid to join the dance. She did so. Immediately the appearance of the dancers changed. It was a splendid party. The men and women were well dressed and they were dancing a waltz, *The Snow Star*.

Ain't it funny how the iron system and slipping away from the iron system are both articulated in relation to a blackness that is never fully articulated? The transformation of the negro tom-tom into a waltz not only leaves open the question concerning the location of regulation, of regulatory musical time; it also leaves indeterminate the racial make-up of the dancers and the players. This is not to say that the music of the tom-tom is not to be indexed to blackness; it is, rather, to assert that whatever it is to which the waltz is indexed is appositional, rather than oppositional, to blackness, which is, in the end, a massive enactment of apposition. The waking dream technique required her to join the dance she feared; to disrupt the circle by way of her own irruption into it.

Her treatment demands that she keeps bringing back and entering into her recurrent symptoms of fearful, racialized musical recurrence. She keeps bringing them back so she can enter and break. They come back broken. "She entered them. They broke, rose again, then gently, one after another, fell away into the void. I told her to listen to the tom-tom. She did not hear it. She called to it. She heard it on the left." She is told that an angel will go with her to the tom-tom, repeating with a difference the deployment, in the first session, of the cross. Now, when the angel takes her closer to the tom-tom, a more secure racialization is in place. "There were only black men there, and they were dancing round a large fire and looked evil. The angel asked her what they were going to do; she said they were going to burn a white man. She looked for him everywhere. She could not see him." David Macey points out, in his reading of Fanon's recounting and analysis of this scene, that a mode of therapy is here enacted in which "The material thrown up during the day-dream allows the therapist to provoke new situations so as to observe the subject's affective reactions and gradually to reduce the level of anxiety by releasing tension at both the psychological and physiological level." He adds, "There is no attempt to establish a transference or the relationship that allows the patient to actualize unconscious wishes by projecting them on to the figure of the analyst." However, the absence of any attempt to establish a transference does not mean that one does not emerge only to recede into precisely that indeterminate mode that intimates a transversality beyond transference. Note that the angel who leads her back into the circle as if he were her doctor asks the young woman what "[the black men] were going to do." Note that she finally sees a white man of about fifty years, "half undressed." Note that the black chief says they will burn him because he was from another country. Note that she will later desire the angel to lead her "somewhere where she would really be at home, with her mother, her brothers and her sisters." One can imagine a flurry of interpretive activity in relation to this version. In that flurry, attention would be paid to the specter of anticolonial resistance; to colonial displacement and the disruption of metropolitan domestic space and familial relations; to the actualization of unconscious wishes deferred by techniques that

are shaped by other concerns. Perhaps Fanon's text is best understood as another anticipatory, improvisational disruption of psychoanalytic interpretation. Or perhaps it will emerge, more sharply, as a text that strenuously seeks to avoid its own antinormative implications by locking itself into an interpretive structure that, nevertheless, it cannot help but escape. On the one hand, the avoidance of blackness-as-escape breaks down in Fanon; on the other hand, Fanon insists upon the necessity of disavowing blackness-as-escape.

When the treatment—which consists of voluntarily entering into the symptoms of which she desires a cure—ceases, the symptoms return and so occasion another voluntary entrance into the broken circle that she has to break. While before she had no desire to know the chief, but rather only wanted to be taken home, now she makes an approach, desires to know, lets a negro who had stopped dancing only to resume but in a new rhythm, as if her entrance into the circle required its recalibration, take her hands. Later, in another session, she thinks of the circles again. Some are broken but the smaller ones remain intact: "She wanted to break them. She took them in her hands and bent them, and then they broke. One, however, was still left. She went through it. On the other side she found she was in darkness. But she was not afraid. She called someone and her guardian angel came down, friendly and smiling. He led her to the right, back into the daylight."

What is the nature of this enlightenment which is, after all, temporary and recedes when the patient is alone, withdrawn from her *voluntary* entrance into that turning, returning circle of blackness? It seems to me that Fanon's entire body of work, from the earliest instances of its revolutionary professional unsuitability, is best understood as a slow, tortured approach to this question, prematurely suspended but for the ongoing project of an extended, transverse, improvisation (through, among other things, the opposition of interpretation and reading). Fanon could not suspend this circular approach—that in this case the beat beat beat of the tom-tom instantiates—to the appositional encounter of darkness and light, night and day. Even in his rushed refusal "to elaborate on the infrastructure of this psycho-neurosis," in order to establish that the patient suffered from "a fear of imaginary negroes," Fanon cannot seize the forces set in motion by the interinanimation of blackness and imagination. According to Fanon, the "circles are easily recognizable as a kind of defence mechanism against her hallucinosis," which is to say against her placement within the general hallucinosis that structures the general and unbounded field of colonial relations that would include every determination of what turns out to be radically indetermined metropolitan domesticity. Fanon asserts that the "defence mechanism had taken over without reference to what had brought it on." He adds, "By now it was the circles *alone* that produced the motor reactions: outcries, facial tics, random gesticulation."

My interest in another international, in a politics and publicity that is shaped by the choreophonographic attunements that the violence of diaspora makes possible but does not determine, requires that I try to pay attention to that which Fanon avoids and, paradoxically, begins to illuminate: that the psychic and physical brutality of racialization is scandalously interinanimate with the chance to say, Here's your chance—in this wayward, out-of-round bassline that you still can claim by

imagining—to dance your way out of your constrictions and into some dizzy transversal mood or sphere. Similarly, madness always threatens to offend the reason it constitutes, disrupts, and augments; and obesity, an auto-excessive or invaginative roundness that moves and inspires movement out of all compass, persistently endangers normative health, which is to say wholeness, and the illusion that one's life is one's own. Mingus and the French Lady are one another's instruments. There is a constant duet of interactive thingliness that leaves its disruptive trace on certain clinical decisions, whether in Bellevue (where Mingus checked himself in to try to get at, to prepare to compose, his own internal trio) or in the Saint Ylié hospital in a small town north of Lyon. Is "rotary perception" Mingus's defense against the hallucinatory myth of the negro? Or is it a choreography whose liberatory effect demands precisely his entrance into the hallucinatory field he fears and by which he is constrained? Is this why Mingus ends his book by coming round again to the eccentric cosmological concentricities of a broken trumpeter named Fats Navarro, the one they called Fat Girl? Fred Hopkins speaks of big, fat, round Ray Brown notes. The sound barrier is a floating game. William Parker speaks of the tone world which is a surround held in faith by those for whom the prospects of what Fanon calls "a normal life in society" are doubtful.

To connect with the texts with which I have taken such liberties, see Frantz Fanon, *Black Skin, White Masks*, trans. Charles Lem Markmann (London: Paladin, 1970), 145–48; David Macey, *Frantz Fanon* (New York: Picador USA, 2001), 135–39; and Mingus, *Beneath the Underdog*, 261–63.

44 Thanks to Alice Echols for calling to my attention Bob Dylan's remarks on Joni Mitchell. See Echols, "'The Soul of a Martian': A Conversation with Joni Mitchell," in *Shaky Ground: The Sixties and Its Aftershocks* (New York: Columbia University Press, 2002). Also see John Cohen, "Liner Notes," in Roscoe Holcomb, *An Untamed Sense of Control*, Smithsonian Folkways Recordings, CD 40144, 2003. For more on the sexual politics and aesthetics of the falsetto, see my *In the Break: The Aesthetics of the Black Radical Tradition* (Minneapolis: University of Minnesota Press, 2003), 211–31.

45 Three interventions are in the front of my mind here. Barbara Johnson speaks of "letting the other takes our time" in her "Response" to Henry Louis Gates Jr., "Canon-Formation, Literary History, and the Afro-American Literary Tradition: From the Seen to the Told," in *Afro-American Literary Study in the 1990s*, ed. Houston A. Baker Jr. and Patricia Redmond (Chicago: University of Chicago Press, 1989), 44. Rosalind Krauss speaks of a certain order of the invisible/fantasmatic that Lyotard calls "the matrix," and which is aligned with "a beat, or pulse, or throb . . . that works not only against the formal premises of modernist opticality—the premises that connect the dematerialization of the visual field to the dilated instantaneity or peculiar timelessness of the moment of its perception—but it works as well against . . . the notion that low art, or mass-cultural practice, can be made to serve the ambitions of high art as a kind of denatured accessory, the allegory of a playfulness that high-art practice will have no trouble recuperating and reformulating in its own terms." See her "The Im/pulse to See," in *Vision and Visuality*, ed. Hal Foster (Seattle: Bay Press, 1988), 53–54.

Laura Doyle speaks of another matrix, "the racial matrix of modern fiction and culture" that is manifest in a "universal, race transcending mother complex" that marks and explains the commons, the circle, that modernism disruptively inhabits. See her *Bordering on the Body: The Racial Matrix of Modern Fiction and Culture* (New York: Oxford University Press, 1994), 3.

46 I'm thinking of, in order to think with and against, William Carlos William's beautiful, virulent misprision of New Orleans trumpeter Bunk Johnson's band:

Ol' Bunk's Band
These are men! The gaunt, unfore—sold, the vocal,
blatant, Stand up, stand up! the
slap of a bass-string.
Pick, ping! The horn, the
hollow horn
long drawn out, a hound deep
tone—
Choking, choking! while the
treble reed
races—alone, ripples, screams
slow to fast—
to second to first! These are men!

Drum, drum, drum, drum, drum
drum, drum! The
ancient cry, escaping crapulence
eats through
transcendent—torn, tears, term
town, tense,
turns and backs off whole, leaps
up, stomps down,
rips through! These are men
beneath
whose force the melody limps—
to
proclaim, proclaims—Run and
lie down,
in slow measures, to rest and
not never
need no more! These are men!
Men!

Williams's romance with sound misheard as erect, unforesold command of time is cut by an attunement to the cut, cutting force of proclamations of recline and declining speed. The melodic slowdown is enacted by way of the stomp down, torn terms and turns derived from an old, fugitive cry that speaks against what Williams means it to signify: a national manhood, manifest in a black masculinist musicianship it excludes by fetishizing. Williams offers a prefigurative mirror

image of Mingus's articulations of his own ambivalent technical desire; Williams perceives but cannot admit the maternity Mingus claims and disavows. See *The Collected Poems of William Carlos Williams: Volume II, 1939–1962* (New York: New Directions, 1988), 149–50.

47 The formulation "swing is sound" is that of percussionist Billy Higgins. It is recorded in Ingrid Monson, *Saying Something: Jazz Improvisation and Interaction* (Chicago: University of Chicago Press, 1996), 64. I have mixed it with the phrase *high lonesome sound*, one used by a host of musicians and critics to characterize a sonority essential to music such as Holcomb's. At the risk of explaining away whatever allusive clarity that may have emerged from certain activities of wandering, digging, leaping, leaving, giving up, turning, turning loose, and returning, let me say that I hope the range of reference within which I am trying to operate intimates the complex ensemble to which it is necessary to listen in order really to listen to Mingus and Lord Invader.

48 For more on the motherhood of the rhythm section, see Monson, *Saying Something*, 64–66.

49 Dudley, "Judging 'By the Beat,'" 278.

50 Dudley, "Judging 'By the Beat,'" 279; see Gordon Rohlehr, *Calypso and Society in Pre-Independence Trinidad* (St. Augustine, Trinidad: Gordon Rohlehr, 1990).

51 Consider the American occupation of Trinidad during World War II; or the Caribbean incursion into the New York musical scene after that war; or Lord Invader's own irruption out of Trinidad's second city, San Fernando, into the Carnival tents of Port-of-Spain; or the complicated itinerary of Ornette Coleman—from the impossible origin that Mingus assigns him in the Antilles to his "actual" birthplace in Texas, through Los Angeles, to New York; or Mingus's own migration from (his birthplace, Nogales, Arizona, to) Los Angeles to New York. Lord Invader speaks of "the American social invasion" in dialogue with Alan Lomax at a 1946 concert at New York City's Town Hall recorded as *Calypso at Midnight*, Rounder 11661-1840-2, CD, 1999. David Rudder criticizes rapper Jay-Z for his unauthorized use of scenes from Trinidadian carnival in his music videos and for the increased presence of his music in the Trinidadian cultural milieu, particularly during the carnival season, in "Bigger Pimpin';" see *The Autobiography of the Now*, Lypsoland CD 45692, 2001. For commentary on Rudder's response to Jay-Z, see Harvey Neptune, "Manly Rivalries and Mopsies: Gender, Nationality, and Sexuality in United States-Occupied Trinidad," *Radical History Review* 87 (2003): 90–92.

52 Dudley, "Judging 'By the Beat,'" 284.

53 Charles Keil, "The Theory of Participatory Discrepancies: A Progress Report," *Ethnomusicology* 39, no. 1 (1995): 8, quoted in Dudley, "Judging 'By the Beat,'" 284.

54 See Nahum Dimitri Chandler, "Originary Displacement," *boundary 2* 27 no. 3 (2000): 249–86.

55 See Mary Pat Brady, *Extinct Lands, Temporal Geographies* (Durham, NC: Duke University Press, 2002).

56 See Edward Spicer, *Cycles of Conquest: The Impact of Spain, Mexico and the United States on the Indians of the Southwest, 1533–1960* (Tucson: University of Arizona Press, 1981).

57 See Herman L. Bennett, *Africans in Colonial Mexico: Absolutism, Christianity, and Afro-Creole Consciousness, 1570–1640* (Bloomington: Indiana University Press, 2003); Martha Menchaca, *Recovering History, Constructing Race: The Indian, Black, and White Roots of Mexican Americans* (Austin: University of Texas Press, 2001); and Maria Josefina Saldaña-Portillo, *The Revolutionary Imagination in the Americas and the Age of Development* (Durham, NC: Duke University Press, 2003).

58 See Cedric Robinson, *Black Marxism: The Making of the Black Radical Tradition* (Chapel Hill: University of North Carolina Press, 2000).

59 See Kevin Mulroy, *Freedom on the Border: The Seminole Maroons in Florida, the Indian Territory, Coahuila, and Texas* (Lubbock: Texas Tech University Press), 1993.

60 Robinson, *Black Marxism*, 171.

61 See Brent Hayes Edwards, *The Practice of Diaspora* (Cambridge, MA: Harvard University Press, 2003); Rafael Pérez-Torres, "Refiguring Aztlán," *Aztlán* 22, no. 2 (1997): 15–41; and Genaro Padillo, "Myth and Comparative Cultural Nationalism: The Ideological Uses of Aztlán," in *Aztlán: Essays on the Chicano Homeland*, ed. Rudolfo Anaya and Francisco Lomelí (Albuquerque: University of New Mexico Press, 1989).

62 Neptune, "Manly Rivalries," 78.

63 Lord Invader sings about the putatively emasculating force of U.S. weaponry and U.S. currency in his most famous song "Rum and Coca-Cola," stolen by U.S. comic Morey Amsterdam while in Trinidad entertaining North American troops on a USO tour and turned into a huge hit by the Andrews Sisters in another modality of imperial invasion and occupation. For more on the genealogy of "Rum and Coca-Cola," see Donald R. Hill, *Calypso Calaloo: Early Carnival Music in Trinidad* (Gainesville: University Press of Florida, 1993), 234–40.

64 See Sally Marks, "Black Watch on the Rhine: A Study in Propaganda, Prejudice and Prurience," *European Studies Review* 13, no. 3 (1983): 297–333; and LeRoi Jones (Amiri Baraka), *The System of Dante's Hell* (New York: Grove Press, 1965).

65 See John Cowley, "Liner Notes," in Lord Invader, *Calypso in New York*, 24.

66 Mingus, *Charles Mingus Presents Charles Mingus*, Candid LP 9005, 1960.

67 Samuel R. Delany, "Time Considered as a Helix of Semi-Precious Stones," *Driftglass* (New York: Signet, 1971) 223–59; and LeRoi Jones (Amiri Baraka), *Black Music* (New York: William Morrow, 1967).

68 Lyrics published in Mingus, *More Than a Fake Book* (New York: Jazz Workshop, 1991), 47.

69 Lippit's phrase *inalienable wrong* was uttered during a May 2003 discussion on the work of Gayatri Chakravorty Spivak at the University of California, Irvine's Critical Theory Institute. Recent left critiques of a certain tendency on the left toward attachment to injury and to identities forged in injury take their lead from Wendy Brown, *States of Injury: Power and Freedom in Late Modernity* (Princeton, NJ: Princeton University Press, 1995).

70 Lippit might say it is an archive of shadows. Edwards might say it is an archive of the shadow of shadows. See Lippit, *Atomic Light (Shadow Optics)* (Minneapolis:

University of Minnesota Press, 2006); and Brent Hayes Edwards, "The Shadow of Shadows," *positions: East Asia Cultures Critique* 11, no. 1 (2003): 11–49.

Chapter 7. The Phonographic Mise-En-Scène

1 *Monodrama* is an interesting word. The trajectory of its definition moves from words to which music was meant to correspond and to accentuate toward visual spectacle (which doubles and is meant to be doubled by the music). *Erwartung* recoils from that trajectory and Adorno admires such critical "regression." See Arnold Schoenberg, *Erwartung/Brettl-Lieder*, performed by Jessye Norman, Metropolitan Opera Orchestra, James Levine, Philips 426 621-2 CD, 1993.

2 The definitive account of Adorno's adherence to the ideal of "structural listening" is that of Rose Rosengard Subotnik. See her "Toward a Deconstruction of Structural Listening: A Critique of Schoenberg, Adorno, and Stravinsky," in *Deconstructive Variations: Music and Reason in Western Society* (Minneapolis: University of Minnesota Press, 1996).

3 Theodor Adorno, "Transparencies on Film," trans. Thomas Y. Levin, *New German Critique* 24/25 (fall/winter 1981–82): 204.

4 See Michael Fried, "Art and Objecthood," in *Art and Objecthood: Essays and Reviews*, 148–72 (Chicago: University of Chicago Press, 1998).

5 Miriam B. Hansen, "Introduction to Adorno, 'Transparencies on Film' (1966)," *New German Critique* 24/25 (fall/winter 1981–82): 188n5.

6 I am working, here, under the influence of Avery Gordon's formulation of the animaterial and Akira Mizuta Lippit's notion of the animetaphor. See Avery F. Gordon, *Ghostly Matters: Haunting and the Sociological Imagination* (Minneapolis: University of Minnesota Press, 1997); and Akira Mizuta Lippit, *Electric Animal: Toward a Rhetoric of Wildlife* (Minneapolis: University of Minnesota Press, 2000).

7 Theodor Adorno, "The Form of the Phonograph Record," trans. Thomas Y. Levin, *October* 55 (winter 1990): 59. See also Adorno, "The Natural History of the Theatre," in *Quasi una Fantasia: Essays on Modern Music*, trans. Rodney Livingstone, 65–78 (New York: Verso, 1992).

8 Subotnik, "Toward a Deconstruction of Structural Listening," 161.

9 Arnold Schoenberg, *Style and Idea*, ed. Leonard Stein, trans. Leo Black (Berkeley: University of California Press, 1975), 105.

10 Theodor Adorno, *Philosophy of Modern Music*, trans. Anne G. Mitchell and Wesley V. Blomster (New York: Continuum, 1973).

11 Subotnik, "Toward a Deconstruction of Structural Listening," 150.

12 Susan McClary, *Feminine Endings: Music, Gender, and Sexuality* (Minneapolis: University of Minnesota Press, 1991), 12.

13 Theodor Adorno, "The Curves of the Needle," trans. Thomas Y. Levin, *October* 55 (winter 1990): 49–50.

14 Adorno, "The Form of the Phonograph Record," 58. See also Adorno, "The Curves of the Needle," 51.

15 Adorno, "The Curves of the Needle," 50.

16 Adorno, "The Curves of the Needle," 54.

17 Adorno, "The Curves of the Needle," 54.
18 Adorno, "Opera and the Long-Playing Record," trans. Thomas Y. Levin, *October* 55 (winter 1990): 63.
19 Adorno, "Opera and the Long-Playing Record," 64.
20 Adorno, "Opera and the Long-Playing Record," 64–65. For an excellent overview of and introduction to the three articles by Adorno I have just discussed, see Thomas Y. Levin, "For the Record: Adorno on Music in the Age of Its Technological Reproducibility," *October* 55 (winter 1990): 23–47.
21 Adorno, *Philosophy of Modern Music*, 43.
22 Adorno, *Philosophy of Modern Music*, 47.
23 See Schoenberg, *Style and Idea*, 84, 91, 216–17.
24 Charles Rosen, *Arnold Schoenberg* (Chicago: University of Chicago Press, 1996), 24–25.
25 See Saidiya V. Hartman, *Scenes of Subjection: Terror, Slavery, and Self-Making in Nineteenth-Century America* (New York: Oxford University Press, 1997).
26 Theodor Adorno, *Beethoven: The Philosophy of Music*, ed. Rolf Tiedemann, trans. Edmund Jephcott (Stanford, CA: Stanford University Press, 1998), 44.
27 Sandra L. Richards, "Writing the Absent Potential: Drama, Performance, and the Canon of African-American Literature," in *Performance and Performativity*, ed. Andrew Parker and Eve Kosofsky Sedgwick (New York: Routledge, 1995), 83.
28 Richards, "Writing the Absent Potential," 83.
29 Cedric Robinson, *Black Marxism: The Making of the Black Radical Tradition* (Chapel Hill: University of North Carolina Press, 2000), 171.
30 For more on the "black sound" in operatic and concert performance, see Rosalyn M. Story, *And So I Sing: African-American Divas of Opera and Concert* (New York: Amistad Press, 1990), 184–86.
31 Theodor Adorno, "On Jazz," trans. Jaime Owen Daniel, *Discourse* 12, no. 1 (1989–90): 53–54.
32 Adorno, "The Natural History of the Theatre," 66.

Chapter 8. Liner Notes for *Lick Piece*

Epigraph: Benjamin Patterson, *Methods and Processes*, 2nd ed. (Tokyo: Gallery 360°, 2004).

1 Rebecca Schneider, *The Explicit Body in Performance* (New York: Routledge, 1997), 31.
2 Letty Lou Eisenhauer, "A Version of Trace in 2008; An Interpretation of Scores," in *Fluxus Scores and Instructions: The Transformative Years*, ed. Jon Hendricks, with Marianne Bech and Media Farzin (Roskilde, Denmark: Museet for Samtidskunst, 2008), 33–34.
3 Philip Auslander, "Fluxus Art-Amusement: The Music of the Future?" in *Contours of the Theatrical Avant-Garde: Performance and Textuality*, ed. James M. Harding, 110–29 (Ann Arbor: University of Michigan Press, 2000).
4 Certain iconic moments in nineteenth-century French art seem intent on playing this out in a range of inadequate modular calculations—*Olympia* is one instance,

Carmen's Afro-Cuban/Afro-Romani thing is another. This is something Jennifer DeVere Brody illuminates with great precision. See "Black Cat Fever: Manifestations of Manet's *Olympia*," *Theatre Journal* 53, no. 1 (2001): 95–118.

5 See Schneider, *The Explicit Body*, 189n24.

6 Benjamin Patterson, "What Makes George Laugh?" in *Mr. Fluxus: A Collective Portrait of George Maciunas, 1931–1978*, ed. Emmett Williams and Ann Noël, 260–63 (London: Thames and Hudson, 1997).

7 Giorgio Agamben, *Means without End: Notes on Politics*, trans. Vincenzo Binetti and Cesare Casarino (Minneapolis: University of Minnesota Press, 2000), 56.

8 Bertolt Brecht, "The Modern Theatre Is the Epic Theatre (Notes to the Opera *Aufstieg und Fall der Stadt Mahagonny*)," in *Brecht on Theatre: The Development of an Aesthetic*, ed. and trans. John Willett, 39–40 (New York: Hill and Wang, 1964).

9 *Tristan and Isolde* and *Carmen* were performed at the Asolo Film Festival XXVI on November 22 and 23, 2007, respectively. Excerpts from *Carmen* last accessed August 18, 2010, at www.youtube.com/watch?v=4XStjkF2hC0&feature=related. *Tristan and Isolde* last accessed August 18, 2010, at www.youtube.com/watch?v=tKJhWR96MIc&feature=related.

10 Adrian Piper, "Critical Hegemony and Aesthetic Acculturation," *Nous* 19, no. 1 (1985): 29–40.

Chapter 9. Rough Americana

1 DJ Mutamassik & Morgan Craft, *Rough Americana*, Circle of Light COL 002 CD, 2003.

Chapter 10. Nothing, Everything

1 See Dianne Swann-Wright, *A Way Out of No Way: Claiming Family and Freedom in the New South* (Charlottesville: University of Virginia Press, 2002); and Deborah E. McDowell, *Leaving Pipe Shop: Memories of Kin* (New York: W. W. Norton, 1998).

Chapter 11. Nowhere, Everywhere

1 Theaster Gates, Glass Lantern Slide Archive Relocation, August 7, 2012, theastergates.com.

2 M. NourbeSe Philip, *Zong* (Middletown, CT: Wesleyan University Press, 2008), 203.

3 Reading by M. NourbeSe Philip at Duke University, Durham, North Carolina, April 19, 2012.

4 Lorna Goodison, *Guinea Woman: New and Selected Poems* (Manchester, UK: Carcanet Press, 2000), 24; David Kazanjian, *The Colonizing Trick: National Culture and Imperial Citizenship in Early America* (Minneapolis: University of Minnesota Press, 2003), 33–88; Little Walter, *The Complete Chess Masters (1950–1967)* (B001RLD6AM), Hip-O Records, 5 compact discs, 2009.

5 Burning Spear, *Marcus Garvey* (ILPS 9377), Island Records, CD, 1975.

6 Reading by Philip at Duke University.

7 Steven Feld, "From Ethnomusicology to Echo-Muse-Ecology: Reading R. Murray Schafer in Papua New Guinea," *The Soundscape Newsletter/World Forum for Acoustic Ecology* 8 (June 1994): 4–6; Steven Feld, *Jazz Cosmopolitanism in Accra: Five Musical Years in Ghana* (Durham, NC: Duke University Press, 2012).

8 Thanks to Lynne Feeley for this insight.

9 Maurice Wallace, *Constructing the Black Masculine: Identity and Ideality in African American Men's Literature and Culture, 1775–1995* (Durham, NC: Duke University Press, 2002).

10 Bertolt Brecht, quoted in Martin Jay, *Permanent Exiles: Essays on the Intellectual Migration from Germany to America* (New York: Columbia University Press, 1986), 28.

11 Permit me to mention two outstanding examples: Deborah A. Thomas, *Modern Blackness: Nationalism, Globalization, and the Politics of Culture in Jamaica* (Durham, NC: Duke University Press, 2004); Michelle M. Wright, *Becoming Black: Creating Identity in the African Diaspora* (Durham, NC: Duke University Press, 2004).

12 Paul Gilroy, *Darker Than Blue: On the Moral Economies of Black Atlantic Culture* (Cambridge, MA: Harvard University Press, 2010), 5.

13 Gilroy, *Darker Than Blue*, 171.

14 Gilroy, *Darker Than Blue*, 176, 175.

15 Tavia Nyong'o, "So Say We All," *Social Text Online*, January 4, 2012, socialtextjournal.org/periscope_article/so_say_we_all/.

16 Theaster Gates, "Thinking about Language and Things That Matter," pers. comm., June 27, 2012.

17 Gates, "Thinking about Language."

18 Gilroy, *Darker Than Blue*, 5.

19 Gilroy, *Darker Than Blue*, 5.

20 Gilroy, *Darker Than Blue*, 5.

Chapter 14. Amuse-Bouche

1 This passage is from notes taken during a presentation by Abbey Lincoln at the Ford Foundation Jazz Study Group, Columbia University, November 1999.

2 Samuel R. Delany, "The Tale of Old Venn," in *Tales of Nevèrÿon* (Middletown, CT: Wesleyan University Press, 1993), 121.

3 Chris Funkhouser, "Being Matter Ignited: An Interview with Cecil Taylor," *Hambone* 12 (1999): 18–19.

4 Denise Ferreira da Silva, "No-Bodies: Law, Raciality and Violence," *Griffith Law Review* 18, no. 2 (2009): 212–36.

5 Samuel R. Delany, "Atlantis: Model 1924," in *Atlantis: Three Tales* (Middletown, CT: Wesleyan University Press, 1995), 8.

6 Cecil Taylor, "Sound Structure of Subculture Becoming Major Breath/Naked Fire Gesture," liner notes, *Unit Structures*, LP 84237. Blue Note, 1966.

7 Buell Neidlinger, quoted in A. B. Spellman, *Four Lives in the Bebop Business* (New York: Limelight Editions, 1985), 45.

8 Cecil Taylor, quoted in Spellman, *Four Lives*, 53.

9 Taylor, quoted in Spellman, *Four Lives*, 44–45.

10 Spellman, *Four Lives*, 42.

11 Neidlinger, quoted in Spellman, *Four Lives*, 46.

12 Delany, *The Motion of Light in Water*, 6.

13 Delany, *The Motion of Light in Water*, 13.

14 Delany, *The Motion of Light in Water*, 149.

15 Neidlinger, quoted in Spellman, *Four Lives*, 36–37.

16 Samuel R. Delany, "The Tale of Fog and Granite," in *Flight from Nevèrÿon* (Middletown, CT: Wesleyan University Press, 1994), 30–31.

17 Samuel R. Delany, "The Tale of Plagues and Carnivals, or: Some Informal Remarks towards the Modular Calculus, Part Five," in *Flight from Nevèrÿon*, 183.

Chapter 15. Collective Head

1 Karl Marx, *Grundrisse: Foundations of the Critique of Political Economy*, trans. Martin Nicolaus (New York: Vintage, 1973), 483, 487.

2 See José Gil, *Metamorphoses of the Body*, trans. Stephen Muecke (Minneapolis: University of Minnesota Press, 1998); Kevin Lynch, *The Image of the City* (Cambridge: MIT Press, 1960); and Samuel R. Delany, *Neveryóna* (New York: Bantam, 1983); and *The Motion of Light in Water: Sex and Science Fiction Writing in the East Village* (Minneapolis: University of Minnesota Press, 2004).

3 Masao Miyoshi, "Outside Architecture," in *Anywise*, ed. Cynthia C. Davidson (Cambridge, MA: MIT Press, 1996), 44.

4 Miyoshi, "Outside Architecture," 45.

5 Miyoshi, "Outside Architecture," 47.

6 José Esteban Muñoz, "Gesture, Ephemera and Queer Feeling: Approaching Kevin Aviance," in *Cruising Utopia: The Then and There of Queer Futurity* (New York: New York University Press, 2009), 78.

7 Muñoz, "Gesture, Ephemera and Queer Feeling," 74.

8 Masao Miyoshi, "A Borderless World? From Colonialism to Transnationalism over the Decline of the Nation-State," in *Politics-Poetics: Documenta X—the Book*, ed. Jean-François Chevrier (Kassel, DE: Cantz, 1997), 182–202. Originally published in *Critical Inquiry* 19, no. 4 (1993): 726–51.

9 André Lepecki, "Affective Geometry, Immanent Acts: Lygia Clark and Performance," in *Lygia Clark: The Abandonment of Art, 1948-1988*, ed. Cornelia Butler and Luis Pérez-Oramas, 279 (New York: Museum of Modern Art, 2014). See also Eleonora Fabião, "The Making of a Body: Lygia Clark's *Anthropophagic Slobber*," and Antonio Sergio Bessa, "Word-Drool: The Constructive Secretions of Lygia Clark," in *Lygia Clark: The Abandonment of Art*, 294–99 and 301–5.

10 Lepecki, "Affective Geometry, Immanent Acts," 282. See also Denise Ferreira da Silva, "No-Bodies: Law, Raciality and Violence," *Griffith Law Review* 18 (2009): 212–36.

11 Miyoshi, "A Borderless World?," 202.

12 Randy Martin, *Financialization of Daily Life* (Philadelphia: Temple University Press, 2002).

Chapter 16. Cornered, Taken, Made to Leave

1 Johanna Burton, "Cultural Interference," in Johanna Burton and Anne Ellegood, *Take It or Leave It: Institution, Image, Ideology* (New York: Prestel, 2014), 15.
2 Darby English, "Good Fences," in Burton and Ellegood, *Take It or Leave It*, 240.
3 Paul Guyer, *Kant and the Claims of Taste*, 2nd ed. (Cambridge: Cambridge University Press, 1997), 7.
4 Ludwig Wittgenstein, *Philosophical Occasions, 1912–1951*, ed. James Klagge and Alfred Nordmann (Indianapolis: Hackett, 1993), 356. Quoted in Klagge, *Wittgenstein in Exile* (Cambridge, MA: MIT Press, 2014), 32.
5 Ludwig Wittgenstein, *Wittgenstein's Lectures on Philosophical Psychology, 1946–1947*, ed. P. T. Geach, with notes by P. T. Geach, K. J. Shah, and A. C. Jackson (Chicago: University of Chicago Press, 1988), 17. Quoted in Klagge, *Wittgenstein in Exile*, 32.

Chapter 19. To Feel, to Feel More, to Feel More Than

1 Ralph Ellison, *Invisible Man*, 2nd ed. (New York: Vintage International, 1995), 7–8, 341, 344–45.

Chapter 20. Irruptions and Incoherences for Jimmie Durham

1 Jimmie Durham, "The Immortal State," in *A Certain Lack of Coherence: Writings on Art and Cultural Politics* (New York: Kala Press, 1993), 191–92. See also Durham, "A Friend of Mine Said That Art Is a European Invention," in *Jimmie Durham*, ed. Dirk Snauwaert, Laura Mulvey, Mark Alice Durant, and Jimmie Durham (New York: Phaidon Press, 1995), 140–47.
2 Jimmie Durham, "Artists *Must* Begin Helping Themselves," in *A Certain Lack of Coherence*, 62.
3 Wallace Stevens, "The Poems of Our Climate," in *The Collected Poems: The Corrected Edition* (New York: Vintage, 2015), 206.
4 Jimmie Durham, "Material," in *Waiting to Be Interrupted: Selected Writings, 1993–2012* (Milan: Mousse Publishing, 2014), 351–55.
5 Jimmie Durham, "Interview: Dirk Snauwaert in Conversation with Jimmie Durham," in *Waiting to Be Interrupted*, 25.
6 Durham, "Interview," 9.
7 Durham, "Interview," 10.

Chapter 21. Black and Blue on White. In and And in Space.

1 Steve Cannon, "David Hammons: Concerto in Black and Blue," *A Gathering of the Tribes*, July 2, 2001, www.tribes.org/web/2001/07/02/david-hammons-concerto-in-black-and-blue.

Chapter 22. Blue Vespers

1 This essay began as a series of letters to Alicia Ritson, written in preparation for a lecture delivered at the New Museum of Contemporary Art, January 29, 2015. It's dedicated to her as it wouldn't have come about without her arrangement and without the occasion of what I have to call, but hopefully just for a minute, in the spirit of complementarity, and with my complements to Alicia, her "address." There are three other friends/mentors who are here but not really or who aren't here but really are and whom I want to invoke from the start. Nahum Dimitri Chandler's work is one of the foundations upon which I'm trying to stand and move. The key term he has given us is *paraontology*, something that comes out of his deep reading of Du Bois and Fanon. If you recall, in *Black Skin, White Masks*, when Fanon says, "The black man has no ontological resistance in the eyes of the white man," then where Chandler comes in is in making it possible for one to say, with indirect precision (more + less than vis-à-vis Fanon, always in Du Bois's general buzz), that, in fact, blackness offers paraontological resistance to whiteness which it brings into existence by way of that resistance. Fanon is anxious about the capacity of the black man to be which is, for him, always to be in relation. But Chandler makes it possible to relinquish that anxiety in a perilous operation that allows and requires us to disavow the desire to be (in relation). It seems impossible not to ask—paradoxically, and with great technical imprecision—well, what else is there? "Is" is under a general erasure whose gestural analog is not the "scare quote" finger curl but rather the aggressively self-inflicted throat-slash. One of the implications of Chandler's work is that such a gesture is all we ought to give to is. And if, moreover, being is only insofar as it is in relation then we have to put that term under the sign of the cut as well. Now the way that plays itself out is in an ongoing concern with (what is [not in]) between." This is from the third page of *X: The Problem of the Negro as a Problem for Thought*:

> The very first word of this first paragraph of [*The*] *Souls* [*of Black Folk*], the word *between*, inaugurates itself as and according to a kind of logic. The word *between* could present itself, recalling certain semantic sedimentations, as both defining and defined by an opposition, as producing and produced by an oppositional logic. Such a logic would presuppose or intend the possibility that a distinction could be made radical: either/or, all *or* nothing: without remainder (Aristotle's law of contradiction or noncontradiction). The *word* "between" could, in the case of an oppositional coherence, on the one hand, appear (as explicit theme or proposition and implicit metaphor) as that very thing which separates the one and the other, "me and the other"; appearing to offer them *its* own coherence as their possibility. As presented, "Between me and the other world there is . . . ," this oppositional determination of the *word* "between" is precisely the propositional theme of this sentence. And, I would suggest, this thematized oppositional positioning communicates with a formal aspect. By one entire aspect of its grammar, according to its function as a preposition, this *word* appears as that quite solid structure which gives the referent for this prepositional phrase,

"*me* and the other," its specific and determining sense. It would, on the other hand, by the (unavoidable) structure of its enunciation, assume its own predication: "there," "there is," "is ever." The verb seems to explicitly thematize its capacity to predicate sense (redoubled, if you will, since this is just the *word* "being" folded into the precomprehension of being): it is the third person singular of the present indicative of the verb "to be." This stable solid structure that is presented as the word *between* would authorize the movement of an oppositional logic and a reading of it as radical.

In Chandler's wake and hum, recognizing that de-authorization is neither the point nor the path, I am concerned with what is not in between us, or with the nothing that lies between us. The words that have come to stand in for that, in the wake of Chris Ofili's work, the appositional (r)enunciations that displace being in relation and that dislocate being in "the *word* 'between,'" are blue, black, *blur*. The word my friend Denise Ferreira da Silva here, not here, would use, by way of her immersive formation of a discourse at the intersection of liberation theology, quantum mechanics, tarot and black radicalism, is entanglement, which she further elaborates as difference without separation: again, blue, black, *blur*. My third friend is more severely differentiated from us, within us, while remaining inseparable from us. His name is Randy Martin and he passed away on January 28, 2015. He's here, though; I would like to say that he visited me that next morning when I revisited the museum's third floor to lose myself in the contact improvisation that is, and that are—neither verb being adequate insofar as they are verbs of being in/as adequation—*The Blue Rider*. Anyway, in the general imbalance, we're not alone, we're not all one, which is a condition that induces prayer.

2 Ralph Ellison, *Invisible Man*, 2nd ed. (New York: Vintage International, 1995), 8.

3 Frantz Fanon, *Wretched of the Earth*, trans. Richard Philcox (New York: Grove Press, 2005), 176.

4 Johann Wolfgang von Goethe, *Theory of Colours*, trans. Charles L. Eastlake (Mineola, NY: Dover, 2006), 126. Quoted in Glenn Ligon, "Blue Black," in *Chris Ofili: Night and Day*, ed. Massimiliano Gioni (New York: Rizzoli, 2014), 87.

5 Ligon, "Blue Black," 82.

6 Maggie Nelson, *Bluets* (Seattle: Wave Books, 2009), 54.

7 Earl Lovelace, *The Dragon Can't Dance* (New York: Persea Books, [1979] 1998), 35–36.

8 Judith Butler, *The Psychic Life of Power: Theories of Subjection* (Stanford, CA: Stanford University Press, 1997), 123–24.

9 Friedrich Hölderlin, *Hymns and Fragments*, trans. Richard Sieburth (Princeton, NJ: Princeton University Press, 1984), 249.

10 Attendance to (not) (in) between is as devotional as it is historical: *blue is (not) (in) between Ofili and Tshibumba.*

11 Butler, *The Psychic Life of Power*, 92.

12 Butler, *The Psychic Life of Power*, 131.

13 Butler, *The Psychic Life of Power*, 131.

14 T. J. Clark, "World of Faces," *London Review of Books*, December 4, 2014, 16.

15 Clark, "World of Faces," 17.

16 Judith Butler, *Precarious Life: The Powers of Mourning and Violence* (New York: Verso, 2006), 25.

17 Butler, *Precarious Life*, 130.

18 Erica Hunt, "All About You," *Los Angeles Review of Books*, December 8, 2014, lareviewofbooks.org/article/all-about-you/.

19 Claudia Rankine, *Citizen: An American Lyric* (Minneapolis, MN: Graywolf Press, 2014), 73.

20 See Michael Fried, *Absorption and Theatricality: Painting and Beholder in the Age of Diderot* (Berkeley: University of California Press, 1980).

Chapter 23. The Blur and Breathe Books

1 Stokely Carmichael, "Speech given at Garfield High School, Seattle, Washington, April 19, 1967," *African-American Involvement in the Vietnam War: Speeches and Sounds*, www.aavw.org/special_features/speeches_speech_carmichael01.html.

2 Consider, for instance, that one of the primary effects for black people in the United States of the election of Barack Obama to the presidency, which was widely, if temporarily, hailed as the moment of our fuller emergence into self-determination, has been the periodic reprise, from the bulliest of pulpits, of a certain self-condemnatory rhetoric regarding inadequate black father-hood, or intractable black-on-black violence that marks inclusion into the relay of shame and exaltation that is the citizen subject's proper enactment and inhabitation.

3 Emmanuel Levinas, "Interview with Francis Poiré," in *Is It Righteous to Be? Interviews with Emmanuel Levinas*, ed. Jill Robbins (Stanford, CA: Stanford University Press, 2001), 64–65.

4 Mark Swed, "Music Review: L. A. Philharmonic Shines with 'La Vida Breve,'" *Los Angeles Times*, November 9, 2012, articles.latimes.com/2012/nov/09 /entertainment/la-et-cm-la-phil-review-20121110.

5 Of course, I'm thinking, here, (by way) of Avery Gordon's indispensable *Ghostly Matters* (Minneapolis: University of Minnesota Press, 1997).

6 Laura U. Marks, *The Skin of the Film: Intercultural Cinema, Embodiment, and the Senses* (Durham, NC: Duke University Press, 2000).

7 Charles Gaines, "The Theater of Refusal: Black Art and Mainstream Criticism," in *The Theater of Refusal: Black Art and Mainstream Criticism*, ed. Catherine Lord, 13 (Irvine: Fine Arts Gallery, University of California, Irvine, 1993).

8 Gaines, "The Theater of Refusal," 14.

9 Gaines, "The Theater of Refusal," 20.

10 Marshall Sahlins, *What Kinship Is—and Is Not* (Chicago: University of Chicago Press, 2013), 19. I thank Edgar Garcia for generously bringing this text to my attention.

11 I am thinking of Charles Gaines, *Librettos: Manuel de Falla/Stokeley Carmichael*, an installation shown at the gallery Art + Practice in Leimert Park, Los Angeles.

See hammer.ucla.edu/exhibitions/2015/off-site-exhibition-charles-gaines-librettos
-manuel-de-falla-stokely-carmichael/.

12 See Toni Morrison, "The Site of Memory," in Morrison, *What Moves at the Margin:
Selected Nonfiction*, ed. Carolyn C. Denard (Jackson: University Press of Missis-
sippi), 65–80.

13 Gaines, "The Theater of Refusal," 20.

14 Gaines, "The Theater of Refusal," 12.

15 Samuel R. Delany, *The Motion of Light in Water: Sex and Science Fiction Writing
in the East Village* (Minneapolis: University of Minnesota Press, 2004), 291–92.

16 Delany, *The Motion of Light in Water: Sex and Science Fiction Writing in the East
Village, 1957–1965* (New York: Plume, 1988).

17 Delany, *The Motion of Light in Water* (1988), 148.

18 Marilyn Hacker, *First Cities: Collected Early Poems 1960–1979* (New York: W. W.
Norton, 2003), 160–61.

19 Hacker, *First Cities*, 163–64.

20 Samuel R. Delany, *The American Shore: Meditations on a Tale of Science Fiction by
Thomas M. Disch—"Angouelme"* (Middletown, CT: Wesleyan University Press, 2014).

21 José Esteban Muñoz, "Phenomenological Flights: From Latino over There and
Cubania's Here and Now," unpublished manuscript, 2.

22 Muñoz, "Phenomenological Flights," 4–5.

23 Muñoz, "Phenomenological Flights," 6.

Chapter 24. Entanglement and Virtuosity

1 Eric B & Rakim, "I Know You Got Soul," *Paid in Full*, 4th and Broadway, BWAY-
4005, LP, 1987.

2 Gayatri Chakravorty Spivak, "Righting Wrongs," *South Atlantic Quarterly* 103,
no. 2/3 (spring/summer 2004): 526.

3 Dancer and choreographer K. K. Roberts once spoke to me, with regard to Cecil
Taylor's music, of an "endless suddenness" that "reinforces one's desire to hear
things differently."

4 Adam Shatz, "Kamasi Washington's Giant Step," *New York Times Magazine*, Janu-
ary 21, 2016, www.nytimes.com/2016/01/24/magazine/kamasi-washingtons-giant
-step.html, paragraph 36.

5 Hear her *Listening in Detail: Performances of Cuban Music* (Durham, NC: Duke
University Press, 2013).

6 See Hortense J. Spillers, "The Crisis of the Negro Intellectual: A Post-date," in
Black and White and In Color: Essays on American Literature and Culture (Chi-
cago: University of Chicago Press, 2003), 460.

Chapter 25. Bobby Lee's Hands

1 This writing is indebted and seeks to respond to two films, each of which contain
a scene, a view, of an extraordinary force that, in these particular manifestations,
is known as Bobby Lee, an inveterate sociality in defiance of portraiture. The

films are *American Revolution 2* (1969), codirected by Mike Gray and Howard Alk for The Film Group, and Mike Gray's *The Organizer: A Preview of a Work in Progress* (2007). They are both to be found on Facets Video DV 86930, 2007. This writing is in memory of Robert E. Lee III, December 16, 1942–March 21, 2017.

WORKS CITED

Acosta, Oscar Zeta. *The Revolt of the Cockroach People.* New York: Vintage, 1989.

Adorno, Theodor. *Aesthetic Theory.* Translated by Robert Hullot-Kentor. Minneapolis: University of Minnesota Press, 1997.

———. "Bach Defended against His Devotees." In *Prisms*, translated by Samuel and Shierry Weber, 133–46. Cambridge, MA: MIT Press, 1981.

———. *Beethoven: The Philosophy of Music.* Edited by Rolf Tiedemann. Translated by Edmund Jephcott. Stanford, CA: Stanford University Press, 1998.

———. "The Curves of the Needle." Translated by Thomas Y. Levin. *October* 55 (winter 1990): 48–55.

———. "The Form of the Phonograph Record." Translated by Thomas Y. Levin. *October* 55 (winter 1990): 56–61.

———. "The Function of Counterpoint in New Music." In *Sound Figures*, translated by Rodney Livingstone, 123–44. Stanford, CA: Stanford University Press, 1999.

———. "Little Heresy." Translated by Susan H. Gillespie. In *Essays on Music*, selected, with introduction, commentary, and notes by Richard Leppert, 318–24. Berkeley: University of California Press, 2002.

———. "The Natural History of the Theatre." In *Quasi Una Fantasia: Essays on Modern Music*, translated by Rodney Livingstone, 65–78. New York: Verso, 1992.

———. *Negative Dialectics.* Translated by E. B. Ashton. New York: Continuum, 1972.

———. "On Jazz." Translated by Jaime Owen Daniel. *Discourse* 12, no. 1 (1989–90): 45–69.

———. "On Some Relationships between Music and Painting." Translated by Susan Gillespie. *Musical Quarterly* 79, no. 1 (1995): 66–79.

———. "On the Fetish-Character in Music and the Regression of Listening," In *Essays on Music*, selected, with introduction, commentary, and notes by Richard Leppert, 288–317. Berkeley: University of California Press, 2002.

———. "Opera and the Long-Playing Record." Translated by Thomas Y. Levin. *October* 55 (winter 1990): 62–66.

———. *Philosophy of Modern Music.* Translated by Anne G. Mitchell and Wesley V. Blomster. New York: Continuum, 1973.

———. "The Radio Symphony." Translated by Susan H. Gillespie. In *Essays on Music*, selected, with introduction, commentary, and notes by Richard Leppert, 251–70. Berkeley: University of California Press, 2002.

———. "Transparencies on Film." Translated by Thomas Y. Levin. *New German Critique* 24/25 (fall–winter 1981–82): 199–205.

Agamben, Giorgio. *Means without End: Notes on Politics.* Translated by Vincenzo Binetti and Cesare Casarino. Minneapolis: University of Minnesota Press, 2000.

Althusser, Louis. "Cremonini, Painter of the Abstract." In *Lenin and Philosophy*, translated by Ben Brewster, 229–42. New York: Monthly Review Press, 1971.

Auslander, Philip. "Fluxus Art-Amusement: The Music of the Future?" In *Contours of the Theatrical Avant-Garde: Performance and Textuality*, edited by James M. Harding, 110–29. Ann Arbor: University of Michigan Press, 2000.

Barenboim, Daniel, and Edward Said. *Parallels and Paradoxes: Explorations in Music and Society.* New York: Pantheon, 2002.

Bennett, Herman L. *Africans in Colonial Mexico: Absolutism, Christianity, and Afro-Creole Consciousness, 1570–1640.* Bloomington: Indiana University Press, 2003.

Bernstein, Leonard. "The Truth about a Legend." In *Glenn Gould Variations: By Himself and His Friends*, edited by John McGreevy, 17–22. Toronto: Doubleday Canada, 1983.

Bessa, Antonio Sergio. "Word-Drool: The Constructive Secretions of Lygia Clark." In *Lygia Clark: The Abandonment of Art*, edited by Cornelia Butler and Luis Pérez-Oramas, 301–5. New York: Museum of Modern Art, 2014.

Blom, Eric. *The New Everyman Dictionary of Music.* 6th ed. Revised and edited by David Cummings. New York: Grove Weidenfeld, [1958] 1988.

Brady, Mary Pat. *Extinct Lands, Temporal Geographies.* Durham, NC: Duke University Press, 2002.

Brecht, Bertolt. "The Modern Theatre Is the Epic Theatre (Notes to the Opera *Aufstieg und Fall der Stadt Mahagonny*)." In *Brecht on Theatre: The Development of an Aesthetic*, edited and translated by John Willett, 33–43. New York: Hill and Wang, 1964.

Brody, Jennifer DeVere. "Black Cat Fever: Manifestations of Manet's *Olympia*." *Theatre Journal* 53, no. 1 (2001): 95–118.

Brooks, Daphne A. *Bodies in Dissent: Spectacular Performances of Race and Freedom, 1850–1910.* Durham, NC: Duke University Press, 2006.

Brown, Wendy. *States of Injury: Power and Freedom in Late Modernity.* Princeton, NJ: Princeton University Press, 1995.

Burning Spear. *Marcus Garvey.* Island Records ILPS 9377, CD, 1975.

Burton, Johanna. "Cultural Interference: The Reunion of Appropriation and Institutional Critique." In *Take It or Leave It: Institution, Image, Ideology*, edited by Anne Ellegood and Johanna Burton, 15–23. New York: Prestel, 2014.

Butler, Judith. *Precarious Life: The Powers of Mourning and Violence.* New York: Verso, 2006.

———. *The Psychic Life of Power: Theories of Subjection.* Stanford, CA: Stanford University Press, 1997.

Cannon, Steve. "David Hammons: Concerto in Black and Blue." http://www.tribes.org/web/2001/07/02/david-hammons-concerto-in-black-and-blue.

Carby, Hazel R. *Race Men.* Cambridge, MA: Harvard University Press, 2000.

Carmichael, Stokely. "Speech given at Garfield High School, Seattle, Washington, April 19, 1967," *African-American Involvement in the Vietnam War: Speeches and Sounds*, www.aavw.org/special_features/speeches_speech_carmichael01.html.

Cervenak, Sarah. *Wandering: Philosophical Performances of Racial and Sexual Freedom.* Durham, NC: Duke University Press, 2014.

Chandler, Nahum Dimitri. "Originary Displacement." *boundary 2* 27, no. 3 (2000): 249–86.

———. *X: The Problem of the Negro as a Problem for Thought.* New York: Fordham University Press, 2013.

Clark, T. J. *The Painting of Modern Life: Paris in the Era of Manet and His Followers.* Princeton, NJ: Princeton University Press, 1984.

Clouzet, Jean, and Guy Kopelowicz. "*Interview de Charles Mingus: Un Inconfortable Après-midi.*" *Jazz*, June 1964, 26–32.

Cohen, John. "Liner Notes." In *An Untamed Sense of Control*, by Roscoe Holscomb. Smithsonian Folkways Recordings, CD 40144, 2003.

Cott, Jonathan. *Conversations with Glenn Gould.* Boston: Little, Brown, 1984.

Davis, Miles. "The Buzzard Song," *Porgy and Bess*, orchestra dir. Gil Evans, Columbia Cl 1274, LP, 1958.

Delany, Samuel R. *The American Shore: Meditations on a Tale of Science Fiction by Thomas M. Disch—"Angouelme."* Middletown, CT: Wesleyan University Press, 2014.

———. "Atlantis: Model 1924." In *Atlantis: Three Tales*, 1–121. Middletown, CT: Wesleyan University Press, 1995.

———. *The Motion of Light in Water: Sex and Science Fiction Writing in the East Village.* Minneapolis: University of Minnesota Press, 2004.

———. *The Motion of Light in Water: Sex and Science Fiction Writing in the East Village, 1957–1965.* New York: Plume, 1988.

———. *Neveryóna.* New York: Bantam, 1983.

———. "The Tale of Fog and Granite." In *Flight from Nevèrÿon*, 11–133. Middletown, CT: Wesleyan University Press, 1994.

———. "The Tale of Old Venn." In *Tales of Nevèrÿon*, 79–138. Middletown, CT: Wesleyan University Press, 1993.

———. "The Tale of Plagues and Carnivals, or: Some Informal Remarks towards the Modular Calculus, Part Five." In *Flight from Nevèrÿon*, 181–359. Middletown, CT: Wesleyan University Press, 1994.

———. "Time Considered as a Helix of Semi-Precious Stones." In *Driftglass*, 223–59. New York: Signet, 1971.

Deleuze, Gilles, and Félix Guattari. *Anti-Oedipus: Capitalism and Schizophrenia.* Translated by Robert Hurley. Minneapolis: University of Minnesota Press, 1983.

———. *A Thousand Plateaus.* Translated by Brian Massumi. Minneapolis: University of Minnesota Press, 1987.

Derrida, Jacques. *Resistances of Psychoanalysis.* Translated by Peggy Kamuf, Pascale-Anne Brault, and Michael Naas. Stanford, CA: Stanford University Press, 1997.

Dirlik, Arif. "The Postcolonial Aura: Third World Criticism in the Age of Global Capitalism." *Critical Inquiry* 20, no. 2 (1994): 328–56.

DJ Mutamassik & Morgan Craft. *Rough Americana.* Circle of Light COL 002 CD, 2003.

Donne, John. *Devotions upon Emergent Occasions.* Edited by Anthony Raspa. Montreal: McGill-Queen's University Press, 1975.

Douglass, Frederick. *Narrative of the Life of Frederick Douglass, an American Slave, Written by Himself*. In *Frederick Douglass: The Narrative and Selected Writings*, edited by Michael Meyer, 3–127. New York: Modern Library, 1984.

Doyle, Jennifer. *Sex Objects: Art and the Dialectics of Desire*. Minneapolis: University of Minnesota Press, 2006.

Doyle, Laura. *Bordering on the Body: The Racial Matrix of Modern Fiction and Culture*. New York: Oxford University Press, 1994.

Du Bois, W. E. B. *The Philadelphia Negro: A Social Study*. Rev. ed. Philadelphia: University of Pennsylvania Press, [1899] 1996.

Dudley, Shannon. "Judging 'By the Beat': Calypso versus Soca." *Ethnomusicology* 40, no. 2 (1996): 269–98.

Dumas, Henry. "Will the Circle Be Unbroken?" In *Echo Tree: The Collected Short Fiction of Henry Dumas*, edited by Eugene B. Redmond, 105–10. Minneapolis: Coffee House Press, 2003.

Durham, Jimmie. "Artists *Must* Begin Helping Themselves." In *A Certain Lack of Coherence: Writings on Art and Cultural Politics*, 61–63. New York: Kala Press, 1993.

———. "A Friend of Mine Said That Art Is a European Invention." In *Jimmie Durham*, ed. Dirk Snauwaert, Laura Mulvey, Mark Alice Durant, and Jimmie Durham, 140–47. New York: Phaidon Press, 1995.

———. "The Immortal State." In *A Certain Lack of Coherence: Writings on Art and Cultural Politics*, 191–92. New York: Kala Press, 1993.

———. "Interview: Dirk Snauwaert in Conversation with Jimmie Durham." In *Jimmie Durham*, ed. Dirk Snauwaert, Laura Mulvey, Mark Alice Durant, and Jimmie Durham, 6–31. New York: Phaidon Press, 1995.

———. "Material." In *Waiting to Be Interrupted: Selected Writings, 1993–2012*, 347–55. Milan: Mousse Publishing, 2014.

Echols, Alice. "'The Soul of a Martian': A Conversation with Joni Mitchell." In *Shaky Ground: The Sixties and Its Aftershocks*, 207–22. New York: Columbia University Press, 2002.

Edwards, Brent Hayes. *The Practice of Diaspora*. Cambridge, MA: Harvard University Press, 2003.

———. "The Shadow of Shadows." *positions: East Asia Cultures Critique* 11, no. 1 (2003): 11–49.

Eisenhauer, Letty Lou. "A Version of Trace in 2008; An Interpretation of Scores." In *Fluxus Scores and Instructions: The Transformative Years*, edited by Jon Hendricks, with Marianne Bech and Media Farzin, 32–36. Roskilde, Denmark: Museet for Samtidskunst, 2008.

Eisenstein, Sergei. "A Dialectic Approach to Film Form." In *Film Form: Essays in Film Theory*, edited and translated by Jay Leyda, 45–63. New York: Harcourt Brace Jovanovich, 1969.

———. *The Film Sense*. New York: Harcourt Brace Jovanovich, 1942.

Ellison, Ralph. *Invisible Man*. 2nd ed. New York: Vintage International, 1995.

English, Darby. "Good Fences." In *Take It or Leave It: Institution, Image, Ideology*, edited by Anne Ellegood and Johanna Burton, 239–41. New York: Prestel, 2014.

Eric B & Rakim. "I Know You Got Soul," *Paid in Full*, 4th and Broadway, BWAY-4005 LP, 1987.

Fabian, Johannes. *Moments of Freedom: Anthropology and Popular Culture*. Charlottesville: University of Virginia Press, 1998.

———. With narratives and paintings by Tshibumba Kanda Matulu. *Remembering the Present: Painting and Popular History in Zaire*. Berkeley: University of California Press, 1996.

Fabião, Eleonora. "The Making of a Body: Lygia Clark's *Anthropophagic Slobber*." In *Lygia Clark: The Abandonment of Art*, edited by Cornelia Butler and Luis Pérez-Oramas, 294–99. New York: Museum of Modern Art, 2014.

Fanon, Frantz. *Black Skin, White Masks*. Translated by Charles Lem Markmann. London: Paladin, 1970.

———. *Wretched of the Earth*. Translated by Richard Philcox. New York: Grove Press, 2005.

Feld, Steve. "From Ethnomusicology to Echo-Muse-Ecology: Reading R. Murray Schafer in Papua New Guineau." *The Soundscape Newsletter/World Forum for Acoustic Ecology* 8 (June 1994): 4–6.

———. *Jazz Cosmopolitanism in Accra: Five Musical Years in Ghana*. Durham, NC: Duke University Press, 2012.

Ferreira da Silva, Denise. "No-Bodies: Law, Raciality and Violence." *Griffith Law Review* 18, no. 2 (2009): 212–36.

Foucault, Michel. *The History of Sexuality, Volume I: An Introduction*. Translated by Robert Hurley. New York: Vintage Books, 1978.

———. "Maurice Blanchot: The Thought from Outside." In *Foucault/Blanchot*, translated by Jeffrey Mehlman and Brian Massumi, 7–58. New York: Zone Books, 1987.

Freud, Sigmund. "The Unconscious." In *The Standard Edition of the Complete Psychological Works of Sigmund Freud*, vol. 14, 159–204. London: Hogarth Press, 1953–1973.

Fried, Michael. *Absorption and Theatricality: Painting and Beholder in the Age of Diderot*. Berkeley: University of California Press, 1980.

———. "Art and Objecthood." In *Art and Objecthood: Essays and Reviews*, 148–72. Chicago: University of Chicago Press, 1998.

Friedrich, Otto. *Glenn Gould: A Life and Variations*. New York: Random House, 1969.

Funkhouser, Chris. "Being Matter Ignited: An Interview with Cecil Taylor." *Hambone* 12 (fall 1995): 18–19.

Gaines, Charles. *Librettos: Manuel de Falla/Stokeley Carmichael*, an installation shown at the gallery Art + Practice in Leimert Park, Los Angeles. hammer.ucla.edu/exhibitions/2015/off-site-exhibition-charles-gaines-librettos-manuel-de-falla-stokely-carmichael/.

———. "The Theater of Refusal: Black Art and Mainstream Criticism." In *The Theater of Refusal: Black Art and Mainstream Criticism*, edited by Catherine Lord, 13–21. Irvine: Fine Arts Gallery, University of California, Irvine, 1993.

García Lorca, Federico. *In Search of Duende*. Translated by Norman Di Giovanni. New York: New Directions, 1998.

Gates, Theaster. "The Glass Lantern Slide Archive Relocation," August 7, 2012. theastergates.com/.

————. "Thinking about Language and Things That Matter." Email message to author, June 27, 2012.

Gaye, Marvin. "Since I Had You," *I Want You*, Motown CD 3746352922, 1976.

Gil, José. *Metamorphoses of the Body*. Translated by Stephen Muecke. Minneapolis: University of Minnesota Press, 1998.

Gilroy, Paul. *The Black Atlantic: Modernity and Double Consciousness*. Cambridge, MA: Harvard University Press, 1993.

————. *Darker Than Blue: On the Moral Economies of Black Atlantic Culture*. Cambridge, MA: Harvard University Press, 2010.

————. "Multiculture, Double Consciousness and the 'War on Terror.'" *Patterns of Prejudice* 39, no. 4 (2005): 431–43.

Girard, François, and Don McKellar. *Thirty two Short Films about Glenn Gould: The Screenplay*. Toronto: Coach House, 1995.

Glissant, Édouard. "One World in Relation: Édouard Glissant in Conversation with Manthia Diawara." Translated by Christopher Winks. *Journal of Contemporary African Art* 28 (spring 2011): 4–19.

Goethe, Johann Wolfgang von. *Theory of Colours*. Translated by Charles L. Eastlake. Mineoloa, NY: Dover, 2006.

Goodison, Lorna. *Guinea Woman: New and Selected Poems*. Manchester, UK: Carcanet Press, 2000.

Gordon, Avery F. *Ghostly Matters: Haunting and the Sociological Imagination*. Minneapolis: University of Minnesota Press, 1997.

Gould, Glenn. "Advice to a Graduation." In *The Glenn Gould Reader*, edited by Tim Page, 1–7. New York: Vintage, 1990.

————. "Glenn Gould Interviews Glenn Gould about Glenn Gould." In *The Glenn Gould Reader*, edited by Tim Page, 313–28. New York: Vintage, 1990.

————. "Piano Music by Grieg and Bizet, with a Confidential Caution to Critics." In *The Glenn Gould Reader*, edited by Tim Page, 76–79. New York: Vintage, 1990.

————. "Radio as Music: Glenn Gould in Conversation with John Jessup," In *The Glenn Gould Reader*, edited by Tim Page, 374–88. New York: Vintage, 1990.

————. *A State of Wonder: The Complete Goldberg Variations, 1955 and 1981*. Columbia S3K 87703, CDs, 2002.

Gould, Glenn, and Curtis Davis. "The Well-Tempered Listener." In *Glenn Gould Variations: By Himself and His Friends*, edited by John McGreevy, 275–94. Toronto: Doubleday Canada, 1983.

Gräwe, Karl Dietrich. "Fixing the Moment: The Conductor William Furtwängler," liner notes for William Furtwängler, *Recordings: 1942–1944, Vol. 1*. Deutsche Grammaphon CD Mono 471 289–2, 2002.

Gray, Mike, and Howard Alk. *American Revolution 2* (1969). Facets Video DV 86930, 2007.

Guyer, Paul. *Kant and the Claims of Taste*. 2nd ed. Cambridge: Cambridge University Press, 1997.

Hacker, Marilyn. *First Cities: Collected Early Poems, 1960–1979*. New York: W. W. Norton, 2003.

Hansen, Miriam B. "Introduction to Adorno, 'Transparencies on Film' (1966)." *New German Critique* 24–25 (fall/winter 1981–82): 186–98.

Harris, Laura. "Whatever Happened to the Motley Crew? C. L. R. James, Helio Oiticica and the Aesthetic Sociality of Blackness." *Social Text* 112, 30, no. 3 (2012): 49–75.

Hartman, Saidiya V. *Scenes of Subjection: Terror, Slavery, and Self-Making in Nineteenth-Century America.* New York: Oxford University Press, 1997.

Hill, Donald R. *Calypso Calaloo: Early Carnival Music in Trinidad.* Gainesville: University Press of Florida, 1993.

Hölderlin, Friedrich. *Hymns and Fragments.* Translated by Richard Sieburth. Princeton, NJ: Princeton University Press, 1984.

Hunter, Tera W. *To 'Joy My Freedom: Southern Black Women's Lives and Labors after the Civil War.* Cambridge, MA: Harvard University Press, 1997.

Jacobs, Harriet. *Incidents in the Life of a Slave Girl.* New York: W. W. Norton, 2001.

James, C. L. R. *The Black Jacobins: Toussaint L'Ouverture and the San Domingo Revolution.* 2nd ed., revised. New York: Vintage Books, 1989.

Jay, Martin. *Permanent Exiles: Essays on the Intellectual Migration from Germany to America.* New York: Columbia University Press, 1986.

Johnson, Barbara E. "Response" [to "Canon-Formation, Literary History, and the Afro-American Literary Tradition: From the Seen to the Told," by Henry Louis Gates, Jr.]. In *Afro-American Literary Study in the 1990s,* edited by Houston A. Baker Jr. and Patricia Redmond, 39–44. Chicago: University of Chicago Press, 1989.

Jones, LeRoi (Amiri Baraka). *Black Music.* New York: William Morrow, 1967.

———. *The System of Dante's Hell.* New York: Grove Press, 1965.

Kant, Immanuel. "Answer to the Question: What Is Enlightenment?" Translated by Thomas K. Abbott. In *Basic Writings of Kant,* edited by Allen K. Wood, 133–42. New York: Modern Library, 2001.

Kazanjian, David. *The Colonizing Trick: National Culture and Imperial Citizenship in Early America.* Minneapolis: University of Minnesota Press, 2003.

Keil, Charles. "The Theory of Participatory Discrepancies: A Progress Report." *Ethnomusicology* 39, no. 1 (1995): 1–19.

Klagge, James. *Wittgenstein in Exile.* Cambridge, MA: MIT Press, 2014.

Krauss, Rosalind. "The Im/pulse to See." In *Vision and Visuality,* edited by Hal Foster. Seattle: Bay Press, 1988.

Kun, Josh. *Audiotopia: Music, Race, and America.* Berkeley: University of California Press, 2005.

Laplanche, J., and J.-B. Pontalis. *The Language of Psycho-Analysis.* Translated by Donald Nicholson-Smith. New York: W. W. Norton, 1973.

Lepecki, André. "Affective Geometry, Immanent Acts: Lygia Clark and Performance." In *Lygia Clark: The Abandonment of Art, 1948–1988,* edited by Cornelia Butler and Luis Pérez-Oramas, 278–89. New York: Museum of Modern Art, 2014.

———. *Exhausting Dance: Performance and the Politics of Movement.* New York: Routledge, 2006.

Levin, Thomas Y. "For the Record: Adorno on Music in the Age of Its Technological Reproducibility." *October* 55 (winter 1990): 23–47.

Levinas, Emmanuel. "Interview with Francis Poiré." In *Is It Righteous to Be? Interviews with Emmanuel Levinas*, edited by Jill Robbins, translated by Jill Robbins and Marcus Coelen with Thomas Loebel 23–83. Stanford, CA: Stanford University Press, 2001.

Lewis, George. "Toneburst (Piece for 3 Trombones Simultaneously)." *The Solo Trombone Record*, Sackville SKCD2-3012, CD, 2001.

Ligon, Glenn. "Blue Black." In *Chris Ofili: Night and Day*, edited by Massimiliano Gioni. New York: Rizzoli, 2014.

Lincoln, Abbey. "At the Ford Foundation Jazz Study Group." Columbia University, November 1999. Unpublished remarks.

Lippard, Lucy. *Six Years: The Dematerialization of the Art Object from 1966–1972*. Berkeley: University of California Press, 1973.

Lippit, Akira Mizuta. *Atomic Light (Shadow Optics)*. Minneapolis: University of Minnesota Press, 2006.

———. *Electronic Animal: Toward a Rhetoric of Wildlife*. Minneapolis: University of Minnesota Press, 2000.

Little Walter. *The Complete Chess Masters (1950–1967)*. B001RLD6AM, Hip-O Records, 2009.

Lord Invader. *Calypso at Midnight*. Rounder 11661-1840-2, CD, 1999.

———. *Calypso in New York*. Smithsonian Folkways Recordings CD 40454, liner notes by John Cowley, 2000.

Lovelace, Earl. *The Dragon Can't Dance*. New York: Persea Books, [1979] 1998.

Lynch, Kevin. *The Image of the City*. Cambridge, MA: MIT Press, 1960.

McClary, Susan. *Feminine Endings: Music, Gender, and Sexuality*. Minneapolis: University of Minnesota Press, 1991.

McDowell, Deborah E. *Leaving Pipe Shop: Memories of Kin*. New York: W. W. Norton, 1998.

Macey, David. *Frantz Fanon*. New York: Picador USA, 2001.

Mackey, Nathaniel. *Atet A.D.* San Francisco: City Lights Books, 2001.

———. *Bedouin Hornbook (From a Broken Bottle/Traces of Perfume Still Emanate)*, Callaloo Fiction Series, Volume 2. Lexington: University Press of Kentucky, 1987.

———. "Cante Moro." In *Sound States: Innovative Poetics and Acoustical Technologies*, edited by Adalaide Morris, 194–212. Chapel Hill: University of North Carolina Press, 1997.

———. "Destination Out." *Callaloo* 23, no. 2 (2000): 814.

Marks, Laura U. *The Skin of the Film: Intercultural Cinema, Embodiment, and the Senses*. Durham, NC: Duke University Press, 2000.

Marks, Sally. "Black Watch on the Rhine: A Study in Propaganda, Prejudice and Prurience." *European Studies Review* 13, no. 3 (1983): 297–333.

Martin, Randy. *Critical Moves: Dance Studies in Theory and Politics*. Durham, NC: Duke University Press, 1998.

———. *Financialization of Daily Life*. Philadelphia: Temple University Press, 2002.

Marx, Karl. *Grundrisse: Foundations of the Critique of Political Economy*. Translated by Martin Nicolaus. New York: Vintage, 1973.

Melhem, D. H. "Revolution: The Constancy of Change." In *Conversations with Amiri Baraka*, ed. Charlie Reilly, 181–220. Jackson: University Press of Mississippi, 1994.

Menchaca, Martha. *Recovering History, Constructing Race: The Indian, Black, and White Roots of Mexican Americans*. Austin: University of Texas Press, 2001.

Michel, Prakazrel "Pras." With kris ex. *Ghetto Supastar*. New York: Pocket Books, 1997.

Mingus, Charles. *Beneath the Underdog*, edited by Nel King. New York: Penguin, 1971.

———. *Charles Mingus Presents Charles Mingus*. Candid LP 9005, 1960.

———. *Mingus Ah Um*. Columbia/Legacy CD CK 65512, 1998.

———. *More Than a Fake Book*, 47. New York: Jazz Workshop, 1991.

Mingus, Sue Graham. *Tonight at Noon: A Love Story*. New York: Da Capo, 2002.

Miyoshi, Masao. "A Borderless World? From Colonialism to Transnationalism over the Decline of the Nation-State." In *Politics-Poetics: Documenta X—the Book*, edited by Jean-François Chevrier, 182–202. Kassel, DE: Cantz, 1997.

———. "Outside Architecture." In *Anywise*, edited by Cynthia C. Davidson, 40–47. Cambridge, MA: MIT Press, 1996.

Monson, Ingrid. *Saying Something: Jazz Improvisation and Interaction*. Chicago: University of Chicago Press, 1996.

Morris, Lawrence D. ("Butch"). "First Curiosity," liner notes for *Testament: A Conduction Collection*. New World Records, CD, 1995.

———. "Theory and Contradiction: Notes on Conduction," liner notes for *Testament: A Conduction Collection*. New World Records, CD, 1995.

Morrison, Toni. "The Site of Memory." In *What Moves at the Margin: Selected Nonfiction*, edited by Carolyn C. Denard, 65–80. Jackson: University Press of Mississippi, 2008.

Morse, Chuck. "Capitalism, Marxism, and the Black Radical Tradition: An Interview with Cedric Robinson." *Perspectives on Anarchist Theory* 3, no. 1. flag.blackened .net/ias/5robinsoninterview.htm, paragraph 35.

Morton, Ferdinand "Jelly Roll." *The Complete Library of Congress Recordings*, disc six, Rounder Records B000GFLE35, 2005.

Moten, Fred. *In the Break: The Aesthetics of the Black Radical Tradition*. Minneapolis: University of Minnesota Press, 2003.

Mullen, Harryette. "African Signs and Spirit Writing." *Callaloo* 19, no. 3 (1996): 670–89.

———. "Runaway Tongue: Resistant Orality in *Uncle Tom's Cabin, Our Nig, Incidents in the Life of a Slave Girl*, and *Beloved*." In *The Culture of Sentiment: Race, Gender, and Sentimentality in Nineteenth-Century America*, edited by Shirley Samuels, 244–64. New York: Oxford University Press, 1992.

Mulroy, Kevin. *Freedom on the Border: The Seminole Maroons in Florida, the Indian Territory, Coahuila, and Texas*. Lubbock: Texas Tech University Press, 1993.

Muñoz, José Esteban. "Gesture, Ephemera and Queer Feeling: Approaching Kevin Aviance." In *Cruising Utopia: The Then and There of Queer Futurity*, 65–82. New York: New York University Press, 2009.

———. "Phenomenological Flights: From Latino over There and Cubania's Here and Now." Unpublished manuscript, 2.

Negri, Antonio, and Michael Hardt. *Commonwealth*. Cambridge, MA: Harvard University Press, 2009.

Nelson, Maggie. *Bluets*. Seattle: Wave Books, 2009.

Neptune, Harvey. "Manly Rivalries and Mopsies: Gender, Nationality, and Sexuality in United States-Occupied Trinidad." *Radical History Review* 87 (2003): 90–92.

Nyong'o, Tavia. "So Say We All." *Social Text Online*, January 4, 2012. socialtextjournal .org/periscope_article/so_say_we_all/.

O'Grady, Lorraine. "Olympia's Maid: Reclaiming Black Female Subjectivity." In *Art, Activism and Oppositionality: Essays from Afterimage*, edited by Grant H. Kester, 268–86. Durham, NC: Duke University Press, 1998.

Ostwald, Peter. *Glenn Gould: The Ecstasy and Tragedy of Genius*. New York: W. W. Norton, 1997.

Padillo, Genaro M. "Myth and Comparative Cultural Nationalism: The Ideological Uses of Aztlán." In *Aztlán: Essays on the Chicano Homeland*, edited by Rudolfo Anaya and Francisco Lomelí, 111–34. Albuquerque: University of New Mexico Press, 1989.

Patterson, Benjamin. *Ben Patterson Tells Fluxus Stories (From 1962 to 2002)*. Records Q 07, 2002, 29'20"—31'13".

——. *Methods and Processes*. 2nd ed. Tokyo: Gallery 360°, 2004.

——. "What Makes George Laugh?" In *Mr. Fluxus: A Collective Portrait of George Maciunas, 1931–1978*, edited by Emmett Williams and Ann Noël, 260–63. London: Thames and Hudson, 1997.

Pérez-Torres, Rafael. "Refiguring Aztlán." *Aztlán* 22, no. 2 (fall 1997): 15–41.

Philip, M. NourbeSe. *Zong*. Middletown, CT: Wesleyan University Press, 2008.

Piper, Adrian. "Critical Hegemony and Aesthetic Acculturation." *Nous* 19, no. 1 (1985): 29–40.

Priestly, Brian. *Mingus: A Critical Biography*. New York: Da Capo, 1982.

Rankine, Claudia. *Citizen: An American Lyric*. Minneapolis, MN: Graywolf Press, 2014.

Rapaport, Herman. "Of Musical Headings: Toscanini's and Furtwängler's *Fifth Symphonies, 1939–54*." In *Threshholds of Western Culture: Identity, Postcoloniality, Transnationalism*, edited by John Burt Foster Jr. and Wayne Jeffrey Froman, 60–68. New York: Continuum, 2002.

Reid-Pharr, Robert. *Black Gay Man*. New York: New York University Press, 2002.

Richards, Sandra L. "Writing the Absent Potential: Drama, Performance, and the Canon of African-American Literature." In *Performance and Performativity*, edited by Andrew Parker and Eve Kosofsky Sedgwick, 64–88. New York: Routledge, 1995.

Robinson, Cedric J. *Black Marxism: The Making of the Black Radical Tradition*. Chapel Hill: University of North Carolina Press, 2000.

Roddy, Joseph. "Apollonian." In *Glenn Gould Variations: By Himself and His Friends*, edited by John McGreevy. Toronto: Doubleday Canada, 1983.

Rodney, Walter. *A History of the Guyanese Working People, 1881–1905*. Baltimore: Johns Hopkins University Press, 1981.

Rohlehr, Gordon. *Calypso and Society in Pre-Independence Trinidad*. St. Augustine, Trinidad and Tobago: Gordon Rohlehr, 1990.

Rosen, Charles. *Arnold Schoenberg*. Chicago: University of Chicago Press, 1996.

Rudder, David. *The Autobiography of the Now*. Lypsoland CD 45692, 2001.

Sahlins, Marshall. *What Kinship Is—and Is Not*. Chicago: University of Chicago Press, 2013.

Said, Edward W. "The Music Itself: Glenn Gould's Contrapuntal Vision." In *Glenn Gould Variations: By Himself and His Friends*, edited by John McGreevy. Toronto: Doubleday Canada, 1983.

Saldaña-Portillo, María Josefina. *The Revolutionary Imagination in the Americas and the Age of Development*. Durham, NC: Duke University Press, 2003.

Saul, Scott. *Freedom Is, Freedom Ain't*. Cambridge, MA: Harvard University Press, 2003.

Schneider, Rebecca. *The Explicit Body in Performance*. New York: Routledge, 1997.

Schoenberg, Arnold. *Erwartung/Brettl-Lieder*, performed by Jessye Norman, Metropolitan Opera Orchestra, James Levine, Philips CD 426 621–2, 1993.

———. *Style and Idea*. Edited by Leonard Stein. Translated by Leo Black. Berkeley: University of California Press, 1975.

Shakespeare, William. *Richard II*. Edited by Frances E. Dolan. New York: Penguin, 2000.

Spellman, A. B. *Four Lives in the Bebop Business*. New York: Limelight Editions, 1985.

Spicer, Edward. *Cycles of Conquest: The Impact of Spain, Mexico and the United States on the Indians of the Southwest, 1533–1960*. Tucson: University of Arizona Press, 1981.

Spillers, Hortense J. "The Crisis of the Negro Intellectual: A Post-date." In *Black and White and In Color: Essays on American Literature and Culture*, 428–70. Chicago: University of Chicago Press, 2003.

———. "Mama's Baby, Papa's Maybe: An American Grammar Book." In *Black and White and In Color: Essays on American Literature and Culture*, 203–29. Chicago: University of Chicago Press, 2003.

Spivak, Gayatri Chakravorty. "Righting Wrongs." *South Atlantic Quarterly* 103, no. 2/3 (spring/summer 2004): 523–81.

Stevens, Wallace. "The Poems of Our Climate." In *The Collected Poems: The Corrected Edition*, 205–6. New York: Vintage, 2015.

Story, Rosalyn M. *And So I Sing: African-American Divas of Opera and Concert*. New York: Amistad Press, 1990.

Subotnik, Rose Rosengard. *Deconstructive Variations: Music and Reason in Western Society*. Minneapolis: University of Minnesota Press, 1996.

Swann-Wright, Dianne. *A Way Out of No Way: Claiming Family and Freedom in the New South*. Charlottesville: University of Virginia Press, 2002.

Taylor, Cecil. "Sound Structure of Subculture Becoming Major Breath/Naked Fire Gesture." Liner notes, *Unit Structures*, LP 84237. Blue Note, 1966.

Thomas, Deborah A. *Modern Blackness: Nationalism, Globalization, and the Politics of Culture in Jamaica*. Durham, NC: Duke University Press, 2004.

Vazquez, Alexandra T. *Listening in Detail: Performances of Cuban Music*. Durham, NC: Duke University Press, 2013.

Wall, Cheryl. *Worrying the Line: Black Women Writers, Lineage, and Literary Tradition*. Chapel Hill: University of North Carolina Press, 2005.

Wallace, Maurice. *Constructing the Black Masculine: Identity and Ideality in African American Men's Literature and Culture, 1775–1995*. Durham, NC: Duke University Press, 2002.

Weinberg, H. Barbara. "Studies in Paris and Spain." In *Thomas Eakins: American Realist*, edited by Darrel Sewel, 13–26. Philadelphia: Philadelphia Museum of Art, 2001.

Williams, William Carlos. *The Collected Poems of William Carlos Williams: Volume II, 1939–1962*. New York: New Directions, 1988.

Willis, Deborah, and Carla Williams. *The Black Female Body: A Photographic History*. Philadelphia: Temple University Press, 2002.

Wilson, Olly. "The Significance of the Relationship between Afro-American Music and West African Music." *Black Perspectives in Music* 2, no. 1 (1974): 3–22.

Wittgenstein, Ludwig. *The Blue and Brown Books: Preliminary Studies for the "Philosophical Investigations."* New York: Harper Torchbooks, 1965.

———. *Philosophical Occasions, 1912–1951*. Edited by James Klagge and Alfred Nordmann. Indianapolis: Hackett, 1993.

———. *Wittgenstein's Lectures on Philosophical Psychology, 1946–1947*, with notes by P. T. Geach, K. J. Shah, and A. C. Jackson. Edited by P. T. Geach. Chicago: University of Chicago Press, 1988.

Wright, Michelle M. *Becoming Black: Creating Identity in the African Diaspora*. Durham, NC: Duke University Press, 2004.

INDEX

abandonment, 133, 178, 183, 208

absolution, 255, 260

absorption, 244

abstraction, 82–83

Acosta, Oscar Zeta, 212–13

addressability, 241–42

Adorno, Theodor, 28, 52, 53, 58, 63; on Beethoven, 40–41, 48–51, 54, 59, 85; *Erwartung* and, 132, 306n1; jazz criticisms, 50, 55, 84, 129, 130–32; on loneliness, 127, 172; on long-playing records, 126–27, 144; on the movement of artwork, 86, 298n42; on the musical whole, 80–81; on music's temporality, 77–79; object of theory, 66, 298n42; operatic performance and, 118, 120, 126; on phonographs/gramophones, 121, 123–26; on radio symphony, 80; on sonorities, 56–57; structural listening and, 81, 84, 119, 126, 306n2; terror of Schoenberg and Webern, 84–85; "The Fetish Character in Music and the Regression of Listening," 83; "Transparencies on Film," 119; on writing, 81–82, 118–19, 120, 128

aesthetics: acculturation of, 143; architecture and, 186–88, 191; insurgency, 159, 256; judgment and, 29; Mingus's, 92–93, 115; musical headings and, 99; politics and, 17, 23, 26, 87, 109, 115, 117; radical, 152; of self-in-relation, 249; sentimentalism as, 186; subjectivity and, 122; theory, 221–22; traditional, 298n42; value of, 28, 143; of wealth and beauty, 196

African American, term usage, 294n3

African diaspora, 1, 110, 116–17, 161, 165, 293n3; colonial Trinidad and, 111–13; European diaspora and, 98; music/musicians and, 87, 92, 96, 115, 295n4; tradition, 2

Agamben, Giorgio, 139–40, 172

agency, 68, 75–76, 135, 141

Althusser, Louis, 29, 30, 31, 193, 204–5; Butler on, 236–37

anarchy, 20–21

animateriality, xiii, 64, 239

animation, 12, 24, 67, 278; of image, 74, 76, 81

animetaphor, 78, 120

anti-blackness, viii, x

anticolonialism/anticoloniality, 12, 186, 188, 221, 231, 250

aporia, xii, 2

apposition, 2, 37, 72, 76, 140, 142; blackness and, 300n43

appropriation, 199–200

architecture: of attractions, 188; modernism and, 190–91; outside, 195–96; performance and, 187; utopian nature of, 189–90

Armstrong, Louis, 215–16, 218, 231, 273

Arom, Simha, 105

art history, 168, 206–8, 233. *See also under* historians

artist, idea of the, 222–23

assembly or assemblage, 185, 186, 190, 196–97

attraction, 188, 191, 194

audiovisuality, 81–82, 132, 133, 246
aurality, 3, 17, 62
Auslander, Philip, 137
Aviance, Kevin, 192–94, 195, 197
Aztlán, 110

Bach, Johann Sebastian, 28, 57, 61; *Goldberg Variations*, 47–48, 104
Baldwin, James, 177, 228
Baraka, Amiri, 3, 114, 242, 280; on "place/meant," ix, 277; *The System of Dante's Hell*, 113
Barenboim, Daniel, 102–3, 108
Barry, Judith, 233
beauty, 155, 188, 192, 196, 223–24; as kitsch, 207, 210; nothingness and, 228; rough, 148, 186
Beethoven, Ludwig van, 59, 62, 80; Adorno's notes on, 40–41, 48–51, 54, 59, 85; bourgeois origins, 54, 59; First Piano Concerto, 42, 44, 47–48; Furtwängler and Toscanini conducting, 96–97; Heideggerian philosophy and, 98–99; musical form, 56; Piano Sonata 13, op. 27, no. 1, "Quasi una Fantasia," 40–41, 43–44, 48, 53, 58
being-sent, concept, 67, 75, 76
Bernstein, Leonard, 58
between, logic of, 312n1
between things, relationship, 204–5
black art, 67, 161, 242, 260–61; trauma/violence and, ix–x, xiii
black body, 137; female, 72
Black Jacobins, The (James): black radical tradition and, 7–9; dialectics in, 10–12; enlightenment and darkness phrasing, 4–7, 10; lyric and narrative, 2–3
Black Marxism: The Making of the Black Radical Tradition (Robinson), 7–9, 285n8
black music, 147–48, 151, 273–75; terror in, x, xi. *See also specific musical genres*
blackness: in African American culture, 165; anti-blackness and, viii; apposition and, 299n43; art and, 206, 231;

Beethoven's, 289n22; as black Americanness, 116–17; of blacks in Chicago, 162; blueblack and, 227–28; body and, 137; defining what "is," vii, xiii, 117, 133, 202, 279; as escape, 301n43; female sexuality and, 74; Glenn Gould's, 288n3; jazz and, 130–32; Mingus and, 113–14; national identity and, 294n3; new world, 2; no-thingness of, 210, 244; opera and, 130; origins of, 91; as a permeable circle, 299n43; predication of, viii, xii; queer, 207; sociality of, 272, 275; violence and, xi; whiteness and, 281, 312n1
Black Panther Party, 281–82
black radical tradition, 4, 10, 33, 91, 153; Marx and, 30; origins, 9, 13; Robinson's theories, 6, 7–9, 29, 110, 285n8
black study, viii, xiii, 160, 163, 202
Blom, Eric, 287n2
blue and black: blur of, 226–27, 231, 233, 255, 313n1; the face and, 234; matters, 230; medium of, 239; not-in-between, 237, 238; ordinary, 278; pigment and, 234–35; seriality, 240; in white, 228
Blue Rider(s) (Ofili), 230, 232–34, 238, 313n1
blues (musical genre), 229, 274
blur, 74, 163, 218, 239, 259, 281; absolute presence of, 226; in artwork, 244, 246; of blueblack, 226–27, 231, 233, 255, 313n1; and breathe, 266, 268–69; to bring forth in the, 254; evangelical mission of, 223; fear and, 262; in Gaines's work, 252–53; of Koreatown and South Central L.A., 254; of movement, 248; of score and speech, 247–48; vision and, 261, 263
Bonaparte, Napoleon, 5, 6, 7, 10
borders, concepts, 109–10, 227, 239
bourgeoisie, 9, 12, 50, 125, 140, 142; Beethoven's origins, 54, 59; loss of gestures and, 139; Marx on, 185–86; opera and, 143
Brady, Mary Pat, 109–10, 117

Delany, Samuel R., 154, 261, 277; death of parents, 178, 179; encounter with Cecil Taylor, 175–76; *The Motion of Light and Water*, 103, 188, 262–63, 265–66; references to bridges, 177, 181–82; relationship with Hacker, 266, 269; "Time Considered as a Helix of Semi-Precious Stones," 114

Deleuze, Gilles, 19–20, 26, 56, 78

democratization, 20–21

Derrida, Jacques, 11, 56, 69, 97, 100, 257, 260; *Of Grammatology*, 3–4

Dessalines, Jean-Jacques, 4–7, 9, 12

Dial, Thornton, 152–57, 171; conversation with Mike Kelley, 207–8

dialectics, 64, 257, 261; in *The Black Jacobins*, 2, 7, 8–12, 286n17; of historical materialism, 9

diffusion: problem of, xii; of terror, viii, x–xi

Disch, Thomas, 266

disenfranchised subjectivity, 131, 132–33

dispersion, 159–60, 162, 165

displacement, 9, 84, 193, 200, 201, 205; colonial, 300n43; literary, 118; originary, 108, 110, 198; of queerness, 192; resistance to, 109; utopian, 190

dispossession, 85, 106, 117, 153, 192, 222

dissolution, 254–55

dissonance, 75, 82, 85, 119; absolute, 255; calypso's, 100; collective, 187; dissidence and, 96, 113, 114, 115; Rosen's theory of, 127–30

Dolar, Mladen, 236

Dolphy, Eric, 106, 297n30

Donne, John, 86, 103, 117

Douglass, Frederick, viii–x, 90, 299n43

Doyle, Laura, 303n45

Dr. Faustus (Mann), 57

Du Bois, W. E. B., 71, 294n3, 312n1

Dudley, Shannon, 96, 103–6, 108

Dumas, Henry, 90–91, 106

Durham, Jimmie, 220–25

Dylan, Bob, 106

Eakins, Thomas, 71, 72–75, 80, 82–83

economy, 34, 153, 195, 209, 210; general, 107, 161, 187, 194; global, 190

Edwards, Brent Hayes, 110, 232

Edwards, Erica, 217, 277

Eisenhauer, Letty Lou, 136, 138–39

Eisenstein, Sergei, 21–22, 40–41, 48; on counterpoint in film, 57, 64–65

Ellison, Ralph, 97, 273, 274; *Invisible Man*, 216–17, 229, 231

English, Darby, 200–203, 205

entanglement and virtuosity, 275, 277, 279

ephemera, 193–94

escape, 193, 194, 214; blackness and, 140, 301n43; constant, 84–85, 174, 177; musical, 114; from slavery, 68–69

ethnographer/ethnography, 13, 15, 17

Evans, Gil, 85

exceptionalism, 87, 116, 294n3

Fabian, Johannes: on anarchy and democratization, 20–21; dialogue with Tshibumba, 1, 13–18, 24–25; ethnographic performance, 22; political aesthetics and, 23

Fabião, Eleonora, 194

faces, 234, 240–41, 244, 252

Falla, Manuel de, 246–49, 252, 266, 269

fallenness, 181, 228, 239, 250, 252

Fanon, Frantz, 158, 164, 231, 234, 238; *Black Skin, White Masks*, 312n1; case of Mlle. B., 298n43; failure of, 11

fantasy, 290n24, 299n43; counterpoint and, 56; definition of, 52; in documentary film, 40–42, 44–48, 51–52, 63–64; Freud's analyses, 52–56; musical and political, 117; phylogenetic, 53–54, 288n3

Faubus, Orval E., 87, 88, 113–14

Feld, Steven, 160

femininity, 132, 133, 137

Ferreira da Silva, Denise, 165, 175, 195, 313n1

multiculturalism, 293n3

Muñoz, José, 37, 196, 261; Kevin Aviance and, 192–94; "Phenomenological Flights: From Latino Over There and Cubania's Here and Now," 267–69; on queerness, 192

music: African–Western distinction, 104–5; analysis and, 178; and cinema intersection, 70–71; constant escape and, 84–85; fantasy and, 52; image of, 63, 65; improvisation in, 81–82; impulse and taming of, 83; muting of, 125; racialization of, 299n43; spatiality in, 52; totality and temporality of, 40, 77–78, 96–98; truth in, 44, 51, 64; as whole, 80–81; writing and, 68–69, 81–83, 122, 126, 128–29. *See also* black music; rhythm and beat; *and specific musical genres*

musical headings, 96–100

musicology, 118, 121, 129

narrative: cinema and, 47, 76; historical trajectory and, 6, 13; improvisation of, 120; lyric/lyricism and, 1–3, 10–12, 17–18; music and, 6, 13; of photographs, 80, 82; on resistance, 237

Negri, Antonio, 30, 152, 153

Nelson, Maggie, 235

Neptune, Harvey, 94, 111–12

Newton, Huey P., 250

New York City, 176–77

Nkrumah, Kwame, 231

Norman, Jessye, 118, 120, 121, 129, 132–33

nothingness and no-thingness, 154, 158, 201–3, 204, 224; absolute, 261; beauty and, 228; of blackness, 210; future and, 240; misunderstood, 241; practice of, 220

not-in-between, concepts, 266, 269; of addressability, 242; of blue and black, 237, 238; in James's *The Black Jacobins*, 2, 4, 6, 8, 10, 12; postcolonial

and the, 26; problem of, 230; seriality of, 233

nowhere–everywhere relationship, 158, 167

Nyong'o, Tavia, 165–66

Obama, Barack, 314n2

object: art and, 119, 136; changing, 219, 220, 222–23; dematerialization of, 205; image of the, 82; of performance, vii, 33, 35–37, 68; practices and, 34–35; public/private, 203; resistance of the, 33, 68; sexual, 135; surplus and, 38–39; theory, 66, 298n42

Ofili, Chris, 239, 242, 244, 313n1; *The Blue Rider(s)*, 230, 232–34, 238, 313n1; colors used in works, 230–31

Olympia (Manet), 72–73, 136, 138, 307n4

openness, 175

opera: black sound in, 130; *Carmen*, 134, 137, 144–45, 308n9; culinary moment of, 145–46; *Erwartung*, 118, 122–23, 127, 129–33, 306n1; *La Vida Breve*, 246–49, 251–52; objectification of, 126; sense and sensuality of, 140–41; *Tristan and Isolde*, 134, 137, 145, 308n9; vulgarity of, 142–43

Ostwald, Peter, 47, 61–62

painting: aural accompaniments, 18–19; exhibits, 73; lyricism in, 21; materiality of, 238; performance and, 23–24, 26; realist, 74; sociality of, 83; temporalization of, 77–80; truth of, 239; Tshibumba's, 13–19; writing and, 82

paradise, 171–72

paraontology, 312n1

Parker, William, 302n43

patriarchy, 208, 278

Patterson, Benjamin, 134–35, 142–46; *Lick Piece*, 135–39

Pérez-Torres, Rafael, 110

performance: aesthetic and, 26; architecture and, 187; body in, 134–35, 140;

Rodney, Walter, 286n17
Rollins, Sonny, 295n12
Rosen, Charles, 127–30
Rough Americana (Mutamassik/Morgan Craft), 147–51
Rudder, David, 108, 117, 304n51

Sahlins, Marshall, 258–59
Said, Edward, 56, 58, 101, 108, 196
Saul, Scott, 103
Schneemann, Carolee, 134–38, 145
Schneider, Rebecca, 134–36, 291n8
Schoenberg (Schönberg), Arnold, 57, 85, 288n7; on dissonance, 127, 128; *Erwartung*, 118, 122–23, 127, 129–33, 306n1
Searle, John, 259
self-condemnation and self-determination, 214, 249–50, 255–56, 314n2
self-reflection, 251, 256
sense and sensuality, 140–41, 238
sense datum, 204
seriality, 233, 234, 253, 254; blue, 240; motion and, 75
severalty, 220–22
sexuality, 74–75; autonomy, 111; musicians and, 100, 103, 106–7
Shatz, Adam, 271, 276, 278
Skinner, B. F., 37
slavery: escape, 68–69; freedom and, xii, 76; global modernity and, 198; knowledge of, 76, 90; proletariat and, 286n17; violence of, x
Smith, Wadada Leo, xiii
Snoop Dogg, 276–77, 278
sociality and antisociality, 202–3, 204, 244; of blackness, 272, 275
solitude, 44, 46, 48, 58, 269
something–nothing relationship, 154–57
Son, Hoyun, 253, 269
sonata: definition, 287n2; fantasy and, 56. *See also under* Beethoven, Ludwig van
sonorities, 56–57, 304n47
sound: black, 130; body and, 125–26; color and, 22, 88; counterpoint and,

57; dissonance, 128, 130; image and, 26–27, 41, 70, 79; light and, 218; in literature, 3; painting and, 18–20, 26; relative place of, 52; in *Rough Americana*, 147–51; valorization of, 121. *See also* music; opera
soundscape, 148–49, 151
sovereignty, 73, 247, 254–56, 266, 269; autopositioning of, 72; democratization of, 251; resistance to, 222
spatialization, 77, 78, 109–10
speech–writing interplay, 3–4, 7
Spicer, Edward, 109
Spillers, Hortense, ix, xi, xiii, 67, 69, 278
Spivak, Gayatri, 273, 305n69
Stevens, Wallace, 226, 229, 257
Subotnik, Rose Rosengard, 121, 123, 128, 131, 306n2
surplus, 17, 34–35, 101; lyricism, 1, 20, 21; object and, 38–39
Swann-Wright, Dianne, 153
Swed, Mark, 252
swing, 94, 95, 99–100, 304n47; in Gershwin, 98; originary displacement of, 108

tactile experience, 61–64
Taylor, Cecil, 53; death of parents, 178, 180; encounter with Samuel Delany, 175–77; piano playing, 180–81
temporal geography, 109
thingliness: of artwork, 99; audiovisual, 132; counterpoint and, 46; image and, 205; machinic, 177; personhood and, 186; of swing music, 99–100; temporality and, 77, 96, 101
Thirty Two Short Films about Glenn Gould (Girard): *Forty-Nine*, 288n7; *Glenn Gould Meets Glenn Gould*, 44–45; Gould's performativity, 64; *Hamburg*, 40–44, 45–47, 48, 56, 63, 289n8; *The Idea of North*, 47, 58; "Practice" and "Passion according to Gould," 65
thought, concepts, 66–67
time signature, 104–6